FROM STUDIO

TO STUDIOLO

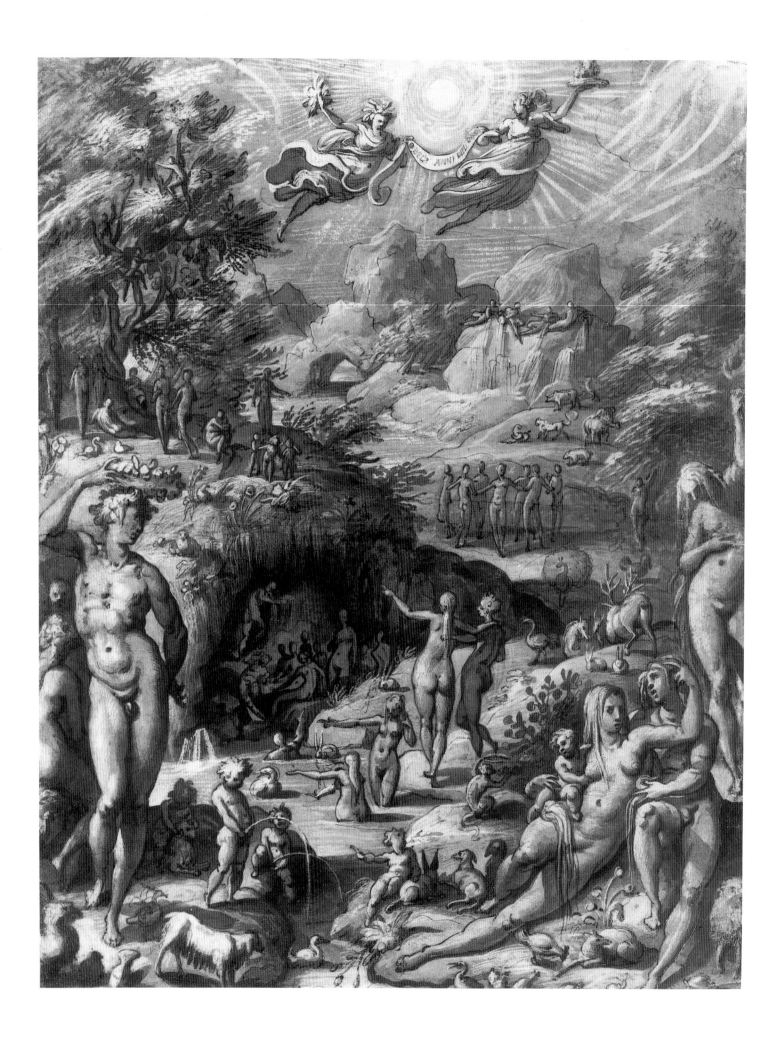

From Studio to Studiolo:

Florentine Draftsmanship under the First Medici Grand Dukes

Larry J. Feinberg

with an essay by Karen-edis Barzman

Allen Memorial Art Museum
Oberlin College

Distributed by
University of Washington Press
Seattle and London

Exhibition Itinerary

Allen Memorial Art Museum
Oberlin College
October 14–December 1, 1991

Bowdoin College Museum of Art
January 27–March 15, 1992

Hood Museum of Art
Dartmouth College
April 6–May 24, 1992

Produced by Marquand Books, Inc., Seattle
Edited by Suzanne Kotz and Fronia Simpson
Designed by Scott Hudson
Composition by The Type Gallery
Printed and bound in Japan by Toppan Printing Co., Ltd.

Cover: Jacopo Zucchi, *The Story of Prometheus* (cat. no. 57)
Back cover: Jacopo Ligozzi, *Allegory of Avarice* (cat. no. 21)
Frontispiece: Jacopo Zucchi, *The Age of Gold* (cat. no. 61)

Library of Congress Cataloging-in-Publication Data
Feinberg, Larry J.
 From studio to studiolo: Florentine draftsmanship under the first Medici grand dukes/ Larry J. Feinberg; with an essay by Karen-edis Barzman.
 p. cm.
 Exhibition schedule: Allen Memorial Art Museum, Oberlin College, Oct. 14–Dec. 1, 1991; Bowdoin College Museum of Art, Jan. 27–March 15, 1992; Hood Museum of Art, Dartmouth College, April 6–May 24, 1992.
 Includes bibliographical references.
 ISBN 0-295-97145-2: $24.95
 1. Drawing, Italian—Italy—Florence—Exhibitions. 2. Mannerism (Art)—Italy—Florence—Exhibitions. 3. Drawing—16th century—Italy—Florence—Exhibitions. I. Allen Memorial Art Museum. II. Title.
NC 256.F5F4 1991
741.945′51′0903107474—dc20 91-18170

Photo credits
Alinari/Art Resource, New York: Feinberg figs. 2–3, 8, 14, 20, 22, 33; © 1990 The Art Institute of Chicago. All rights reserved: cat. nos. 42, 54; Dean Beasom: cat. nos. 21, 59; © 1991 British Museum: Feinberg figs. 5, 15, 21; © 1991 The Fine Arts Museums of San Francisco: cat. no. 46; Allan Finkelman: cat. no. 6; Gabinetto Fotografico Soprintendenza Beni Artistici e Storici di Firenze: Feinberg figs. 4, 26; Gabinetto Fotografico Soprintendenza Gallerie, Firenze: Feinberg fig. 25; All rights reserved, The Metropolitan Museum of Art: cat. no. 52; Otto E. Nelson: cat. no. 47; Prudence Cuming Associates Ltd.: cat. no. 22; © 1991 R.M.N.: Feinberg figs. 18, 32, Barzman fig. 4; Joseph Szaszfai: cat. nos. 3, 8, 15 (recto), 31; © 1991 Trustees of Princeton University: cat. nos. 5, 17, 24, 29, 35, 60

Contents

FOREWORD

This exhibition represents several years of hard work by Larry J. Feinberg, the Allen Memorial Art Museum's Chief Curator. Early in his tenure at Oberlin, we discussed exhibitions that needed to be done in his area of expertise, Italian art of the Renaissance. The exhibition he chose to organize is unusually focused and breaks new ground in a heretofore little-examined chapter in the development of Florentine draftsmanship.

This exhibition is, in many ways, a model for a college or university art museum. It will also be, we hope, an exhibition of considerable visual delight for all those who love fine drawings. Many of the drawings are being published here for the first time, and so the exhibition brings a fresh perspective and new insights by its very content as well as by its analysis of the body of work presented.

We are very pleased to share this exhibition with the Bowdoin College Museum of Art and the Hood Museum of Art, Dartmouth College. I thank their respective directors, Katharine J. Watson and James M. Cuno, for their commitment to this project, which has made such an expensive undertaking more feasible financially, while giving a much larger audience the opportunity to study and enjoy the exhibition.

I would also like to give special thanks to the National Endowment for the Arts for its early and generous support of this exhibition. My thanks also to the Ohio Arts Council for their overall support of the museum's exhibition program for 1991–1992, the season in which this project falls. We also deeply appreciate the funds contributed by the drawings departments of Sotheby's and Colnaghi in London for the color illustrations in the catalogue.

Nineteen ninety-two marks the seventy-fifth anniversary of the Allen Memorial Art Museum, which first opened its doors in 1917. I am happy to designate *From Studio to Studiolo: Florentine Draftsmanship under the First Medici Grand Dukes* as the first of several exhibitions to celebrate this important occasion.

WILLIAM J. CHIEGO
DIRECTOR

ACKNOWLEDGMENTS

Even a relatively small and focused exhibition such as this requires the labor and support of many individuals. First I should like to express my gratitude to Professor Karen-edis Barzman, for contributing to the catalogue an important essay that investigates the relation of the theory of *disegno* to academic practice in late sixteenth-century Florence. Through our discussions and her work, she has also helped me to refine and clarify my own ideas. In addition, she has provided invaluable assistance in resolving some of the practical problems involved in the production of this catalogue. I wish to express my appreciation as well to Professors Sydney J. Freedberg and Richard E. Spear for carefully reading through my essay and offering numerous suggestions and warm support.

I am also grateful to Julien Stock for his abundant enthusiasm for and support of this project. We would not have been able to assemble such a rich and varied group of works without his generous assistance in locating drawings in private collections. He and the Old Master Drawings Department of Sotheby's in London are responsible as well for the transport of drawings from private collections in Great Britain to the United States and for funding the color reproductions found in this catalogue. The Drawings Department of Colnaghi in London also generously provided support for the color illustrations.

Many thanks are due to the staff members of the Allen Memorial Art Museum for their hard work and dedication: William J. Chiego, Director; Elizabeth A. Brown, Curator of Modern Art; Anne F. Moore, Curator for Academic Programs; Joan-Elisabeth Reid, Registrar; Leslie J. Miller, Administrator of Special Events and Membership; Scott Carpenter, Preparator; Marjorie L. Burton, Museum Security Supervisor; Elsie Phillips, Housekeeper; John T. Seyfried, Photographer for Special Projects; Corinne Fryhle, Intern/Assistant to the Curator for Academic Programs; Susannah Michalson, Registrar's Assistant; Beth Wolfe, Intern/Assistant to Preparator and Sachi Yamari, NEA Curatorial Intern. I wish particularly to thank Bea Clapp, Administrative Assistant, for her boundless patience and good humor in typing and revising the catalogue manuscript, and Lisa Cheng and Amy McIntyre, Graduate Assistants at the Allen, for their compilation and careful checking of bibliographical references in the catalogue. Special acknowledgment is due Gianvittorio Dillon and Silvia Meloni Trkulja for their aid in securing photographs for the catalogue essays.

The following individuals have kindly given their assistance in a variety of ways: Morton C. Abramson, Jean-Luc Baroni, Jacob Bean, David Becker, Nancy Benson, Mark Brady, Mungo Campbell, Timothy Clifford, Cara D. Dennison, Amy Eshoo, Richard Field, Hilliard Goldfarb, Nicholas Hall, Mary Jane Harris, Julius Held, Scott Hudson, Laurence Kantor, Diane Keshner, Suzanne Kotz, Elizabeth Llewellyn, Catherine Monbeig-Goguel, Joan L. Nissman, Kelly Pask, William Robinson, Donald A. Rosenthal, Arlette Sérullaz, Robert Simon, Jack Spalding, Miriam Stewart, Roger Ward, Mia Wiener, Thomas Williams, and Linda Wolk-Simon.

Finally and foremost, I must express my gratitude to my wife, Starr Siegele, for sharing her insights and for her sustaining encouragement as I worked on this project.

LARRY J. FEINBERG
CHIEF CURATOR

FLORENTINE DRAFTSMANSHIP UNDER

THE FIRST MEDICI GRAND DUKES

BY LARRY J. FEINBERG

For an artist working in Florence in the last four decades of the sixteenth century, the rule of the Medici family meant both unprecedented opportunity and restriction. Artists, like their fellow citizens, enjoyed the stability—political, social, and economic—imposed on Florence and the surrounding region of Tuscany by the Medici grand dukes through the threat of military force and an extensive network of neighborhood spies and informers (*denunziatori*). Cosimo I de' Medici (1519–74), who had himself named the first grand duke of Tuscany, was the architect of this totalitarian state (fig. 1). Its bureaucratic and political cohesion was such that it functioned well even under the sometimes far less competent management of Cosimo's successors, his sons Francesco I (1541–87) and Ferdinando I (1549–1609).

Ostensibly operating within the framework of a republican government, with councils and committees supposedly elected by the Florentine populace, the Medici state was in fact corrupted or compromised at every level. Pro-Medici hacks held almost every key position in government and ensured that the Florentine *borse* (ballot bags) yielded the desired results. Those who opposed the system were usually condemned to the *secrete*, the political prisons. Whispered stories about the *secrete*, from which enemies of the state seldom emerged, were enough to inhibit any discussion about sedition. Even Cosimo's founding, in 1540, of the Accademia Fiorentina, the Florentine literary academy, was to a large degree an attempt to control what was said about him; the rules of the academy were formulated to discourage progressive political thought. Under its previous name, the Accademia degli Umidi, it had sometimes served as a political instrument of those opposed to the Medici. Cosimo's supporters gradually infiltrated

and gained control of the academy, transforming it into an organ of the state. The historians Cosimo supported, Benedetto Varchi, who was made official state historian in 1547, and Scipione Ammirato, whom Cosimo brought to Florence in 1570, also obligingly held to the Medici party line. Ammirato, in accordance with Cosimo's wishes, advocated in his historical writings the reestablishment of the complete political unity of Tuscany.

Although the Accademia del Disegno, the first artists' academy in Europe, was initiated in 1563 by the artists themselves to elevate their social status and to advance artistic education and training, it is likely that this institution, too, was fostered by the regulatory spirit of Cosimo's Florence. Artists perhaps believed it preferable to regulate their activities themselves rather than allow Cosimo the chance to impose his own order. The grand duke was quick to recognize the academy's potential as a propaganda organ and gave it his full support. The academicians responded by aggrandizing Medici history in their first major projects: the decorations for Michelangelo's funeral in San Lorenzo in 1564 and Francesco I's wedding to Giovanna of Austria in 1565. In the art and attitudes it generated, the academy promoted not only Cosimo's reign but his philosophy of discipline, meticulous organization and systematization, and adherence to tradition.[1]

Questions about the legitimacy of such a repressive regime were in Cosimo's case compounded by the weakness of the bloodlines that tied him to the noble Medici clan. Raised in the backwater of Trebbio, Cosimo descended from a provincial branch of the illustrious family. When his predecessor Alessandro de' Medici left no heir, he was plucked from relative obscurity and brought, with the blessing of

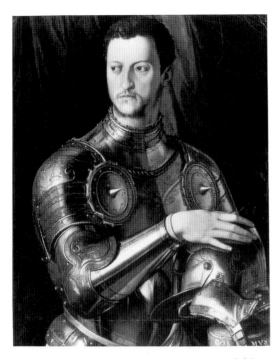

FIG. 1 Agnolo Bronzino, *Portrait of Cosimo I de' Medici*, c. 1543, oil on panel, private collection.

Emperor Charles V, to Florence to rule. Because his claim to power was dubious, Cosimo found it necessary to promote the idea of continuity of Medici succession. To this end, he stressed the historical and astrological connections between himself and his fourteenth- and fifteenth-century ancestors and attempted to trace the Medici lineage to ancient Etruscan kings. On the grand duke's orders, scores of artists and artisans participated in the refurbishing of the Palazzo Vecchio, Cosimo's state and living quarters, which involved the painting of countless Medici allegories and scenes of Medici history, transforming the old republican town hall into a dynastic monument. He actually encouraged an Etruscan revival of sorts in order to advance the myth of a renewed Tuscan *imperium*. Investigations were made, at Cosimo's request, of the supposed Etruscan origins of the Tuscan language. The primary goals of his literary academy were to purify the Tuscan tongue and republish its classics.

These and other endeavors fostered in Florence a strong historical consciousness, which must have profoundly affected the city's artistic community. Florentine painters closely imitated and synthesized the works of their predecessors, particularly those such as Jacopo Pontormo, with a long record of ser-

vice to the Medici. Masaccio's frescoes (1425–27) in the Brancacci Chapel of Santa Maria del Carmine and Lorenzo Ghiberti's bronze Gates of Paradise (1425–52), the latter described by Vasari as "the most beautiful work ever seen in the world, whether ancient or modern,"[2] were also much venerated and were regarded as schools of art for young painters. As a result of these interests, by the end of the century artistic styles practiced 50 to 150 years earlier saw revivals, and a pure Florentine artistic dialect emerged. The term "dialect" is appropriate because it suggests at once the notion of variations in a language and the interplay of artistic and literary thought.[3]

A generic Florentine style, largely dependent on the art of Pontormo and Andrea del Sarto, was only one of several artistic modes the late sixteenth-century Florentine painter could employ. The historical consciousness of the period and the constant borrowing from earlier artists' work brought about a growing style-consciousness in the second half of the century. As a predictable outcome of this concern for style, an uncodified yet de facto theory of "manners" evolved. Certain artistic styles became associated with particular genres of art, and painters could choose from a small repertory of styles, or modes, depending on the circumstances of a specific commission.

The concept of artistic modes actually had currency long before the time of G. P. Lomazzo, the late sixteenth-century Lombard painter and art theorist, and subsequent Baroque theorists. The Renaissance acceptance of the Horatian dictum of *ut pictura poesis*—the equivalence of word and picture—easily led to the corollary that the principles of rhetoric in speech and literature, including their systems of modes, could be applied to art. Giovanni Battista Armenini, Pontanus, Benedetto Varchi, and other sixteenth-century writers frequently drew parallels between painting and poetry. Likewise, educated artists of the period, especially poets such as Baccio Bandinelli, Agnolo Bronzino, and Michelangelo, would have been well acquainted with the literary criticism of Aristotle, "Demetrius" of Phaleron, and Horace, and with the Ciceronian modes for public speaking and writing. Notions of stylistic decorum, the use of manners appropriate to the grandness or

lowliness of the subject, would have been inculcated into the artists' habits of thought.[4]

For Medici propaganda and other secular histories, many late sixteenth-century Florentine artists would employ a very legible and prosaic Sartesque or Pontormesque mode (cat. no. 19); for a pious, old-fashioned patron, an archaistic and uncomplicated *arte sacra* style (cat. no. 9); for a sophisticated nobleman, an extravagant and complex *maniera* (cat. no. 42); and so on. Artistic modes were nothing new to Florence,[5] but they seem to have become much more defined and systematized at the end of the sixteenth century with the enthusiastic study and emulation of the rhetorical literary modes of Horace and Cicero and the establishment of the Accademia del Disegno. While no hard evidence proves that any mode was officially sanctioned by the academy, the frequent and almost unvaried use of certain manners, such as the "secular-prose" style (cat. no. 19), suggests institutional endorsement. The systemization of styles was in some respects a practical outcome of contemporary art theory, which had organized the abstract principles that lay behind the practice of the arts into the doctrine of *disegno*.[6] In a more general way, the artistic community must have been affected as well by the habit of categorization that was so fundamental to the thought and activities of Cosimo and then Francesco.

Under Francesco I (fig. 2), who had the title of grand duke conferred on him in 1576, the Florentine government and cultural organizations continued to function as if Cosimo were still alive. Melancholic and reclusive, Francesco had little aptitude for statecraft and almost no interest in foreign affairs. While he worked to maintain the good relations with Spain that his father had achieved, Francesco let his diplomats handle, without much guidance, policy involving Austria, France, and other major powers. Although he did foster some domestic stability—he prohibited gambling and forbade the carrying of arms in the city—many of his contemporaries viewed him as an absentee grand duke, an enigma who retreated from public life in order to engage in private, unwholesome activities. Rumors of his participation in orgies and witchcraft circulated around Florence and resulted in a perception of Francesco that persisted until the nineteenth century in the

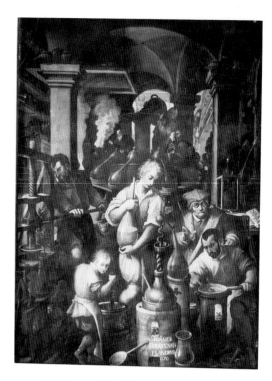

FIG. 2 Giovanni Stradano, *Francesco I (Seated) in His Alchemy Laboratory*, 1570, oil on slate, Studiolo of Francesco I, Palazzo Vecchio, Florence.

romanticized accounts of his life by Gherardi and Sabottini.[7]

We now know that a good deal of Francesco's time was spent in the workshops and laboratories established by Cosimo. If he did not inherit his father's mastery of government, he did, at least, inherit his intellectual curiosity and interests in chemistry, alchemy, metallurgy, and botany.[8] In the Medici laboratories (which were at first located in the Palazzo Vecchio but transferred later to the Boboli Gardens and eventually to the Uffizi), Francesco conducted countless metallurgical and pharmaceutical experiments. There, too, he discovered, according to the contemporary accounts of English travelers, ways to renew the lustre of pearls, developed new forms of porcelain, and did research on crystals. The latter enterprise, together with his predilection for semi-precious stones, led to his founding of the *pietra dura* industry in Florence. The application of science to even the luxury crafts is indicative of the methodical and practical character of his thought. In certain activities he demonstrated the intellectual rigor and discipline of his father. Like Cosimo, Francesco emulated the rituals of the Spanish court, but the rigid

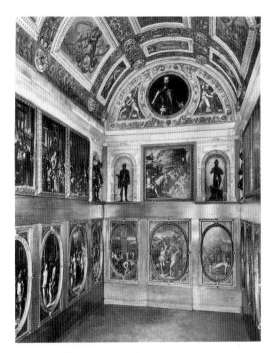

decorum he observed far exceeded the formality of his father. For Cosimo, court ceremony was necessary primarily for the public image it projected; he wished to elevate the Medici to the status of other ruling houses of Europe. For Francesco, a thoroughly ritualized lifestyle seemed to fulfill a neurotic need.

Early in his reign Francesco was an enthusiastic patron of the fine arts, continuing the course set by his father. He commissioned public sculpture (Giambologna's *Rape of the Sabines*), festival decorations from Bernardo Buontalenti and other academicians, and he completed projects left unfinished at Cosimo's death (e.g., the painting of the Salone del Cinquecento in the Palazzo Vecchio). Occasionally Francesco ordered frescoes to be painted in the villas he had constructed or reconstructed in the Tuscan countryside. Gradually, however, he seems to have focused more on the minor arts, and he preferred to collect works of art rather than initiate their creation. Satisfying his taste for the curious and bizarre, Francesco formed large collections of unusual or rare biological, geological, and botanical specimens. Some of these oddities, together with other precious materials, were stored in the small sanctum—known as the Studiolo but actually a vault room—that Francesco had constructed in the Palazzo Vecchio

between 1570 and 1573 (fig. 3).[9] The decorative program of the room was devised by Vincenzo Borghini (the prior of the Ospedale degli Innocenti and first *luogotenente* [director] of the academy) and had as its principal theme the relation between art and nature. Organized according to their affiliations with the four elements (the Pythagorean tetrad of earth, air, fire, and water), the objects were kept in thirty-four cabinets on four walls. Each cabinet was covered by a panel with the representation of a scene—religious, mythological, historical, or industrial—which in some way referred to the material behind it. The artist Giorgio Vasari, for example, contributed a depiction of the myth of Perseus and Andromeda that offered a graphic account of the origin of coral, the material its cupboard contained. Because of coral's association with the sea, Francesco's samples, in some instances fashioned into jewelry, were stored in a cabinet on the Water wall. Flints and gunpowder were kept in a cabinet on the Fire wall.

Francesco's tendency to systematize, which in the case of the Studiolo resulted in the employment of paintings as signs to denote contents,[10] had a more profound consequence for the arts in general. It was Francesco who was responsible for gathering together the Medici's vast collection of paintings and antiquities and assembling them in an organized fashion in the Uffizi. Francesco's act was a logical and practical extension of the historicizing of Cosimo's propaganda and of Vasari's compendium of artists' biographies—the *Lives of the Artists*—with its division of the history of art into periods. Not coincidentally, just a few years earlier, Vasari's friend Paolo Giovio had coined the term (and idea of) "museum" for his collection of portraits of famous men in Como.[11] By arranging works of art chronologically and geographically, Francesco could more easily see what his collection lacked and try to fill the lacunae.[12] Thus even his acquisitive impulse was conditioned by a desire to complete categories and keep a relatively balanced order in an encyclopedic collection. Francesco's amassing of works was also due to his desire to preserve Florence's cultural patrimony. Vasari credited Cosimo and Francesco with reversing the trend of exportation of art from Florence and the placement of works in private collections.[13]

Ferdinando I (fig. 4), who succeeded his brother

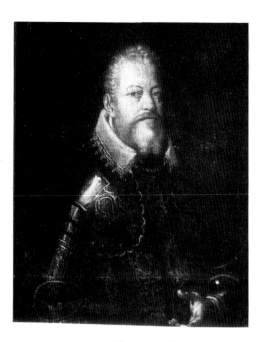

FIG. 4 Anonymous Florentine, *Portrait of Ferdinando I*, oil on canvas, Uffizi, Florence.

Francesco in 1587, augmented the Medici collection with the many antiquities he acquired while a cardinal in Rome. More important for the Medici—and Florence—were the diplomatic skills he acquired at the Vatican. If he did not have his father's vision for government, he did, at least, have a keen sense for public relations, and he was able to restore political ties and constituencies that had been neglected during Francesco's reign. He fought corruption, firing the dishonest head of the wool guild, and he managed to keep food prices within the reach of the poor. With the calculated benevolence of a modern politician, Ferdinando walked through the streets of Florence distributing grain to the victims of the floods of 1589 and 1601. In happier times, he entertained his public with grand festivals and pageants, more elaborate even than those sponsored by Cosimo.[14] Following Francesco, Ferdinando relied on Buontalenti, the court artist Jacopo Ligozzi, and other academicians to design lavish floats and costumes for those events and also to create precious objects—vases, chalices, portable altarpieces—to be given as gifts to foreign rulers and visiting dignitaries. The success of Ferdinando's diplomacy, both international and local, can be measured by the immense popularity he enjoyed, particularly among the patrician class.

Although the noble families of Florence were participants in the governments of Cosimo and Francesco, aristocrats were somewhat outnumbered by the bureaucrats the Medici had brought in from the Tuscan provinces, lawyers and competent bourgeoisie whose gratitude inspired their loyalty. Cosimo ennobled some of these men so they could become members of the Florentine senate. The true nobility were nonetheless content with the power they were allotted and their courtier status. Many, no doubt, accepted the severity of the Medici regime because of the protection it afforded them, for during the time of Francesco and Ferdinando, armies of bandits—two to three hundred strong—roamed the Tuscan countryside.

In Ferdinando's administration, the patricians played a much more significant role, assuming key positions on the highest councils in the government. Spanish court etiquette increasingly became the model for social intercourse, and social life itself gradually became stratified and rigid. Nobles no longer would play the denigrating roles in church ritual or engage in *la lavanda*, ritual washing.[15] In the elitist climate of the 1580s and 1590s, few cared to make the symbolic adoption of poverty. The neo-feudal caste that evolved, of self-absorbed and pleasure-seeking aristocrats, had in certain respects a chilling effect on Florentine culture.

For his part, Ferdinando remained supportive of the Florentine academy, engaging the services of its

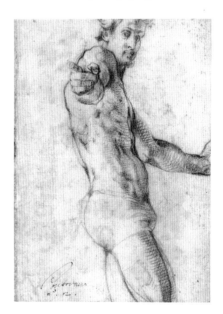

FIG. 5 Jacopo Pontormo, *Self-Portrait*, c. 1525, red chalk, British Museum, London (no. 1936-10-10-10r).

members for numerous projects, including some of ambitious scale. He ordered the construction of a new Medici funerary chapel in San Lorenzo, the Cappella dei Principi, and commissioned three new villas. Aside from the ephemeral decorations he ordered for theatre festivals and processions, such as those celebrating the marriage of his son Cosimo II to Maria Maddalena of Austria, his main patronage of the visual arts was of works of sculpture. It was Ferdinando who commissioned and had distributed throughout Florence the many likenesses of his father and of himself that can be found in the city to this day, in the *piazze* before the Palazzo Vecchio and the church of Santissima Annunziata, on countless building façades, and at seemingly every major intersection. The political circumstances that were simply and silently understood in the era of Cosimo and Francesco were made manifest during Ferdinando's reign, when the acceptance of Medici dominance was virtually complete. By then a divine-right theory of Medici rule had emerged.[16]

The regimentation of daily life and consequent conditioning of thought in grand ducal Florence affected artistic production in a number of ways, including, it would seem, general working methods. Toward the end of the sixteenth century, painters returned to older, more thorough procedures for developing their compositions. Senior artists appear to have instructed young painters and sculptors to abandon many of the shortcuts that had been practiced since mid-century. Instead they advocated Michelangelo (1475–1564), Andrea del Sarto (1486–

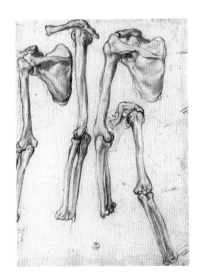

FIG. 7 Jacopo Pontormo, *Studies of Bones*, c. 1519–21, red chalk, Uffizi, Florence (no. 6522F).

1530), and especially Pontormo (1494–1557) as academic models. One of the results was an epidemic of life studies and anatomical drawings.

Responding enthusiastically to the novelties and peculiarities of Pontormo's art, scholars have tended to overlook the impact that his consummate draftsmanship and his more naturalistic essays in paint had on young artists (fig. 5). Written in the 1960s, when even in art history the unconventional became the ideal, two of the most important and influential studies of Pontormo's work perhaps overemphasized his eccentricities and consequently neglected his more academic side.[17] No artist in Florence had a more rigorous and disciplined working method; for each major picture Pontormo created countless life studies (sometimes including the study of skeletons), compositional drawings, and, occasionally, clay models (figs. 6–7).[18] He continued the laborious method of transferring cartoons by pricking and pouncing, even though most of his contemporaries, from mid-century on, used a stylus for transferring designs, a much quicker if less precise procedure. Bronzino, Pontormo's pupil, and other Florentine academicians must have regarded his graphic legacy as a fine example to young painters, not only in respect to the naturalism and quality of his life studies but in the lessons of diligence and professionalism they taught.

Despite certain implications to the contrary in Vasari's *Lives*, Pontormo was held in extremely high esteem during his entire lifetime and for several

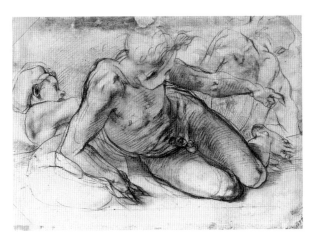

FIG. 6 Jacopo Pontormo, *Nude Studies*, c. 1520, red chalk, Uffizi, Florence (no. 6677Fv).

decades after his death. He was in effect if not in title the Medici court painter for some twenty years, entrusted with the decoration of the family's villas at Poggio a Caiano, Careggi, and Castello and with frescoes for the choir of the Medici church of San Lorenzo in Florence. The villas were not merely private hunting lodges for the Medici but resting spots for important visiting dignitaries, places where foreign heads of state could sleep and bathe before making their ceremonial procession into Florence itself. Often banquet tables were set up for visiting guests in the loggia of a villa, which consequently became a popular site for frescoes depicting scenes of family virtue (e.g., Pontormo's figures symbolizing the fortunes and virtues of Alessandro de' Medici in the villa at Careggi). The formal gardens of Castello and other villas also provided a proper setting for certain ducal and, later, grand ducal ceremonies and functions. Thus, much prestige was attached to the commissions for the decoration of these villas, and presumably the project would have been entrusted to the artist considered most talented by the Medici. In the 1540s and 1550s this seems to have been Pontormo, who was also asked to paint the portraits of numerous Medici, including Alessandro and Cosimo I. When in 1562 the newly revived Compagnia di San Luca (the artists' confraternity) had constructed, with Cosimo's support, a communal tomb for artists in the church of the Annunziata, it was decided that Pontormo's remains should be the first interred there. (His body had to be exhumed from the Chiostro dei Morti in the Annunziata complex where he had been buried in 1557.) On May 21, 1562, just days after Pontormo was reburied, the formation of the Accademia del Disegno was announced. When one considers all of the great Florentine masters who could have been chosen for this honor, one realizes how immense Pontormo's posthumous stature must have been at the time of the academy's founding.

A number of artists active in that period, Mirabello Cavalori (c. 1530–72), Maso da San Friano (1531–71), and Francesco Morandini, called Il Poppi (1544–97), among them, participated in a Pontormo revival of sorts. The young Pontormo revivalists were, no doubt, encouraged in their endeavors and directed to some degree by artists of an older generation, painters such as Bronzino (1503–72), who actually studied with Pontormo, and others, such as Pier Francesco Foschi (1502–67) and Carlo Portelli (before 1510–74), who obviously appreciated and reacted to Pontormo's art throughout their careers. Thanks to the combined works of these senior artists, a subcurrent of Pontormo's style persisted in Florence from the time of his death until the late 1590s. In the first decades of the seventeenth century his art was still so highly regarded and valued that portraits by Bronzino and Sarto were often assigned to Pontormo in contemporary inventories.[19]

Vasari is to blame for some of the modern misconceptions about Pontormo and his place in the Florentine artistic tradition, particularly the views that the painter was almost wholly isolated from his contemporaries and the succeeding generation of artists and that his style was irrelevant for late sixteenth-century tastes. To increase his own historical stature as Medici court painter, Vasari tried to diminish Pontormo's in the Lives by attacking his professional conduct and by making other—mainly arbitrary—criticisms of his paintings. For example, he severely reprimanded Pontormo for borrowing motifs from Albrecht Dürer and for being too experimental, for going beyond his nature.[20] By asserting that Pontormo's mature works, specifically his Passion frescoes (1523–24) in the Certosa di Val d'Ema, are tainted by Germanisms, Vasari was not merely being jingoistic but implying that the pictures were unacceptable models for the pure Tuscan style being developed at that time by the academicians. That his remarks are primarily political in nature and meant to discredit Pontormo is suggested by the fact that Vasari had little or no criticism for Francesco Bacchiacca, Baccio Bandinelli, and Sarto, who were guilty of the same offense.[21] Interestingly, in his Life of Bronzino, Vasari admitted to making drawings after the Certosa paintings to improve his own manner.[22]

Vasari's Lives of the Artists (first published in 1550 and in greatly expanded form in 1568) was based on Plutarch's Lives and similarly reveals a blend of history and hyperbolic rhetoric. Each of Vasari's Lives was concocted to conform to a certain conceit and to provide a succinct morality play. Taking the advice of his friend and supporter Paolo Giovio, Vasari described acts in relation to the personality of the

FIG. 8 Jacopo Pontormo, *Deposition (Christ's Departure for the Tomb)*, c. 1526–28, oil on canvas, Santa Felicita, Florence.

individual or the particular character of each agent. In Pontormo's case, he offered the fable of a wunderkind who tried too hard to expand his talents, was untrue to his nature, and went astray. In presenting this scenario, he paid Pontormo some decidedly backhanded compliments, such as when he referred to the latter's very early *Madonna and Saints* in San Michele Visdomini (1518) as his most beautiful altarpiece and asserted that Pontormo's panels for the Borgherini, also relatively early pictures (1515–19), were the artist's finest works.[23] According to Vasari, Pontormo had already lost his wonderful early manner by the time he created his altarpiece and frescoes for the Capponi Chapel in Santa Felicita (1525–28; fig. 8).[24] Not wishing to offend Bronzino, who, unlike Pontormo, was alive and still a major force to be reckoned with when the second edition of the *Lives* was published, Vasari said that the Evangelists painted in tondi on the Capponi Chapel ceiling were executed in Pontormo's good "maniera di prima."[25] Ever the skillful diplomat, Vasari knew that Bronzino was responsible for one or two of those pictures.[26]

Wishing to keep them as allies, Vasari was always extremely careful when writing about living artists. In the first edition of the *Lives*, completed

when Michelangelo was still active, Vasari offered a panegyric to the senior artist, encouraging others to "try to imitate Michelangelo in all things."[27] But his assessment is somewhat different in the second edition, published one year after the artist's death. There, Vasari accused Michelangelo the painter of being narrowly concerned with the human figure and neglecting other aspects of his art.[28] Vasari went on to elevate Raphael to the plane of Michelangelo by stressing how the younger artist had the talent to do many things well.[29] In addition, Vasari emphasized Raphael's skill at maintaining unity and harmony in a shop staffed with an army of assistants.[30] Discussion of Raphael's managerial talents and tact is meant not only as professional advice for artist-readers but as a discreet form of self-promotion. Vasari was an adequate painter and a superb organizer who prided himself on finishing projects quickly and on time. To eclipse Pontormo in the eyes of the Medici and posterity, he dwelled on Pontormo's eccentric behavior and attempted to portray his conduct as unprofessional. According to Vasari, the painter was not very accommodating with patrons, but worked only when and for whom he pleased and "after his own fancy."[31] He told of Pontormo's obsessive need for solitude, his leaving works unfinished, and his radical revision of assistants' paintings (insinuating that Pontormo had to paint over pupils' works because he could not properly guide and instruct them).[32]

If Pontormo's artistic modus operandi is any indication of his personality, then he surely was not quite the unpredictable and unconventional character that Vasari described. Unlike Vasari, who appears to have avoided making life studies whenever possible, Pontormo was extremely disciplined in his working method; if he did not complete a few pictures, it was because he was delayed by his careful and elaborate preparatory work. The absolute privacy on which he sometimes insisted was perhaps necessary for his intense concentration and meticulous preparation. Vasari had to make much of Pontormo's odd character and habits since it was only in social grace that he surpassed him. Certainly Pontormo's idiosyncrasies were not severe enough to affect his patronage. The Medici kept him continuously employed in their villas in the 1530s and 1540s and apparently found him dependable. He was also revered by the mem-

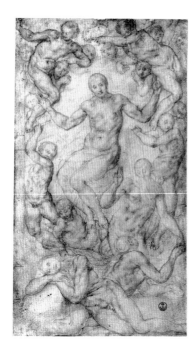

FIG. 9 Jacopo Pontormo, *Study for Christ in Glory with the Creation of Eve*, c. 1546–51, black chalk, Uffizi, Florence (no. 6609F).

bers of the Accademia del Disegno, which emphasized professional conduct; in fact, the academicians considered a candidate's deportment and personal qualities when deciding about his admittance.[33]

In building his case against Pontormo, Vasari also disparaged the villa frescoes he painted for the Medici, asserting that Pontormo's contemporaries did not appreciate or understand those and other of his late works.[34] One must assume that Vasari's report is, at best, an exaggeration. Obviously, the Medici were pleased with Pontormo's late manner or they would have enlisted the services of other artists. And contemporary painters were interested in the works as well; there exist many copies after Pontormo's drawings for the Castello loggia, and masters such as Bronzino often drew upon his late works in their own compositions. For example, Bronzino's *Allegory of Fortune* (c. 1565–70; Uffizi) and *Trinity* (1571; Florence, Santissima Annunziata, Cappella di San Luca) are indebted to Pontormo's works in the San Lorenzo choir (fig. 9).

The text of Pontormo's diary, discovered at the beginning of this century, has been seen by some as confirmation of Vasari's depiction of Pontormo as acutely abnormal, for it reveals that he had peculiar fixations not only on what he ate but also on his bowel movements.[35] The passages recording these obsessions have unfortunately drawn attention away from the more important aspects of the diary, particularly the notations that indicate how painstakingly and conscientiously Pontormo considered each figure he painted on the wall of the San Lorenzo choir. Pontormo's personal account is at odds with Vasari's estimation of the artist's late works, which he regarded as capricious. While Pontormo's descriptions of the configurations of his feces may indeed point to neuroses, he possibly had a practical, medical reason for his scatological concerns. Lead poisoning from paint often affected the digestive system early on, and signs of disease would frequently appear first in the stool.[36] Perhaps Pontormo was watching for or suffered from the illness that afflicted some artists.

For every four or five criticisms of Pontormo, Vasari astutely issued one statement in Pontormo's defense. While he disparaged the artist's antisocial behavior, brought on by his desire for privacy, Vasari, at one point, played apologist and recalled the old saying that "solitude . . . is the greatest friend of study."[37] Such statements, ostensibly made on Pontormo's behalf, hardly offset the weight of his negative comments and seem instead simply to focus more attention on what Vasari regarded as Pontormo's shortcomings. Vasari employed the same rhetorical ruse to emphasize the slowness of Pontormo's execution of works. In many places in the Life of Pontormo, Vasari took the artist to task for what he considered to be an inordinate amount of time spent on projects; in only one passage does he attribute Pontormo's plodding pace to the profound thought that he put into each of his works.[38]

Although Pontormo's working methods were thorough, they were not necessarily inefficient. Clearly Pontormo loved to draw and experimented with a range of drafting styles and techniques. Yet when one examines his graphic oeuvre closely, one finds few sheets that seem to have been created as ends in themselves or for the sake of personal expression. Contrary to the standard thesis, Pontormo's drawings do not have a stylistic identity independent of the paintings for which they were produced.[39] Rather, each drawing had an analytical purpose and helped Pontormo to solve a particular

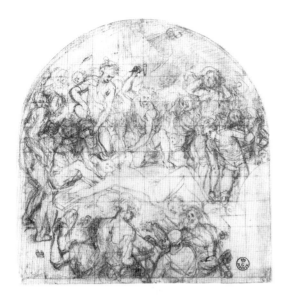

FIG. 10 Jacopo Pontormo, *Study for a Nailing to the Cross*, c. 1523–24, black chalk heightened with white, squared with red chalk, Uffizi, Florence (no. 6671F).

problem as he developed a composition. Like Raphael, he had a practical reason for almost every drawing he made, and he seems to have used (or intended to use) in some way virtually every study he executed.

The efficiency and economy of his draftsmanship can be observed in both its style and technique. A consummate "saver," Pontormo frequently went to his file of old drawings to locate studies that would serve his new needs. For instance, a nude he drew about 1519–20, around the time of the Poggio a Caiano project, was reworked approximately thirty years later on the verso of a sheet for the project at San Lorenzo (Uffizi, no. 465F).[40] Often, when Pontormo wished to rework designs, he transferred them through the paper, from recto to verso, by tracing the lines with a stylus.[41]

For reasons of speed and efficiency, Pontormo also employed a stylus when transferring his designs from one sheet to another, rather than using the older, more tedious methods of pricking and pouncing or squaring. (He was quite capable of copying freehand as well.) In fact, with just a few exceptions, he appears to have squared drawings only when he wished to change scale, particularly when he enlarged a design to produce a cartoon. The majority of Pontormo's squared compositional drawings, even those that appear somewhat unresolved, are his final

working studies. Apparently, he did not bother to make highly finished *modelli* unless they were requested by a patron. Instead, he would create his cartoon by multiplying the dimensions of the grid on drawings such as the large compositional study for the Certosa *Nailing to the Cross* (fig. 10) and would consult individual studies (fig. 13) when drawing the various figures. Because of the slight changes and roughly handled areas in the *Nailing to the Cross* sheet and in Pontormo's full compositional study for the Carmignano *Visitation* (c. 1528), at least one scholar believes that these drawings were not his *modelli*, or final preparatory studies.[42] This opinion, at odds with those of the earlier Pontormo scholars Clapp and Marcucci, is surely incorrect;[43] Pontormo would not have wasted time in working up replicas of those complex sheets in order to make a few minor alterations before advancing to the cartoon stage. He simply made his final adjustments in the full compositional working drawing or, frequently, in the individual figure studies.

In many instances, Pontormo executed his final working drawings on tinted paper—not for effect but for efficiency, since the intermediate tone of the paper allowed him greater flexibility for making changes. If an artist continually alters a drawing with black chalk on cream-colored paper, it can become muddled. By employing a pink-tinted paper (appropriate for nudes), Pontormo could also edit what he had drawn with white heightening and could use the white to indicate or fix the final arrangements or poses.[44] For example, on figure studies for his fresco of *Vertumnus and Pomona* (1519–21; Poggio a Caiano),

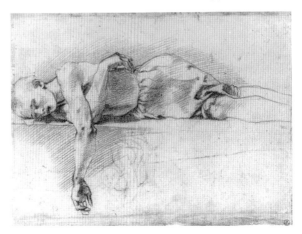

FIG. 11 Jacopo Pontormo, *Sleeping Boy*, c. 1523–25, red chalk, Uffizi, Florence (no. 6632Fv).

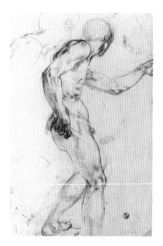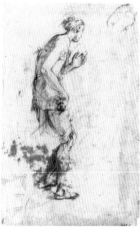

FIG. 12 Jacopo Pontormo, *Nude Study for a Nailing to the Cross*, c. 1523–24, red chalk, Uffizi, Florence (no. 6657F).

FIG. 13 Jacopo Pontormo, *Study of a Male Figure for a Nailing to the Cross*, c. 1523–24, red chalk, Uffizi, Florence (no. 447Fv).

Pontormo applied white heightening to indicate which of the many changes he made was the final one.[45] When drawing on tinted paper, Pontormo seems to have been more concerned with practical advantages than aesthetic effects, and consequently, his studies bear little resemblance to the highly finished, tinted chiaroscuro sheets of Northern artists. He found the technique suitable not only for whole compositional studies, such as the one for the Visdomini altar (Rome, Gabinetto Nazionale delle Stampe, no. FC147),[46] but for all kinds of working and anatomical drawings and even *primi pensieri* ("first-idea") sketches.

Some of the stylistic variations in Pontormo's draftsmanship that Cox-Rearick has regarded as expressive in nature and intent are, quite possibly, merely the results of expediency. She sees an important stylistic shift in Pontormo's preparatory figure studies for the Certosa frescoes; in several sheets the artist abandoned his pliant, naturalistic manner of rendering figures in favor of a more brittle and schematic style.[47] While this latter style does convey to some degree, in its formal elements, a sense of physical and psychological pain and is thus well suited for some studies associated with the *Nailing to the Cross*, Pontormo applied this manner to figures for which its expressive tenor was decidedly inappropriate, such as Christ's antagonists.[48] It is probable that this style

was simply a quick, abbreviated notation that Pontormo devised. He employed it mainly in studies for the *Nailing to the Cross*, a work that Pontormo never realized in paint and which he may have been rushing to finish before he left the Certosa in 1524 and returned to Florence. In similar fashion, Pontormo often blocked in the faces of the figures in his studies with masklike ovals, directing his attention primarily to the delineation of the body or drapery.[49] Although strangely evocative, these rudimentary heads were for Pontormo another shorthand cipher, a convenient notation and not, as some have suggested,[50] an anti-classical statement.

Pontormo's devotion to the study of the human form was as extreme as Michelangelo's, and his production of figure and life studies was no less prolific. There exist several extremely fresh and immediate portrait studies he made from life, and some of his sketches of the *garzoni* (assistants) in his shop are of an unprecedented casualness (fig. 11).[51] His so-called Corsini sketchbook (now disassembled) alone contained at least thirty-six life studies.[52] From Michelangelo, he learned the practice of sketching a nude from life in the center of a sheet and then, in the surrounding margins, experimenting with the pose of the figure and drapery or carefully rendering certain details such as the hands and face. Although sheets of this kind by Michelangelo were well known and tremendously influential in the first half of the century; many of the artists working in the 1560s and 1570s, including Bronzino, Girolamo Macchietti, and Giovanni Battista Naldini, may have picked up the format from Pontormo. They were also clearly impressed and influenced by the extraordinary informality and naturalism of many of Pontormo's studio sketches, which seem to have been regarded by some as an antidote to the highly refined and ornamental style of the *maniera*.

The frankness and pedestrian character of some of those sketches have caused a few scholars to doubt Pontormo's authorship, just as, fifty years earlier, Raphael's earthier studies were usually ascribed to Giulio Romano and other assistants.[53] Often, late sixteenth-century Florentine artists, reacting against Mannerist excess, attempted to achieve in their paintings a hybrid of Pontormo's most prosaic life studies and Sarto's bland but credible narrative style. This

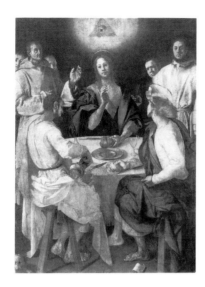

FIG. 14 Jacopo Pontormo, *Supper at Emmaus*, 1525, oil on canvas, Uffizi, Florence (ex-Certosa di Val d'Ema).

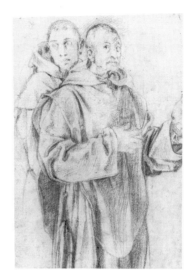

FIG. 15 Jacopo Pontormo, *Studies of Two Monks for the Supper at Emmaus*, c. 1525, red chalk, British Museum, London (no. 1936-10-10-10v).

compromised, compound style was perfectly suited in its clarity for Medici propagandist narrative and Counter-Reformation tastes. A number of Pontormo's nude studies, especially the group of Raphaelesque drawings he executed in the early 1520s (fig. 12), became "academies" for the generation of artists that matured in the 1570s. The popularity of his model studies among young artists at the end of the century can be gauged by the large number of copies after his drawings that are preserved in the Uffizi and elsewhere. It seems that, during the 1570s and 1580s, Pontormo's nude studies gradually replaced those of Bandinelli as academic models. The influence of Bandinelli, who made a specialty of nude male life studies (usually executed in red chalk as ends in themselves), can still be detected at the century's end in the drawing styles of Andrea Boscoli and, sometimes, Naldini.[54]

The intrusion of almost unaltered life studies into the paintings of Mirabello Cavalori, Macchietti, Naldini, and other Pontormo followers is remarkable yet not completely novel. Normally when designing a painting, a sixteenth-century Florentine artist created, in addition to life studies, an intermediate type of drawing which idealized or imposed his individual style upon the life study. When developing his Certosa *Nailing to the Cross*, for instance, Pontormo transcribed the sketches he made from models in the studio (fig. 12) into his more personal idiom (fig.

13).[55] The artist then went from these idiomatic drawings to the cartoon. Occasionally, however, he streamlined the procedure by eliminating the intermediate step, and translated his life studies directly into paint. This working method was partly responsible for the stunning, quasi-Baroque naturalism of Pontormo's *Supper at Emmaus* (1525) executed for the Certosa (fig. 14). Pontormo's shortcut was recognized and admired by his contemporaries. Vasari, who deplored most of the work Pontormo executed at Val d'Ema, had high praise for the *Supper at Emmaus*, noting that the monks in the picture were drawn from life and depicted with great accuracy.[56] The drawings for those figures attest to the directness with which the artist transferred them to his composition (fig. 15).[57] Pontormo apparently depended on his "raw" life studies when painting several other works as well. Among the life studies that he seems to have squared for enlargement and transfer to cartoons are a drawing for a portrait (Uffizi, no. 452Fr) and a study for the Capponi Chapel *God the Father with the Four Patriarchs* (Uffizi, no. 6590F).[58]

Pontormo is known to have required his pupils to draw constantly. In his Life of Giovanni Antonio Lappoli, Vasari reported that "under Pontormo's discipline Lappoli was forever drawing."[59] Naldini, who had an early, eight-year apprenticeship with Pontormo, was also an extremely prolific draftsman. Even those artists not under Pontormo's tutelage

seem to have responded to his diligent working methods and draftsmanship, perhaps with the encouragement of Bronzino and other senior academicians. The younger generation of artists in the 1570s and 1580s—Boscoli, Cavalori, Jacopo Chimenti da Empoli, Macchietti, Naldini, Bernardino Poccetti, Francesco Morandini (Il Poppi)—appear to have studied (and copied) drawings from all periods of Pontormo's career, including his earliest sheets and his late designs, the latter of which were much maligned by Vasari. The young artists also examined and emulated the entire range of Pontormo's graphic work, from life drawings of studio models and anatomical studies to full compositional sheets (see cat. no. 37).

Naldini, who trained with Pontormo, seems to have used the master's graphic oeuvre as a touchstone throughout his career. The head studies by Naldini on a sheet in the Uffizi (no. 311F) are probably copies of Pontormo's (lost) drawings for the head of Saint Matthew, one of the figures Pontormo painted for the Carro della Zecca (1514), his first important commission. Many other drawings by Naldini, such as two red and black chalk nude studies preserved in the Kupferstichkabinett, Berlin-Dahlem (nos. 5153, 5716), also reflect Pontormo's earliest manner. Apparently a number of Pontormo's sheets came into Naldini's possession and he felt free to alter them. In one instance, Naldini reworked a nude study that Pontormo executed during his Poggio a Caiano period, adding his own sketches to the verso of the sheet.[60] The graphic manner of a disciple often derives primarily from one period or phase of a master's development; for Naldini, the studies Pontormo created for the Poggio a Caiano project and other drawings of about 1520–21 were a major point of departure. A group of drawings in the Louvre that either imitate or directly copy studies by Pontormo of the early 1520s are almost certainly by Naldini's hand,[61] and some pen and ink figure studies by him that are based on Pontormo's Poggio a Caiano style can be found in the Uffizi.[62]

The drawing styles of several other later sixteenth-century Florentine artists seem to have sprung from Pontormo sketches that mainly date to about 1525, the period after he completed the Certosa frescoes and before he began to paint in the Capponi

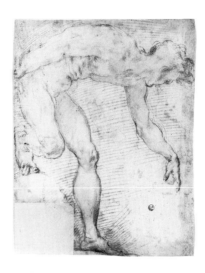

FIG. 16 Jacopo Pontormo, *Study of a Bending Nude*, black chalk heightened with white, c. 1525–26, Uffizi, Florence (no. 6610F).

Chapel in Santa Felicita. Poccetti's drawing style is indebted to such Pontormo drawings as the *Study of a Bending Nude* (c. 1525–26; fig. 16). Cavalori, Empoli, and Macchietti were interested in Pontormo life studies such as his preparatory drawings (c. 1524–25) for the Certosa *Supper at Emmaus* (fig. 15; and Munich, Staatliche Graphische Sammlung, no. 10142v) and drawings of posed studio models (fig. 17 and cat. no. 36). Cavalori seems to have been looking at Pontormo's *Seated Nude* (fig. 17) when he created his strange study for a *Pietà* (or *Plague Ex-Voto?*, fig. 18).[63] His sketch of a *Standing Monk* (Uffizi, no. 6523F)[64] is very close to several of Pontormo's monk studies (fig. 15). As opposed to some of his contemporaries, who sought inspiration primarily in the early or mature Pontormo, Poppi appears to have been impressed by the master's late works, and he exploited their attenuations and pliancy of form for effects of sheer fantasy (cat. no. 38).[65]

From time to time, Empoli and Poccetti even imitated the schematic, masklike faces Pontormo appended to his figures (Uffizi, nos. 932F, 1613F, 1788E). Alessandro Allori, whose style was based mainly on those of Bronzino and Michelangelo, was interested in Pontormo's anatomical drawings and did numerous similar studies. Following Pontormo, he occasionally sketched individual bones, an unusual practice in that most early skeletal studies include muscles and sinews.[66]

Cavalori, Santi di Tito, and some of their col-

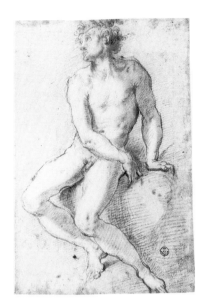

FIG. 17 Jacopo Pontormo, *Seated Nude*, c. 1525,
black chalk heightened with white, Uffizi,
Florence (no. 6742Fr).

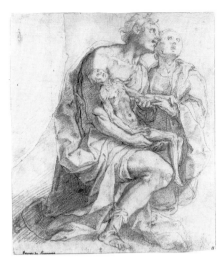

FIG. 18 Mirabello Cavalori, *Pietà*(?), c. 1567–69,
black chalk, Louvre, Paris (no. 948).

leagues were as much attracted to the natural light-
ing of the *Supper at Emmaus* as to the naturalism of
the figures; this is evident in their drawings as well
as in their paintings, especially Cavalori's Studiolo
works (fig. 20) and *Benediction of Isaac* (c. 1569–70; fig.
19) and Santi di Tito's *Supper at Emmaus* (1574; Flor-
ence, Santa Croce). Boscoli and Santi di Tito, to some
degree, were also interested in the dramatic effects of
light Pontormo achieved in the Certosa frescoes,
especially in the *Agony in the Garden* and *Resurrec-
tion*. Boscoli copied the latter in pen and ink (Berlin-
Dahlem, Kupferstichkabinett, no. 7715), exaggerat-
ing its burst of light.

As a senior academician and an artist who,
according to Vasari, encouraged serious study in his
workshop beyond proficiency in practical matters,
Bronzino may have been a strong advocate of the
study of Pontormo's drawings and working methods.
In accordance with the institution's statutes, he and
the other *consoli* (chief officers) of the Accademia del
Disegno were given much of the responsibility for
guiding young artists.[67] Bronzino himself followed
Pontormo's procedures and was faithful to the Floren-
tine tradition of scrupulous care in the preparations
for a work of art. In his numerous detailed studies,
he showed little concession to the ideal of speed in
execution for which Vasari praised painters in the
third quarter of the century. When, at mid-century,

the old practice of studying figures from the model
was being abandoned by Florentine artists, Bronzino
was one of the few who held to traditional ways. He
adopted Pontormo's sketching format, traceable ulti-
mately to Michelangelo, of placing a life study at the
center of the sheet and then working out the details
of drapery, hands, and feet in the margins (see cat.
no. 10). Although numerous Florentine artists of the
later sixteenth century picked up, via Pontormo or
Bronzino, Michelangelo's drawing format and fre-
quently made sketches after his sculpture (see cat. no.
29) and paintings, few closely emulated his draw-
ing style. They concerned themselves more with his
artistic theory and how it related to practice.[68]

Some young artists, notably Cavalori, Mac-
chietti, and Domenico Cresti (Il Passignano), con-
tinued Pontormo's practice of integrating virtually
unaltered life studies into final painted compositions.
Macchietti's *Study of a Prone Figure* (Louvre, no. 8819)
appears almost unrevised in his *Baths of Pozzuoli*
(c. 1570–72) in the Studiolo of Francesco I. Similarly,
Cavalori's *Wool Factory* in the Studiolo (c. 1570–72; fig.
20) presents a *popolo minuto* ballet of posed studio
models. The direct translation of life studies into
paint is even more apparent in his *Benediction of Isaac*
(fig. 19) in which the figure of Rebecca clearly
depends on a study Cavalori made of a tall, flatfooted
male model dressed in women's clothes. Unfortu-
nately, no preparatory drawings for that work have
been located. Later in the century, Passignano
inserted into his *Translation of the Body of Sant'Antonio*

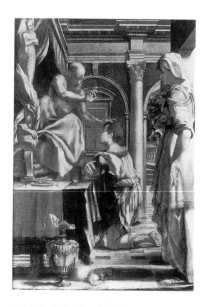

FIG. 19 Mirabello Cavalori, *Benediction of Isaac*, c. 1569–70, oil on panel, private collection, London.

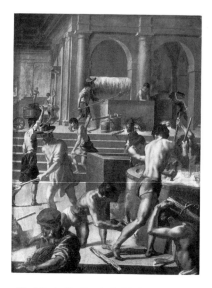

FIG. 20 Mirabello Cavalori, *Wool Factory*, c. 1570–72, oil on panel, Studiolo of Francesco I, Palazzo Vecchio, Florence.

(1589; Florence, San Marco) a figure drawn unchanged from one of his sheets of studies of nude models (Rome, Farnesina, F.C. 125359).[69]

This insertion of life studies into final compositions was, in part, a result of the working methods of many later sixteenth-century Florentine painters, which they seem to have inherited from Pontormo. As discussed above, Pontormo would often create his cartoon by looking at a squared, somewhat rough compositional sketch for the placement of figures, and would consult individual studies—some life drawings, some idiomatic—when rendering the figures themselves. Santi di Tito and Lodovico Cardi, among others, availed themselves of these efficient procedures. Santi did this, for example, when creating his painting of the *Capture of Jerusalem in the First Crusade* for an *apparato* of 1589 for the wedding of Ferdinando I and Christine of Lorraine in Florence. His squared final working design, with summarily indicated figures, is preserved in the Farnesina, Rome (F.C. 130632).[70] A similar type of drawing by Cigoli, on which the artist depended for the distribution of lights and darks as well as figure placement, can also be found in the drawings cabinet of the Farnesina (F.C. 124998).[71] Cigoli's drawing was preparatory for his *Nativity* (1602) for the church of San Francesco in Pisa (now Museo Nazionale di San Matteo). Boscoli, too, found this to be a practical procedure, as evidenced by his squared compositional study for the

Fall of the Rebel Angels (Farnesina, F.C. 124166).[72]

Concomitant with the renewed (or continuing) interest in the works of Pontormo, particularly the more naturalistic drawings, was a revival during the last four decades of the century of interest in the art of Andrea del Sarto. This popularity stemmed in part from his appeal to Counter-Reformation taste, which placed a premium on naturalism and legibility of presentation.[73] Such qualities also served the needs of the pictorial propaganda of the Medici court, for which a Sartesque style came to be de rigueur by the early seventeenth century. These revivals, it must be stressed, are not merely reactions against the Mannerism of Bronzino and Vasari but also are the results of young artists returning to the teachers of those masters, returning to the same wells for inspiration.

According to the visual evidence and to Vasari, who was one of his pupils, Sarto's paintings were studied more than his drawings. In his Life of Sarto, Vasari lauded his paintings, while his praise for Sarto's drawings was faint. After describing Sarto's drawings as "simple" and his paintings as "divine," Vasari explained:

> When [Sarto] drew natural objects for reproduction in his works, he made mere sketches dashed off on the spot, contenting himself with marking the character of reality; and afterwards, when reproducing them in works, he brought them to perfection. His drawings, therefore, served him rather as memoranda of what he

had seen than as models from which to make exact copies in his pictures.[74]

Although Vasari would seem to be characterizing Rembrandt's drawings more than Sarto's, his description is telling in its suggestion that Sarto's working method did not involve a well-organized and defined progression and that his drawings were made without clear purpose. Examination of some drawings by Sarto bears out the fact that, more often than many other sixteenth-century draftsmen, he combined (and so blurred the distinctions between) the different kinds of preparatory drawings (fig. 21). He sometimes would take a rough "first idea" sketch and work it up and revise it until it could almost serve as a *modello*.[75] To cut corners, he seems occasionally to have eliminated the cartoon stage from his preparations for panel paintings. The *Sacrifice of Isaac* (c. 1527; Cleveland Museum of Art) has numerous pentimenti which reveal that Sarto was still sketching and inventing on the panel itself.[76] In some of his *garzone* studies, he attempted to solve many problems at once rather than just trying to find the structure of a pose. Like Raphael, Sarto sometimes worked out two or three different compositions on the same sheet. This was less typical of Pontormo, who, following Leon Battista Alberti's advice, tended to plan out his pictures one at a time.[77] In fact, Pontormo's general approach was more Albertian, in that his working method, though not rigidly fixed, did include many of the clearly defined stages that the architect and theorist outlined in his treatise on painting, *Della pittura* (1436). For example, Pontormo sometimes did series of studies in which he first sketched bones, then drew them clothed in flesh, and finally covered by skin or drapery.[78]

Sarto's evolving, complex drawings were more difficult for students to copy and assimilate than Pontormo's studies, and fewer of them were available for examination. We know from Vasari that the heir to most of Sarto's drawings, Domenico Conti, was robbed of them by persons unknown.[79] Vasari owned several Sarto drawings (he mounted them in his *Libro dei disegni*), which he probably shared with his assistants, but the number of studies for artists to copy must have been quite limited in comparison to the quantity of Pontormo sheets in circulation.

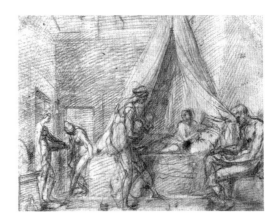

FIG. 21 Andrea del Sarto, *Study for the Birth of Saint John the Baptist*, c. 1526, red chalk, British Museum, London (no. 5226-86).

There was nothing to prevent young artists from studying and copying Sarto's paintings, however, and the demands of the Florentine art market at the end of the sixteenth century encouraged such replication. Vasari, Allori, Empoli, and Andrea del Minga were all engaged in the lucrative business of making copies of Sarto's paintings. At the same time, Maso da San Friano, Naldini, Poppi, and other young artists honed their skills by making countless sketches after Sarto's frescoes of the life of Saint John the Baptist in the Chiostro dello Scalzo (fig. 22).

Vasari, in his *Lives*, spoke of Sarto's unassertive personality, noting that while the painter (and consequently his art) lacked the ardor and boldness of other great masters, he nonetheless created pictures that were praiseworthy for their technical accomplishment, works that were "senza errori."[80] In the Florentine academy, where, for obvious reasons, technical perfection attained through training would have been emphasized more than innate artistic disposition, Sarto's art was venerated for its "correctness." When asked to create propagandist narrative paintings for the Medici grand dukes, such as family histories for festival *apparati*, the academicians invariably turned to Sarto's Scalzo frescoes. That series provided handsome examples both of multifigured compositions that were legibly and credibly organized and of the grisaille technique. The artists applied these lessons to the scenes for temporary triumphal arches and other grand Medici festival structures, which were painted in monochrome to simulate stone edifices. Vasari probably had such

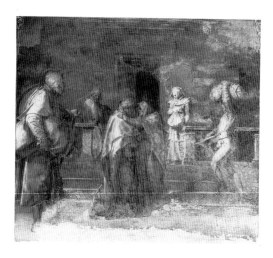

FIG. 22 Andrea del Sarto, *Visitation*, 1524, Chiostro dello Scalzo, Florence.

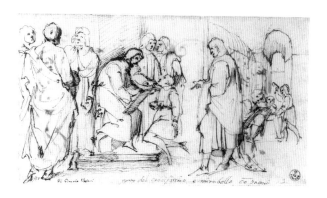

FIG. 23 Giovanni Battista Naldini (after Mirabello Cavalori and Girolamo Macchietti), *Lorenzo the Magnificent Receiving Michelangelo in the Garden beside San Marco*, c. 1564, pen and brown ink, Uffizi, Florence (no. 7286F).

façade and temporary festival and funerary decorations in mind when he declared, in his discussion of artistic technique in the introduction to the *Lives*, that the compositions of monochromes should be without complications or difficulties (*non stento*) because they had to be seen and recognized from a distance.[81]

The grisaille paintings that adorned Michelangelo's catafalque, known to us from Naldini's sketches made after the works,[82] were among the first examples of the revival of Sartesque compositions for secular histories and Medici propaganda. Created mainly by young artists who wished to gain admission to the academy, the pictures employed a Sartesque stage-play format, with figures distributed in regular intervals across a shallow spatial register to form a compositional "X." The plain and extremely legible depiction of the apocryphal scene of *Lorenzo the Magnificent Receiving Michelangelo in the Garden beside San Marco* (fig. 23), the contribution of Cavalori and Macchietti, was as much a pitch to the Medici as a paean to Michelangelo.[83] Lorenzo the Magnificent, a champion of philosophers and poets but no great patron of the visual arts, was portrayed in the painting (the first seen upon entering the nave of San Lorenzo) as the generous benefactor of the young sculptor. In celebrating instances of Medici patronage—both real and invented—Vasari hoped to encourage Francesco I's sponsorship of the arts and of the Accademia del Disegno. To get that idea across, Vasari must have instructed the artists, especially those painters like Cavalori and Macchietti who were assigned to illustrate untruths, to create compositions that were both comprehensible and plausible.

This undistinguished pictorial prose seems to have become the semi-official style for Medici ceremonial decor and propaganda. Empoli and his colleagues employed it in the large canvases they painted for the exequies of Henry IV sponsored by Cosimo II de' Medici in 1610.[84] The grand duke arranged to have the ceremony in the Medici church of San Lorenzo not only to commemorate the death of his cousin by marriage but to underscore the legitimacy of the regency of his cousin Marie de' Medici and, ultimately, to confirm the succession of her son, Louis XIII. The legible, if stilted, *Sartismo* of Empoli's design for the painting *Henry IV of France Signing the Ratification of his Abjuration before Cardinal Alessandro de' Medici* communicates in unambiguous terms the idea of Medici dynastic rule.[85] Adherence to such a compositional formula ensured a certain degree of uniformity in paintings executed by many artists. And these simple formulas enabled artists to design works quickly for commemorative projects such as funeral decorations which inevitably were assigned on short notice. The explicit prose style remained popular in Florence well into the seventeenth century and was practiced by many of the major painters of that period, including Giovanni Bilivert, Agostino Ciampelli, and Matteo Rosselli.[86]

The Sartesque narrative manner was but one of a variety of modes employed in the last decades of the sixteenth century. Responding in part to artistic developments in Rome and to the conservative attitudes of the Medici, who promoted the

FIG. 24 Mirabello Cavalori, *Group Portrait of the Founders of the Confraternita di San Tommaso d'Aquino with the Trinity*, 1568, oil on panel, Palazzo Pitti, Florence (ex-Oratorio di San Tommaso d'Aquino).

study of the Florentine past, many artists fabricated and employed *retardataire* styles to suggest an old-fashioned and unsophisticated piety. For the figures of God the Father and Christ in his group portrait of the founders of the Oratorio di San Tommaso d'Aquino (1568), Cavalori developed an archaistic, vaguely quattrocentesque manner (fig. 24).[87] His model, however, was not a fifteenth-century painting but a work by Bronzino, who in his later years, also had found the need to concoct a popular devotional style. Although somewhat different in pose, the figures in Cavalori's Trinity are virtually identical in physiognomy and in the crudeness of their execution to those in Bronzino's *Immaculate Conception* (c. 1570–72; Florence, Chiesa della Regina della Pace).[88]

The anachronistic manner of the Cavalori and Bronzino pictures seems to have been a preferred vocabulary for conservative patrons and for works that illustrated dogma rather than histories. Macchietti employed such a style in his iconic *Crucifixion* (Arezzo, Galleria e Museo Medioevale).[89] Santi di Tito also vacillated between styles, employing a plain, rustic manner when painting for a provincial audience (*Pentecost*; Prato, Santo Spirito) and a more ornamental manner for the sophisticated and urbane public of Florence (*Resurrection*; Santa Croce, fig. 25, see also cat. no. 41).[90] When necessary for conservative rural or Counter-Reformation patrons, Boscoli

too could summon up an inelegant but clear narrative style with sturdy plebian figures.[91] While the development of an *arte sacra*, or *counter-maniera*, style in Rome has been considered in depth,[92] the emergence of a similar Counter-Reformation manner in Florence has only recently begun to receive adequate attention in art historical literature.[93] Some of the other categories of style, such as the "secular-history manner" that would become prevalent in seventeenth-century Florentine art, have yet to be sufficiently explored.

Of the painters working in Florence at the end of the century, the Verona-born Ligozzi had perhaps the greatest range of artistic manners, which, though distinctive, were not necessarily mutually exclusive. His painting of *San Diego Healing the Sick* (1595; fig. 26) is realized in his *arte sacra* style; his *Martyrdom of Saint Dorothy* (Pescia, San Francesco) is an example of his opulent Venetian manner; and in *Margherita of Austria Receiving the Papal Legates* (Florence, Palazzo Pitti) he employed his prosy "secular-history" style. To these categories might be added the formula for court portraiture, which by the later sixteenth century had become extremely well defined (see, for example, Ligozzi's *Portrait of Maria de' Medici* in the Museum in Lisbon), and the almost internationally accepted florid style for drawings of pageant costumes and *apparati* (probably derived from the festival studies of Salviati), which Ligozzi also imitated.[94] Ligozzi's drawings entail an even greater

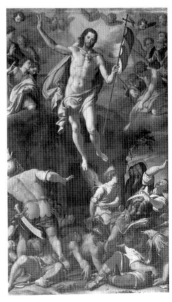

FIG. 25 Santi di Tito, *Resurrection*, c. 1574, oil on canvas, Santa Croce, Florence.

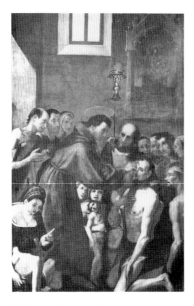

FIG. 26 Jacopo Ligozzi, *San Diego Healing the Sick*, 1595, oil on canvas, Ognissanti, Florence.

range of manners than his paintings, including a highly detailed, illustrative style for the recording of biological and botanical specimens (fig. 27).

Occasionally Ligozzi simulated what may be called a "Northern" (that is, German or Flemish) mode, as can be seen in the *Allegory of Avarice* (cat. no. 21) and in some of his other depictions of action and violence. Throughout the sixteenth-century, Florentine artists found inspiration in German and Flemish art, which is not surprising given that Northern art had been collected and admired by the Medici since at least the time of Lorenzo the Magnificent. Cosimo I recruited Flemish craftsmen for his Arazzeria (tapestry factory), placed a small *Passion* by Hans Memling in his villa at Careggi, and had Hugo van der Goes's Portinari altarpiece conserved for Santa Maria Novella.[95] So as not to discourage the matriculation of the best artists from the north into their ranks, Cosimo's Accademia del Disegno imposed no special fees on foreign members.[96]

Francesco's patronage of Stradano (Jan van der Straet) and Giambologna (1529–1608) suggests that he shared certain aspects of his father's taste.[97] Some of Stradano's genre drawings demonstrate how thoroughly Northern in feeling, energy, and casual detail the style he practiced in Florence could be (see cat. nos. 49–50). Bronzino's tapestry designs for the Medici often have a decidedly Flemish character. He must have thought of the products of Flanders which

he wished to emulate and surpass. The sprightly character of movement and highly developed landscapes in some of the Studiolo pictures, and to a certain extent in Jacopo Zucchi's study for the *Age of Gold* (cat. no. 61), probably are indebted to Northern European painting. Of the other Studiolo artists, Poppi especially seems to have found inspiration in the works of Stradano. His somewhat eccentric artistic temperament discovered a kindred spirit in the pictures of Stradano, with their sense of urgency and slightly bizarre, Flemish emphasis on silhouettes and exaggerated foreshortening of figures. Flemish artists were especially highly regarded by the Italians for their ability to paint landscapes. From Northern art, Poppi and Zucchi also seem to have learned ways to render expansive landscapes into which figures were successfully integrated.[98]

As noted above, Pontormo and Sarto, who had such great stature in Florence at the end of the sixteenth century, borrowed extensively from the prints of Albrecht Dürer. Their disciples and others working from the 1570s until the end of the century continued the study and assimilation of Northern prints, particularly Dürer's. As Graham Smith has shown, Bronzino on several occasions made use of Dürer's compositions.[99] Boscoli, like Pontormo, looked to Dürer's *Nailing to the Cross* from the Small Passion (1511) when formulating his own version of the subject in a drawing (Oxford, Ashmolean Museum, Parker no. 126) and perhaps consulted Dürer's prints when composing his *Road to Calvary* (cat. no. 8). In creating his painting of the *Trinity* (1592) for the church of Santa Croce in Florence, Cigoli used Dürer's large woodcut version of the theme as a point of departure.[100]

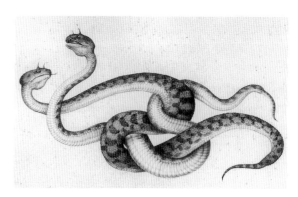

FIG. 27 Jacopo Ligozzi, *Studies of Vipers*, watercolor, Uffizi, Florence (no. 1973).

The emergence of distinct artistic modes is to some degree symptomatic of the concern for rigorous order and system that seems to have worked its way into every level of Florentine society. Allori, who in certain respects typified academic practice and achievement, wrote a treatise (c. 1565) for dilettantes and amateurs that attempted to schematize the activities of the painter, breaking down the creative act into simple rules and exercises; one learned to render the human head through repetitious exercises, drawing each of its features numerous times without variation until it was memorized.[101] Draftsmanship by rote was nothing new—even some of Michelangelo's pupils trained themselves by that means[102]—but the textbook codification of such practice was novel, as was the confident and widespread neo-Albertian acceptance of the notion that art must be circumscribed by rules and attained by practice. In the prologue of *Della pittura*, Alberti asserted that "the power of acquiring wide fame in any art or science lies in our industry and diligence more than in the times or in the gifts of nature."[103]

The Accademia del Disegno clearly accepted Alberti's theories of art as well as the main courses of study that he suggested: the investigation of the natural world in terms of its mathematical structure and the systematic study of human anatomy, particularly those parts of the body responsible for motion. Karen-edis Barzman has observed that a renewed, intensified interest in Alberti's writings is indicated by the many editions of his texts that were republished in the second half of the century.[104] She also notes that Bartoli's editions (1568) of Alberti's *Della statua* and *Della pittura*, although published in Venice, would have been particularly timely for the Florentine artistic community and relatively new academy. As she points out, the dedication of the edition to Bartolommeo Ammannati and Giorgio Vasari might indicate that Bartoli's translations were intended specifically (or especially) for Florentine academic consumption.

In recent years, the purposes of the academy and the degree to which it was an active teaching institution have been much debated among scholars. Nicholas Pevsner's long-standing view of the academy as almost wholly concerned with elevating the status of artists and with no sincere commitment to teaching has been increasingly challenged.[105] Zygmunt Waźbiński, Charles Dempsey, and, more recently, Barzman have argued that the Accademia del Disegno did attempt to fulfill its mission for teaching and seems to have had, in some respects, a dynamic program of instruction.[106] Pointing to certain statutes of the academy, particularly articles 30, 31, and 34, which call for exhibitions, artistic competitions, and the establishment of a library to house drawings and models, Waźbiński and Dempsey have suggested that membership in the academy did involve intellectual and practical discourse.[107] As evidence that the regulations were carried out, Waźbiński calls attention to records of exhibitions in the Ospedale degli Innocenti and in the academy's quarters of paintings executed by academicians for funerals and festivals. Waźbiński has offered as additional evidence the description of the institution's premises given by Vincente Carducho in his *Dialogos de la pintura* (1633).[108] When he visited the academy between 1593 and 1606, Carducho saw drawings, cartoons, models, paintings, sculpture, mathematical instruments, and globes. Agreeing with Waźbiński's conjectures, Dempsey submits as further proof of the Accademia del Disegno's vitality the statements of the Genoese painter Giovanni Battista Paggi, who in 1591 observed lively lectures and debates sponsored by the academy.[109] That the Florentine academy was highly and seriously regarded is indicated, as Dempsey rightly argues, by the fact that the artistic academies of Perugia, Rome, and Bologna were modeled on it.[110] Additional tangible evidence of the Accademia del Disegno's activities has been provided by the archival research of Barzman, which has turned up records for furniture and equipment purchased by the academy, including lecturers' podiums, frames, canvases, gesso, rulers, and compasses.[111] Thus, while the academicians were interested in social advancement and in making social connections (the academy facilitated intercourse with the aristocracy), they seem also to have developed a veritable—although perhaps not comprehensive or entirely systematic—teaching program.

The academicians considered mathematics to be the core of the institution's curriculum. The incorporating statutes of the organization required that one of the three annual visiting instructors (*visitori*) lec-

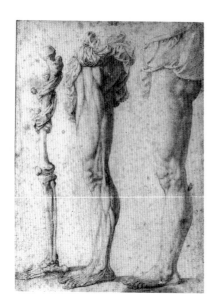

FIG. 28 Alessandro Allori, *Anatomical Studies of a Leg*, black chalk, Uffizi, Florence (no. 190S).

ture on the writings of Euclid, Vitruvius, and authors of other mathematical texts. The first salaried instructor was the eminent Bolognese mathematician Pier Antonio Cataldi. The position had gained such prestige by the 1580s that, in 1588, Galileo wished to be considered for it; instead, he was appointed by Ferdinando I to the chair in mathematics at the university in Pisa. The benefits of such instruction are not immediately apparent in the works of the academicians, but one must wonder if the natural and convincing projections of space in the works of Santi di Tito, Cavalori, and Macchietti owe something to this advanced training in geometry and mathematics.

The study of human anatomy was also considered essential in academic training. Vasari emphasized its importance in the *Lives*, suggesting that Raphael freed himself from the style of Perugino by studying flayed human bodies. Raphael, Bandinelli, Leonardo, and Michelangelo all supposedly performed dissections. As previously discussed, Alberti had advocated the practice of drawing or painting a figure by rendering its bones first and then adding, in steps, flesh, skin, and clothing. Similar procedures — or exercises — were followed by Pontormo and by Michelangelo's pupils in the first half of the century; on one sheet (Uffizi, no. 598Ev), a student of Michelangelo first copied a head drawn by the master, and then rendered the same head without skin, and then without flesh.[112] Probably in the 1560s Allori made his now well-known anatomical study in

black chalk of a leg represented in the same three stages of disclosure (fig. 28).[113] Allori's knowledge of leg musculature was not derived solely from his study of the writings of Vesalius, Valverde, and other anatomical treatises. Surviving drawings, such as his study of a cadaver held upright by ropes (Uffizi, no. 10306F),[114] indicate Allori's firsthand study of anatomy, in which he was guided by Alessandro Menchi, the academy's first physician and an instructor in anatomy. Allori no doubt began his anatomical research under the tutelage of his teacher Bronzino, who, Allori reports, performed many dissections singlehandedly.[115]

Allori and Bronzino also would have benefited from the dissection the academy held each winter in the hospital of Santa Maria Nuova in Florence.[116] This annual event, written into the statutes of the academy, would have been more useful to artists than the public dissections done at the Florentine university; while the academicians wished to investigate the structure of the skeleton and muscles, medical students and doctors were more concerned with the principal organs. To augment the dissections, the academy apparently kept skeletons in one of its rooms. When artists wished to draw from them, they were suspended and posed, in marionette fashion, by a system of ropes and pulleys. A drawing by Stradano (British Museum, no. 5214-2) for the *Arts of Painting and Sculpture*, made to be engraved by Cort, illustrates how cadavers and skeletons were used for

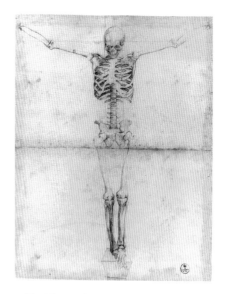

FIG. 29 Alessandro Allori, *Study of a Crucified Skeleton*, black chalk, Uffizi, Florence (no. 10321F).

study (see Barzman, below, fig. 2).[117] In creating his drawing of a crucified skeleton (fig. 29),[118] Allori perhaps availed himself of an academy specimen. Cigoli, Passignano, and others continued into the next century to make sketches after the academy's posturing skeletons (Louvre, nos. 908, 909, 1104).[119]

The infrequent availability of cadavers for study necessitated the creation of models of the flayed human form. These *scorticati*, usually composed of clay or wax, were fabricated for the academy's drawing classes. The most famous and influential *scorticati* were those produced by the academician and sculptor Pietro Francavilla, a pupil of Giambologna, and by Cigoli, who was directed in his anatomical research by Allori and, later, by the Flemish anatomist Theodore de Mayerne. Because of their quality and utility, Francavilla's and Cigoli's models were widely duplicated and eventually cast in bronze. Both Boscoli and Andrea Commodi made pen and ink studies after a *scorticato* by Francavilla, apparently at the same drawing session (figs. 30–31).[120]

Although the study of *scorticato* models was helpful, much more time was spent by artists before living models, and the last three decades of the century saw a great increase in the number of drawings done from studio models. There was even a revival of drapery drawings, akin to those Leonardo and Lorenzo di Credi executed a century before; every Thursday and Sunday, members of the academy draped clay figures with cloth and drew them. Bronzino, whom Vasari described as the oldest and most important of the academicians, probably did much to promote these activities.[121] He continued to draw from models even though, around mid-century, the practice began to be abandoned by many of his colleagues whose priority was speed of execution. Eventually Bronzino's views concerning working procedures prevailed, and late in the century, art theorists and critics such as Armenini railed against artists who executed paintings in a hurried fashion.[122]

A product of Pontormo's shop and a proponent of his artistic values, Bronzino advocated to young academicians by example—and perhaps verbally—the virtues of thorough preparation and drawing from life. When describing Bronzino's works, Vasari repeatedly stressed the study and labor Bronzino put into them and how closely his figures approximated

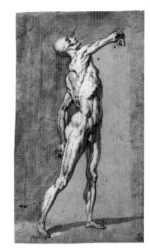

FIG. 30 Andrea Boscoli (after Pietro Francavilla), *Scorticato*, pen and brown ink with wash, Uffizi, Florence (no. 8228F).

FIG. 31 Andrea Commodi (after Pietro Francavilla), *Scorticato*, pen and brown ink, Uffizi, Florence (no. 10336F).

life. The modern reader might find Vasari's praise of Bronzino's "naturalism" inexplicable or inappropriately excessive, but one must consider that Vasari was probably writing what he thought his colleague wanted to hear. The general formulaic praise of artistic fidelity to natural appearance in his other *Lives* becomes in Vasari's Life of Bronzino a relentless promotion of the artist's studious academic approach and employment of models. According to Vasari, Bronzino's portraits are all "very natural" and "executed with incredible diligence"; his Panciatichi Madonnas are "so natural they seem alive" and "nothing is wanting save breath"; the Panciatichi *Christ on the Cross* was "executed with much study and pains" and was "copied . . . from a real dead body fixed on a cross"; the frescoes in the Chapel of Eleonora were painted with the "greatest possible diligence and study"; and the flayed Saint Bartholomew in Bronzino's altarpiece in the Pisa cathedral "has the appearance of a true anatomical subject and of a man flayed in reality, so natural it is and imitated with such diligence from an anatomical subject."[123] Clearly, Vasari wished that young artists would regard Bronzino, as they did Michelangelo and Pontormo, as a model for his disciplined working methods.[124]

The renewed interest in life drawing also seems to have stimulated intensive examination of the life

studies created by artists decades earlier, particularly of Pontormo and Michelangelo. Some of these drawings were most likely pooled and kept in a room in the academy's seat at the Cistercian monastery of Cestello, where they would have been available to young members. Article 31 of the academy's statutes called for the establishment of a library to house drawings. Unfortunately no complete sixteenth-century inventory of the academy's property has yet come to light, and whether such a collection of drawings was formed in the last decades of the century cannot be confirmed. The passing of drawings across shop lines would seem to indicate that some studies were freely shared. For instance, Pontormo's drawing of a *Seated Nude* (fig. 17) was probably a possession of the Bronzino shop; on the verso of the sheet is a study for Pontormo's *Pygmalion and Galatea* (c. 1530; Florence, Palazzo Vecchio), a project on which Bronzino collaborated with Pontormo. Yet Cavalori, who in the later 1560s was either a member of Tosini's shop or an independent artist, seems to have had access to the drawing (or one very much like it) and imitated it in his curious black chalk *Pietà* study (fig. 18).

Pointing to the existence of late sixteenth-century drawings by Florentines from different workshops that depict the same models from different vantage points, Barzman has suggested that artists participated in life drawing classes that crossed workshop lines. Such forums, she surmises, most likely would have taken place at the academy or at least under its auspices.[125] To engender communication between workshops, the academy occasionally sponsored field trips to workshops where artists could observe and discuss works under production. This sort of exchange, as Barzman has commented, would have been in keeping with the advice of Alberti, who encouraged artists to seek the counsel and opinions of their colleagues.[126] Many of the myriad life studies created toward the end of the century were in some ways different in character and purpose than those executed in the years before the advent of the academy. The studies of posed models produced by Boscoli, Cigoli, Santi di Tito, and others are as much concerned with the action of light on the figure as with its anatomical structure (fig. 32). Few in the last decades of the century emulated Michelangelo's drawing style with its emphasis on

FIG. 32 Lodovico Cigoli, *Study of a Male Nude*, black chalk with white heightening on blue paper, Louvre, Paris (no. 910).

volume and sculptural values. Instead, the more progressive Florentine artists saw life drawing as an opportunity not only to study anatomy but to scrutinize and try to record the complexities of light as it played across flesh and drapery. To set down his observations of light quickly and efficiently, Cigoli developed a bold, summarizing style (cat. no. 16).

In his Life of Raphael, Vasari declared that the rendering of light was one of the problems that remained for artists to solve.[127] In his autobiography Vasari described his own difficulties in painting armor because of its reflective properties.[128] Undoubtedly, for a generation of artists and academicians who held sacred Albertian principles of rule and mathematical order, the (then) immeasurable and unquantifiable nature of light would have been somewhat vexing.

Several gifted artists were up to the challenge, however, including Boscoli, Cigoli, Santi di Tito, and Cavalori, whose *Benediction of Isaac* (fig. 19) and Studiolo paintings (fig. 20) represented, in their time, some of the most ambitious attempts made in Florence to record the subtleties and range of natural illumination. Cavalori's works offer a brilliant description of the different kinds of light—diffused, reflected, refracted—that animate the surfaces of a variety of materials. Santi di Tito's researches into the

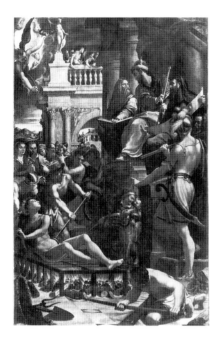

FIG. 33 Girolamo Macchietti, *Martyrdom of Saint Lawrence*, 1573, oil on canvas, Santa Maria Novella, Florence.

properties of light, surely influenced by Cavalori, led to more dramatic results in altarpieces he executed, such as the *Resurrection* (c. 1574; fig. 25) and *Supper at Emmaus* (1574) for Santa Croce and the *Annunciation* (c. 1602) for Santa Maria Novella, in which he attained an almost trompe l'oeil descriptive realism.

Despite his training with Santi di Tito, Boscoli possessed artistic sensibilities that were essentially in accord with Poppi's or even Rosso's, and he largely eschewed Santi's naturalism and Roman *gravitas*. Boscoli did inherit from Santi, however, the quick, energized light of the master's works of about 1574; it is quite possible that Boscoli was an assistant in Santi's shop at that time. A pen and wash study for a *Resurrection* by Boscoli (Uffizi, no. 8204F) documents his interest in Santi's version of the theme, imitating not only the quality of illumination of the Santa Croce altar, but also Santi's figure and drawing style.[129] Many of Boscoli's sheets (cat. nos. 6–7) are galvanized by this swift light. Occasionally he accelerated the speed of Santi's light to an extent that it no longer has a rational, descriptive function, creating instead bizarre, arbitrary patterns of illumination and prismatic separations of color (cat. no. 7).[130]

Macchietti's contribution to Santa Maria Novella, an altarpiece for the Giuochi Chapel depicting the martyrdom of Saint Lawrence (1573; fig. 33), also

achieved a stunning naturalism of illumination. Yet in this case the quality of light may depend less on the works of Macchietti's colleagues Cavalori and Santi di Tito than on Venetian art; the *Martyrdom of Saint Lawrence*, in its composition and certain details, indicates that Macchietti had direct knowledge of Titian's painting of the subject in the Church of the Gesuiti in Venice and an acquaintance with Paolo Veronese's architectural backdrops.[131] Macchietti was only one of many Florentine artists (the list includes Bronzino, Cavalori, Cigoli, Passignano, Santi di Tito, and Vasari) who were stimulated by the example of Venetian art and the presence in Florence of artists from the Veneto such as Ligozzi. From the Venetian painters, Cigoli learned to manipulate light in his paintings and drawings (cat. no. 16) in order to accentuate the hues and textures of materials and, in Venetian fashion, to create a light that vibrates as it interacts with the surrounding atmosphere. That Cigoli, who was a close friend of Galileo, at times recorded the effects of light with the meticulous accuracy of a scientist is not surprising. In fact, the carefully rendered moon in Cigoli's *Immaculate Conception* (1610–12) in the dome of the Pauline Chapel of Santa Maria Maggiore is almost certainly based on the sketches Galileo made when studying the illumination of the moon's surface through a telescope.[132] The wedding of art and science, the theme of Francesco's Studiolo and goal of the Florentine academy, never came closer to being realized than there in the nascent art of the Baroque period.

NOTES

1. For the history of Cosimo's reign, see Gaetano Pieraccini, *La Stirpe de' Medici di Cafaggiolo* (Florence, 1925); Luigi Carcereri, *Cosimo, prima granduca* (Verona, 1926); Eric W. Cochrane, *Florence in the Forgotten Centuries 1527–1800: A History of Florence and the Florentines in the Age of the Grand Dukes* (Chicago and London, 1973); and J. R. Hale, *Florence and the Medici: The Pattern of Control* (London, 1977; rpt., 1983). Cosimo's patronage of the arts is considered in Janet Cox-Rearick's recent study, *Dynasty and Destiny in Medici Art—Pontormo, Leo X, and the Two Cosimos* (Princeton, 1984).

2. Giorgio Vasari, *Le Vite de' più eccellenti pittori, scultori ed architettori*, ed. Gaetano Milanesi (Florence, 1878–85; rpt., 1906), vol. 2, p. 242 (hereafter Vasari-Milanesi). Michelangelo and Girolamo Macchietti are among the artists who are known to have copied figures from Masaccio's frescoes in the Brancacci Chapel. See Luitpold

Dussler, *Die Zeichnungen des Michelangelo—Kritischer Katalog* (Berlin, 1959), no. 186, and Larry J. Feinberg, *The Works of Mirabello Cavalori* (Ann Arbor, 1986), p. 101 (hereafter *Cavalori*). Pontormo, Cavalori, and Gabbiani all borrowed motifs from or copied reliefs in Ghiberti's Gates of Paradise; for Pontormo's debt to Ghiberti, see Janet Cox-Rearick, *The Drawings of Pontormo* (Cambridge, Mass., 1964), vol. 1, p. 116; for the interest of Cavalori and Gabbiani in Ghiberti's Jacob relief, see, respectively, Feinberg, *Cavalori*, pp. 83–84, 214, and Françoise Viatte, *Dessins baroques florentins du Musée du Louvre*, exh. cat., Musée du Louvre (Paris, 1981), no. 130. As Cox-Rearick noted ("Some Early Drawings by Bronzino," *Master Drawings*, vol. 2 [1964], p. 374, figs. 7–8), Agnolo Bronzino translated into paint a late Quattrocento relief of the *Madonna and Child* by Desiderio da Settignano. Alessandro Allori, in the 1580s, replicated fifteenth-century paintings. One of these works, a facsimile of a *Mater Dolorosa* attributed to Zanetto Bugatto, was on the art market in 1988 (Christie's, London, 8 July 1988, lot no. 74, illus.).

The love of antiquity and a desire to preserve the old was also expressed by Florence's average citizens. In his diary of 1593, Baccio di Gianmaria di Baccio Cecchi angrily wrote about how the proposed construction of a new Strozzi palace would require the destruction of an old loggia belonging to another family. He also condemned the construction of four shops that closed off the loggia of the Frescobaldi family at the foot of the bridge of Santa Trinità. The "avaricious act," he declared, was "done by a lady of a family which placed utility before honor and maintenance of so ancient a memorial" (quoted from Samuel J. Berner, "Florentine Society in the Late Sixteenth and Early Seventeenth Centuries," *Studies in the Renaissance*, vol. 18 [1971], p. 232). Francesco Bocchi's *Le Bellezze della città di Fiorenza* (1591) and other guidebooks of the period convey the impression that in the later sixteenth century the passion for the Florentine past was so strong that the city came to regard itself as a museum.

3. See Elizabeth Cropper's important article, "On Beautiful Women, Parmigianino, *Petrarchismo*, and the Vernacular Style," *Art Bulletin*, vol. 58 (1976), pp. 372–92, for the sixteenth-century interest in developing a visual vernacular style.

4. For a discussion of a similar emergence of artistic modes at the late sixteenth-century court at Prague, see Thomas Da Costa Kaufmann, *The School of Prague, Painting at the Court of Rudolf II* (Chicago and London, 1988), pp. 90–99.

5. Raffaellino del Garbo, Bronzino's first master, employed several modes, including a Botticellian manner. See M. G. Carpaneto, "Raffaellino del Garbo, I. Parte," *Antichità viva*, vol. 9 (1970), p. 13, fig. 13.

6. For a concise discussion of the definitions and use of the term *disegno* (drawing or design) in the sixteenth century and before, see David Summers, *Michelangelo and the Language of Art* (Princeton, 1981), pp. 250–61. See also Barzman, below.

7. Francesco's alleged diabolical behavior became the subject of plays as early as the seventeenth century; see T. S. R. Boase, "The Medici in Elizabethan and Jacobean Drama," *Journal of the Warburg and Courtauld Institutes*, vol. 37 (1974), pp. 373–78.

8. For Francesco's scientific interests, some useful sources are: G. E. Saltini, "L'Educazione del principe Francesco de' Medici," *Archivio storico italiano*, vol. 4, no. 11 (1883), pp. 49–84; G. Targioni-Tozzetti, *Notizie sulla storia della scienze fisiche in Toscana* (Florence, 1852), pp. 235–38; Riccardo Grassini, "La Chimica e la farmacia in Firenze sotto il governo Mediceo," *Rivista di fisica, matematiche, e scienze naturali*, vol. 94 (1907), pp. 335–46, and vol. 95 (1907), pp. 426–41; Luciano Berti, *Il Principe dello Studiolo. Francesco I dei Medici e la fine del Rinascimento fiorentino* (Florence, 1967); and Giulio Lensi-Orlandi, *Cosimo e Francesco de' Medici alchimisti* (Florence, 1978).

9. For additional information on the Studiolo of Francesco I, see Adolfo Lensi, *Il Palazzo Vecchio* (Milan and Rome, 1929); Berti, *Il Principe dello Studiolo*; Scott Schaefer, *The Studiolo of Francesco I de' Medici in the Palazzo Vecchio in Florence* (Ann Arbor, 1976); Giulio Lensi-Orlandi, *Il Palazzo Vecchio di Firenze* (Florence, 1977); Ettore Allegri and Alessandro Cecchi, *Palazzo Vecchio e i Medici. Guida storica* (Florence, 1980); Marco Dezzi Bardeschi et al., *Lo Stanzino del principe in Palazzo Vecchio. I Concetti, le immagini, il desiderio* (Florence, 1980); and Michael Rinehart, "A Document for the Studiolo of Francesco I," *Art the Ape of Nature—Studies in Honor of H. W. Janson*, ed. Mosche Barasch and Lucy Freeman Sandler (New York, 1981), pp. 275–89.

10. The idea of having painted panels denote the content of cabinets originated with Cosimo, who had his Sala del Mappamondo (begun in 1563, Palazzo Vecchio) decorated in that way; painted maps covered compartments in which objects indigenous to the region represented were stored.

11. Eugène Muntz, "Le Musée des portraits de Paul Jove," *Mémoires de l'Académie des Inscriptions et Belles Lettres*, vol. 36 (Paris, 1900); Luigi Rovelli, *L'Opera storica ed artistica di Paolo Giovio Comasco. Il Museo dei ritratti* (Como, 1928); and T. C. Price Zimmermann, "Paolo Giovio and the Evolution of Renaissance Art Criticism," *Cultural Aspects of the Italian Renaissance: Essays in Honour of Paul Oskar Kristeller*, ed. Cecil H. Clough (Manchester and New York, 1976), pp. 406–24.

12. Similarly, in creating his *Libro dei disegni*, Vasari edited, by reordering and mounting, the collection of drawings he inherited from a descendant of Lorenzo Ghiberti.

13. The Florentine academy also wished to regulate the export of works of art from Florence and Tuscany; see Girolamo Ticciati, "Storia della Accademia del Disegno," in *Spigolatura Michelangiolesca*, ed. P. Fanfani (Pistoia, 1876), pp. 262–64.

14. The literature on sixteenth-century Medici costume

designs and festival decorations is extensive. Some of the most important sources and studies are: Baccio Baldini, *Discorso sopra la mascherata della geneologia degli dei de' gentili mandata fuori dall'illustrissimo et eccellentissimo S. Duca di Firenze et Siena* (Florence, 1565); Giovanni Battista Cini, *Descrizione dell'apparato fatto in Firenze per le nozze dell'illustrissimo ed eccellentissimo Don Francesco de' Medici principe di Firenze e di Siena e della serenissima regina Giovanna d'Austria* (Florence, 1565; rpt. in Vasari-Milanesi), vol. 8; Domenico Mellini, *Descrizione dell'entrata della Sereniss. Reina Giovanna d'Austria et dell'apparato, fatto in Firenze nelle venuta & per le felicissime nozze di S. Altezza et dell'illustrissimo & eccellentiss. S. Don Francesco de' Medici, principe di Fiorenza & di Siena* (Florence, 1566); R. Gualterotti, *Descrizione del regale apparato per le nozze della Ser. Madama Cristina di Lorena* (Florence, 1589); Piero Ginori Conti, *L'Apparato per le nozze di Francesco de' Medici e di Giovanna d'Austria* (Florence, 1936); A. M. Nagler, *Theatre Festivals of the Medici, 1539–1637* (New Haven, 1964); Annamaria Petrioli, *Mostra di disegni vasariani. Carri trionfali e costume per la genealogia degli dei (1565)* (Florence, 1966); G. Gaeta Bertelà and Annamaria Petrioli Tofani, *Feste e apparati medicei da Cosimo I a Cosimo II*, exh. cat., Gabinetto Disegni e Stampe degli Uffizi (Florence, 1969); H. W. Haufmann, "Art for the Wedding of Cosimo de' Medici and Eleonora of Toledo, 1539," *Paragone*, vol. 31, no. 243 (1970), pp. 52–67; Michel Plaisance, "La Politique culturelle de Côme Ier et les fêtes annuelles à Florence de 1541 à 1550," in *Les Fêtes de la Renaissance*, ed. J. Jacquot (Paris, 1975), vol. 3, pp. 135–52; R. A. Scorza, "Vincenzo Borghini and *Invenzione*: the Florentine *Apparato* of 1565," *Journal of the Warburg and Courtauld Institutes*, vol. 44 (1981), pp. 57–75; and Annamaria Petrioli Tofani, "Contributi allo studio degli apparati e delle feste medicee," in *Musica e spettacolo scienze dell'uomo e della natura. Firenze e la Toscana dei Medici nell'Europa del '500* (Florence, 1983), vol. 2, pp. 645–61.

15. Ronald F. E. Weissman, *Ritual Brotherhood in Renaissance Florence* (New York, 1982), p. 228.

16. Samuel J. Berner, "Florentine Political Thought in the Late Cinquecento," *Il Pensiero politico*, vol. 2 (1970), pp. 177–99.

17. Cox-Rearick, *Drawings of Pontormo*, vol. 1, pp. 49–58, 93–94, and Kurt Forster, *Pontormo* (Munich, 1966), pp. 79–83, 109–12. In more recent publications, particularly *Dynasty and Destiny in Medici Art*, Cox-Rearick has altered her view of Pontormo, seeing his art less as a vehicle of personal expression and more as an instrument for Medici glorification and propaganda.

18. In his meticulous working methods, particularly in the use of clay *bozzetti*, he may have been following the example of Michelangelo.

19. John Shearman, "Bronzino," *Burlington Magazine*, vol. 105 (Sept. 1963), p. 416.

20. Vasari-Milanesi, vol. 6, pp. 265, 271. In addition to deploring Pontormo's Germanisms, Vasari criticized the

drapery for being too abundant in his *Vertumnus and Pomona* fresco at Poggio a Caiano, and he found fault with the Santa Felicita *Deposition*, saying it lacked strong shadows and contrasts.

21. Vasari-Milanesi, vol. 6, pp. 265–70.

22. Ibid., vol. 7, p. 605.

23. Ibid., vol. 6, pp. 258, 261.

24. Ibid., vol. 6, pp. 271–72.

25. Ibid., vol. 6, p. 271.

26. In his Life of Pontormo, Vasari stated that Bronzino executed one tondo, while in his Life of Bronzino, he said that the young artist painted two (ibid., vol. 6, p. 271, and vol. 7, p. 594).

27. Giorgio Vasari, *Le Vite de' più eccellenti architetti, pittori, et scultori italiani, da Cimabue insino a' tempi nostri* (Florence: Lorenzo Torrentino, 1550; rpt., Turin, 1986), p. 899.

28. Vasari-Milanesi, vol. 7, p. 210.

29. Ibid., vol. 3, pp. 375–76.

30. Ibid., vol. 3, p. 384.

31. Ibid., vol. 4, pp. 272, 280.

32. Ibid., vol. 4, pp. 259, 266, 269, 271.

33. Karen-edis Barzman, *The Università, Compagnia, ed Accademia del Disegno* (Ann Arbor, 1985), p. 251 (hereafter *Accademia del Disegno*).

34. Vasari-Milanesi, vol. 4, pp. 282–83, 286–87.

35. For a full transcription of Pontormo's diary, which contains a record of his work at San Lorenzo, among other activities, between 1554 and his death on January 1, 1557, see F. M. Clapp, *Jacopo Carucci da Pontormo, His Life and Work* (New Haven, 1916), app. 3.

36. A discussion of the effects of lead poisoning on painters can be found in John F. Moffitt, "Painters 'Born under Saturn': The Physiological Explanation," *Art History*, vol. 11, no. 2 (June 1988), pp. 195–216, esp. p. 209.

37. Vasari-Milanesi, vol. 6, p. 280.

38. Ibid., vol. 6, p. 289.

39. Cox-Rearick, *Drawings of Pontormo*, vol. 1, pp. 15–17, 28–29.

40. See ibid., vol. 1, nos. 104, 361, and vol. 2, figs. 114, 343.

41. This was a fairly common practice in the fifteenth and sixteenth centuries, used by Michelangelo among others (e.g., his studies for the Cascina bathers on both sides of a sheet in the British Museum [no. 1887-5-2-116]).

42. Ibid., vol. 1, nos. 206, 289, and vol. 2, figs. 198, 281. Cox-Rearick makes the same error with the final compositional study for the *Deposition* in Santa Felicita (ibid., vol. 1, no. 272, and vol. 2, fig. 254).

43. F. M. Clapp, *Les Dessins de Pontormo* (Paris, 1914), pp. 104–5, 222–23; Luisa Marcucci, *Mostra del Pontormo e del primo manierismo fiorentino*, exh. cat., Palazzo Strozzi (Florence, 1956), no. 109; and Luisa Marcucci, *Mostra di disegni dei primi manieristi italiani*, exh. cat., Gabinetto Disegni e Stampe degli Uffizi (Florence, 1954), no. 54. The stylus marks on the *Nailing* and *Visitation* sheets do not match the chalk lines, indicating that the designs were transferred from other sheets. (Pontormo used the *incisioni a secco* as guides but did not follow them

slavishly.) If Pontormo had traced the designs on those full compositional studies onto other sheets (the *modelli* postulated by Cox-Rearick), then the stylus marks on the former works would trace their lines exactly.

44. As Cox-Rearick (*Drawings of Pontormo*, vol. 1, p. 124) points out, Pontormo probably learned to use this combination of media from Fra Bartolommeo, who was experimenting with them in his drawings of about 1516.

45. Ibid., vol. 1, no. 134, and vol. 2, fig. 126.

46. Ibid., vol. 1, no. 29, and vol. 2, fig. 37.

47. Ibid., vol. 1, p. 216, nos. 197–98.

48. Ibid., vol. 1, nos. 202, 204, and vol. 2, figs. 195–96.

49. For example, ibid., vol. 1, nos. 31, 96, and vol. 2, figs. 38, 97. Pontormo's master, Sarto, made similar facial abbreviations; see, for example, the sheet of figure studies by Sarto in the Lugt collection, reproduced in James Byam Shaw, *The Italian Drawings of the Frits Lugt Collection* (Paris, 1983), pl. 20.

50. Cox-Rearick, *Drawings of Pontormo*, vol. 1, pp. 29–30.

51. Ibid., vol. 1, nos. 242–43, and vol. 2, figs. 231–32; vol. 1, nos. 239, 255, and vol. 2, figs. 233, 240.

52. For the Corsini sketchbook, see ibid., vol. 1, p. 167.

53. Even as recently as 1958, Hartt ascribed to Giulio Romano Raphael's red chalk figure studies for the *Fire in the Borgo* (Vienna, Albertina, S.R. 283) and the *Battle of Ostia* (Vienna, Albertina, S.R. 282); the latter bears an inscription from Dürer indicating that he received it as a gift from Raphael. See Frederick Hartt, *Giulio Romano* (New Haven, 1958), vol. 1, pp. 23–24, nos. 7, 9.

54. For Bandinelli's "academic" nude studies, see Roger Ward, "Observations of the Red Chalk Figure Studies of Baccio Bandinelli: Two Examples at Melbourne," *Art Bulletin of Victoria*, no. 23 (1982), 1983, pp. 19–37. Bandinelli's influence in the mid to late sixteenth century is still underestimated, partly because he too suffered from Vasari's poison pen. Discussions of Bandinelli's importance can be found in Janet Cox-Rearick, "From Bandinelli to Bronzino: The Genesis of the Lamentation for the Chapel of Eleonora di Toledo," *Mitteilungen des Kunsthistorischen Institutes in Florenz*, vol. 33 (1989), pp. 37–84; and Zygmunt Waźbiński, *L'Accademia medicea del Disegno a Firenze nel Cinquecento. Idea e institizione* (Florence, 1987), vol. 1, pp. 47–48.

55. Uffizi nos. 6657F, 447Fv; Cox-Rearick, *Drawings of Pontormo*, vol. 1, nos. 208–9, and vol. 2, figs. 200–201.

56. Vasari-Milanesi, vol. 6, p. 270.

57. Uffizi, no. 6656Fv, and British Museum, no. 1936-10-10-10v; Cox-Rearick, *Drawings of Pontormo*, vol. 1, nos. 215–16, and vol. 2, figs. 209–10.

58. The former drawing is perhaps for a portrait of Ippolito de' Medici, and if so, it was probably made after a model in costume. Pontormo was clearly more interested in the drapery than the face in this sheet, and he would not have wasted the time of an important patron by making him pose for what is primarily a costume study. For the identification of the sitter, see Cox-Rearick, ibid., vol. 1, no. 223, and vol. 2, fig. 219. Uffizi no. 6665F, also appar-

ently a life study, was to be integrated virtually unchanged into Pontormo's *Nailing to the Cross* composition (ibid., vol. 1, no. 207, and vol. 2, fig. 199).

59. Vasari-Milanesi, vol. 6, p. 6.

60. Cox-Rearick, *Drawings of Pontormo*, vol. 1, nos. 171, A4.

61. Louvre, Cabinet des Dessins, nos. 1015, 1017, 1020–1023.

62. Uffizi, nos. 445F, 459F, 526F, 6575F, 6700F, 6743F.

63. Louvre, Cabinet des Dessins, no. 948. See Feinberg, *Cavalori*, no. 3.

64. Ibid., no. 4.

65. Many of the copies after Pontormo's late studies were done by as yet unidentified hands (e.g., Uffizi nos. 6580F, 6724F, 6745F, after drawings for the Castello loggia and San Lorenzo *Resurrection*). See Cox-Rearick, *Drawings of Pontormo*, vol. 1, nos. A88, A151, A159.

66. See the anatomical studies by Pontormo (Uffizi, no. 6522F) and Allori (Uffizi, no. 18726F) in Roberto P. Ciardi and Lucia Tongiorgi Tomasi, *Immagini anatomiche e naturalistiche nei disegni degli Uffizi, secc. XVI e XVII*, exh. cat., Gabinetto Disegni e Stampe degli Uffizi (Florence, 1984), nos. 7, 26–27, figs. 9, 27, 33. Sarto also did some studies of individual bones (British Museum, Fawkener 5210.63v, and Uffizi, no. 6423F).

67. The *consoli* or consuls were the chief officers of the academy, directly beneath the *luogotenente*, the director. For a summary of the consuls' official responsibilities, see Barzman, *Accademia del Disegno*, pp. 170–73.

68. In his recent book on the Accademia del Disegno, Waźbiński greatly overstates the influence of Michelangelo in this period. Incredibly, in describing what he believes to have been a cult of Michelangelo in later sixteenth-century Florence, he actually revives the notion, championed by Burckhardt in *Der Cicerone* (1855), Passavant in *Raphaël d'Urbin* (1860), and other nineteenth-century writers, that Mannerist art was primarily caused by excessive imitation of Michelangelo; see Waźbiński, *L'Accademia medicea*, sec. 2, chap. 2.

 Waźbiński is incorrect in asserting that later sixteenth-century Florentine artists had a fixation on Michelangelo and on the notions of *idea* (the divine inspiration of art) that he promoted. Rather, attitudes seem to have changed after the founding of the academy, and artists, accepting the basic premises of Alberti's writings, came to believe that art does not descend from God, but is gained through training and practice, even rote learning.

69. Illustrated in Simonetta Prosperi Valenti Rodinò, *Disegni fiorentini 1560–1641*, exh. cat., Villa della Farnesina, Gabinetto Nazionale delle Stampe (Rome, 1979), no. 42.

70. Ibid., no. 17.

71. Ibid., no. 47.

72. Ibid., no. 57. For an example of Bernardino Poccetti's employment of this working method, see Nicholas Turner, *Florentine Drawings of the Sixteenth Century* (London, 1986), no. 192.

73. Sarto's naturalism is much celebrated in writing in the latter part of the century, particularly in Francesco Boc-

chi's *Le Bellezze della città di Fiorenza* (Florence, 1591; rpt., London, 1971), pp. 134–43, and in his *Discorso sopra l'eccellenza dell'opere d'Andrea del Sarto, pittore fiorentino* (probably composed in 1567). For the treatise on Sarto, see Robert Williams, ''A Treatise by Francesco Bocchi in Praise of Andrea del Sarto,'' *Journal of the Warburg and Courtauld Institutes*, vol. 52 (1989), pp. 111–39, esp. pp. 116n13, 136.

74. Giorgio Vasari, *Lives of the Most Eminent Painters, Sculptors, and Architects*, trans. and ed. Gaston DuC. deVere (London, 1912–14), vol. 5, p. 118, and Vasari-Milanesi, vol. 5, p. 57.

75. For example, British Museum no. 1912-12-14-1, reproduced in S. J. Freedberg, *Andrea del Sarto* (Cambridge, Mass., 1963), vol. 2, as fig. 98.

76. See ibid., vol. 1, no. 66, p. 147, and John Shearman, *Andrea del Sarto* (Oxford, 1965), vol. 2, no. 79, p. 269.

77. Leon Battista Alberti, *On Painting*, trans. and ed. John R. Spencer (New Haven and London, 1966), p. 97.

78. Ibid., p. 73, and see Cox-Rearick, *Drawings of Pontormo*, vol. 1, nos. 294, 378–79, and vol. 2, figs. 290, 361–62 (Uffizi, nos. 6588F and 17411F).

79. Vasari-Milanesi, vol. 5, p. 59.

80. Ibid., vol. 5, pp. 6, 60.

81. Ibid., vol. 1, p. 191.

82. See Feinberg, *Cavalori*, pp. 260–62.

83. Naldini's sketch after the Cavalori-Macchietti canvas is preserved in the Uffizi (no. 7286F), where it is catalogued as by Cavalori.

84. For another example of this secular-prose style, see cat. no. 19.

85. The painting, on deposit at the Pitti Gallery, was created by an anonymous Florentine artist after Empoli's drawings, two of which are preserved in the Uffizi (no. 959F) and the British Museum (no. 1886-10-12-540). See Eve Borsook, ''Art and Politics at the Medici Court. IV: Funeral Decor for Henry IV of France,'' *Mitteilungen des Kunsthistorischen Institutes in Florenz*, vol. 14, no. 2 (Dec. 1969), pp. 222–23, fig. 24, and Turner, *Florentine Drawings*, no. 199, pp. 253–54. Empoli, a pupil of Maso da San Friano (who was himself prominent among the Sarto revivalists), arranged his composition in the typical quincunxial fashion of those of Sarto's Scalzo works. See also cat. no. 19.

86. For examples, see Valenti Rodinò, *Disegni fiorentini*, nos. 67–68, 81–82, 91.

87. Feinberg, *Cavalori*, pp. 19–20, 72–76, no. 10.

88. See Luciano Berti, ''Un ritrovamento: La 'concezione' del Bronzino,'' *Rivista d'arte*, vol. 27 (1951–52), pp. 191–93.

89. Berti, *Il Principe dello Studiolo*, fig. 181.

90. Marcia B. Hall, *Renovation and Counter-Reformation: Vasari and Duke Cosimo in Sta. Maria Novella and Sta. Croce 1565–1577* (Oxford, 1979), p. 82, fig. 101.

91. Turner, *Florentine Drawings*, no. 186, pp. 235, 238.

92. Federico Zeri, *Pittura e controriforma. L'Arte senza tempo di Scipione da Gaeta* (Turin, 1957), and Sydney J. Freedberg,

Painting in Italy 1500–1600 (Harmondsworth, 1979).

93. Notably in Marcia Hall's *Renovation and Counter-Reformation* and in the catalogue of the 1980 exhibition entitled *La Comunità cristiana fiorentina e toscana nella dialettica religiosa del Cinquecento*.

94. See Mina Bacci, ''Jacopo Ligozzi e la sua posizione nella pittura fiorentina,'' *Proporzioni*, vol. 4 (1963), pp. 53, 57, figs. 5–7, 8–9, 12.

95. Vasari-Milanesi, vol. 1, pp. 184–85, and vol. 7, p. 580.

96. Barzman, *Accademia del Disegno*, p. 300.

97. According to the traveler Fynes Moryson, who visited Florence in 1594, Francesco kept in the Uffizi Tribuna, together with precious and rare objects, two paintings by Flemings; see Fynes Moryson, *An Itinerary . . . Containing His Ten Yeeres Travell Through the 12 Dominions of Germany, Bohmerland, Sweitzerland, Netherland, Denmarke, Poland, Italy, Turky, France, England, Scotland, and Ireland* (Glasgow, 1907), vol. 1, p. 322.

98. Cf. Stradano's *Hunt Landscape* in the Uffizi (no. 2346F), reproduced in Paola Barocchi, Anna Forlani, et al., *Mostra di disegni dei fondatori dell'Accademia delle Arti del Disegno*, exh. cat., Gabinetto Disegni e Stampe degli Uffizi (Florence, 1963), fig. 26.

99. Graham Smith, ''Bronzino and Dürer,'' *Burlington Magazine*, vol. 119 (Oct. 1977), pp. 708–10.

100. Cigoli's reworking of Dürer's composition is discussed in Annamaria Petrioli Tofani, ''Ludovico Cigoli: Variazione su un tema di Dürer,'' *Scritti di storia dell'arte in onore di Roberto Salvini* (Florence, 1984), pp. 461–65. Poccetti made a pen and wash copy of Lucas van Leyden's print, the *Mocking of Christ*; the drawing is preserved in the Farnesina (F.C. 127634).

101. Allori's unfinished treatise, entitled *Il Primo libro de' ragionamenti delle regole del disegno*, is published in Paola Barocchi, *Scritti d'arte del Cinquecento* (Milan, 1971), vol. 2, pp. 1941–81. Also see Roberto P. Ciardi, ''Le Regole del disegno di Alessandro Allori e la nascita del dilettantismo pittorico,'' *Storia dell'arte*, vol. 12 (1971), pp. 267–84, and pp. 46–47, note 25 of Barzman, below.

102. An example of this, on a sheet in the Ashmolean Museum, Oxford (Parker no. 323v), is reproduced and discussed in Michael Hirst, *Michelangelo and His Drawings* (New Haven and London, 1988), pp. 13–14, pl. 20. A sheet of studies by Pagani in the British Museum (no. 1946-7-13-437; Turner, *Florentine Drawings*, no. 200) also appears to exemplify this sort of memory training through repetition. The sheet contains some fourteen studies of the same kneeling figure without noticeable variation. The artist also practiced making a fancy letter ''A'' several times in the lower left corner of the page.

103. Alberti, *On Painting*, p. 39.

104. Barzman, *Accademia del Disegno*, pp. 353–54, and pp. 38, 45, note 9 of Barzman, below.

105. Nicholas Pevsner, *Academics of Art Past and Present* (Cambridge, Mass., 1940), pp. 39–66. For the history of the Accademia del Disegno, see also: Vasari-Milanesi, vol. 6, pp. 655–60; Camillo Cavallucci, *Notizie storiche*

intorno alla R. Accademia delle Arti del Disegno (Florence, 1873); Ticciati, ''Storia della Accademia del Disegno,'' pp. 193–307; Karl Frey, *Der literarische Nachlass Giorgio Vasaris* (Munich, 1923), vol. 1, pp. 706–11; A. Nocentini, *Cenni storici sull'Accademia delle Arti del Disegno* (Florence, 1963); *Mostra documentaria e iconografica dell'Accademia delle Arti del Disegno* (Florence, 1963); Carl Goldstein, ''Vasari and the Florentine Accademia del Disegno,'' *Zeitschrift für Kunstgeschichte*, vol. 38 (1975), pp. 145–52; and Mary Ann Jack Ward, ''The Accademia del Disegno in Late Renaissance Florence,'' *Sixteenth-Century Journal*, vol. 7, no. 2 (1976), pp. 3–20.

106. Zygmunt Waźbiński, ''La prima mostra dell'Accademia del Disegno a Firenze,'' *Prospettiva*, vol. 14 (July 1978), pp. 47–57; Charles Dempsey, ''Some Observations on the Education of Artists in Florence and Bologna during the Later Sixteenth Century,'' *Art Bulletin*, vol. 62 (Dec. 1980), pp. 552–69; and Barzman, *Accademia del Disegno*. For a view of the Florentine academy still fundamentally in accord with Pevsner's, see Carl Goldstein, *Visual Fact over Verbal Fiction: A Study of the Carracci and the Criticism, Theory, and Practice of Art in Renaissance and Baroque Italy* (Cambridge, Mass., 1988), pp. 81–88.

107. Waźbiński, ''La prima mostra,'' pp. 47–57, and Dempsey, ''Education of Artists,'' pp. 556–57. These statutes are transcribed in Waźbiński, *L'Accademia medicea*, vol. 2, p. 432.

108. Waźbiński, *L'Accademia medicea*, vol. 1, pp. 276–79. Despite this and other evidence of the academy's activities, Waźbiński's new major study to a large extent repudiates his earlier publications on the academy, which present it as a vital educational institution. Waźbiński now seems to believe that the academy in the sixteenth century was somewhat paralyzed by concerns with art theory and ideology and was unable to fulfill its practical, educational purpose.

109. Dempsey, ''Education of Artists,'' p. 556.

110. Ibid., pp. 557–63.

111. Barzman, *Accademia del Disegno*, p. 368. Waźbiński (*L'Accademia medicea*, vol. 2, pp. 480–87) has published some incomplete inventories of the property of the academy.

112. Hirst, *Michelangelo and His Drawings*, p. 13, pl. 19. In an eighteenth-century commentary on Condivi's *Life of Michelangelo*, Pierre-Jean Mariette claimed to have had in his possession several preparatory drawings by Michelangelo for his *Risen Christ* (Santa Maria sopra Minerva) which entailed a similar progression of anatomical investigation: Christ as a skeleton, an *écorché* Christ, and a nude Christ. See Antonio Francesco Gori, ed., *Vita di Michelangelo Buonarroti pittore scultore architetto e gentiluomo fiorentino pubblicata mentre viveva dal suo scolare Ascanio Condivi* (Florence, 1746).

113. See Simona Lecchini Giovannoni, *Mostra di disegni di Alessandro Allori*, exh. cat., Gabinetto Disegni e Stampe degli Uffizi (Florence, 1970), no. 17, fig. 12. Allori advo-

cated and illustrated this practice in his *Regole del disegno*; see Barocchi, *Scritti d'arte*, vol. 2, pp. 1978–80. For a discussion of Allori's sheet of leg studies and its relation to Albertian theory, see Bernard Schultz, *Art and Anatomy in Renaissance Italy* (Ann Arbor, 1985), pp. 32–33.

114. See Simona Lecchini Giovannoni, ''Osservazioni sull'attività giovanile di Alessandro Allori—prima parte,'' *Antichità viva*, vol. 27 (1988), p. 17, fig. 19.

115. Barocchi, *Scritti d'arte*, vol. 2, p. 1950.

116. Barzman, *Accademia del Disegno*, pp. 384–85.

117. See Turner, *Florentine Drawings*, no. 144.

118. Lecchini Giovannoni, *Disegni di Alessandro Allori*, no. 16.

119. Viatte, *Dessins baroque florentins*, nos. 9–10, 26.

120. Barzman, *Accademia del Disegno*, pp. 395–96, and see *La Corte, il mare, i mercanti. La Rinascita della scienza. Editoria e società. Astrologia, magia, e alchimia. Firenze e la Toscana dei Medici nell'Europa del Cinquecento* (Florence, 1980), nos. 5.11, 5.12.

121. Vasari-Milanesi, vol. 7, p. 593.

122. Giovanni Battista Armenini, *On the True Precepts of the Art of Painting*, trans. and ed. Edward J. Olszewski (New York, 1977), p. 142. Paolo Pino (*Dialogo di pittura*, 1548) had the same opinion about speed in the execution of artworks; see Barocchi, *Scritti d'arte*, vol. 1, pp. 118–20.

123. Vasari-DeVere, vol. 10, pp. 5–6, 8, and Vasari-Milanesi, vol. 7, pp. 595, 597, 601.

124. It was a common conceit in sixteenth-century historiography not only to give an account of events but to hold up as models certain prominent citizens, e.g., Vincenzo Acciaiuoli, *Vita di Piero di Gino Capponi* (written c. 1550) and Luca della Robbia, *Vita di Bartolomeo Valori*, both published in *Archivio storico italiano*, vol. 4, pt. 2 (1853). For Vasari's promotion of Leonardo as a model, see Patricia Rubin, ''What Men Saw: Vasari's Life of Leonardo da Vinci and the Image of the Renaissance Artist,'' *Art History*, vol. 13, no. 1 (1990), pp. 34–46.

125. Barzman, *Accademia del Disegno*, p. 398.

126. Ibid., p. 413.

127. Vasari-Milanesi, vol. 4, p. 376, and see E. H. Gombrich, *The Heritage of Apelles: Studies in the Art of the Renaissance* (Ithaca, 1976), p. 128.

128. Vasari-Milanesi, vol. 7, p. 657.

129. Anna Forlani, ''Andrea Boscoli,'' *Proporzioni*, vol. 4 (1963), fig. 2.

130. Boscoli's interest in luministic effects is also indicated by the black chalk and wash copy he made of Correggio's painting *La Notte* (c. 1527–30, Dresden Gallery), preserved in the Gabinetto Nazionale delle Stampe, Rome (F.C. 130054). See Piero Bigongiari et al., *Il Seicento fiorentino. Arte a Firenze da Ferdinando I a Cosimo III*, exh. cat., Palazzo Strozzi (Florence, 1986), vol. 2, no. 2.43.

131. Feinberg, *Cavalori*, p. 85.

132. Anna Matteoli, *Lodovico Cardi-Cigoli, pittore e architetto* (Pisa, 1980), pp. 245–49, and Miles Chappell, ''Cigoli, Galileo, and *Invidia*,'' *Art Bulletin*, vol. 62 (1975), figs. 6–7.

PERCEPTION, KNOWLEDGE, AND THE THEORY OF

DISEGNO IN SIXTEENTH-CENTURY FLORENCE

BY KAREN-EDIS BARZMAN

Disegno was a term of multiple meaning in Renaissance Italy. From city to city, between shop and academy, it took on a range of significations that reflects a layering of contemporary discourses concerning the theory and practice of art. The following essay is an attempt to isolate the theory of *disegno* as it was promoted through the academic circles of Florence in the sixteenth century. Here *disegno* was defined as a cognitive process, moving from perception of sensible particulars to a knowledge of universal things that cannot be seen. Embedded within this theory was the notion of a practice, for the artist of *disegno* needed the ability to render graphically that which he knew—a skill that could only be fostered over time by exercising the hand. While related to the drawing of production (drawing that belonged to the preparatory stages of making works of art), this *disegno* is best described as academic in nature, constituting a practice that was discrete from the business associated with the shop. It was promoted on an institutional scale through the Florentine Accademia del Disegno, the first incorporated school for artists in early modern Europe.

In 1547, in a public lecture delivered in the Accademia Fiorentina, Benedetto Varchi quoted the following lines from Dante's *Divine Comedy*:

> Cimabue thought to hold the field in painting, and now Giotto has the cry, so that the other's fame is dim; so has the one Guido taken from the other the glory of our tongue—and he perchance is born that shall chase the one and the other from the nest.[1]

When Varchi cited this well-known verse, Michelangelo had already produced his greatest works in Rome and Florence, and he held the field in painting and sculpture, according to many having

surpassed the ancients, the moderns, and nature itself. Varchi's lecture was paired with another he had read the week before on Michelangelo's sonnet, "The perfect artist cannot conceive other than that which is circumscribed within the block of stone . . ." ("Non ha l'ottimo artista alcuna concetto . . .").[2] Together, they cast Michelangelo as the exemplar among artists past and present, and on first reading (the lectures were subsequently published in 1550), they seem to leave little hope for advancement by others beyond his incomparable achievements. When invoking Dante, however, Varchi's optimism about the future of art could not have been doubted, as he commented: "Thus I believe one could say with truth that no art has yet reached its zenith."[3] By drawing this pointed analogy with the present, Varchi was asserting that the advent of such daunting figures as Cimabue, Giotto, and even Michelangelo did not signal the demise of art. Rather, their advent held the promise of a bright and glorious future when art would reach unimagined heights through the agency not of one, but of numerous artists.[4]

Varchi's lectures in the Accademia Fiorentina, which were attended by leading artists, intellectuals, and influential figures in the world of business and politics, must have fallen on sympathetic ears in 1547. Indeed, the future of Florentine art was a concern shared by artists and patrons alike, for Michelangelo, universally championed as the preeminent figure of the local school, had withdrawn permanently from Florence with the fall of the Republic in the 1530s. He thus had deprived the artistic community of its titular head and its patrons of their most renowned servant.

No patron was more concerned about Michelangelo's absence and its effect on the future of Floren-

tine art than Cosimo I de' Medici, duke of Florence in 1537 and first grand duke of Tuscany in 1569. Michelangelo's self-imposed exile was clearly a gesture of disaffection with the new Medici regime and an enduring source of consternation for Cosimo, whose patronage has been appropriately characterized as "cultural politics."[5] In matters of art Florence had long been recognized as a leading Italian center, and Cosimo hoped to sustain this tradition of local preeminence, not least as a means to promote the hegemony of his fledgling Tuscan state. With Michelangelo in Rome, however, this was no easy task. In the first edition of the *Lives of the Artists* (written in the late 1540s and published in 1550), Giorgio Vasari asserted the primacy of the Tuscan manner and Michelangelo's role as its greatest exponent with the conviction of historical truth.[6] Bearing a dedication to Cosimo I, the *Lives* were part of a strategy intended to win Vasari a pivotal role in the Medici machine of culture production. It appeared in an expanded edition in 1568 (four years after the death of Michelangelo), concluding with biographies of living Florentines whose artistic achievements read like a list of Medici commissions. Thus the preeminence of the local school was secured, along with the repatriation of Michelangelo—if not in fact, then at least rhetorically.

In terms of cultural politics, one of Cosimo's most ambitious undertakings was the foundation *ex novo* of the Accademia del Disegno, a school for painters, sculptors, and architects, which was incorporated in 1563 with the old Compagnia di San Luca, a lay confraternity for artists.[7] While confraternities in this period were commonly organized around professional affiliations, the concept of an incorporated school for artists, crossing not only shop but traditional guild lines, was unprecedented and stands as one of Cosimo's most enduring contributions to the development of the early modern state. The academy promoted the best of the local traditions in artistic training in order to enable practitioners in succeeding generations to sustain, if not surpass, established levels of achievement. Thus it may be seen as a monumental expression of Varchi's optimism about the future of Florentine art.[8] The academy's educational program was formalized within an unprecedented institutional context and included mathematics, ana-

tomical studies, and natural philosophy. The similarities between it and the program advocated by Leon Battista Alberti in the fifteenth century can hardly be coincidental, as the publication of a series of Italian translations of Alberti's works on painting, sculpture, and architecture just at this time suggests.[9]

The academy's name indicates that it was also founded on the centrality of *disegno* in artistic training and practice. With Michelangelo named (in absentia) as one of its honorary heads, it is appropriate to recall those well-rehearsed lines that he addressed to one of his shop assistants: "Draw, Antonio, draw, Antonio, draw and don't waste time."[10] The academy, however (on the example of Michelangelo as well as other luminaries of the local school), was devoted to more than the development of manual dexterity with chalk or pen. Indeed, in sixteenth-century Florence *disegno* signified a variety of things in different contexts, only some of which correspond to "drawing" as we construe the term today: graphic work after the model, after nature, or from the imagination. In the context of the shop, for example, *disegniare* (literally "to draw" or "drawing" as an activity) belonged to preparatory stages in the making of finished works of art. Thus its expected association with production is clear. Yet in the mid-1500s *disegno* also belonged to a theoretical discourse that sprang up around the *paragone*, or comparison, between painting and sculpture (which is more noble?), which was itself embedded within broader discussions concerning the epistemological status of the visual arts within a range of human activity and cognition.

It was Varchi who initially provided the discursive foundation for the theory of *disegno* as a process of cognition in his public lectures. There, among other things, he articulated a framework for discussions of artistic theory and practice that departed from the prevailing neo-Platonic model. To this end Varchi drew heavily upon the authority of Plato's student Aristotle, citing that ancient philosopher's texts, or those of his scholastic commentators, for an audience that was clearly acquainted with Aristotelian theories of knowledge. In the sixteenth century, then, it was not the framework itself that was new but Varchi's discussion of the status of painting

and sculpture within it. In earlier Renaissance debates concerning the nobility of the arts, theorists had cast painting and sculpture as liberal activities of the intellect, aligning them with the liberal arts (particularly with the science of geometry as a means to reflect the order of nature and, in turn, higher truths). Thus theorists were able to downplay the manual or productive aspects of artistic practice and to insist on the moral function of art. Varchi, however, shifted the parameters of the debate in his public lectures of the late 1540s, arguing that the arts belonged to something called the universal reason ("la ragione universale") of the human soul, an Aristotelian construct which was itself divided into inferior and superior parts (fig. 1).[11] Following the paradigm of human cognition laid out in book 6 of Aristotle's *Nicomachean Ethics*, Varchi placed the arts in the lower part of universal reason, defining them as the reasoned consideration of how things come to be that are not necessary (the products of art can either be or not be) and whose origin is not in themselves (like the objects of nature) but in their maker.[12] Within this Aristotelian framework Varchi was constrained to distinguish rather than elide the arts with such sciences as geometry, which belonged to the realm of superior universal reason.[13] Their inferior classification notwithstanding, the arts were identified as habits of the intellect ("abiti dell'intelletto") simply by their inclusion within Aristotle's construct of universal reason.[14] Thus their noble status was affirmed, and without the need to obscure manual production. For Varchi (following Aristotle) asserted that although the nobility of the sciences depended on their subjects and the certitude of their demonstrations, the nobility of art was to be judged by its ends, and while the end of science is to know the causes of things and to contemplate truth, the end of art is to make (i.e., to produce, which involves manual labor).[15] Given that Varchi held the ends of painting and sculpture to be one and the same (namely to imitate nature and to instruct by means of their products), he grouped them together under an umbrella he termed *disegno*, rhetorically collapsing the terms of their comparison and, in principle, the discursive polarization between the two practices.[16]

Although Varchi must be credited with providing the framework for a discussion of *disegno* as a

FIG. 1 Benedetto Varchi's division of the human soul into particular reason and universal reason, based on the model of Aristotle.

process of cognition involving the apprehension of universal knowledge, he did not define the term himself beyond asserting that it was "il principio" of painting and sculpture, by which he meant their origin or source (as when Aristotle explained: "We call a principle the first point from which a thing either is or comes to be or is known").[17] Vasari was just one among many who attempted to define *disegno* in greater detail; yet it was he who spearheaded the founding of the Accademia del Disegno in the early 1560s, and thus, it is with his definition that we are centrally concerned.[18] All artists working in Florence in the second half of the sixteenth century matriculated in the academy, an institution of the state that gave formal expression to Vasari's ideas within the context of pedagogy. Therefore Vasari's *disegno* (which was developed within Varchi's Aristotelian theory of knowledge) framed the making of art, and discourse about it, for several generations of Florentine artists.[19]

Vasari presented his theory of *disegno* in the introduction to the 1568 edition of the *Lives*:

Father of our three arts (architecture, sculpture, and painting), *disegno* proceeds from the intellect, drawing

from many things a universal judgment similar to a form or idea of all the things of nature, which is most singular in its measures. . . . [And] from this cognition is born a certain concept . . . such that something is formed in the mind and then expressed with the hands, which is called *disegno*. One could conclude [then] that this *disegno* is none other than an apparent expression and declaration of the concept that evolves in the soul. . . .

When it has derived from [a universal] judgment an image of something, *disegno* [then] requires that the hand be trained through study and practice to draw and express (with pen, with silver-point, with charcoal or with chalk) whatever nature has created. For when the intellect puts forth concepts and judgments purged [of the accidents of nature], the hands that have many years of practice make known the perfection and excellence of the arts along with the knowledge of the artist.[20]

Vasari described *disegno* as a complex intellective process that combined the acquisition of universal knowledge with the ability to suggest with line that which is inaccessible to sight. Underlying Vasari's definition were certain assumptions about perception and knowledge that depart significantly from present-day conventions and thus merit elaboration. Writing, as had Varchi, within an Aristotelian framework, Vasari based his definition on the distinction between sensory perception of an object and knowledge of its unenmattered form, which is intelligible as an abstraction. For example, "bed" or "man" can be understood as particular composites of form and matter, or as abstractions drawn from sensible particulars but not known directly through the senses.[21] Nonetheless Vasari adhered to Aristotle in maintaining that such knowledge ultimately derives from perception, for the human agent must proceed by way of induction, drawing from particular examples of composite substances (form and matter) a universal judgment ("un giudizio universale") or knowledge of the forms.[22] What Vasari described in his definition of *disegno* exemplifies the process of induction par excellence. Thus we are given an Aristotelian model of a cognitive continuum, within which one moves from perception to intellection—from the objects of sense to the objects of thought, which are surely related but cannot be collapsed one into the other.[23]

It is crucial for Vasari's definition of *disegno* that,

for Aristotle, the senses do not perceive objects themselves, but only their qualities and, moreover, that the quality associated with the sense of sight is not line (which is not a sensible quality at all, given that the eye cannot perceive it in phenomenal nature) but color (which Aristotle says is a property of physical surfaces).[24] Thus Vasari asserted that after the artist moves through the stages of induction and is prepared to send forth that which the intellect has purged of particulars ("concetti purgati"), it is with pure line that the forms are suggested.[25]

Vasari must insist that *disegno* is only an apparent expression of form ("una apparente espressione e dichiarazione del concetto che si ha nell'animo"), for it can never be purely formal in the Aristotelian sense, which is to say, it does not transcend material instantiation, as spare as ink or chalk may be. Thus, in a certain way, the products of this *disegno* are analogous to the figures of geometry, which are abstracted from natural bodies (like a sphere from the sun) and are intended to prompt consideration of universal truths.[26] The linear configurations used by geometers are sensible representations standing in for things that are only intelligible; thus they are suggestive of Aristotelian form but must not be (mis)taken for the forms themselves, given that they are enmattered, as are, perforce, the renderings described by Vasari.[27]

To assert that Vasari's *disegno* has something essentially in common with geometry may seem contradictory. Indeed the stratified classification of the arts and sciences within Aristotle's universal reason (arts below, sciences above), which Varchi had placed at the center of Florentine debates about the nature and status of painting and sculpture, would seem to keep them categorically apart (fig. 1). However, the arts of *disegno* did not fit as neatly into this system of classification as other human activities, for they seem to belong simultaneously to various parts of the cognitive scheme, looking at times like other arts and even, on occasion, like the sciences. In order to explain *disegno*'s mobility within this otherwise inflexible order, it is important to look briefly at book 1 of the *Metaphysics*, one of the *loci classici* for Aristotle's definition of art, along with book 6 of the *Ethics* discussed above. Here we are told that experience is knowledge of individual things, and that connected

experience is knowledge of universals. Therefore the arts, which are concerned with universals, are born from connected experience. Aristotle then goes on to assert that men of art know the "why" or the causes of the products of their making, which men of mere experience do not.[28] For example, those of connected experience who are concerned with health know the causes of health, while those concerned with the making of beds know the "why" or the theory behind the production of a bed (what is the nature of "bed" and how is one put together?). The artist of *disegno*, however, was supposed to know much more than the causes of the production of a particular kind of artifact (what is the nature of a painting, for example, and how is it put together?). The artist of *disegno* also needed universal knowledge of the objects of which his work was an imitation—of beds and chairs, of animals and plant life, but primarily of "man," the parts of his body, and the "why" of their particular configuration. The mediation of drawing was crucial in this process, for it was through the connected experiences of drawing diverse bodies (flayed corpses, live models, *scorticati*, or *écorché* figures, and exemplary works of art, both ancient and modern) that one could acquire universal knowledge of the human form, coupled with a hand trained to render such knowledge graphically.

The Accademia del Disegno sponsored a variety of activities that wedded acute observation with drawing, by means of which artists were supposed to acquire knowledge of the male form.[29] Thus it put into practice Vasari's *disegno* on an institutional scale previously unimagined. The activities included the academy's annual dissection, mandated by an addendum to its statutes in July 1563, through which the artist was intended to acquire knowledge of bone structure, musculature, and flesh.[30] The tripartite drawing of the anatomy of a leg by the painter and academician Alessandro Allori illustrates precisely this sequence of study (see Feinberg, above, fig. 28).[31] The parts of the body had to be understood in their individual appearances and functions, and in their proportional and functional relationships one to another, for the artist to suggest figures in motion. The underlying assumption was that spoken or written language could move by the skills of oratory,

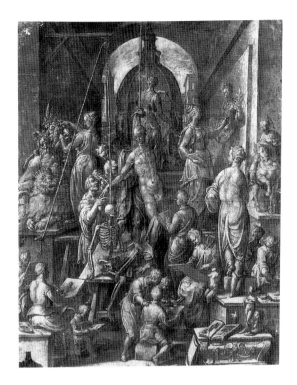

FIG. 2 Giovanni Stradano, allegorical drawing of the academy, pen and ink with wash, Kurpfäl-zisches Museum, Heidelberg.

while figures of paint or stone had to speak through a language of the body, with their inner thoughts and passions ("affetti dell'animo") made visibly manifest. The drawing of dissected corpses was intended to help the artist understand how a language of the body was articulated, and the amount of graphic work dedicated to anatomical study indicates the degree to which Florentines were committed to the concept.[32]

Although the academy reserved the hospital of Santa Maria Nuova in Florence for anatomical dissections, it might well have kept a human skeleton on its premises for study. An allegorical drawing of the academy by the painter and academician Giovanni Stradano suggests that a skeleton was hung in one of its rooms and placed in various poses by means of rope and pulleys (fig. 2).[33] It thus would have been drawn by artists to help them visualize the interrelated mechanisms involved in mobilizing the human form.[34] Academic drawing, then, which used the skeleton as a point of departure was an ideal complement to anatomical dissection.

As a supplement to the study of human cadavers, anatomical texts in Latin, accompanied by illustrations, were consulted by members of the acad-

emy, and similar works in the vernacular were planned with aspiring artists in mind. For example, eight of the fourteen books outlined by the sculptor and academician Vincenzo Danti in the mid-1560s for his incomplete *Trattato delle perfette proporzioni* were to be devoted to the subject of anatomy, while the fragments that remain of the rules of *disegno*, composed by Allori in the 1560s, treat anatomy as well.[35] Pietro Francavilla, a sculptor and academician of the succeeding generation, also produced a treatise on the human body (now lost) entitled *Il Microcosmo*, which was accompanied by his own illustrations. According to Filippo Baldinucci in his *Notizie de' professori del disegno*, Francavilla's text covered physiognomy and the various humors and temperaments in addition to human anatomy, subjects all covered in the academy's curriculum.[36] The drawings that were to accompany these volumes would have served as more than illustrations to the text; they would have provided ideal models for copying, as Allori makes clear in his own treatise.[37]

Novel study aids produced in the circle of the Accademia del Disegno further enabled artists to acquire knowledge of the human body through the process of drawing. *Scorticati*, figurines stripped of skin, were modeled of inexpensive material (gesso, clay, or wax), with their exposed muscles alternatively flexed or relaxed depending on the positions in which they were posed. The figurines were crafted as objects of drawing exercises, some of which were apparently conducted in the academy. For example, judging by the identical play of light and shadow on a famous *scorticato* by Francavilla in pen and ink drawings by Andrea Boscoli and Andrea Commodi, it has been suggested that the drawings were produced at one sitting (see Feinberg, above, figs. 30–31).[38] Boscoli and Commodi came from different shops but were both members of the academy, which would have provided the obvious setting for drawing classes that crossed shop lines.[39]

Drawing after the live model was an integral part of the academy's program and complemented the study of internal anatomy. Primary sources such as Baldinucci's *Notizie* provide evidence of the academy's commitment to figure drawing in the sixteenth century as an essential component in the artist's education. For example, in his notes on the painter Santi di

FIG. 3 Santi di Tito, *Study of a Prone Figure*, black chalk on blue paper, Uffizi, Florence (no. 7585F)

Tito, Baldinucci wrote:

> [Santi] was from his youth through his later years much devoted to the faculty of drawing . . . [so much so that he] always committed his spare time to that activity, particularly in the evenings, which did not permit him to work with colors. In those hours, when figure-drawing was not held in the public academy, which he usually frequented along with every other master of renown, and when he had nothing else to do, he drew [from life] his wife, sons, and daughters.[40]

Baldinucci's reference to figure drawing in the academy suggests that private study in the artist's shop or home supplemented that within the public institution, which was apparently held with relative frequency. Some of Santi's surviving figure studies, which were clearly drawn after the live model but have yet to be associated with any of his finished paintings as preparatory shop pieces, might be the products of such purely academic figure drawing (fig. 3). Although documents concerning the election of figure drawing instructors or payments made to models have not been found in archival records before the seventeenth century, there can be little doubt that drawing after the live model was an integral part of the artist's academic education in sixteenth-century Florence.[41]

In what appears to be a paradox to the modern observer, in the sixteenth century certain works of the masters of the distant and not so distant past came to represent a higher and even truer form of "naturalism" than nature itself. It was commonly believed that matter was not often ready to receive the perfect forms intended by nature, whose objects

(including the bodies of men) do not always present themselves as ideal objects of study. Thus drawing after exalted works of art came to be seen as a kind of shortcut for artists of *disegno* intent on developing universal judgment, which was thought to come from knowledge of forms or essences. Painters were sometimes said to imitate the accidental appearances of things more than their forms, and sculptors essential form more than accidental appearance.[42] Perhaps it was for this reason that drawing after works of sculpture became a common practice in the circle of the academy. Giovanni Battista Naldini's study of Michelangelo's *Lorenzo de' Medici* in the New Sacristy in San Lorenzo is a good example of this practice (cat. no. 29). Indeed, the sacristy became something of a school in itself in the mid-sixteenth century, briefly housing the Accademia del Disegno in the early 1560s as Vasari and other academicians attempted to bring its decorations to completion and to secure the space for teaching purposes.[43] Federico Zuccaro's drawing from the early 1560s, which depicts artists sketching in the chapel, suggests that Naldini's drawing was executed (or at least initiated) in the sacristy and in the presence of other students connected with the academy (fig. 4).[44]

The practice of drawing after painted works was a close second to that of drawing after sculpture in sixteenth-century Florence. Artists probably visited Masaccio's Brancacci Chapel as frequently as Michelangelo's New Sacristy. In his Life of Masaccio, Vasari included Leonardo and Raphael along with Michelangelo among the more than twenty-five artists he identified by name as "studiosi" and "disegnatori" of Masaccio's frescoes.[45] Youthful drawings by Michelangelo after figures from the Brancacci *Tribute Money* and *Consecration of the Carmine* (Munich, Graphische Sammlung, no. 2191, and Vienna, Albertina, no. 116) provide graphic evidence to corroborate Vasari's claims.[46] The Brancacci Chapel was famous as a "school" for aspiring artists, but Florentines also drew avidly after the paintings and frescoes of other artists. Notable among them were the works of Andrea del Sarto, particularly in the second half of the sixteenth century when Sarto's painting was embraced for its formal simplicity and legibility (see Feinberg, above, pp. 22–25). It was undoubtedly in the spirit of the Counter-Reformation as well as in the

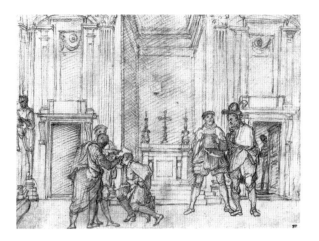

FIG. 4 Federico Zuccaro, *Artists Sketching in Michelangelo's New Sacristy*, black chalk, Louvre, Paris (no. 4555).

service of court propaganda that his style then found favor among members of the academy.

Last but not least was the practice of drawing after drawings, from anatomical studies and figures drawn by instructors expressly for copy work by students to *modelli*, or highly finished preparatory works with multiple figures. Feinberg has written at length of academic interest in Florence in the drawings, for example, of Jacopo Pontormo, particularly in the 1570s and 1580s (see pp. 13–22). The range and number of Pontormo's drawings that were valued as study pieces, including detailed studies of human bones and drawings after the live model (see Feinberg, above, figs. 5–7, 11–12, 16–17), suggest more than an appreciation for his graphic style. They indicate an interest in his rigorous working method, a process that exceeded the manual aspects of drawing and in important ways exemplified Vasari's *disegno* "avanti la lettera."

In addition to understanding human anatomy, the artist of *disegno* was expected to master drapery as an ornament of the body itself, a skill that was developed in part by drawing after masterpieces of the past, both in paint and in stone. The Accademia del Disegno, however, also sponsored classes with a particular emphasis on drawing still-life arrangements of drapery. In 1570 it was decided that members were to prepare a clay figure, drape it with cloth, and bring it to the school for purposes of study and drawing twice a week (on Thursdays and Sundays); by drawing lots, they were then to exchange places

and draw after each other's models.[47] A postscript added in the academy's book recording this decision stipulated that no one could come to observe the draped figures unless the intention was to draw ("e nessuno non possa venire a vedere se non disegna").[48] This last injunction renders all but explicit what might well have been inferred from a survey of the other activities sponsored by the academy, the presumed connection that bound together perception, drawing, and the acquisition of knowledge among artists of *disegno*.

Acknowledgments: I would like to thank the following people for commenting on the manuscript at various stages: Salvatore Camporeale, Michael Howard, Patricia Rubin, William Wallace, and Robert Williams, who is currently writing a book on epistemology and sixteenth-century art theory in Florence.

NOTES

1. "Credette Cimabue nella pittura tener lo campo, et ora ha Giotto il grido, sì che la fama di colui oscura. Così ha tolto l'uno a l'altro Guido la gloria del la lingua, e forse è nato chi l'uno e l'altro caccerà del nido."

 For excerpts of Varchi's lecture, entitled *Lezzione di Benedetto Varchi, nella quale si disputa della maggioranza delle arti e qual sia più nobile, la scultura o la pittura, fatta da lui publicamente nella Accademia Fiorentina la terza domenica di Quaresima, l'anno 1546 (1547 stile comune),* see Paola Barocchi, *Scritti d'arte del Cinquecento* (Milan, 1971), vol. 1, pp. 133–51; see p. 135 for the quotation from Dante. For the English translation of the verse in the text, see Dante Alighieri, *The Divine Comedy: Purgatory,* trans. Charles S. Singleton (Princeton, 1973), vol. 2, pt. 1, pp. 114–15. All subsequent translations are my own unless otherwise indicated.

2. For an insightful discussion of Varchi's two lectures, which underscores the joining of Aristotelianism in Varchi's texts to the neo-Platonism more typically associated with Renaissance Florence, see Leatrice Mendelsohn, *Paragoni: Benedetto Varchi's "Due Lezzioni" and Cinquecento Art Theory* (Ann Arbor, 1982).

3. "Anzi credo io che si possa dire con verità che niuna arte sia ancora giunta al colmo," Barocchi, *Scritti d'arte,* vol. 1, p. 135.

4. Varchi introduced his quotation of Dante by asserting: "Indeed it is true that no art was invented or developed at once or by a single person, but over a period of time and by many. For one always proceeds by adding what is lacking or revising what is rough and unfinished." (Ben è vero che nessuna arte fu trovata e compiuta o in un medesimo tempo o da un solo, ma di mano in mano e da diversi, perché sempre si va o aggiugnendo o ripulendo o quello che manca o quello che è rozzo et imperfetto.) (Barocchi, *Scritti d'arte,* vol. 1, p. 134). The notion that the advancement of art is a collective enterprise clearly informed the foundation of the Accademia del Disegno, with which Varchi was at least marginally involved. On Varchi's involvement in the Accademia del Disegno, see n. 8.

5. On the cultural politics of Cosimo I and academies in Florence, see Eric W. Cochrane, *Tradition and Enlightenment in the Tuscan Academies, 1690–1800* (Rome, 1961), esp. pp. 1–34; Michel Plaisance, "Une Première affirmation de la politique culturelle de Come Ier: La transformation de l'Académie des 'Humidi' en Académie Florentine (1540–42)," in *Les Ecrivains et le pouvoir en Italie à l'époque de la Renaissance,* ed. A. Rochon (Paris, 1973), vol. 2, pp. 361–438, and "Culture et politique à Florence de 1542 à 1551: Lasca et les 'Humidi' aux prises avec l'Académie Florentine," in *Les Ecrivains et le pouvoir en Italie à l'époque de la Renaissance* (Paris, 1974), vol. 3, pp. 149–242. On Cosimo's cultural politics and the visual arts, see Janet Cox-Rearick, *Dynasty and Destiny in Medici Art: Pontormo, Leo X, and the Two Cosimos* (Princeton, 1984).

6. For Vasari's text, see Giorgio Vasari, *Le Vite de' più eccellenti pittori scultori e architettori, nelle redazioni del 1550 e 1568,* ed. Rosanna Bettarini and Paola Barocchi (Florence, 1966), 9 vols. For a critical analysis of the *Lives,* see Patricia Rubin, *Giorgio Vasari: Art and History,* forthcoming, Yale University Press.

7. The Accademia del Disegno has attracted an increasing amount of attention since Nicholas Pevsner's *Academies of Art Past and Present* (1940), in which the teaching functions of the school were obscured by an emphasis on its concern with the elevation of the social status of artists. The debates that ensued surrounding the academy (school in deed or name alone?) can be traced through the following literature: Detlef Heikamp, "Appunti sull'Accademia del Disegno," *Arte illustrata,* vol. 5 (Sept. 1972), pp. 298–304; Carl Goldstein, "Vasari and the Florentine Accademia del Disegno," *Zeitschrift für Kunstgeschichte,* vol. 38 (1975), pp. 145–52; Mary Ann Jack Ward, "The Accademia del Disegno in Late Renaissance Florence," *Sixteenth Century Journal,* vol. 3 (Oct. 1976), pp. 3–30; Zygmunt Waźbiński, "La prima mostra dell'Accademia del Disegno a Firenze," *Prospettiva,* vol. 14 (July 1978), pp. 47–57; Charles Dempsey, "Some Observations on the Education of Artists in Florence and Bologna during the Late Sixteenth Century," *Art Bulletin,* vol. 62 (Dec. 1980), pp. 555–69; Anthony Hughes, "An Academy for Doing. I: The Accademia del Disegno, the Guilds and the Principate in Sixteenth-Century Florence," and "II: Academies, Status and Power in Early Modern Europe," *Oxford Art Journal,* vol. 9, no. 1, and vol. 9, no. 2 (1986), pp. 3–9 and 50–62 respectively; Waźbiński, *L'Accademia medicea del Disegno a Firenze nel Cinquecento. Idea e istituzione* (Florence, 1987), 2 vols.; Karen-edis Barzman, review of Waźbiński's book, *Burlington Magazine* (Nov. 1988), pp. 856–57; Barzman,

"Liberal Academicians and the New Social Elite in Grand Ducal Florence," in *World Art, Themes of Unity in Diversity: Acts of the XXVIth International Congress of the History of Art*, ed. Irving Lavin (University Park, Penn., 1989), vol. 2, pp. 459–63; Barzman, "The Florentine Accademia del Disegno: Liberal Education and the Renaissance Artist," in *Academies of Art Between Renaissance and Romanticism*, ed. Anton Boschloo et al. (The Hague, 1989), pp. 14–32; Barzman, " 'Disegniare al naturale': Figure-Drawing in the Florentine Accademia del Disegno," in press.

8. The connection between Varchi and the Accademia del Disegno is based on more than speculation. His name appears in the organization's documents in 1564, when he was entrusted with the keys to its headquarters (see Archivio di Stato di Firenze, Accademia del Disegno, no. 24, fol. 4r). This suggests that Varchi was at least marginally involved with the academy at the time of its founding, just prior to his death in 1565.

9. The following editions of Alberti's texts appeared in translation at mid-century: Pietro Lauro, *I Dieci libri de l'architettura* (Venice, 1546), the first printed edition; Lodovico Domenichi, *La Pittura di Leonbattista Alberti* (Venice, 1547), the first printed translation; Cosimo Bartoli, *L'Architettura di Leonbattista Alberti* (Florence, 1550), the first illustrated edition with woodcuts reflecting contemporary building practice; and Cosimo Bartoli, *Della statua* and *Della pittura* (Venice, 1568), published in a compendium with other works of Alberti, including the *Ludi matematici*, entitled *Opuscoli morali di Leonbattista Alberti*.

 The publication of almost all these translations in Venice does not preclude the possibility that their intended audience was Florentine. Bartoli's translations of 1568 were particularly timely for the Accademia del Disegno. In fact, Bartoli's dedications to Bartolommeo Ammannati in *Della statua* and to Giorgio Vasari in *Della pittura* suggest that the publications might have been based on the pedagogical needs of the Florentine artistic community. Although Bartoli does not refer to the academy by name, no other institutions in the city were associated with the kind of programmatic instruction alluded to in the dedications. Workshops, even Vasari's, were primarily places of business that could not accommodate extended formal instruction. It would be reasonable to assume, then, that Bartoli's 1568 translations were intended (at least in part) for the academy, with which both Ammannati and Vasari were closely associated as pedagogues.

10. The original Italian appears on a drawing by Michelangelo (British Museum, no. 1859-5-14-818) with studies in pen and ink for the marble figures of the Virgin and Child in the Medici Chapel: "Disegnia Antonio disegnia Antonio disegnia e no[n] p[er]der te[m]po." The admonition, in Michelangelo's hand, was directed to Antonio Mini, a shop assistant, whose relatively feeble attempts to copy in chalk the figures penned by the master appear just above the inscription.

11. For Varchi's discussion of the human soul and of universal reason, see Paola Barocchi, *Trattati d'arte del Cinquecento* (Bari, 1960), vol. 1, p. 7. On Varchi's shifting of the terms of the debate, see Mendelsohn, *Paragoni*, pp. 38–39, and Elizabeth Cropper, *The Ideal of Painting: Pietro Testa's Düsseldorf Notebook* (Princeton, 1984), esp. p. 92.

12. "[L]'arte è uno abito fattivo, con vera ragione, di quelle cose che non sono necessarie, il principio delle quali è non nelle cose che si fanno, ma in colui che le fa" (Barocchi, *Trattati*, vol. 1, pp. 9–10). For the relevant passage in Aristotle, see *Nicomachean Ethics*, bk. 6, sec. 4, ll. 1140a1–23 (*The Complete Works of Aristotle*, rev. Oxford trans., ed. Jonathan Barnes [Princeton, 1984]).

13. For the Aristotelian classification of human knowledge within which Varchi was working, see *Nicomachean Ethics*, bk. 6, esp. secs. 3 and 4. Varchi was clearly reading the Latin translation of this text and its commentary by Thomas Aquinas, citing him as Aristotle's "grandissimo Comentatore [sic]"; for the citation see Barocchi, *Trattati*, vol. 1, p. 7. Barocchi identifies the commentator as Averroes, but the allusion is certainly to Aquinas, as is clear by Varchi's use of Aquinas' term "cogitativa" (among other things) as a gloss on the particular reason ("la ragione particolare"). For Aquinas' comments see *S. Thomae Aquinatis in decem libros ethicorum Aristotelis ad Nichomachum expositio* (Marietti, 1964), esp. p. 307 on "ratio particularis, sive vis cogitativa."

14. For Varchi's use of the term "abiti dell'intelletto," see Barocchi, *Trattati*, vol. 1, pp. 5, 9–10. Varchi limited his discussion in the lecture to Aristotle's universal reason, given that he was particularly interested in the habits of the intellect of which it was comprised. For Aristotle's discussion of the particular reason, see, for example, *Nicomachean Ethics*, bk. 1, sec. 13, and bk. 6, secs. 1 and 4. Here Aristotle discusses particular reason as the irrational part of the soul (universal reason constituting its rational counterpart).

15. Barocchi, *Trattati*, vol. 1, p. 11; Aristotle, *Nicomachean Ethics*, bks. 6 and 10.

16. The use of *disegno* as a term uniting the practices of painting and sculpture can be traced at least as far back as Lorenzo Ghiberti in his *Commentaries* of the fifteenth century: "*Disegno* is the foundation and the theory of these two arts ("Il disegno è il fondamento e teorica di queste due arti"), see Barocchi, *Scritti d'arte*, vol. 2, p. 1899. Here *disegno* seems to imply something more than draftsmanship, differing from Cennino Cennini's earlier and more technical definition of the term as "drawing." Despite the traditional meaning of the word as an umbrella term, however, Varchi was the first to provide a developed theoretical framework for his use of *disegno* to unite painting and sculpture.

 Although Varchi's lectures collapsed the terms of the *paragone* on a rhetorical level, debates about the relative nobility of painting and sculpture continued to rage in

Florence. Varchi himself seemed to end up favoring sculpture over painting, arguing in his lectures that artists must imitate the form of things as well as their accidental appearances, which belong to matter alone, and since painters imitate appearances more than form, sculptors form more than appearances, sculpture de facto comes closer to the ideal. For Varchi's privileging of sculpture over painting, see Barocchi, *Trattati*, vol. 1, p. 47. See also Mendelsohn, p. 77.

17. For Varchi's definition of *disegno*, see Barocchi, *Trattati*, vol. 1, pp. 44ff. Varchi uses "l'origine" (origin) and "la fonte" (source) interchangeably with "il principio" in his definition of *disegno*; see esp. p. 45. For Aristotle's definition of a principle, see *Metaphysics*, bk. 5, sec. 1, l. 1013a17; Barnes (vol. 2, p. 1599n1) indicates that "principle," "origin," and "source" are used interchangeably in translations of the text.

18. For a summary of other definitions of *disegno* in circulation in Florence, see Wolfgang Kemp, "Disegno— Beiträge zur Geschichte des Begriffs zwischen 1547 und 1607," *Marburger Jahrbuch für Kunstwissenschaft*, 1974, pp. 219–40, and David Summers, *Michelangelo and the Language of Art* (Princeton, 1981), esp. ch. 17, pp. 250ff.; on the latter, see Charles Dempsey's review in *Burlington Magazine*, vol. 125 (Oct. 1983), pp. 624–27. For excerpts from the relevant primary texts, see Barocchi, *Scritti d'arte*, vol. 2, sec. 12.

19. It is likely that, when formulating his theory of *disegno*, Vasari was influenced by Vincenzo Borghini, director of the Ospedale degli Innocenti in Florence and adviser to Cosimo I in administrative as well as artistic affairs; see, for example, Vasari, *Le Vite*, Bettarini/Barocchi, vol. 1, pp. 192–93. Borghini's involvement in the Accademia del Disegno, particularly in its early years when he served as its director, is well documented; see the bibliography cited above in n. 7.

20. "Perché il disegno, padre delle tre arti nostre architettura, scultura e pittura, procedendo dall'intelletto cava di molte cose un giudizio universale simile a una forma overo idea di tutte le cose della natura, la quale è singolarissima nelle sue misure . . .; e perché da questa cognizione nasce un certo concetto . . . che si forma nella mente quella tal cosa che poi espressa con le mani si chiama disegno, si può conchiudere che esso disegno altro non sia che una apparente espressione e dichiarazione del concetto che si ha nell'animo . . .

"Questo disegno ha bisogno, quando cava l'invenzione d'una qualche cosa dal guidizio, che la mano sia mediante lo studio et essercizio di molti anni spedita et atta a disegnare et esprimere bene qualunche cosa ha la natura creato, con penna, con stile, con carbone, con matita o con altra cosa; perché, quando l'intelletto manda fuori i concetti purgati e con giudizio, fanno quelle mani che hanno molti anni essercitato il disegno conoscere la perfezzione e eccellenza dell'arti et il sapere dell'artefice insieme" (Vasari, *Le Vite*, Bettarini/Barocchi, vol. 1, pp. 111–14).

21. The qualities of the matter are known directly through the senses; see Deborah K. W. Modrak, *Aristotle: The Power of Perception* (Chicago, 1987), esp. pp. 39–43 and pp. 55–80.

22. For Aristotle on induction and the dependence of knowledge on perception, see, for example, *Posterior Analytics*, bk. 1, sec. 18, and bk. 2, sec. 19; see also *Metaphysics*, bk. 1, sec. 1. It is interesting to note that Vasari's definition of *disegno* reads like a paraphrase of the opening of *Metaphysics*, where Aristotle states: "[A]rt arises, when from many notions gained by experience one universal judgment about similar objects is produced" (bk. 1, sec. 1, ll. 981a5–7).

23. For further discussion of the Aristotelian stages of cognition, beginning with particulars and perception and moving on to universals and thought, see Modrak, *Aristotle*, pp. 113–32.

24. The qualities of matter that are the proper objects of the senses are: color for sight, sound for hearing, odor for smell, flavor for taste, and tactile qualities for touch.

25. The painter and academician Alessandro Allori, in his unfinished treatise of the mid-1560s entitled *Delle regole del disegno*, also defined *disegno* in terms of pure line. In the opening pages of the treatise he asserted: "By *disegno* I mean all those things that can be expressed . . . with simple lines . . . [that is] outlines and, in all, those things which do not have either shadows or highlights [added to them]." (Per il disegno intend'io tutte quelle cose che si possono formare. . . . delle semplici linee . . . i dintorni et in soma tutte quelle cose che non hanno né ombre, né lumi.) See Biblioteca Nazionale Centrale di Firenze, Fondo Palatino, E.C. 16, 4, fols. 1–2 recto.

Allori's treatise informs a series of problematic conclusions in recent scholarship concerning the Accademia del Disegno. *Delle regole del disegno* was conceived for an audience of Florentine noblemen who were drawn to the academy despite their lack of formal training or inclination to practice the arts of *disegno* professionally. Allori's fragmentary treatise represents an attempt to teach such dilettantes how to draw by means of a schematic "grammar" of external human features (here restricted to the head for the most part), which could be learned through repetitive copying; see Roberto P. Ciardi, "Le Regole del disegno di Alessandro Allori e la nascità del dilettantismo pittorico," *Storia dell'arte*, vol. 12 (1971), pp. 267–84. Waźbiński (*L'Accademia medicea*) has recently argued that the academy widely promoted the teaching of such a standardized language of art, codifying a vocabulary of form and a fixed rule or grammar for its deployment. It is important to note, however, that Allori's treatise was conceived for a circumscribed audience and, moreover, in an atmosphere of controversy resulting from the academy's policy of waiving normal admission procedures for aristocrats, who were granted the title of *accademico* upon entry. Professional artists were awarded the less exalted title of *membro del corpo* upon joining, although a

screening process preceded their entry; see "Liberal Academicians and the New Social Elite." The preferential treatment extended to the aristocrats, who technically were not eligible for membership given that they were not practicing artists and most could barely draw, was the cause of anger among the professionals. Allori's rules can be seen as an attempt to provide a quick and easy method for the acquisition of basic skills in drawing, which would have helped to legitimize the presence of the dilettantes and to disarm those who opposed their membership. Such schematizing as the rules represented, however, undermined *disegno* as a process of cognition, presenting a concretized and inflexible taxonomy of the outward features of the body without the knowledge of why the features were so configured. This practice clearly could not be reconciled with the theoretical tenets of the new institution, which might well have been what prompted Allori to abandon the treatise.

26. Aristotle's philosophy of mathematics supports the analogy between *disegno* and geometry. Aristotle dispensed with the notion of a separate realm of pure numbers and shapes, which Plato held to be the objects of mathematical study. For Aristotle, the subject matter of mathematics (points, lines, volumes, etc.) ultimately derives from physical bodies, which are not, however, considered in their material instantiation. For a lucid summary of the relevant passages in Aristotle's corpus (particularly *Physics*, bk. 2, sec. 2, and *Metaphysics*, bk. 13, secs. 2, 3), see Jonathan Lear, *Aristotle: The Desire to Understand* (Cambridge, Mass., 1988), pp. 122, 231–43.

27. Significantly, Vasari does not discuss chiaroscuro or relief modeling in his definition of *disegno*. Although obviously an integral part of drawing in Renaissance Florence, chiaroscuro did not belong to Vasari's theoretical concept of *disegno* as the graphic analogue of pure form. When he speaks of adding shadows and highlights ("l'ombre che poi vi si aggiungono ed i lumi"), it is couched within a discussion of painting, which he defines (once again, in Aristotelian terms) as a field of color on a plane surface—color that, when coupled with the pure line of *disegno*, gives the figures the appearance of relief ("colori . . . i quali circondano la figura. . . . [T]utto . . . si rilieva ed apparisce tondo e spiccato"); see Vasari, *Le Vite*, Bettarini/Barocchi, vol. 1, p. 113. Thus one might infer that, with regard to *disegno*, chiaroscuro belongs more properly to applied drawing, where it can be used, for example, to indicate the orchestration of color in paint. In the process of producing sculpture, the introduction of highlights and shadows in preparatory drawings also plays a role, enabling the artist to work out the modeling of a three-dimensional form, the visual perception of which is dependent upon light.

28. Men of mere experience, however, often succeed more than those who have knowledge of universals alone, because action and production are both concerned with the individual. For example, the physician does not cure the human body but, rather, individuals who have been taken ill. Yet while men of experience know that such-and-such cures this or that individual body, they do not know why. They do not know the cause, which men of art, connected experience, do. The ability to teach was taken to be a sign of the man of art, for only when the causes of things are known can they be imparted to others (*Metaphysics*, bk. 1, sec. 1, 981b5; for Varchi on the ability to teach, see Barocchi, *Trattati*, p. 32). This was important within the context of the academy, which selected instructors from the ranks of its membership.

29. Renaissance interest in the human figure was restricted almost exclusively to the male form. Female figures in painting and sculpture were generally worked up from studies after male models. That the bodies of women were almost completely absent in Florentine drawings of the sixteenth century, which dealt so extensively with the human form, reflects the general marginality of women in the dominant culture.

30. "Vogliamo etiamdio che que' Consoli saranno in ufficio nel tempo verno siano tenuti e debbano procurare che si faccia in Santa Maria Nuova una Anathomia a beneficio de giovani dell'Arte del Disegno, alla quale debbono tutti esser chiamati, per ordine di essi Consoli" (see Biblioteca Nazionale Centrale di Firenze, magl. II, I, 399, chap. 2, "Dell'ordini, governo, e ufficiali dell'Accademia").

Scheduling the dissections in winter ("nel tempo verno") was intended to ensure the best possible conditions for preservation of the cadavers, which were generally kept beyond the four days allotted to medical students for the purposes of study. Indeed written accounts of artists' dissections in Florence allude to the cadavers' advanced stages of putrefaction. See, for example, Filippo Baldinucci's biography of the painter and academician Lodovico Cigoli in his *Notizie de' professori del disegno*, ed. Paola Barocchi (Florence, 1974–75), vol. 3, pp. 235ff. Here we are told that the young Cigoli took ill while studying and drawing after dissected corpses under the direction of his master, Alessandro Allori, given the advanced decay and odor of the cadavers.

31. Scholars have traditionally associated Allori's drawing with his unfinished treatise on the rules of *disegno*, suggesting that it would have served as one of the illustrations for a section on anatomy never completed; see, for example, Roberto P. Ciardi and Lucia Tongiorgi Tomasi, *Immagini anatomiche e naturalistiche nei disegni degli Uffizi, secc. XVI e XVII*, exh. cat., Gabinetto Disegni e Stampe degli Uffizi (Florence, 1984), pp. 85–86, and Bernard Schultz, *Art and Anatomy in Renaissance Italy* (Ann Arbor, 1985), p. 33.

32. For a selection of the anatomical drawings produced in Florence in the sixteenth century, see Ciardi and Tomasi, *Immagini anatomiche*.

33. The drawing was undoubtedly intended for reproduction as an engraving, like its pendant by Stradano of the Accademia di San Luca in Rome (the latter published as

a print in 1578 by Cornelius Cort). Stradano's drawing of the Accademia del Disegno was never engraved (due perhaps to the untimely death of Cort).

34. The inclusion of a human cadaver at the center of Stradano's drawing, suspended like the skeleton by means of rope and pulley, suggests that dissection might have been conducted on the academy's premises as well as at Santa Maria Nuova.

35. On Danti's treatise, see Margaret Daly Davis, "Beyond the 'primo libro' of Vincenzo Danti's 'Trattato delle perfette proporzioni,' " *Mitteilungen des Kunsthistorisches Institutes in Florenz*, vol. 26 (1982), pp. 63–85. On Allori's, see above, n. 25. Allori's treatise, conceived for dilettante members of the academy, departs in significant ways from Danti's.

36. See Baldinucci, *Notizie*, vol. 3, p. 71. On the academy's curriculum, see Barzman, "The Florentine Accademia del Disegno."

37. See the comparison of the various manuscript copies of Allori's work in Ciardi, "Le Regole del disegno," p. 277n38, where Ciardi records that the folios contain drawings that were to be copied numerous times; the student copies were then to be presented to the master for correction.

38. See *La corte, il mare, i mercanti. La Rinascita della Scienza. Editoria e società. Astrologia, magia e alchimia. Firenze e la Toscana dei Medici nell'Europa del Cinquecento* (Florence, 1980), p. 173. Of interest here is a second drawing by Boscoli of the Francavilla *scorticato* (Uffizi 8235F, reproduced in Ciardi and Tomasi, *Immagini anatomiche*, fig. 59), also apparently executed at the same sitting but from a different vantage point than the other. The existence of at least two such drawings by the same artist suggests the disciplined method of study fostered by the academy.

39. Boscoli came out of the shop of Santi di Tito, Commodi out of that of Cigoli, for which see Baldinucci, *Notizie*, vol. 3, pp. 72–78, 655–65.

40. "[Santi di Tito fu] si da giovane, come da vecchio, tanto innamorato di questa bella faculta del disegno . . . che v'impiegò sempre tutti gli avanzi del tempo, nel quale non eragli permesso il colorire, particolarmente l'ore di quelle veglie, nelle quali non favevasi tornata a disegnare il naturale alla publica accademia, la quale egli insieme con ogn'altro maestro di primo nome era solito frequentare, ed allora quando altra cosa non gli dava fra mano, disegnava . . . la moglie, i figliuoli, e figliuole" (Baldinucci, *Notizie*, vol. 2, p. 551).

41. On the documentation of figure drawing in the Accademia del Disegno in the seventeenth century, see Barzman, "Disegniare al naturale."

42. On the ability of sculptors to imitate essential form more than painters, see above, n. 16.

43. On the academy's interest in the New Sacristy, see Waźbiński, *L'Accademia medicea*, vol. 1, pp. 75–110. Waźbiński speculates that the drawings on the walls of the crypt of the New Sacristy, which were brought to light in the 1970s, were produced by members of the Accademia del Disegno during the mid-1560s when they briefly took up residence in the space. For an alternative argument, see Caroline Elam, "The Mural Drawings in Michelangelo's New Sacristy," *Burlington Magazine*, vol. 122 (Oct. 1981), pp. 593–602.

44. Study in the New Sacristy was not limited to drawing after the sculpted figures. The architectural sculpture was also of interest, as is evident from a number of drawings produced in the mid to late sixteenth century. For the drawings, some of which record measurements of the architectural details, see Charles De Tolnay, *Michelangelo* (Princeton, 1948), vol. 3, figs. 210–17. I would like to thank William Wallace for bringing these drawings to my attention.

45. See Vasari, *Le Vite*, Bettarini/Barocchi, vol. 3, pp. 130–32. It was ostensibly in the Brancacci Chapel that the sculptor Pietro Torrigiano punched Michelangelo in the nose as they both sat with pen in hand, drawing after Masaccio's figures; ibid., vol. 6, p. 12. In his treatise on *disegno*, Allori mentioned a trip to the Carmine taken around 1565 by the dilettantes he addressed in his dialogue; Allori asserted that they, too, went specifically to study Masaccio's frescoes, on the model of professional artists; see Ciardi, "Le Regole del disegno," p. 276.

46. For illustrations of the drawings, see Frederick Hartt, *Michelangelo Drawings* (New York, 1970), fig. 2, and Michael Hirst, *Michelangelo and His Drawings* (New Haven, 1988), fig. 111, respectively.

47. Archivio di Stato di Firenze, Accademia del Disegno no. 24, fol. 30.

48. Ibid.

LENDERS TO THE EXHIBITION

ACHENBACH FOUNDATION FOR THE GRAPHIC ARTS,

THE FINE ARTS MUSEUMS OF SAN FRANCISCO

ACKLAND ART MUSEUM, THE UNIVERSITY

OF NORTH CAROLINA AT CHAPEL HILL

ALLEN MEMORIAL ART MUSEUM, OBERLIN COLLEGE

THE ART INSTITUTE OF CHICAGO

THE ART MUSEUM, PRINCETON UNIVERSITY

THE BARBARA PIASECKA JOHNSON COLLECTION

BOWDOIN COLLEGE MUSEUM OF ART

THE CLEVELAND MUSEUM OF ART

CROCKER ART MUSEUM

THE FOGG ART MUSEUM, HARVARD UNIVERSITY

THE J. PAUL GETTY MUSEUM

LOS ANGELES COUNTY MUSEUM OF ART

THE METROPOLITAN MUSEUM OF ART

NATIONAL GALLERY OF ART

PHILADELPHIA MUSEUM OF ART

THE PIERPONT MORGAN LIBRARY

ELMAR W. SEIBEL

SUIDA MANNING COLLECTION

MRS. A. ALFRED TAUBMAN

THOMAS WILLIAMS

YALE UNIVERSITY ART GALLERY

EIGHT ANONYMOUS LENDERS

ALESSANDRO ALLORI

Florence 1535–Florence 1607

.

A pupil of Bronzino, who adopted him when he was five years old, Allori based his style not only on his master's but also on Michelangelo's. While still in his early teens Allori assisted Bronzino in producing cartoons for the borders of the latter's Story of Joseph tapestries for the Palazzo Vecchio. In 1554 he went to Rome, where he enthusiastically studied the works of both antiquity and Michelangelo, whose monumental nudes in the Sistine *Last Judgment* and Pauline Chapel seem especially to have impressed him. On his return to Florence in 1559, he was engaged to decorate the Montauto Chapel in Santissima Annunziata and to paint a *Descent from the Cross* for Santa Croce. Those works reveal the profound, almost disorienting effect, Michelangelo's art had on Allori; in response to the Pauline Chapel, the young artist painted expansive figures that seem curiously inert, as if encumbered by their own flesh. In subsequent projects, such as his *Christ and the Samaritan Woman* (1575; Florence, Santa Maria Novella), Allori's Michelangelism is less pronounced as he invests it with some of the polish and preciosity of form he learned from Bronzino. He employed a similar hybrid style in the two works he executed for Francesco I's Studiolo—the *Gathering of Pearls* (see cat. nos. 1–2) and the *Banquet of Cleopatra* (c. 1570–71)—in which he sought an opulence and refinement befitting the treasures (pearls and jewelry) kept in the cabinets behind them.

Not long after Vasari's death in 1574, Allori advanced to the positions of court painter and director of the Florentine Arazzeria (tapestry factory) and was entrusted by the Medici with the task of completing the decoration of the *salone* of their villa at Poggio a Caiano (1576–82). His decorations there do not differ essentially from the Studiolo paintings in temperament or effect, but rather in what he chooses to quote from the works of Bronzino and Michelangelo. Occasionally, in certain religious pictures, Allori mediated his artifice and imitated the rosy naturalism of Santi di Tito (e.g., his *Last Supper* in the Sacristy of Santa Maria Novella). But of all the painters practicing in Florence in the last three decades of the sixteenth century, Allori, under Medici protection, probably made the fewest concessions to Counter-Reformation demands for naturalism and didactic presentation.

1

Study of a Male Figure

.

Black chalk, 298 × 209 mm

Provenance: G. Sell; Samuel de Festetits (Graf von Festetits); H. M. Calmann

Exhibitions: *Old Master Drawings from American Collections*, exh. cat. by Ebria Feinblatt, Los Angeles County Museum of Art (1976), no. 29

References: Scott Schaefer, "The Studiolo of Francesco I: A Checklist of the Known Drawings," *Master Drawings*, vol. 20 (1982), p. 127

Private collection, United States

One of five or six extant studies for Allori's *Gathering of Pearls* in the Studiolo of Francesco I,[1] this sheet attests to Allori's mastery of anatomy and his debt to Michelangelo, who similarly would often focus on and bring to a high finish only one area of a drawing. This practice was the graphic equivalent of the process by which Michelangelo the sculptor would extract figures from the marble block—excavating one area of the marble, while leaving the rest hardly touched. In its sculptural qualities, Allori's study is reminiscent of certain drawings Michelangelo executed for his *Battle of Cascina* and San Lorenzo tomb figures, the latter's major Florentine projects.[2]

Allori indicated his particular interest in the *Cascina* by including at the center of the *Gathering of Pearls* a climbing figure ultimately based on one of the soldiers in Michelangelo's famous and often copied cartoon.[3] The polished character of Allori's drawing and its fine, tensile contours also betray a debt to the nude studies of his teacher Bronzino, such as his *Male Nude Carrying a Bundle on His Head* (Uffizi, no. 6704F), preparatory for the *Crossing of the Red Sea* in the Chapel of Eleonora.[4]

The very carefully incised stylus marks that follow the contours of the torso indicate that Allori transferred this design to another sheet.

1. For the drawings that can be associated with the *Gathering of Pearls*, see Schaefer, "Checklist of Studiolo Drawings," p. 127. As Simona Lecchini Giovannoni (*Mostra di disegni di Alessandro Allori*, exh. cat., Gabinetto Disegni e Stampe degli Uffizi [Florence, 1970], no. 25) and Schaefer (ibid.) have concluded, Allori's drawing of a fishing scene in the Uffizi (no. 721F) is not connected with the Studiolo picture. The *Study of a Male Nude with Left Arm Raised* in the Louvre (no. 1496) may also have been created for another project (as Schaefer, ibid., suggests). For the program of the Studiolo, see Feinberg, above, p. 11.

2. Cf., for example, Michelangelo's studies for the *Cascina* in the Teylersmuseum, Haarlem (no. A18r), and Albertina, Vienna (S.R. 157v), and for the Medici tomb figures in Haarlem (no. A30r). Many of Michelangelo's figure drawings for the Sistine Chapel ceiling were also done in this manner.

3. Allori may have gleaned the figure from a fragment of or copy after the cartoon, which was cut up about 1512, or from Marcantonio's engraving *The Bathers*, an abbreviated reworking of Michelangelo's design.

4. Reproduced in Craig Hugh Smyth, *Bronzino as Draughtsman: An Introduction* (Locust Valley, N.Y., 1971), fig. 5.

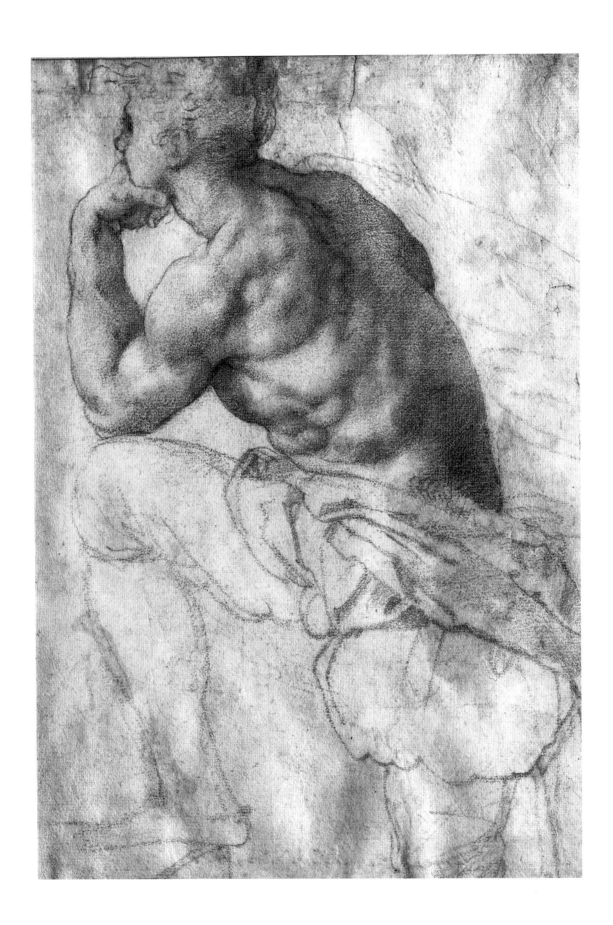

2

STUDY OF A MALE FIGURE
HOLDING AN OYSTER SHELL

.

Black chalk, 273 × 191 mm
Watermark: IHS suspended from a cross on a trefoil
Inscriptions: on verso in pen, *A.A.(?) Bronzini* and musical notations
Provenance: Richard Cosway (Lugt 628); Barry Delany (Lugt 350); Pennsylvania Academy of the Fine Arts
Exhibitions: *The Age of Vasari*, exh. cat., University of Notre Dame Art Gallery and University Art Gallery, State University of New York, Binghamton (1970), no. D2; *Old Master Drawings: Museum and Academy Collections*, Philadelphia Museum of Art (1976); *Old Master Drawings: 1550–1850*, Philadelphia Museum of Art (1984–85); *Figure Drawings from the Collection*, Philadelphia Museum of Art (1990)
References: Simona Lecchini Giovannoni, *Mostra di disegni di Alessandro Allori*, exh. cat., Gabinetto Disegni e Stampe degli Uffizi (Florence, 1970), p. 30; Ebria Feinblatt, *Old Master Drawings from American Collections*, exh. cat., Los Angeles County Museum of Art (1976), p. 28; Scott Schaefer, "The Studiolo of Francesco I: A Checklist of the Known Drawings," *Master Drawings*, vol. 20 (1982), p. 127

Philadelphia Museum of Art, The Muriel and Philip Berman Gift, acquired from the John S. Phillips Bequest to the Pennsylvania Academy of the Fine Arts, 1984-56-75

Probably created after cat. no. 1, this study for the same onlooker in the upper-right corner of Allori's *Gathering of Pearls* is closer to the figure that appears in the painting.[1] As in the finished work, the figure in the present sheet wears a cap and holds an oyster shell in his right hand. Except for those revisions and a slightly more generalized treatment of the musculature of the back, the Philadelphia study is almost identical to cat. no. 1 in pose and refinement of execution. The drawings reveal how carefully Allori worked up his compositions, leaving virtually nothing to be decided or improvised on the final support (in this case, slate). A third, half-length study for the figure, with a larger cap and fur-strapped bag, is preserved in the Uffizi (no. 11338F).[2]

Although now less apparent because of the abraded condition of the sheet, Allori modeled the forms of the present drawing with a delicate system of cross-hatching akin to that used by Michelangelo.

1. For illustrations of the painting, see Walter Vitzthum, *Lo Studiolo di Francesco I a Firenze* (Milan, 1969), pls. 24, 26–27, 36–37.
2. Schaefer, "Checklist of Studiolo Drawings," p. 127, pl. 11b.

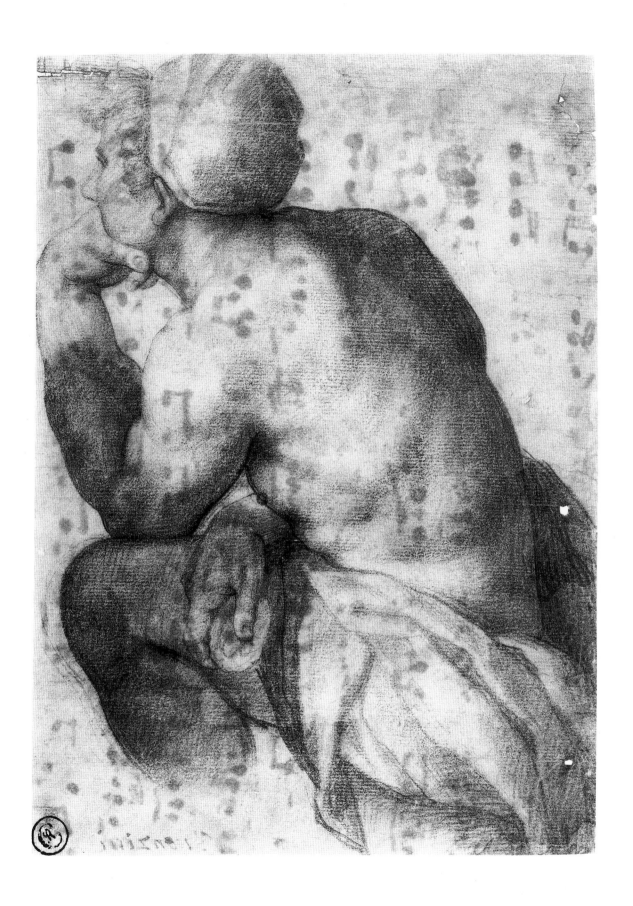

3

CHRIST AND MARY MAGDALENE

(NOLI ME TANGERE)

.

Pen and brown ink with gray wash over black chalk, heightened with white and squared in black chalk on tan paper, 268 × 185 mm

Inscriptions: on recto in pen and brown ink at bottom right, *Alessandro Allori*; on verso in pen and brown ink at top center, *3 Alessandro Allori*

Provenance: John Percival, first earl of Egmont; John T. Graves; Robert Hoe (sale, New York, Anderson Auction Company, 1912, no. 949)

Exhibitions: *A Selection of Italian Drawings from North American Collections*, exh. cat. by Walter Vitzthum, Norman Mackenzie Art Gallery, Regina, Saskatchewan, and Montreal Museum of Fine Arts (1970), no. 21

References: Egbert Haverkamp-Begemann and Anne-Marie S. Logan, *European Drawings and Watercolors in the Yale University Art Gallery, 1500–1900* (New Haven and London, 1970), vol. 2, p. 147

Yale University Art Gallery, Library Transfer, 1961.61.1

This sheet served as the presentation drawing for a painting Allori executed in 1590 which was in a private collection in Rome in the early 1930s.[1] Allori looked to an altarpiece he had painted some years earlier—*Christ and the Adulteress* in Santo Spirito (1570s)—in creating the composition of *Christ and Mary Magdalene*. The head of the Magdalene seems to be derived from one of the studies he created when working up his *Christ and the Canaanite Woman* (c. 1587) for the church of San Giovannino degli Scopoli in Florence,[2] and her pose appears to be based on that of the kneeling woman in Allori's *Descent into Limbo* (1588) in the Salviati Chapel, San Marco.[3] The painter was able to reuse his figure of the Magdalene, with some alterations, in his *Resurrection of Lazarus* (1593) in San Agostino, Montepulciano.[4] The methodical, at times formulaic, way in which Allori mines his earlier compositions for ele-

ments from which to manufacture new works is indicative of his theoretical approach to art. In the same year that he conceived his *Christ and Mary Magdalene*, Allori wrote his *Regole del disegno*, which attempted to break down the complicated processes of artistic creation into simple, step-by-step procedures; Allori demonstrated, for instance, how the head can be constructed by assembling its various components according to mathematical schema.[5]

The beautiful frame design on the present sheet harks back to some of the tapestry borders Allori helped to devise while still an apprentice to Bronzino.[6] Several other drawings survive in which Allori also concerned himself with the frame or architectural context for a particular painting (Uffizi, nos. 741F, 10259F, and Windsor Castle, no. 6018).[7]

1. Discussed and reproduced in Adolfo Venturi, *Storia dell'arte italiana* (Milan, 1933), vol. 9, pt. 6, pp. 108–9, 115, fig. 70.

2. The profile study appears in the upper-right corner of Uffizi drawing no. 10299F, illustrated in Simona Lecchini Giovannoni, *Mostra di disegni di Alessandro Allori*, exh. cat., Gabinetto Disegni e Stampe degli Uffizi (Florence, 1970), fig. 27.

3. Hermann Voss, *Die Malerei der Spätrenaissance in Rom und Florenz* (Berlin, 1920), vol. 2, fig. 127.

4. Venturi, *Storia dell'arte italiana*, fig. 56.

5. Allori's *Regole del disegno* is published in Paola Barocchi, *Scritti d'arte del Cinquecento* (Milan, 1971), vol. 2, pp. 1941–81.

6. Cf. British Museum, no. Pp. 2/95, illustrated in Craig Hugh Smyth, *Bronzino as Draughtsman: An Introduction* (Locust Valley, N.Y., 1971), figs. 18–19.

7. See Lecchini Giovannoni, *Disegni di Allori*, nos. 42, 72, and A. E. Popham and Johannes Wilde, *The Italian Drawings of the XV and XVI Centuries in the Collection of His Majesty the King at Windsor Castle* (London, 1949), no. 59.

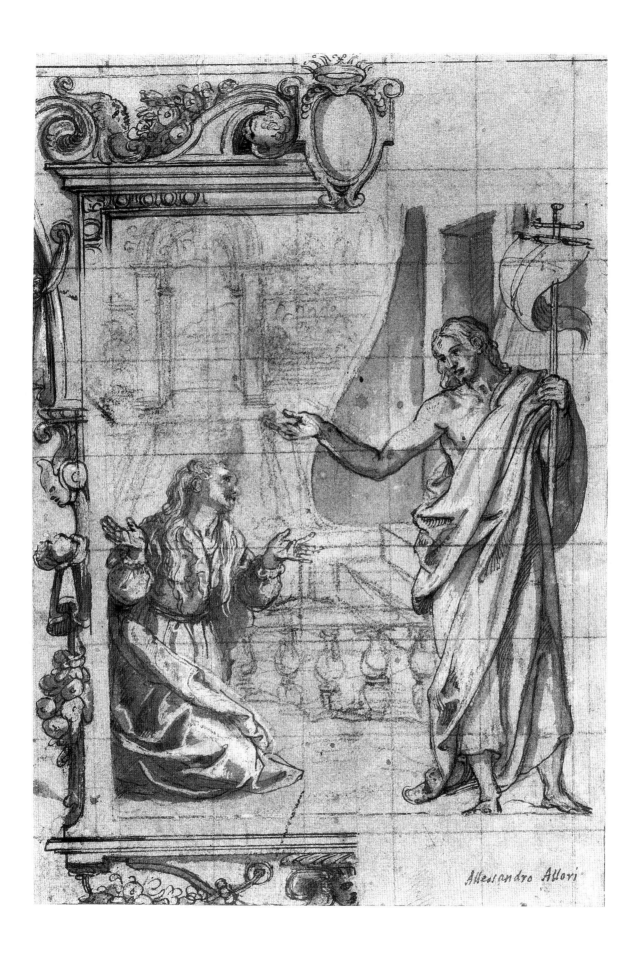

Allessandro Allori

GIOVANNI BALDUCCI,
CALLED IL COSCI

Florence c.1560(?)–Naples, after 1631(?)

.

Raised in the house of his maternal uncle, Raffaello Cosci, from whom he took his nickname, Balducci became one of the most talented and prolific disciples of Naldini. A frequent collaborator with (and executant for) the master, Balducci's mature artistic manner was largely dependent on his teacher's. He matriculated into the Accademia del Disegno in 1578 and by 1579 was already assisting Federico Zuccaro with the completion of the frescoes in the cupola of the cathedral at Florence. The next year he helped Naldini paint the frescoes of the *Resurrection of Lazarus* and the *Vision of Ezekiel* in San Marco. He executed frescoes in five lunettes in the Chiostro Grande of Santa Maria Novella in the early 1580s and was among the artists who contributed to the decorations for the marriage of Ferdinando I de' Medici to Christine of Lorraine in 1589. At the invitation of Cardinal Alessandro de' Medici, he traveled with the artist Agostino Ciampelli to Rome in 1594. After perhaps two years there, and having worked in such important churches as San Giovanni Decollato, San Giovanni in Laterano, and San Giovanni dei Fiorentini, he moved to Naples, where his career flourished.

4

THE WEDDING AT CANA

.

Pen and brown ink with brown wash over black chalk underdrawing, 350 × 273 mm
Provenance: Morton Morris and Co., Ltd., London
Elmar W. Seibel

This animated sheet cannot be connected with any of Balducci's known paintings or with commissions mentioned by the historian Filippo Baldinucci. Nevertheless, the attribution of the drawing seems secure because of its correspondence to other sheets by Balducci, such as the *Adoration of the Magi* in the Staatliche Graphische Sammlung, Munich (no. 21132), which has a similar bending figure in the right foreground and a comparable handling of washes.[1] Although his style derived from Naldini's,[2] he aspired to the polished elegance of Parmigianino, whose influence is suggested by the treatment of Christ and the twisting, attenuated figure in the left foreground.[3] This revision of Naldini's manner, with its smoothing and regularizing of forms, often had a deadening effect in Balducci's paintings as well as in his drawings. But here the well-orchestrated complexities of movement, composition, and illumination—and inclusion of engaging genre incident—save his design from inertia.

1. Paola Barocchi, "Itinerario di Giovambattista Naldini," *Arte antica e moderna*, vols. 31–32 (1965), p. 263, fig. 106e.
2. The composition of the drawing seems to be loosely based on that of Naldini's *Calling of Saint Matthew* (1584–88) in the Salviati Chapel of San Marco in Florence. The bending figure in the lower right of the present sheet appears in reverse in a Balducci design for a *Calling of Saint Matthew* (Uffizi, no. 15639F), which was also influenced by Naldini's version of the subject. For Balducci's drawing of the *Calling of Saint Matthew*, see Annamaria Petrioli Tofani and Graham Smith, *Sixteenth-Century Tuscan Drawings from the Uffizi* (Oxford, 1988), no. 63.
3. Balducci's interest in Parmigianino is even more evident in other drawings; see, for example, his *Adoration of the Magi* (Uffizi, no. 7245), reproduced in Barocchi, "Itinerario di Naldini," fig. 107a.

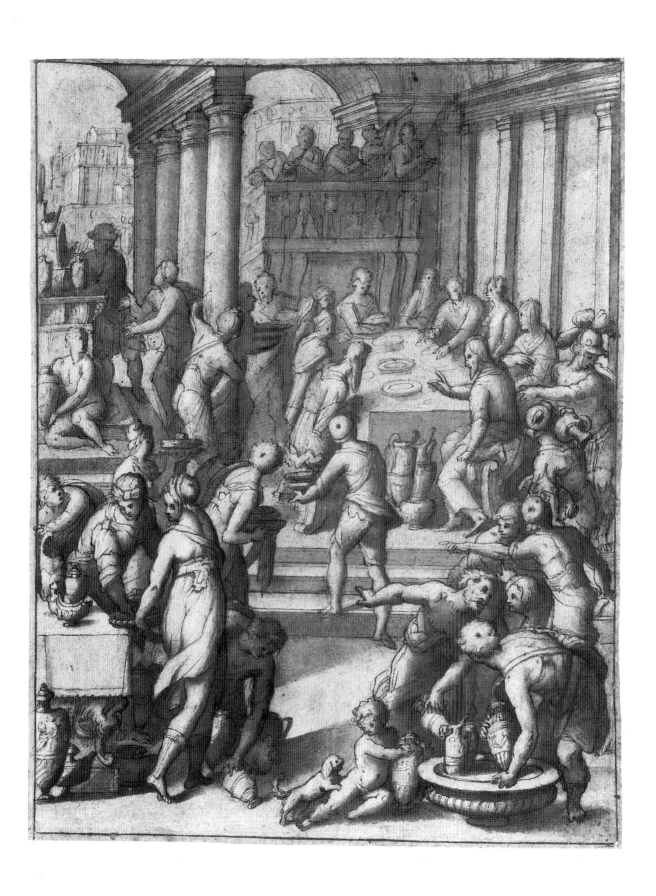

A N D R E A B O S C O L I

Florence c. 1560–Florence 1607

.

Despite his initial training with Santi di Tito, whose experiments in the handling of light had a lasting influence on him, Boscoli's artistic temperament was closer to that of Poppi or the Florentine Rosso. Some of Boscoli's earliest drawings demonstrate one way in which the young Rosso might have responded to Michelangelo. Boscoli's well-known drawing of the *Madonna and Child* in the Uffizi (no. 464F), in its faceted description of form, falls halfway between Rosso's style of the early twenties and that of studies by Michelangelo, such as the *Madonna with Saint Anne* in the Louvre (no. 685). Skimming across the surfaces of Boscoli's forms is the swift light he admired in Santi's Santa Croce *Resurrection* (1574), perhaps created during the period that Boscoli was in the master's shop. Following a period of study in Rome, probably in the early 1580s, where he copied antique sculpture and the works of Polidoro da Caravaggio, Boscoli executed his earliest surviving documented painting, the *Martyrdom of Saint Bartholomew* (1587), in the *chiostrino* of San Pier Maggiore in Florence. There, and in subsequent works, his light, more energetic and varied than Santi's, has an abstracting and fragmenting effect. The irrational patterning of light and prismatic color are congruous

with Boscoli's treatment of the forms which, in terms of the conspicuousness and irregularity of their silhouettes, recall Pontormo's frescoes in the Certosa di Val d'Ema. In his *Triumph of Mordecai* (Los Angeles County Museum of Art), Boscoli's accommodation of the modes of Pontormo and Sarto, combined with Santi's illumination and sense of natural environment, created something strikingly similar to the mature paintings of Cavalori and Macchietti. His painterly tendencies recall Cavalori's as well. But Boscoli's works are distinguished by the obvious and arbitrary geometry he imposed on form. Boscoli worked briefly in Siena (1589) and Pisa (1593–94), and in 1599 he traveled to Rimini. He continued to paint there and in the surrounding region, known as the Marches, until 1606, when he returned to Florence. The geometric abstraction of Boscoli's first works persisted in his paintings (and especially in his drawings) of the last decade of the sixteenth and into the first decade of the seventeenth century. Yet he increasingly admitted into his art the naturalism of Santi and Cigoli and the soft, fluid colors of Federico Barocci and his followers, whose works he would have seen in Siena and during his extended period in the Marches.

5

THE THEBANS BEARING OFFERINGS TO NIOBE (OR LETO?)

AFTER A FAÇADE FRESCO BY POLIDORO DA CARAVAGGIO ON THE PALAZZO MILESI, ROME

.

Pen and brown ink with brown wash, 114 × 391 mm

Inscriptions: on recto in black ink at lower right, *Polidori opus, 16*

Provenance: Pierre-Jean Mariette (Lugt 1852); Count Moriz von Fries (Lugt 2903); Dan Fellows Platt (Lugt supp. 750a and 2066b); purchased from Parsons in 1929

Exhibitions: *Italian Drawings in the Art Museum, Princeton University*, exh. cat. by Jacob Bean, Metropolitan Museum of Art (New York, 1966), no. 26; *Exhibition of Old Master Drawings*, Schickman Gallery (New York, 1968), no. 20

References: Anna Forlani, "Andrea Boscoli," *Proporzioni*, vol. 4 (1963), p. 155, no. 201; Felton Gibbons, *Catalogue of Italian Drawings in the Art Museum, Princeton University* (1977), no. 62

The Art Museum, Princeton University, Bequest of Dan Fellows Platt, 48.666

One of seven known drawings by Boscoli after Polidoro's (lost) frescoes representing the story of Niobe on the Palazzo Milesi façade (c. 1527), this sheet was probably produced during the artist's trip to Rome in the early 1580s.[1] As one can observe in the engraving by Enrico Maccari of the façade of the Palazzo Milesi (in the via della Maschera d'Oro), the frieze that the Princeton drawing partially reproduces ran along the upper story of the palace.[2] Another copy by Boscoli of the left-hand portion of the frieze, virtually identical to the present sheet, is preserved in the Victoria and Albert Museum, London.[3]

Characteristically, Boscoli in this drawing seems concerned less with recording the gestures of the figures than with the scattered play of light. In exaggerating the staccato oblique movement of light, he makes his model—a grisaille painting meant to simulate an antique relief—appear all the more sculptural. Although he was looking at the rhythmic paintings of Polidoro, Boscoli imposed on the actors the angularity of Rosso's figures and, in another copy after the Palazzo Milesi paintings at the Metropolitan Museum,[4] the facial types of Pontormo.

1. Anna Forlani, *Mostra di disegni de Andrea Boscoli*, exh. cat., Gabinetto Disegni e Stampe degli Uffizi (Florence, 1959), no. 21; Forlani, "Andrea Boscoli," pp. 94–95, figs. 16–18 and drawings catalogue nos. 179, 181, 201, 203, 257; Peter Ward-Jackson, *Victoria and Albert Museum Catalogues: Italian Drawings, Fourteenth to Sixteenth Century* (London, 1979), vol. 1, no. 58, and Jacob Bean, *Fifteenth- and Sixteenth-Century Italian Drawings in the Metropolitan Museum of Art* (New York, 1982), no. 35. For other drawings by Boscoli that copy Polidoro's frescoes on Roman houses, see Forlani, *Disegni di Boscoli*, nos. 18–20, 22; and Forlani, "Andrea Boscoli," drawings catalogue nos. 16, 178, 180, 182–85, 253, 256, 298.
2. Enrico Maccari, *Graffiti e chiaroscuri esistenti nell'esterno delle case* (Rome, 1876), pl. 37.
3. Ward-Jackson, *Victoria and Albert: Italian Drawings*, vol. 1, no. 58.
4. Bean, *Fifteenth- and Sixteenth-Century Italian Drawings*, no. 35.

6

A MAN STANDING IN A STUDIO
HOLDING ROPES

.

Black and red chalk, 330 × 213 mm
Inscriptions: on recto in brown ink at lower left, *Baroche*, and at upper right and lower right, *24* and *25*; on verso, *72*
Provenance: Adolf Glüenstein, Hamburg (Lugt 123); W. M. Brady and Co., New York

Private collection, United States

Exhibited at Dartmouth

This study of a model grasping ropes to maintain his pose and a group of other academies by Boscoli, similarly executed with a combination of black and red chalks, may date to the period of his apprenticeship with Santi di Tito[1] or to his first years as an independent artist; one of these studies (Uffizi, no. 788F) was preparatory for Boscoli's early painting of *Temperance*, a monochrome fresco he created in 1587 for San Pier Maggiore.[2] As Mark Brady has noted, a comparable drawing, apparently after the same model and with the same windswept effect, is preserved in the Louvre (no. 672).[3] The *deux crayons* technique was popularized by Taddeo and Federico Zuccaro in the later sixteenth century in Rome, where Boscoli may have learned it. He also might have seen examples of Federico's draftsmanship when the latter was in Florence from 1574 to 1579, painting the dome of the cathedral.

1. As suggested by Annamaria Petrioli Tofani in *Il Primato del disegno, La Scena del principe: Firenze e la Toscana dei Medici nell'Europa del Cinquecento*, exh. cat., Palazzo Strozzi (Florence, 1980), p. 81, and Françoise Viatte, *Dessins baroques florentins du musée du Louvre* (Paris, 1981), p. 63.
2. See Anna Forlani, *Mostra di disegni di Andrea Boscoli*, exh. cat., Gabinetto Disegni e Stampe degli Uffizi (Florence, 1959), no. 33, fig. 11; and Anna Forlani, "Andrea Boscoli," *Proporzioni*, vol. 4 (1963), pp. 129, 141.
3. *Old Master Drawings*, exh. cat., W. M. Brady and Co. (New York, 1990), no. 4. The Louvre sheet is reproduced in Viatte, *Dessins baroques florentins*, p. 65, no. 31, and Françoise Viatte, *Dessins toscans XVIe–XVIIIe siècles*, vol. 1, *1560–1640* (Paris, 1988), no. 46.

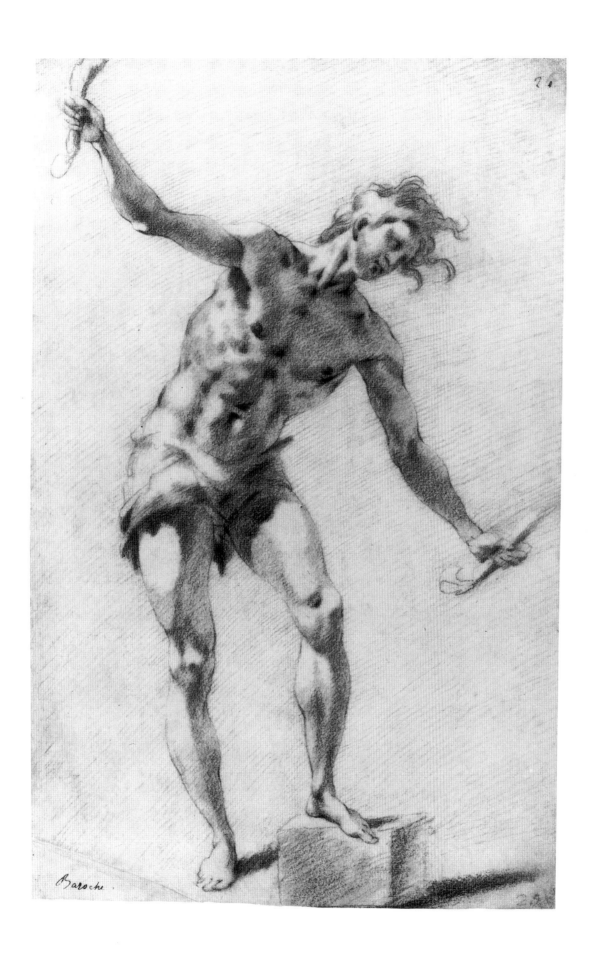

BOSCOLI

67

7

THE ANNUNCIATION RECTO

ORNAMENTAL SKETCH VERSO

.

Red chalk (recto); black chalk (verso), 362 × 288 mm

Inscriptions: on verso in pencil, *Pomerancie*, and in pen and black ink, *Andrea Boscoli*

Provenance: Charles A. Loeser (Lugt 936a)

Exhibitions: *The Draftsman's Eye: Late Italian Renaissance Schools and Styles*, exh. cat. by Edward J. Olszewski, Cleveland Museum of Art [1979] (Cleveland and Bloomington, 1981), no. 8

References: Bernard Berenson, *The Drawings of the Florentine Painters* (Chicago, 1938), vol. 2, p. 317, no. 2458G; Agnes Mongan and Paul J. Sachs, Jr., *Drawings in the Fogg Museum of Art* (Cambridge, Mass., 1940), no. 174; Anna Forlani, *Mostra di disegni di Andrea Boscoli*, exh. cat., Gabinetto Disegni e Stampe degli Uffizi (Florence, 1959), p. 20; Anna Forlani, "Andrea Boscoli," *Proporzioni*, vol. 4 (1963), p. 139, no. 1; Konrad Oberhuber, ed., *Old Master Drawings: Selections from the Charles A. Loeser Bequest* (Cambridge, Mass., 1979), no. 25; Piero Bigongiari et al., *Il Seicento fiorentino. Arte a Firenze da Ferdinando I a Cosimo III*, exh. cat., Palazzo Strozzi (Florence, 1986), no. 2.42; Annamaria Petrioli Tofani and Graham Smith, *Sixteenth-Century Tuscan Drawings from the Uffizi* (Oxford, 1988), p. 153; Agnes Mongan, Konrad Oberhuber, and Jonathan Bober, *The Famous Italian Drawings at the Fogg Art Museum in Cambridge* (Milan, 1988), no. 46

The Fogg Art Museum, Harvard University, Cambridge, Massachusetts, Bequest of Charles A. Loeser, 1932.216

The present study, executed under the spell of Rosso, has been associated with drawings usually assigned to Boscoli's earliest period of activity.[1] The faceting and the shading of the forms' edges can also be seen in his drawings of the *Madonna and Child*, *Resurrection of Lazarus*(?), and *Temperance* in the Uffizi (nos. 464F, 457F, 788F).[2] As Smith has pointed out, Boscoli's chronology as a draftsman is difficult to determine because only a handful of his drawings can be connected with dated paintings.[3] And Forlani's dating of these Rossesque sheets to the 1570s should be viewed with caution, since, as Smith has observed, some of these drawings are more sophisticated than others and would seem to relate to Boscoli's paintings of the later 1580s.[4]

While the influence of Rosso, particularly his works of the 1520s such as the Volterra *Deposition* (1521), is predominant in the *Annunciation*, the drawing may also depend on the examples of Santi di Tito and Francesco Poppi for its optical qualities. Characteristic of Boscoli is the psychological evasiveness he imparts to the study; the relation of the figures to each other and to the viewer is as oblique as are the formal elements of the compositional structure and the action of light. Cavalori and Poppi exhibited a similar emotional reticence and penchant for visual misdirection in their paintings (e.g., Cavalori's *Lavinia at the Altar* and Poppi's *Alexander and Campaspe* in the Studiolo of Francesco I). Luisa Becherucci has referred to such works as "pitture d'evasione."[5]

1. Olszewski, *The Draftsman's Eye*, p. 33; Petrioli Tofani and Smith, *Sixteenth-Century Tuscan Drawings*, p. 153.

2. Illustrated in Forlani, *Disegni di Boscoli*, as figs. 1, 4, and 11.

3. Petrioli Tofani and Smith, *Sixteenth-Century Tuscan Drawings*, pp. 153–55.

4. Ibid., and Forlani, *Disegni di Boscoli*, p. 6. I find untenable Smith's suggestion that one of these drawings, the *Madonna and Child*, may have been created during Boscoli's period in the Marches. The very sculptural conception of the figures in the drawing, where forms appear to be excavated from the paper rather than delineated by the chalk, are quite different from the extremely mobile images of the Madonna in Brefotrofio de Fabriano, Macerata, and San Genesio to which Smith compares it.

5. Luisa Becherucci, "Momenti dell'arte fiorentina nel Cinquecento," in *Il Cinquecento* (Florence, 1955), p. 181.

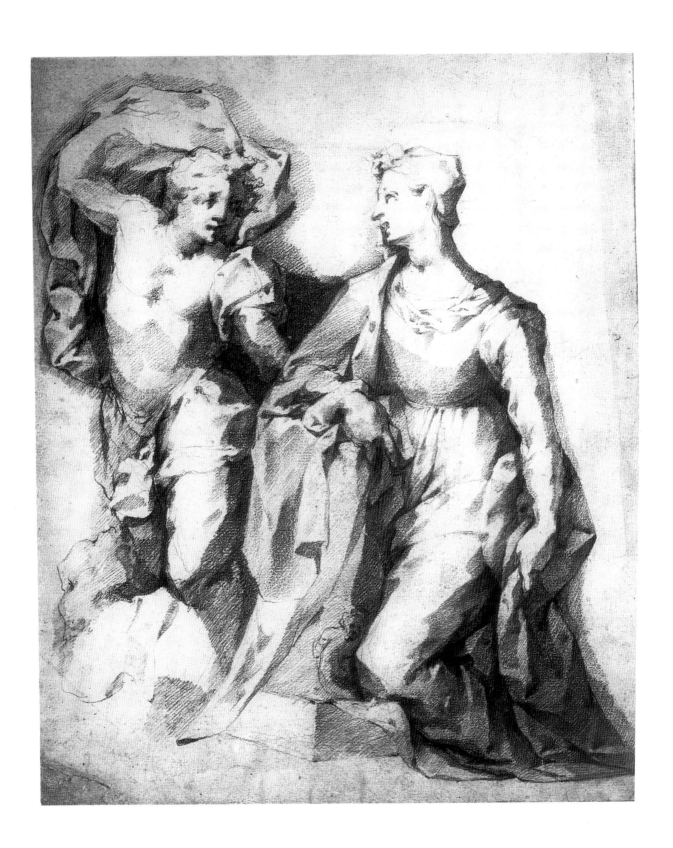

8

THE ROAD TO CALVARY

.

Pen and brown ink, brush, and brown wash over black chalk, 233 × 306 mm

Provenance: Roubiliac Collection, perhaps Louis François Roubiliac; Robert Udney (Lugt 2248); Walter von Wenz; Kasteel Heyen; R. M. Light and Co., Boston

Exhibitions: *The Renaissance*, Agnes Etherington Art Center, Queen's University, Kingston, Ontario (1966), no. 21; *Master Drawings*, John and Mabel Ringling Museum of Art, Sarasota (1967); *A Selection of Italian Drawings from North American Collections*, exh. cat. by Walter Vitzthum, Norman Mackenzie Art Gallery, Regina, Saskatchewan, and Montreal Museum of Fine Arts (1970), no. 28

References: *Yale University Art Gallery Bulletin*, vol. 30, no. 2 (March 1965), p. 13; Egbert Haverkamp-Begemann and Anne-Marie S. Logan, *European Drawings and Watercolors in the Yale University Art Gallery 1500–1900* (New Haven and London, 1970), no. 265; Edmund P. Pillsbury and John Caldwell, *Sixteenth-Century Italian Drawings: Form and Function*, exh. cat., Yale University Art Gallery (New Haven, 1974), no. 38

Yale University Art Gallery, Everett V. Meeks, B.A. 1901, Fund, 1964.9.48

Scholars have suggested that the dense, friezelike composition of this drawing is the result of Boscoli's study of the prints of Albrecht Dürer, Martin Schongauer, and other Northern masters.[1] It may be that Boscoli consulted some of those works, adopting their compositional format, because he had intended to translate the *Road to Calvary* into a print. The calligraphic manner of the drawing, and soldiers extremely similar to those at the right of its composition, can be found in an engraving after Boscoli's design for the *Battle of the Duke of Guisa and the Prince of Condé*.[2] The print reproduces a grisaille painting Boscoli executed in 1589 for the Arco dei Carnesecchi, one of the *apparati* (decorative structures) erected in celebration of the marriage of Ferdinando I de' Medici to Christine of Lorraine.[3] Without indication of authorship, the engraving appeared in R. Gualterotti's *Descrizione del regale apparato per le nozze della ser. madama Cristina di Lorena*, published in Florence in 1589. The Yale drawing may also date to about that time.

1. Haverkamp-Begemann and Logan, *European Drawings and Watercolors*, p. 149, and Pillsbury and Caldwell, *Sixteenth-Century Italian Drawings*, no. 38. Edmund P. Pillsbury ("Drawings by Jacopo Zucchi," *Master Drawings*, vol. 12 [1974], pp. 8–9) has noted that a Zucchi drawing of the *Way to Calvary* in the Louvre (no. 11430) is based on Northern prototypes, specifically the large engraving of the subject by Schongauer.
2. Anna Forlani, "Andrea Boscoli," *Proporzioni*, vol. 4 (1963), fig. 32.
3. Ibid., pp. 97, 134, 170.

9

THE VISITATION

.

Brush and gray wash over black chalk and graphite, 232 × 140 mm

Inscriptions: on verso in graphite, *15*

Provenance: James Bowdoin III

Exhibitions: *Old Master Drawings at Bowdoin College*, exh. cat. by David P. Becker, Bowdoin College Museum of Art (Brunswick, Maine, 1985), no. 47

References: Henry Johnson, *Catalogue of the Bowdoin College Art Collections*, pt. 1, *The Bowdoin Drawings* (Brunswick, Maine, 1885), no. 20; Bowdoin Museum of Fine Arts, *Descriptive Catalogue of the Paintings, Sculpture, and Drawings of the Walker Collection* (Brunswick, Maine, 1930), no. 20; Bowdoin College Museum of Art, *Handbook of the Collections*, ed. M. R. Burke (Brunswick, Maine, 1981), p. 165

Bowdoin College Museum of Art, Brunswick, Maine

In this preparatory study for his painting of the *Visitation* (c. 1596–97) in Sant'Ambrogio, Florence, Boscoli was primarily concerned with the placement of the figures and the darkest shadows.[1] The positions of the main actors and the three onlookers at the left were retained virtually unchanged in the altarpiece, but the artist eliminated the grand temple and woman at the right, and moved the figure of Zacharias (wearing ecclesiastical vestments). In Boscoli's painting, Zacharias, holding a staff, stands just to the right of Mary and Elizabeth. His proximity to the central women and the inclusion, behind him, of a wall work to seal off and compress the composition and increase the intimacy of the scene. Boscoli draws a parallel between the support the staff offers to the elderly gentleman and the mutually supportive gestures of Mary and Elizabeth.

Becker has noted the existence of an earlier, less resolved compositional study for the Sant'Ambrogio *Visitation* (Madrid, Museo Cerralbo, no. 4938) and has suggested that the Bowdoin sheet may be Boscoli's *modello*.[2] In view of the rather rough and abbreviated character of the present drawing and the substantial differences between it and the final painted version, this hypothesis seems unlikely. Another *Visitation* study (Uffizi, no. 8218F), similar in composition but horizontal in format, may also be preparatory for the Sant'Ambrogio altar.[3]

1. For information on and a reproduction of the painting, see Anna Forlani, "Andrea Boscoli," *Proporzioni*, vol. 4 (1963), pp. 104, 129, no. 8, pl. 43.
2. Becker, *Old Master Drawings*, p. 103, and *Museo Cerralbo: Catalogo de dibujos* (Madrid, 1976), no. 10.
3. Forlani, "Andrea Boscoli," p. 146, no. 100. A copy after a lost drawing by Boscoli for the Sant'Ambrogio work is preserved in the Louvre (no. 663); see Françoise Viatte, *Dessins toscans XVIe–XVIIIe siècles*, vol. 1, *1560–1640* (Paris, 1988), no. 88.

BRONZINO

AGNOLO DI COSIMO TORI

Monticelli, near Florence, 1503–Florence 1572

.

Bronzino began his artistic training in the shop of the conservative master Raffaellino del Garbo, but by 1519 he was apprenticed to Pontormo, with whom he developed a lifelong familial bond. In 1523–24 he assisted Pontormo with the decoration of the Certosa di Val d'Ema, painting two small lunettes. When Pontormo worked in the Capponi Chapel of Santa Felicita two years later, his young protégé executed one or two of the vault roundels depicting the Evangelists. Bronzino later helped Pontormo with his decorations in the Medici villas at Poggio a Caiano (1532), Careggi (1535), and Castello (c. 1537–42).

Despite his continuous working relationship with Pontormo, by 1530 Bronzino embarked on an independent career. In that year he traveled to Pesaro, where he enjoyed the patronage of Duke Guidobaldo of Urbino. The paintings Bronzino created there are strongly Pontormesque, including a portrait he did of the duke (Uffizi). After his return to Florence in 1532, he continued to develop the portrait style he inherited from Pontormo, refining and polishing it until he achieved, in works such as the pendant portraits of Bartolommeo and Lucrezia Panciatichi (c. 1540; Uffizi), the conspicuously elegant manner that came to be the model for Medici court portraits in the second half of the sixteenth century.

This same refined sensibility informs his frescoes and altarpiece in the Chapel of Eleonora of Toledo (the wife of Cosimo I) in the Palazzo Vecchio, although Bronzino did admit passages of remarkably natural detail within his densely complex paintings of the *Crossing of the Red Sea* (1541–42) and the *Brazen Serpent* (1542). His famous *Allegory of Venus and Cupid* (c. 1545; London, National Gallery), a paradigm of High Mannerism in Florence in its congealed eroticism and courtly opacity, represents the extreme to which Bronzino was willing to take his art. In some respects it is a synthesis of the formal eccentricities he learned from Pontormo and the cool sculptural style of Michelangelo; the *Allegory* has been seen as an homage to and inversion of the latter's *Doni Tondo* (c. 1504; Uffizi).

The time Bronzino spent in Rome, between 1546 and 1548, seems to have caused him immediately to temper his style, perhaps as a response to the austere recent works of Girolamo Muziano and Girolamo Siciolante da Sermoneta. The sober manner of such works as his *Holy Family with Saint Elizabeth and Saint John* (c. 1550; Vienna, Kunsthistorisches Museum) was more of an option than a constant, however, and Bronzino could occasionally still summon up a full-blown Mannerist style, patrons permitting. Like so many Florentine artists of the late sixteenth century, Bronzino exhibited an artistic schizophrenia, shifting easily from a conservative, even anachronistic, manner to one of the most pretentious and overwrought artifice, as seen in his fresco of the *Martyrdom of Saint Lawrence* (1565–69) in the Medici church of San Lorenzo in Florence. Soon after the *Saint Lawrence*, as much a demonstration piece for young academicians to study as a work of religious art, he produced his *Immaculate Conception* (c. 1570) now in the Chiesa della Regina della Pace. That painting is marked by a feigned naïveté, its figures have a quattrocentesque stiffness, and its execution is in places deliberately coarse.

Bronzino remained, throughout his career, a favorite painter of the Medici court, creating for his patrons numerous tapestry designs and portraits. He was one of the most revered and influential of the academicians; only Vasari wielded as much power in the artistic community in the period between the founding of the academy in 1563 and Bronzino's death in 1572. It is likely that Bronzino promoted, verbally and by example, the Pontormo revival that took place in the last four decades of the century.

STUDIES OF A SEATED MALE NUDE

.

Black chalk, 370 × 203 mm

Provenance: Sir Joshua Reynolds (Lugt 2364); Sir Thomas Lawrence (Lugt 2445); Sir Charles Grenville (Lugt 549); H. S. Reitlinger (Lugt 2274a)

Exhibitions: *Sixteenth-Century Italian Drawings from the Robert Lehman Collection*, exh. cat. by George Szabo, Metropolitan Museum of Art (New York, 1979), no. 24; *Masterpieces of Italian Drawing in the Robert Lehman Collection*, exh. cat. by George Szabo, Metropolitan Museum of Art (New York, 1983–84), no. 38

References: *The Reitlinger Collection, Part I*, sales cat., Sotheby and Co., London, 9 December 1953, no. 85 (as Pontormo); H. M. Calmann, *Old Master Drawings* (London, 1958), no. 9; Seiferheld, *Master Drawings* (New York, 1961), no. 2; Bernard Berenson, *I Disegni dei pittori fiorentini* (Milan, 1961), no. 2255b; E. van Schaak, *Master Drawings in Private Collections* (New York, 1962), no. 6; Janet Cox-Rearick, *The Drawings of Pontormo* (Cambridge, Mass., 1964), vol. 1, no. A233

The Metropolitan Museum of Art, New York, Robert Lehman Collection, 1975, 1975.1.281

Exhibited at Oberlin and Bowdoin

Van Schaak and, later, Szabo believed these studies to be preparatory for the figure of the young shepherd in Bronzino's painting of the *Nativity* (c. 1535–40), now in the Szépmüvészeti Múzeum in Budapest. While possible, that connection is by no means certain, as the pose of the shepherd in the painting is different in several respects, and he does not hold the syrinx, or panpipe, indicated in the drawing. Recently, Forlani Tempesti rejected van Schaak's hypothesis and even questioned the attribution of the sheet to Bronzino, suggesting that it was created by another, unidentifiable follower of Pontormo.[1] She finds the lines rather slack and heavy for a drawing by Bronzino and regards the application of chiaroscuro as somewhat inarticulate. While Forlani Tempesti's caution is warranted, the attribution to Bronzino seems plausible to me. The handling of line and shadow in the Lehman sheet is similar to that of another Bronzino life drawing, the *Study of the Christ Child* (Uffizi, no. 6704F) for the Panciatichi *Holy Family* (Uffizi).[2] While slightly less fine in its execution, the present drawing also corresponds in its mobility of contour to Bronzino's *Study for the Figure of Saint Michael* (Louvre, no. 6356).[3] In its variations and rhythms of contour and thick lines of shadow, the *Studies of a Seated Male Nude* resembles as well Bronzino's *Study of a Nude* (Uffizi, no. 6704F) for his fresco of the *Crossing of the Red Sea* (Palazzo Vecchio, Chapel of Eleonora).[4] Bronzino's rendering of the model's right hand (in the larger study) seems very close to that of the sitter's right hand in the preparatory drawing (Chatsworth, Devonshire Collection)[5] for his *Portrait of a Man with a Lute* (Uffizi).

Once given to Pontormo,[6] the Lehman sheet derives from the works of the older master the mask-like treatment of the face and its slightly neurotic, disoriented expression. The figure type (especially in the construction of the shoulder and back) depends on Pontormo's figures of the late 1520s, such as those in the Santa Felicita paintings and the studies for them. Bronzino was one of the few artists working in the latter half of the sixteenth century who drew heavily on this phase of Pontormo's art for inspiration. In fact, the artistic style with which Bronzino began his independent career was based on the manner he learned from Pontormo while assisting with the Capponi Chapel decorations. Most of the Pontormo revivalists, including Macchietti and Maso, were more interested in the master's works of the early and mid-1520s.

1. Forlani Tempesti, unpublished entry for the forthcoming catalogue of the Lehman drawing collection. Lawrence Kanter, curator of the Lehman Collection, kindly permitted me to consult this manuscript. Cox-Rearick (*Drawings of Pontormo*, vol. 1, p. 399) earlier characterized the drawing as the product of a draftsman active at the end of the century who was influenced by the later works of Bronzino.

2. Craig Hugh Smyth, *Bronzino as Draughtsman: An Introduction* (Locust Valley, N.Y., 1971), fig. 1.

3. Ibid., fig. 8. This is a preliminary drawing for the *Saint Michael* on the ceiling of the Chapel of Eleonora in the Palazzo Vecchio.

4. Ibid., fig. 5.

5. Ibid., fig. 4.

6. Berenson, *I Disegni dei pittori fiorentini*, no. 2255b.

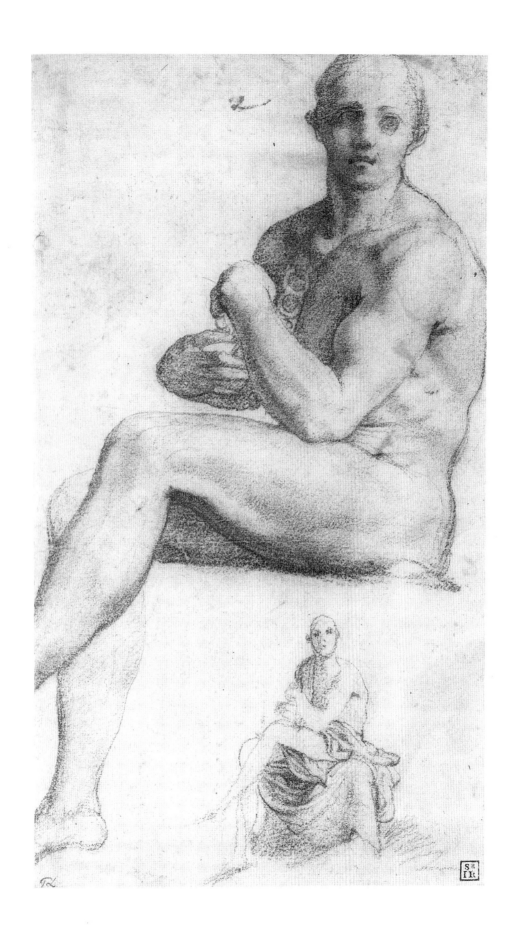

STUDY OF BANDINELLI'S CLEOPATR

.

Black chalk, 385 × 214 mm

Watermark: Angel encircled with six-pointed star above head

Inscriptions: on verso in brown ink at upper right, *Agnolo Bronzino*

Provenance: George William Reid; Charles A. Loeser

Exhibitions: *Italian Drawings, 1330–1780*, exh. cat. by Ruth Wedgewood Kennedy, Smith College Museum of Art (Northampton, Mass., 1941), no. 23; *The Nude in Art*, exh. cat., Wadsworth Atheneum (Hartford, Conn., 1946), no. 8; *Anxiety and Elegance: The Human Figure in Italian Art, 1520–1580*, exh. cat., Fogg Art Museum (Cambridge, Mass., 1962), no. 5; *Italian Drawings, Modern Paintings, and Treasures from the Vatican*, exh. cat., Museum of Art (Birmingham, Ala., 1969), no. 4; *The Draftsman's Eye: Late Italian Renaissance Schools and Styles*, exh. cat. by Edward J. Olszewski, Cleveland Museum of Art [1979] (Cleveland and Bloomington, 1981), no. 9

References: Arthur Kilgore McComb, *Agnolo Bronzino: His Life and Works* (Cambridge, Mass., 1928), p. 147; Bernard Berenson, *The Drawings of the Florentine Painters* (Chicago, 1938), vol. 2, no. 593D; Agnes Mongan and Paul J. Sachs, Jr., *Drawings in the Fogg Museum of Art* (Cambridge, Mass., 1940), no. 71; Charles de Tolnay, *History and Technique of Old Master Drawings* (New York, 1943), p. 120; Craig Hugh Smyth, *Bronzino Studies* (Ann Arbor, 1955), pp. 81–82; Ira Moskowitz, *Great Drawings of All Time* (New York, 1962), no. 204; Winslow Ames, *Italian Drawings from the Fifteenth to the Nineteenth Centuries* (New York, 1963), p. 19; *Ingres*, exh. cat., Petit Palais (Paris, 1967), p. 58; Konrad Oberhuber, ed., *Old Master Drawings: Selections from the Charles A. Loeser Bequest* (Cambridge, Mass., 1979), no. 20; Agnes Mongan, Konrad Oberhuber, and Jonathan Bober, *The Famous Italian Drawings in the Fogg Art Museum in Cambridge* (Milan, 1988), no. 35

The Fogg Art Museum, Harvard University, Cambridge, Massachusetts, Bequest of Charles A. Loeser, 1932.145

The long-standing attribution to Bronzino of this beautiful study after Baccio Bandinelli's bronze statuette (a sculpture owned by Cosimo I) has been doubted by both Smyth and, more recently, Bober.[1] Smyth has suggested that the drawing was created by one of Bronzino's students around 1550.[2] Regarding the sheet as an academic exercise, Bober points to details in it that he considers flawed or labored and finds the drawing generally "lacking . . . the succinctness of notation, the analysis of structure, and the fundamental abstraction of sixteenth-century Florentine draftsmanship at its best."[3]

But the Fogg sheet seems to correspond in some respects quite closely to other, certain Bronzino drawings, such as his *Study of a Nude* (Uffizi, no.

6704F) for the *Crossing of the Re[d . . .]* Chapel of Eleonora and his *Stu[dy . . .]* (Louvre, no. 6356) for the ceiling [. . .] variations in and reinforcement [. . .] present study are quite similar to t[. . .] and Louvre drawings. In the latter [. . .] can find passages that are awkwar[d . . .] (for instance, the neck and lower rig[ht . . .] Michael). Moreover, the hands are re[. . .] same inchoate manner in all three drawi[ngs . . .] the alterations in the Fogg study, such as [. . .] of the legs, may be due not to the indecisive [. . .] amateur draftsman but to the willfulness of [. . .] artist, who wished to improve on Bandinelli's [. . .] The draftsman appears to have at first render[ed . . .] left side of the body as he saw it and then a[. . .] another, more varied line, which gives the cont[our . . .] of the body a rounded flow. The skill of the arti[st . . .] is suggested by the controlled taper of his lines, [. . .] through which he created volumetric effects without shading. In Bronzinesque fashion, the hatching here is employed as much to emphasize the surface as to confirm the volume and mass of the figure.

Whether by Bronzino or a pupil, the study is significant for what it reveals about artistic practices in the second half of the sixteenth century in Florence. The careful study and copying of sculpture, advocated by Alberti and Leonardo,[5] became a crucial part of artistic training in this period, when the emphasis gradually shifted from inspiration to practice, from the notions of God-given talent and Platonic ideals to that of artistic progress through painstaking study.

1. Smyth, *Bronzino Studies*, pp. 81–82, and Bober in Mongan et al., *Famous Italian Drawings in the Fogg*, no. 35. In connection with the Fogg work, Smyth also cites another work, ascribed to a Bronzino follower, that copies a *Jason* by Bandinelli (Uffizi, no. 651S).
2. Smyth, *Bronzino Studies*, pp. 81–82.
3. Mongan et al., no. 35.
4. Craig Hugh Smyth, *Bronzino as Draughtsman: An Introduction* (Locust Valley, N.Y., 1971), figs. 5, 8.
5. Leon Battista Alberti, *On Painting*, ed. and trans. John R. Spencer (New Haven, 1975), pp. 94–95; and Martin Kemp, ed., *Leonardo on Painting* (New Haven, 1989), p. 197.

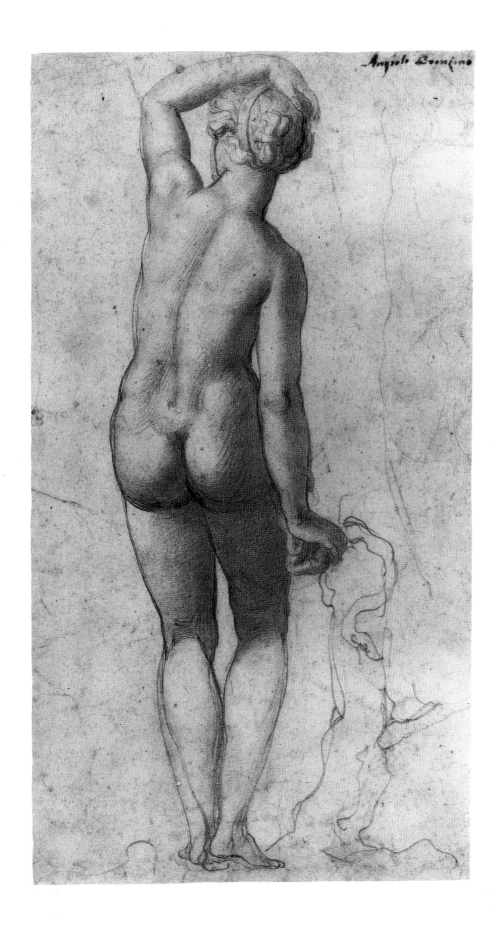

1 2

STUDY OF A MALE NUDE FOR THE
MARTYRDOM OF SAINT LAWRENCE

.

Black chalk, 329 × 446 mm
Inscriptions: on recto in graphite at lower right, *Angelo Bronzino*
Exhibitions and References: omitted at owner's request
Private collection

One of the rare undisputed drawings by Bronzino in the United States, this study was preparatory for his ambitious, late *Martyrdom of Saint Lawrence* (completed 1569) in the Medici church of San Lorenzo in Florence. The contorted nude appears with only slight revision—the sphere he holds here is replaced by an urn and his head is turned a bit more—in the lower-right corner of the fresco. The figure has been identified by some as a river god, specifically a personification of the Tiber, which flows through Rome, where Saint Lawrence was martyred. This suggestion seems dubious, however, since the pose hardly recalls the open and languid posture of typical antique river god representations, and he is not the only urn-bearing figure in the painting. Rather, he appears to be simply an obtrusive member of the crowd of figures attending—with wood, poles, bellows, and water—to the fire beneath the saint.

Anchoring a composition glutted with references to Michelangelo and intended to demonstrate the artist's command of the human form, the figure seems to be an imaginative elaboration on the renowned first-century B.C. sculpture known as the Belvedere Torso. The study, in its precise contours and fine modeling, treats the figure in sculptural terms and recalls some of Michelangelo's highly finished drawings. Another study for the fresco, executed in a similar manner, is preserved in the Louvre (no. 10900).[1] That drawing, for the figure with a pole and sack in the lower-left corner of the composition, has been squared for transfer. The absence of squaring in the present sheet suggests that the artist may have created another (slightly modified) study after it, which he squared and transferred to his cartoon.

1. For an illustration, see Craig Hugh Smyth, *Bronzino as Draughtsman: An Introduction* (Locust Valley, N.Y., 1971), fig. 40. A third study for the fresco can be found in the Uffizi (no. 10220). Also comparable in style to the present sheet is a study of a crawling nude figure for Bronzino's *Christ in Limbo* (Florence, Museo dell'Opera di Santa Croce); that drawing is preserved in the Kupferstich-Kabinett, Dresden; see Scott Schaefer, "Bronzino Drawings: A Plus and a Minus," *Master Drawings*, vol. 14 (Spring 1976), pp. 39–43, pl. 10.

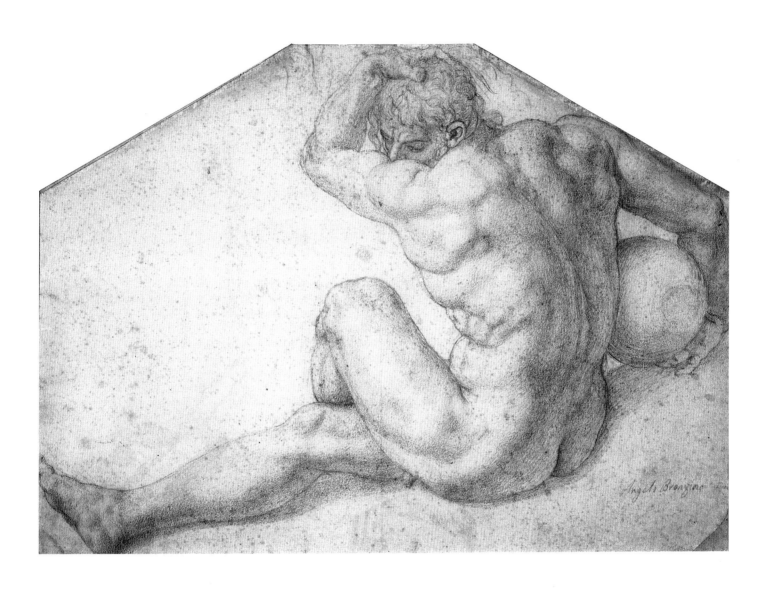

GIOVANNI MARIA BUTTERI

Florence c. 1540–Florence 1606

.

According to Vasari, Butteri was a pupil of Bronzino and a contributor to the decorations for both Michelangelo's funeral and Francesco I's wedding. One of the young artists assigned to create a painting for Michelangelo's catafalque, he depicted the artist-poet accompanied by Apollo and the nine muses. For Francesco's wedding, he worked on a decorative structure (*apparato*) under the direction of Alessandro Allori, with whom he would collaborate on other projects and on whose style he would come to base his own. Some influence of Allori can be detected in the two works Butteri executed for the Studiolo of Francesco I, the *Glass Factory* and the *Landing of Aeneas in Italy* (c. 1570–71). In the *Landing of Aeneas*, in particular, he emulated the facial types and stressed musculature of Allori's figures. Yet the animation of Butteri's actors exceeds Allori's, as their movements, sprightly and free-wheeling if a little angular, differ considerably from those of his models. The spiraling motions of his figures extend into the compositions, which are themselves serpentine and sporadic. Butteri subjugated his lively artistic personality to Allori's when he assisted the latter in the decoration of the villa at Poggio a Caiano sometime between 1579 and 1582. During that time he also painted grotesques in the Uffizi under Allori's supervision. Toward the end of his life, his own manner came to be almost overwhelmed by Allori's, as he practiced a grave and ponderous Counter-Reformation style in such works as the *Christ Healing the Centurion's Servant* (c. 1590) in the Church of the Carmine in Florence.

13

CHRIST HEALING THE
CENTURION'S SERVANT

.

Black chalk and brown wash, squared in black chalk, 345 × 218 mm
Provenance: Sotheby's, New York, 13 January 1988, lot 75
The Barbara Piasecka Johnson Collection

Despite differences between this design and the painting for which it was produced, Butteri's altarpiece in the Church of the Carmine in Florence, this sheet was probably the artist's final working drawing, created just before he advanced to the cartoon.[1] In the painting, completed about 1590, Butteri added a few figures to the crowd surrounding Christ and adjusted the position of the woman at the top right who holds the cross. Such minor alterations would have required only the preparation of a few new studies of individual figures and not another complex, highly finished *modello*.

His association with Allori had a noticeable impact on Butteri's art, as is apparent in the figures of Christ and those immediately surrounding him in the present sheet. He has emulated Allori's expansive figural and facial types as well as his heavy drapery style.[2] For the surprised soldiers at the right, however, he employed a frothy draftsmanship akin to Poppi's, and in their character of movement and emphatically rounded contours, the figures in the sky are reminiscent of Pontormo's.[3]

1. Once attributed to Raphael, the sheet was recognized by Philip Pouncey as preparatory for Butteri's Carmine painting. The picture is reproduced in Adolfo Venturi, *Storia dell'arte italiana* (Milan, 1933), vol. 9, pt. 6, fig. 73.
2. The composition of Butteri's painting may depend on Allori's *Resurrection of Lazarus* in the church of San Agostino in Montepulciano.
3. Cf. the figures in Pontormo's studies for the *Victory and Baptism of the Ten Thousand Martyrs* (Hamburg, Kunsthalle, no. 21253) and the *Adoration of the Magi* (Uffizi, no. 436S); see Janet Cox-Rearick, *The Drawings of Pontormo* (Cambridge, Mass., 1964), vol. 2, figs. 185–86.

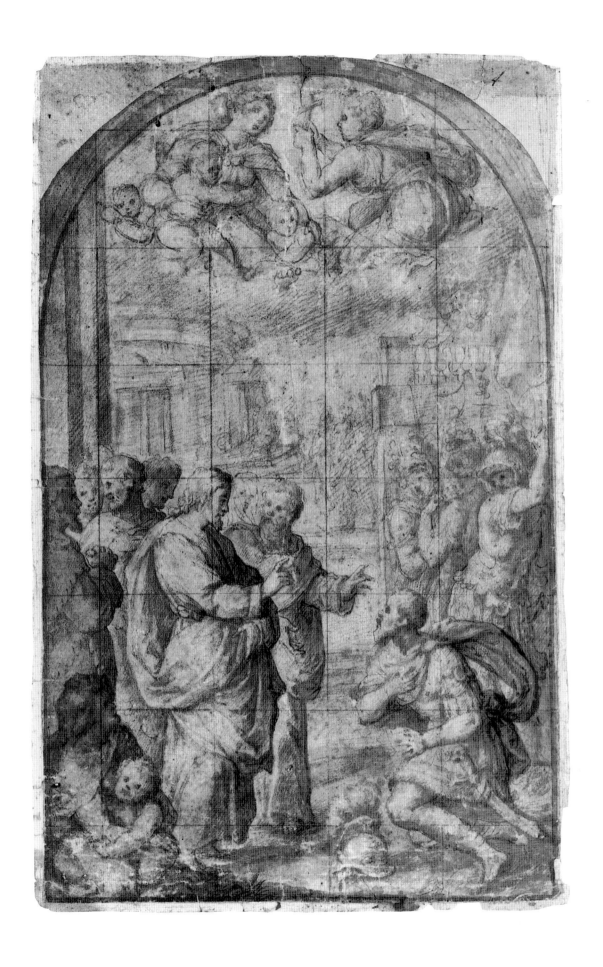

MIRABELLO CAVALORI

MIRABELLO D'ANTONIO DI PACINO CAVALORI; MIRABELLO DI SALINCORNO

Florence c. 1530–Florence 1572

.

An original councillor of the Accademia del Disegno, Cavalori contributed to the academy's first major projects: the decorations for Michelangelo's funeral (1564) and for Francesco I's wedding to Giovanna of Austria (1565). In collaboration with Girolamo Macchietti, Cavalori produced for Michelangelo's catafalque in San Lorenzo a grisaille painting of *Lorenzo the Magnificent Receiving Michelangelo in the Garden beside San Marco* (lost). He also created a monochrome painting of *Saint Francis Founding the Religious Retreat at Vernia and Receiving the Stigmata* (also lost) for the Arch of Religion, a temporary structure erected along the route of Francesco's wedding procession. According to Vasari, Cavalori achieved a reputation as a fine portraitist and painted at least two likenesses of Francesco I. Those are lost, but surviving are the artist's *Portrait of a Young Man Holding a Drawing* (c. 1568–69; Florence, Museo Bardini) and his *Group Portrait of the Founders of the Confraternita di San Tommaso d'Aquino with the Trinity* (signed and dated 1568; Florence, Palazzo Pitti, ex-Oratorio di San Tommaso d'Aquino; see Feinberg, above, fig. 24), which records, in its austere and deliberately archaistic composition, the intrusion of Counter-Reformation attitudes into Florence. Its conservatism may also reflect Cavalori's training with the old Ridolfo Ghirlandaio. Probably around the time, or just before, he painted the San Tommaso

d'Aquino work, Cavalori executed for the Badia in Florence a *Pentecost* that harks back to High Renaissance art in its clarity of exposition and spatial logic.

An extremely versatile artist, Cavalori created, about 1569–70, a *Benediction of Isaac* (London, private collection; see Feinberg, above, fig. 19), in which he made a remarkable approximation of Pontormo's manner of the later 1520s. Stylistic elements from both Pontormo and Sarto can also be discerned in the two brilliantly colored pictures Cavalori conceived for the Studiolo of Francesco I—the *Lavinia at the Altar* and *Wool Factory* (c. 1570–72; see Feinberg, above, fig. 20). Mirabello, together with Maso da San Friano, Poppi, and others, participated in what have been called Pontormo and Sarto "revivals." Unlike most of his colleagues, however, Cavalori emulated the masters he admired not so much by imitation of specific motifs but by truly understanding and simulating their ways of seeing and describing, and by carrying their most advanced researches in the handling of light and space to the next stage. The naturalism of light and environment in the *Wool Factory* seems to have influenced both Macchietti and the important reformer Santi di Tito, and thereby played a minor but consequential role in the formation of a Baroque style in Florence.

1 4

Study of a Young Man
Holding a Shovel

.

Red chalk on paper tinted pinkish brown, 185 × 97 mm
Provenance: Christie's, Rome, 15 May 1986, lot 644; Michel Gaud; Sotheby's, Monaco, 20 June 1987, lot 5

Mrs. A. Alfred Taubman

One of the few sheets that can be ascribed to Cavalori with certainty,[1] and the only known drawing that can be connected with either of his Studiolo pictures, this study was made for the figure of the worker who stands in the left middle ground of the *Wool Factory* (c. 1570–72; see Feinberg, above, fig. 20). Cavalori's interest in recording the subtlest variations in the play of light is apparent even in this drawing of a studio model created primarily to determine the anatomical mechanics of the figure's gesture. Cavalori retained the pose, with little alteration, in the final composition; the principal difference between the drawn and painted figure is the addition of clothes to the latter. The more scantily clad actors in the *Wool Factory*, notably the workers who attend to the large cauldron at right, seem to be direct translations into paint of *garzone* (shop assistant) studies. The continuous, vibrant contours, reminiscent of those in Pontormo drawings, are typical of Cavalori, as are the rather careless looping strokes he employed when rendering hands and feet.

1. See Larry J. Feinberg, *The Works of Mirabello Cavalori* (Ann Arbor, 1986), sec. 5. An article on Cavalori's drawings listing the nine sheets that I believe can be attributed to him with some confidence will soon be published.

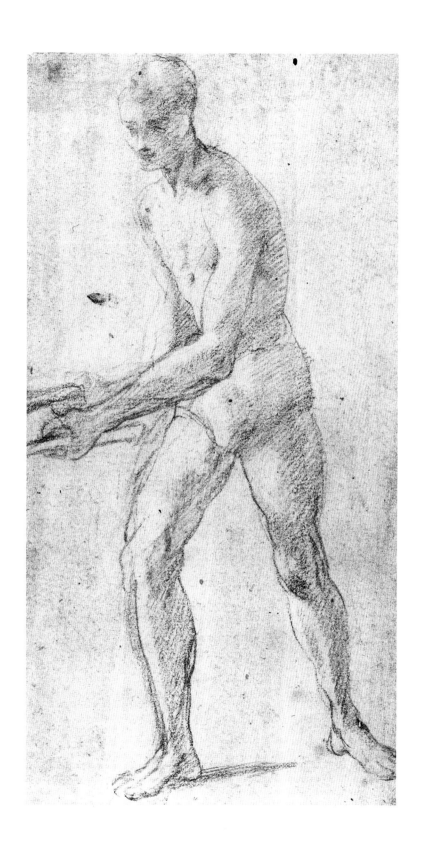

LODOVICO CARDI, CALLED IL CIGOLI

Castelvecchio di Cigoli 1559–Rome 1613

.

The painter and architect Lodovico Cardi was born in the provincial Tuscan town of Cigoli (whose name he eventually assumed) but moved with his family to Florence while still in his early teens. A period of study with Alessandro Allori, who seems to have encouraged him to emulate the works of Sarto, Pontormo, and Michelangelo, was followed by time spent in the studio of Santi di Tito, where he practiced life drawing. Under Bernardo Buontalenti (1536–1608), he also studied architecture and learned to make stage designs.

Like his contemporaries Boscoli and Pagani, Cigoli was much attracted to the works of Federico Barocci. In the early 1580s he saw some of that master's most important paintings when he traveled with Pagani to Arezzo and with Passignano to Perugia, where he encountered Barocci's *Madonna del Popolo* (c. 1575–79; Uffizi, ex-Misercordia of Arezzo) and *Deposition* (1567–69; Perugia, Duomo). In Barocci's art Cigoli discovered an optical, painterly technique that employed *changeant* color and sfumato to create works of an almost evanescent delicacy. Not surprisingly, his interest in Barocci's pictures led him to consult as well the paintings of Correggio, which had been a major source of inspiration for Barocci. Cigoli emulated the chromatic intensity and the sense of compositional flux in Barocci's pictures, but they were transformed to some degree by his ingrained Florentine notions of style and by what he absorbed from Venetian art, especially the paintings of Titian and Paolo Veronese. In his mature works of the 1590s, such as his masterpiece, the *Martyrdom of Saint Stephen* (1597; Florence, Pitti Gallery), he assimilated all these manners and transcended them; the personal idiom he formulated was one of the first truly Baroque styles in Florentine art. Cigoli was well aware of the artistic experiments of Lodovico Carracci in Bologna, and undoubtedly the Tuscan artist's impetus toward reform was stimulated by the latter's example; certain compositional designs and luministic effects in Cigoli's works derive from the paintings of the Bolognese artist.

Cigoli became a favorite of the Medici court, partly owing to his talents as a designer of stage sets, and his painting and drawing styles were highly influential in Florence in the last twenty years of the sixteenth century. He spent the last decade of his life (1604–13) in Rome, where he received some important papal commissions, among them the decoration of the Pauline Chapel of Santa Maria Maggiore (1610–12).

15

RESURRECTION RECTO

STUDIES FOR VARIOUS
FIGURES IN A RESURRECTION VERSO

.

Pen and brown ink and reddish brown wash (recto); pen and brown ink (verso), 273 × 191 mm

Inscriptions: on recto in pen and black ink at upper left, *Cardi detto il Cigoli 1590*, in pen and black ink at lower right, *10*, in graphite at lower right, *20*; on verso in graphite at upper left, *no. 113*

Provenance: Litta family, Milan

Exhibitions: *Sixteenth-Century Italian Drawings: Form and Function*, exh. cat. by Edmund P. Pillsbury and John Caldwell, Yale University Art Gallery (New Haven, 1974), no. 42

References: *Apollo*, vol. 39 (March 1969), p. 21, reproduced in advertisement; "Acquisitions," *Art Journal*, vol. 33, no. 1 (1973), p. 62; Miles Chappell, "Cigoli's 'Resurrection' for the Pitti Palace," *Burlington Magazine*, vol. 116 (Aug. 1974), pp. 470, 472; Harold Joachim and Suzanne Folds McCullagh, *Italian Drawings in the Art Institute of Chicago* (Chicago and London, 1979), p. 47; Franco Faranda, *Ludovico Cardi detto il Cigoli* (Rome, 1986), no. 6a

Yale University Art Gallery, Maitland F. Griggs, B.A. 1896, Fund, 1973.67

Exhibited at Dartmouth

Chappell has connected the studies on the Yale sheet with a painting Cigoli executed about 1590 at the request of Ferdinando de' Medici for his chapel in the Palazzo Pitti.[1] The artist may also have referred back to these sketches when he created in the next year, for the Convento della Ginestra di Montevarchi at Arezzo (now in the Pinacoteca Comunale, Arezzo), another, substantially revised painting of the Resurrection.[2] The drawings, and subsequent paintings, record Cigoli's reactions to Santi di Tito's version of the theme in Santa Croce (see fig. 25 and cat. nos. 41–42). The pose of Christ and the general placement of the soldiers correspond closely to those of Santi's actors. Spalding has suggested that Cigoli was responsible for a drawing in the Uffizi (no. 764F) that copies Santi's altarpiece.[3] In his compositions, Cigoli reduced the residual Mannerist multitude of figures and complications of pose he found in Santi's work. Instead he emulated Santi's naturalism and luministic effects, accentuating them to focus the emotional force of his own works—an impulse stimulated by Counter-Reformation attitudes, which sought a simplicity and directness of presentation.

As Pillsbury and Caldwell have observed, Cigoli almost certainly first drew the large compositional study on the recto and then experimented with the poses of the individual figures in the margins, turning over the sheet when he began to run out of space.[4] His draftsmanship bears some resemblance to that in compositional sketches by Santi (cat. no. 41), although Cigoli's pen moves more rapidly and in some ways is more responsive to subtleties of gesture and to the distribution of the weight of the figures. Similarly spirited sketches by Cigoli can be found in the Louvre (no. 919), Bick collection (Longmeadow, Mass.), Art Institute of Chicago (no. 1922.3059), and Bigongiari collection (Florence).[5]

1. Chappell, "Cigoli's 'Resurrection,' " p. 470, fig. 80. Chappell (p. 470, figs. 81–82) also associates two chalk figure studies with the Pitti *Resurrection*. For the Arezzo and Pitti paintings, see also Miles Chappell, "On the Identification of 'Crocino Pittore di Grand'Aspettazione' and the Early Career of Lodovico Cigoli," *Mitteilungen des Kunsthistorischen Institutes in Florenz*, vol. 26 (1982), pp. 333–34, figs. 5–6.
2. Ibid., p. 470, fig. 79.
3. Jack Spalding, *Santi di Tito* (New York, 1972), no. 8, p. 128, and see Simona Lecchini Giovannoni and Marco Collareta, *Disegni di Santi di Tito (1536–1603)*, exh. cat., Gabinetto Disegni e Stampe degli Uffizi (Florence, 1985), no. 94.
4. Pillsbury and Caldwell, *Sixteenth-Century Italian Drawings*, no. 42.
5. Ibid., nos. 42–43; Joachim and McCullagh, *Italian Drawings in the Art Institute of Chicago*, no. 49, pl. 59; and Miles Chappell, "Missing Pictures by Lodovico Cigoli: Some Problematic Works and Some Proposals in Preparation for a Catalogue," *Paragone*, vol. 32 (March 1981), p. 57, fig. 59b.

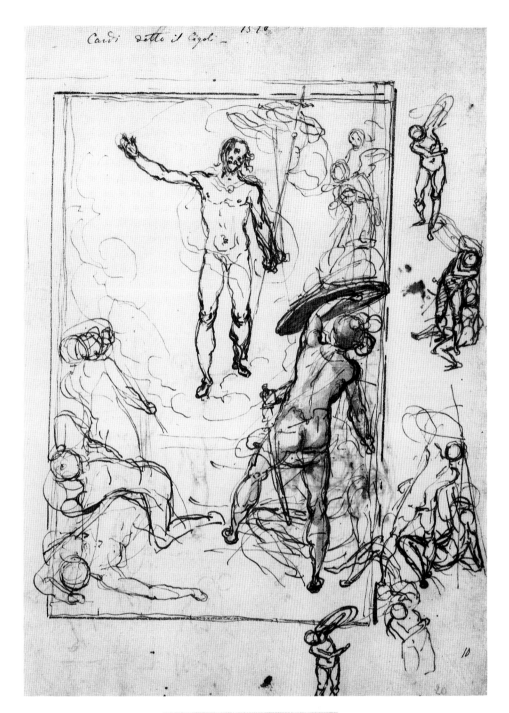

16

Kneeling Youth

.

Brush and brown ink with white gouache on green-brown prepared paper, 390 × 285 mm
Watermark: Ladder on shield over star (Briquet 5927)
Provenance: Sir Peter Lely (Lugt 2092); Charles A. Loeser
Exhibitions: *Art in Italy, 1600–1700*, exh. cat. by Frederick Cummings, Detroit Institute of Arts (1965), no. 125; *Florentine Baroque Art from American Collections*, exh. cat. by Joan Nissman, Metropolitan Museum of Art (New York, 1969), no. 13; *The Draftsman's Eye: Late Italian Renaissance Schools and Styles*, exh. cat. by Edward J. Olszewski, Cleveland Museum of Art [1979] (Cleveland and Bloomington, 1981), no. 11
References: Agnes Mongan and Paul J. Sachs, Jr., *Drawings in the Fogg Museum of Art* (Cambridge, Mass., 1940), no. 245; Konrad Oberhuber, ed., *Old Master Drawings: Selections from the Charles A. Loeser Bequest* (Cambridge, Mass., 1979), no. 26; Agnes Mongan, Konrad Oberhuber, and Jonathan Bober, *The Famous Italian Drawings in the Fogg Art Museum in Cambridge* (Milan, 1988), no. 49

The Fogg Art Museum, Harvard University, Cambridge, Massachusetts, Bequest of Charles A. Loeser, 1932.337

Mongan and Sachs were the first to recognize that this study is preparatory for the figure of the youth in the left foreground of Cigoli's *Entry into Jerusalem* (c. 1610–13), commissioned by the Serristori family for Santa Croce in Florence.[1] Another brush figure study for the painting, for the woman standing at the left, is in the Louvre.[2] There are numerous sketches by Cigoli executed in this broad, summarizing manner, among them studies in Cleveland (no. 29.555) and the Uffizi (nos. 8995F, 8990F).[3]

Cigoli derived his gouache (and oil) sketch technique primarily from Venetian artists, particularly, as Bober has noted, from the sketches of Domenico Tintoretto and Palma Giovane.[4] The fluidity of Cigoli's designs, with their caressing, fleeting movement of light, is also indebted to Barocci and Correggio, whose works he occasionally copied or imitated.[5]

1. Mongan and Sachs, *Drawings in the Fogg*, no. 245.
2. Roseline Bacou and Jacob Bean, *Disegni fiorentini del Museo del Louvre dalla collezione di Filippo Baldinucci*, exh. cat., Gabinetto Nazionale delle Stampe (Rome, 1959), no. 137.
3. Reproduced in Edward J. Olszewski, "New Lodovico Cardi Drawings in Cleveland," *Paragone*, vol. 34 (Jan. 1983), figs. 58, 60, and Miles Chappell, "Missing Pictures by Lodovico Cigoli: Some Problematical Works and Some Proposals in Preparation for a Catalogue," *Paragone*, vol. 32 (March 1981), fig. 60.
4. Mongan et al., *Famous Italian Drawings in the Fogg*, no. 49.
5. Anna Matteoli, *Lodovico Cardi-Cigoli, pittore e architetto* (Pisa, 1980), pp. 232–33, no. 96.

JACOPO CHIMENTI
DA EMPOLI

Florence 1551–Florence 1640

.

Called Empoli after his family's place of origin, Jacopo Chimenti seems to have lived his entire life, and received his artistic education, in grand ducal Florence. According to the historian Filippo Baldinucci, Empoli studied with the painter Maso da San Friano, who was a chief participant in the Pontormo and Sarto revivals of the last quarter of the sixteenth century in Florence. To the *Pontormismo* he inherited from Maso, Empoli added some contemporary stylistic elements, which he found primarily in the works of Santi di Tito and, to a lesser degree, of Alessandro Allori.

Empoli's religious paintings adhere strictly to the dictates of the Counter-Reformation church, which, as formulated at the Council of Trent in 1563, placed a premium on clarity and legibility of artistic presentation. An insistent, clarifying geometry informs all of Empoli's major altarpieces, including the *Immaculate Conception* (1591; Florence, San Remigio), the *Doubting Thomas* (1602; Empoli, Museo della Collegiata),

and *Saint Ives with Widows and Orphans* (1616; Florence, Palazzo Pitti). His somewhat schematized compositions are populated by figures and objects of a prosaic naturalness, and many of his works share the mundane, chatty spirit of the late fifteenth-century paintings of Domenico Ghirlandaio.

This sober style also served him well when he was called on to design secular histories for the Medici, such as those he conceived for the wedding of Marie de' Medici and the funeral decorations of Henry IV (the cousin of Cosimo II by marriage) and Queen Margherita of Spain (Cosimo II's sister-in-law, see cat. no. 19) in 1600, 1610, and 1612, respectively. Wishing to emphasize their newly gained status as an international court, the Medici commissioned paintings of scenes that stressed their familial ties to the rulers of France and Spain. Empoli's manner, akin to the dry language of a legal contract, conveys simply and lends credibility to events depicted for their value as propaganda.

1 7

SAINT JOHN THE BAPTIST PREACHING

.

Black chalk with light tan wash, 246 × 228 mm

Watermark: unidentified

Provenance: Frank Jewett Mather, Jr. (Lugt supp. 1853a)

Exhibitions: *Exhibition of Drawings by Old Masters from the Private Collection of Professor Frank Jewett Mather, Jr.*, exh. cat., Roerich Museum (New York, 1930), no. 23; *A Selection of Italian Drawings from North American Collections*, exh. cat. by Walter Vitzthum, Norman Mackenzie Art Gallery, Regina, Saskatchewan, and Montreal Museum of Fine Arts (1970), no. 29

References: Felton Gibbons, *Catalogue of Italian Drawings in the Art Museum, Princeton University* (1977), no. 180

The Art Museum, Princeton University, Gift of Frank Jewett Mather, Jr., 47.130

The especially Pontormesque character of this drawing connects it with several sheets that Bianchini and Forlani have dated to Empoli's early period of 1570–90.[1] As Gibbons has noted,[2] the artist employs a neo-Pontormesque notation in rendering the faces. The long, looping strokes of the design can also be traced to Pontormo, who executed in a similar manner some of his preliminary studies for the Passion frescoes in the Certosa di Val d'Ema (1523–24).[3] That Empoli should have studied Pontormo's drawings for that project is not surprising, since he was responsible for making faithful copies, on canvas, of the master's frescoes. (Empoli's replicas, together with the severely damaged originals, are now in the museum of the Certosa.)

The strict symmetry of the present study, which also is reminiscent of certain of Pontormo's Certosa compositions, was rejected by Empoli some years later when he took up the theme again in an altarpiece for the church of San Niccolò d'Oltrarno (1608). There he assumed a quasi-Venetian mode he learned from Passignano and Cigoli, and created a casual, obliquely oriented composition.[4]

1. Adelaide Bianchini and Anna Forlani, *Mostra di disegni di Jacopo da Empoli*, exh. cat., Gabinetto Disegni e Stampe degli Uffizi (Florence, 1962), nos. 5, 7, 9, pp. 4–5. Empoli's early development still requires clarification. Contrary to Bianchini and Forlani, I do not see Empoli's mature drawings as being dependent on Maso's. I believe Maso had a greater influence on Empoli in his advocacy of Pontormo and Sarto as models.
2. Gibbons, *Italian Drawings in Princeton*, p. 67, no. 180.
3. See, for example, Uffizi nos. 447Fr and 6622F, reproduced in Janet Cox-Rearick, *The Drawings of Pontormo* (Cambridge, Mass., 1964), vol. 2, figs. 202, 204.
4. Empoli's *modello* for the painting survives (Uffizi, no. 947F); see Simonetta de Vries, "Jacopo Chimenti da Empoli," *Rivista d'arte*, vol. 15 (1933), p. 362, fig. 20, and Bianchini and Forlani, *Disegni di Empoli*, no. 30.

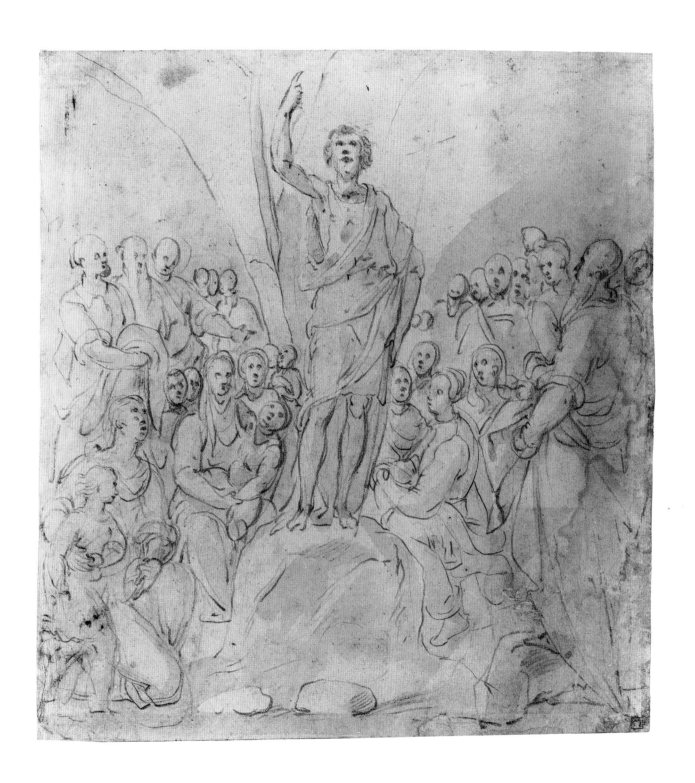

1 8

Two Figure Studies of
a Woman over a Sketch of a Putto

.

Black chalk heightened with white on paper prepared with yellow wash, 226 × 160 mm
Inscriptions: on verso in black chalk, *Russo/Soc G 623/FAA*
Exhibitions: *Year in Review 1962*, Cleveland Museum of Art (1962), no. 136 (as Rosso Fiorentino); *The Draftsman's Eye: Late Italian Renaissance Schools and Styles*, exh. cat. by Edward J. Olszewski, Cleveland Museum of Art [1979] (Cleveland and Bloomington, 1981), no. 13 (as Empoli)
References: "The Year in Review," *Bulletin of the Cleveland Museum of Art*, vol. 49 (Nov. 1962), no. 136

The Cleveland Museum of Art, Gift of Mr. and Mrs. Ralph L. Wilson, in memory of Anna Elizabeth Wilson, 62.202

Empoli's studies record an antique statue of Venus, perhaps the so-called *Venus de' Medici* (Uffizi) whose arms were lost (and subsequently restored) and who similarly turns her head to the left.[1] Empoli chose not merely to copy his model but attempted to invigorate the figure, rendering the hair with lively calligraphic lines and the flesh with the bulging, continuous contours he derived from the drawings of Pontormo. The summarizing treatment of the face owes something to Pontormo as well. In fact, the drawing is very close to Pontormo's *Study for the Statue of a Woman* in the Uffizi (no. 6735Fv).[2] Comparing the present studies with Empoli's drawing of a nude woman of about 1570–75 (Uffizi, no. 3430F), Olszewski rightly places the Cleveland sheet just after those extremely Pontormesque sketches that Bianchini and Forlani have identified as the artist's earliest surviving drawings.[3] The Cleveland studies should, therefore, probably be assigned to the 1570s.

1. Although the earliest record of the work is in François Perrier's anthology of beautiful statues (*Segmenta nobilium signorum et statuarum que temporis dentem invidium evase*), published in Rome and Paris in 1638, the sculpture may have been discovered much earlier. Haskell and Penny have suggested that it may be one of the Venuses listed in the 1598 inventory of the Villa Medici in Rome; see Francis Haskell and Nicholas Penny, *Taste and the Antique: The Lure of Classical Sculpture, 1500–1900* (New Haven and London, 1981), p. 325.
2. See Janet Cox-Rearick, *The Drawings of Pontormo* (Cambridge, Mass., 1964), vol. 1, no. 91.
3. Olszewski, *The Draftsman's Eye*, no. 13, and Adelaide Bianchini and Anna Forlani, *Mostra di disegni di Jacopo da Empoli*, exh. cat., Gabinetto Disegni e Stampe degli Uffizi (Florence, 1962), pp. 4–5, no. 5.

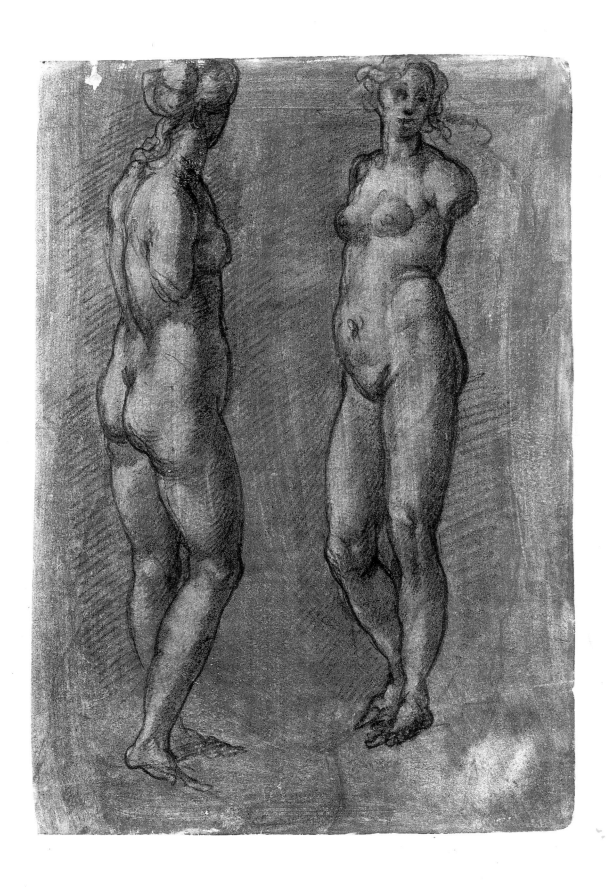

Queen Margherita of Spain Arranging the Marriage of King Sigismund of Poland with Her Sister, Constanza

.

Pen and brown ink with brown wash, over black chalk, squared for transfer in red chalk, 300 × 385 mm

Provenance: Edwin Crocker, Sacramento

Exhibitions: *Master Drawings from California Collections*, exh. cat., ed. Juergen Schulz, University Art Museum, University of California, Berkeley (1968), no. 35:109; *Master Drawings from Sacramento*, exh. cat., E. B. Crocker Art Gallery (Sacramento, 1971), no. 31:12; *Regional Styles of Drawing in Italy, 1600–1700*, exh. cat., University of California, Santa Barbara (1977), no. 26:49; *The World of Old Master Drawings*, Crocker Art Museum (Sacramento, 1985)

Crocker Art Museum, Sacramento, California, E. B. Crocker Collection, 1871.291

This drawing is the *modello* Empoli prepared for one of the twenty-six grisaille paintings that adorned the Medici church of San Lorenzo in Florence during the funeral in 1612 of Queen Margherita of Spain, the wife of King Philipp III and sister of Maria Maddalena of Austria, the wife of Cosimo II de' Medici. The entire series, which illustrated major events in Margherita's life, was etched and published in Florence in the same year. Entitled *Essequie della sacra cattolica e real maestà di Margherita d'Austria. Regina di Spagna*, the book had text by Giovanni Altoviti and etchings by Antonio Tempesta, Raphael Schiaminossi, and Jacques Callot. The prints were Callot's first Medici commission and quite possibly his first etchings. He was responsible for the etching after the scene represented in the Crocker drawing in addition to seventeen other prints.

The painted version of *Queen Margherita Arranging the Marriage of Sigismund and Constanza* (Florence, Palazzo Pitti), was perhaps executed by an assistant following Empoli's design. The need to devise numerous histories on short notice, as when a head of state suddenly died, caused Empoli frequently to rely on compositional formulas and to delegate work to assistants. His designs for paintings displayed at the funeral of Henry IV (also held in San Lorenzo)

were translated into paint by other artists.[1] In fact, the regularity of line and deadening neatness of this and other Empoli *modelli* may be owing to a desire to make them almost diagrammatic, so that assistants could easily enlarge and transfer the designs. The uncomplicated style also permitted quick transcription by printmakers for published volumes; for the Medici, the publicity generated by the prints was almost as important as the decorations and ceremonies themselves.

Empoli has indicated with washes on this sheet, for the benefit of an assistant or for himself, how the lights should be distributed in the composition. Although the washes are applied in a fairly schematic fashion, they do work to galvanize an otherwise stilted Sartesque composition.[2] Such a rigid manner, entirely appropriate for recording a formal court ceremony, is typical of Empoli's *modelli* for wedding and funeral decorations. Similar drawings by him can be found in the British Museum (no. 1886-10-12-540) and the Uffizi (nos. 940F, 941F, 959F).[3]

1. Nicholas Turner, *Florentine Drawings of the Sixteenth Century* (London, 1986), no. 199.
2. See Feinberg, above, pp. 22–24.
3. See Turner, *Florentine Drawings of the Sixteenth Century*, no. 199; *La corte, il mare, i mercanti. La Rinascita della scienza. Editoria e società. Astrologia, magia, e alchimia, Firenze e la Toscana dei Medici nell'Europa del Cinquecento* (Florence, 1980), no. 44.6; Simonetta de Vries, ''Jacopo Chimenti da Empoli,'' *Rivista d'arte*, vol. 15 (1933), p. 354, figs. 13–14; Adelaide Bianchini and Anna Forlani, *Mostra di disegni di Jacopo da Empoli*, exh. cat., Gabinetto Disegni e Stampe degli Uffizi (Florence, 1962), no. 21; Anthony Blunt, ''A Series of Paintings Illustrating the History of the Medici Family Executed for Marie de' Medici II,'' *Burlington Magazine*, vol. 109 (Oct. 1967), pp. 560, 562, figs. 17–18; and Eve Borsook, ''Art and Politics at the Medici Court IV: Funeral Decor for Henry IV of France,'' *Mitteilungen des Kunsthistorischen Institutes in Florenz*, vol. 14 (Dec. 1969), pp. 222–23, fig. 25.

2 0

SAINT IVES WITH
WIDOWS AND ORPHANS

.

Pen and brown ink, light brown wash, over black chalk, 407 ×
278 mm
Inscriptions: on recto in black chalk at lower left, *L. CARDI
DETTO CIGOLI*; stamped on verso, *OBERLIN*
Provenance: Samuel Woodburn; St. Maurice; Edward Che-
ney, Badger Hall, Shropshire; Ferdinando Peretti, London
References: Richard E. Spear, "Jacopo da Empoli's *Saint Ivo
with Widows and Orphans,*" *Allen Memorial Art Museum Bul-
letin*, vol. 30 (1973–74), pp. 63–73; Wolfgang Stechow, *Cata-
logue of Drawings and Watercolors in the Allen Memorial Art
Museum, Oberlin College* (1976), no. 101; Alessandro Marabot-
tini, *Jacopo di Chimenti da Empoli* (Rome, 1988), p. 239; Anna-
maria Petrioli Tofani and Graham Smith, *Sixteenth-Century
Tuscan Drawings from the Uffizi* (Oxford, 1988), p. 182

Allen Memorial Art Museum, Oberlin College, Charles F.
Olney Fund, 71.38

The Oberlin sheet appears to be the final working
drawing for a painting of Saint Ives that Empoli
executed in 1616 for the office of the magistrate of the
pupilli (orphans) in Florence.[1] Ives, a French lawyer
renowned as a protector of the poor, orphans, and
widows, was canonized in 1347. He subsequently
became a patron saint both of those unfortunates and
of lawyers and notaries. In Oberlin's drawing and in
the painting (Florence, Palazzo Pitti), Ives offers
counsel to a group of widows and orphans while
putti shower them with roses, an act signifying
divine blessing.

Recently, Petrioli Tofani has questioned Empoli's
authorship of the Oberlin study, asserting that it is
probably a copy after the painting.[2] But the various
differences between the drawing and painting, some
of which have been pointed out by Spear,[3] suggest
that the sheet is not a *ricordo* (a drawing made as a
record of a painting), but a working sketch. Though
the contours seem to have the hesitancy of a tracer's
line, their carefully drawn character is typical of
Empoli's draftsmanship and can be observed in
many of his full compositional studies (such as cat.

no. 19). The absence of squaring lines in the Oberlin
drawing may indicate that Empoli squared another
compositional sheet for enlarging the design to car-
toon size. He appears to have been primarily con-
cerned in the present sheet with the play of light over
the figures and with attaining a balanced distribution
of shadows.

In the latter part of the sixteenth century, Vasari
seems to have popularized the practice (which he
learned from Sarto) of creating two compositional
studies for a painting, one that meticulously deline-
ated gestures and established the relative positions of
figures and a second, vibrant wash drawing that
served as a guide for the placement of highlights and
shadows. Some of Empoli's contemporaries, includ-
ing Cigoli, Poppi, and Santi di Tito, occasionally
employed this working method as well.[4]

1. Three other preparatory studies for the project are in the
 Uffizi (nos. 1800s, 9382F, 9385F); see Simonetta de Vries,
 "Jacopo Chimenti da Empoli," *Rivista d'arte*, vol. 15
 (1933), p. 368; Adelaide Bianchini and Anna Forlani,
 Mostra di disegni di Jacopo da Empoli, exh. cat., Gabinetto
 Desegni e Stampe degli Uffizi (Florence, 1962), no. 64;
 Spear, "Jacopo da Empoli," p. 68, figs. 3–5; Petrioli
 Tofani and Smith, *Sixteenth-Century Tuscan Drawings*,
 no. 78.
2. Petrioli Tofani and Smith, *Sixteenth-Century Tuscan
 Drawings*, p. 182.
3. Spear, "Jacopo da Empoli," p. 72.
4. For example, Cigoli's drawings for a *Nativity of the Virgin*
 in the Uffizi (nos. 977F, 838F), reproduced in *Mostra del
 Cigoli e del suo ambiente*, exh. cat., Accademia degli
 Euteleti (San Miniato, 1959), no. 74; Poppi's studies for a
 Descent of the Holy Ghost in Lille (Musée des Beaux-Arts,
 no. 336) and the Uffizi (no. 750F), reproduced in Paola
 Barocchi, "Appunti su Francesco Morandini," *Mit-
 teilungen des Kunsthistorischen Institutes in Florenz*, vol. 11
 (Nov. 1964), figs. 26–27; and Santi's studies for the Santa
 Croce *Resurrection*, cat. nos. 41–42.

Jacopo Ligozzi

Verona c. 1547–Florence 1627

.

A native of Verona, Ligozzi received his artistic training there before migrating to Florence in 1577. He was raised in a family of artist-artisans and brought to the court of Francesco I skills in tapestry design as well as in painting. Under Francesco, and later Ferdinando, Ligozzi was primarily employed as a designer of decorative art objects, including glass, furniture, jewelry, and tapestries. He was also entrusted with recording for the Medici countless biological and botanical specimens. For these illustrations of birds, fish, animals, and plants, he developed a precise watercolor technique (see Feinberg, above, fig. 27). In many of his highly finished drawings, Ligozzi's meticulous drafts-manship (with its use of gold heightening) has the character of manuscript illumination. In others, his graphic style seems to be related to Northern chiaroscuro drawings and to chiaroscuro woodcuts, for which he occasionally produced designs. He seems to have been particularly interested in chiaroscuro woodcuts by German artists, such as

Albrecht Altdorfer, Hans Baldung Grien, and Hans Burgkmair the Elder, whose art, in at least one instance, Ligozzi mined for figural motifs. His Germanic sensibilities must have been reinforced by what he saw during a period of residence at the court of Innsbruck.

Although Ligozzi's Northern Italian background and predilection for Northern European art may have isolated him from his contemporaries to some degree, he was not completely unresponsive to progressive trends in later sixteenth-century Flor-entine art. After 1590, when creating altarpieces and other large public works, he could summon up a pietistic Counter-Reformation style based on the works of Sarto (e.g., his *Pietà* in Santissima Annun-ziata) or a conservative early Baroque manner (e.g., his *Martyrdom of Saint Lawrence* in Santa Croce, c. 1611). Acutely responsive to the needs of his patrons, Ligozzi was one of the most stylistically flexible artists of the Cinquecento (see Feinberg, above, pp. 25–26).

ALLEGORY OF AVARICE

.

Pen and brown ink with brown wash, heightened with gold, 306 × 200 mm

Inscriptions: in brown ink at lower left, *I + L*, altered by a later hand to *I + R / 1590*; at lower right, *cezin*(?) / *ongari*(?)

Provenance: X. M. C. von Schönberg-Rothschönberg; sale, E. Arnold, Dresden, 1858; Ludwig von Biegeleben; sale, Vienna, 15 November 1886, lot 2657; Ritter von Kuffner, Vienna; private collection, United States; Artemis Fine Arts, Ltd., London; Robert H. and Clarice Smith

Exhibitions: *An Exhibition of Master Prints and Drawings*, exh. cat., Artemis Fine Arts, Ltd. (London, 1982), no. 13

References: G. K. Nagler, *Die Monogrammisten* (Munich, 1863), vol. 3, pp. 546–47, no. 1398; R. A. Peltzer, "Hans Rottenhamer," *Jahrbuch der kunsthistorischen Sammlungen des allerhöchsten Kaiserhauses* (1916), vol. 33, pp. 298, 315 (as Hans Rottenhamer); Hermann Voss, *Die Malerei der Spätrenaissance in Rom und Florenz* (Berlin, 1920), pp. 422–23; Friedrich Thöne, "Jacopo Ligozzi," *Old Master Drawings*, vol. 13 (1938), p. 26; Mina Bacci, "Jacopo Ligozzi e la sua posizione nella pittura fiorentina," *Proporzioni*, vol. 4 (1963), p. 52; David Cast, *The Calumny of Apelles: A Study in the Humanist Tradition* (New Haven and London, 1981), p. 149; *Around 1610: The Onset of the Baroque*, exh. cat., Matthiesen Fine Art, Ltd. (London, 1985), p. 27; Meinolf Trudzinski, *Die italienischen und französischen Handzeichnungen im Kupferstich Kabinett der Landesgalerie: Niedersächsisches Landesmuseum Hannover* (Hannover, 1987), p. 96; Françoise Viatte, *Dessins toscans XVIe–XVIIIe siècles*, vol. 1, *1560–1640* (Paris, 1988), p. 135, under no. 235

National Gallery of Art, Washington, D.C., Gift of Robert H. and Clarice Smith, 1984.56.1

Exhibited at Oberlin and Bowdoin

The existence of very similar drawings by Ligozzi of allegorical figures of Envy, Vanity, Gluttony, Sloth, and Lust suggests that the present sheet was created as part of a series representing the Seven Deadly Sins. Four of the drawings were at one time together in the collection of von Schönberg-Rothschönberg, who sold them at the Dresden auction house of E. Arnold in 1858.[1] Although the present whereabouts of the *Allegory of Gluttony* is unknown, the depictions of Envy and Vanity are preserved in the Kestner Museum, Hannover, and those of Lust and Sloth in the Louvre.[2]

Although in the Hannover and Louvre drawings Ligozzi presented compilations of the traditional attributes of the figures of Envy, Vanity, Sloth, and Lust, the iconography of the *Allegory of Avarice* is somewhat unconventional. Usually Avarice assumes the form of a blindfolded old woman (or man) clutching a purse and accompanied by a wolf. Here a well-dressed young woman idly holds a money bag while a skeleton tempts her with another. Two other skeletons focus on the activities of a bearded man, who is writing, perhaps in a ledger. Hovering above them is an amphibian demon, suggestive of the toads often associated with Lust. In the distance a woman is being attacked by a swordsman.

According to one theory, Ligozzi was offering an imaginative interpretation of the biblical story of Sapphira and Saint Peter (Acts 5:1–10).[3] Converted Christians were expected to liquidate all their possessions and lay the money they realized at the apostle's feet (Acts 4:34–37). Sapphira and her husband, Ananias, sold their land but decided to retain some of the proceeds for themselves. Discovering this, Peter condemned Ananias and, soon after, Sapphira to death. A devotee of Dante, Ligozzi would have known that the poet associated Sapphira with *avarizia*, placing her among the avaricious in the Fifth Cornice of Purgatory (Canto 20).[4]

Although attractive, the Sapphira–Saint Peter hypothesis is not entirely convincing because of discrepancies between the New Testament passage and Ligozzi's drawing. In the biblical account Sapphira is not felled by a sword, and Ligozzi's work makes no reference to Ananias. Moreover, the female figure's expression appears to be one of acquisitive interest rather than despondency.

It seems more likely that the image stems from the Northern European *Ars Moriendi* (Art of Dying Well) tradition, which inspired paintings of the theme of Death and the Miser by Hieronymus Bosch and others. Ligozzi may have been familiar with those or with prints dealing with the subjects of death and avarice, such as the engraving of *Avarice* by Master E. S. (from his *Ars Moriendi* series), which portrays a dying man tempted by three demons.[5] In Ligozzi's design, a wealthy man appears to be tabulating his riches, with Avarice as a companion and Death lurking nearby. The violent incident depicted

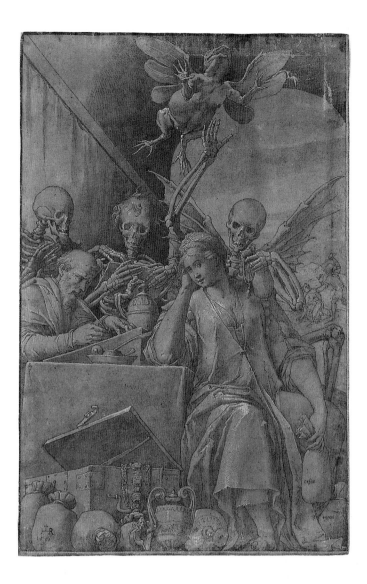

in the background was probably intended as a visual gloss on the theme of the destructiveness of greed.

The fine manner of the drawing, with its gold heightening reminiscent of illuminated manuscripts, is typical of Ligozzi, who considered himself to be primarily a miniaturist.[6] Also characteristic of Ligozzi is the Northern flavor of his draftsmanship, which recalls the highly finished drawings (and chiaroscuro woodcuts) of such German masters as Hans Baldung Grien and Urs Graf.

A painting by Ligozzi based on this drawing was on the London art market in 1985.[7]

1. Nagler, *Die Monogrammisten*, pp. 546–47. *Avarice, Envy, Gluttony,* and *Vanity* were in the possession of von Schönberg-Rothschönberg.
2. Trudzinski, *Die italienischen und französischen Handzeichnungen,* nos. 53–54. Thomas Williams kindly alerted me to the Louvre drawings, for which see Viatte, *Dessins toscans XVIe–XVIIIe siècles,* vol. 1, nos. 235, 236. The *Allegory of Gluttony,* like other drawings in this group, has an altered monogram and is dated 1590. It was in the gallery of C. G. Boerner in 1935; see *Handzeichnungen alter Meister des XV. bis XVIII. Jahrhunderts* (Leipzig, 1930), no. 222, pl. 24.
3. *Around 1610,* pp. 27–28, no. 5.
4. Ibid., p. 28. Three illustrations by Ligozzi of the *Divine Comedy* are preserved at Christ Church, Oxford, and an *Allegory of Death* by Ligozzi, in the Pierpont Morgan Library, is inscribed with the opening words from the *Inferno;* see James Byam Shaw, *Drawings by Old Masters at Christ Church, Oxford* (1976), nos. 215–17; and Jacob Bean and Felice Stampfle, *The Italian Renaissance,* vol. 1 of *Drawings from New York Collections,* exh. cat., Metropolitan Museum of Art (Greenwich, Conn., 1965), no. 146.
5. See Alan Shestack, *Master E. S.: Five-Hundredth Anniversary Exhibition,* exh. cat., Philadelphia Museum of Art (1967), no. 13 (illus.).
6. He inscribed a preparatory drawing for the first painting he created in Florence, *Jacopo Ligozzi miniator;* see Mina Bacci, "Jacopo Ligozzi," in *Maestri della pittura veronese,* ed. Pierpaolo Brugnoli (Verona, 1974), p. 272.
7. *Around 1610,* no. 5.

2 2

PROFILE OF A WOMAN IN A
FANTASTIC HEADDRESS

.

Pen and brown ink, 314 × 215 mm

Private collection

Based ultimately on exquisite drawings of profile heads by Pisanello,[1] which Ligozzi would have seen in his native Verona, this study also reflects the draftsman's interest in Michelangelo's so-called *teste divine* (divine heads)[2] and the elaborately coiffured women in the works of Francesco Bacchiacca. The long, sinuous lines of the present sheet, along with the regularized hatching style, perhaps meant to facilitate translation into an engraving, recall those of both Pisanello and the printmaker Jacopo de' Barbari.[3] In fact, the same delicacy and topographic precision of Ligozzi's *Profile of a Woman* are found in many of his detailed biological and botanical studies, which represent a continuation of the tradition of nature studies practiced by Pisanello and other Veneto-Lombard artists.

Another *Head of a Woman with an Elaborate Coiffure*, rendered in a very similar fashion, was exhibited at P. and D. Colnaghi in London in 1985.[4]

1. See Gian Alberto dell'Acqua and Renzo Chiarelli, *L'Opera completa del Pisanello* (Milan, 1972), pls. 15, 30, nos. 34–36, 43–46.
2. Comparable ideal profile types by Michelangelo are catalogued and reproduced in Luitpold Dussler, *Die Zeichnungen des Michelangelo: Kritischer Katalog* (Berlin, 1959), nos. 342, 491r, 568r, figs. 50, 186, 192.
3. Cf. Jacopo de' Barbari's engraving of the *Sacrifice to Priapus: The Larger Plate*, in Arthur M. Hind, *Early Italian Engraving* (London, 1948), vol. 5, no. 23, and vol. 7, pl. 712. We know of no engraving after the present drawing.
4. *Old Master Drawings*, exh. cat., P. and D. Colnaghi (London, 1985), no. 20 (illus.).

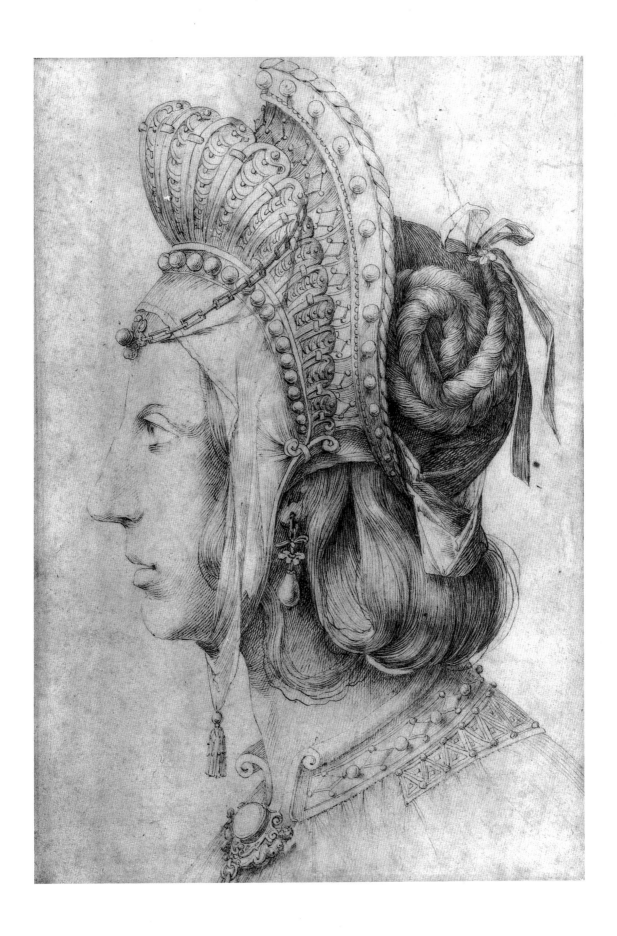

2 3

Suffer Little Children
to Come unto Me

.

Pen and brown ink with brown wash and white heightening over black chalk underdrawing on paper tinted brown, 342 × 418 mm

Inscriptions: in pen and brown ink at lower left, *131*

Provenance: Jean-Baptiste-Florentin-Gabriel de Meryan, marquis de Lagoy (Lugt 1710); Samuel Woodburn; Thomas Dimsdale; Samuel Woodburn; Sir Thomas Lawrence, London (Lugt 2445); Samuel Woodburn; sale, Christie's, London, 4 June 1860, as part of lot 1074; Sir Thomas Phillips; T. Fitzroy Fenwick; Dr. A. S. W. Rosenbach; The Philip H. and A. S. W. Rosenbach Foundation, Philadelphia; British Rail Pension Fund; sale, Sotheby's, New York, 11 January 1990, lot 51

References: J. A. Gere, "The Lawrence-Phillips-Rosenbach 'Zuccaro Album,' " *Master Drawings*, vol. 8 (1970), p. 139, no. 48, pl. 27 (as anonymous draftsman); Thomas Williams and Lutz Riester, *European Master Drawings from the Sixteenth to the Twentieth Centuries*, exh. cat., Paul Drey Gallery (New York, 1991), no. 8

Thomas Williams, London

Julien Stock was the first to recognize this highly refined drawing as the work of Jacopo Ligozzi, by whom comparable sheets can be found in the Uffizi and at Christ Church, Oxford.[1] For this theme of compassion (found in Matt. 19:13–15, Mark 10:13–16, and Luke 18:15–17), popularized by Lucas Cranach in the sixteenth century in Northern Europe but rarely depicted in Italy, Ligozzi combined his most opulent Venetian manner with stylistic elements he admired in the art of Parmigianino and the Zuccari. Christ and those imbedded in the sfumato around him, particularly the woman in profile, recall some of the facial and figural types of the Emilian artist.[2] Forming a luxurious swag of materials and textures around the group in shadow, and serving as a worldly counterpoint to them, are ample, beautifully costumed figures worthy of Veronese. This garlanding and interlacing of figures, as well as the use of an active yet soft light to fuse them, Ligozzi may also have learned from Parmigianino.

Williams has pointed out that the contemporary popularity of this drawing, undoubtedly made as an end in itself, is indicated by the existence of two seventeenth-century copies (Uffizi, no. 15168F, and Art Institute of Chicago, no. 22.2416).[3]

1. See Mina Bacci, "Jacopo Ligozzi e la sua posizione nella pittura fiorentina," *Proporzioni*, vol. 4 (1963), pl. 43; and James Byam Shaw, *Drawings by Old Masters at Christ Church, Oxford* (1976), vol. 2, pls. 142–45.

2. Cf. Parmigianino's drawings of the *Adoration of the Shepherds* at Windsor Castle, *Christ Enthroned* in the Uffizi, *Saturn Devouring One of His Children* in the Louvre; all reproduced in A. E. Popham, *Catalogue of the Drawings of Parmigianino* (New Haven and London, 1971), nos. 115, 385, 644, pls. 154, 237, 398.

3. Williams and Riester, *European Master Drawings*, p. 22; and Gere, "The Lawrence-Phillips-Rosenbach 'Zuccaro Album,' " p. 140.

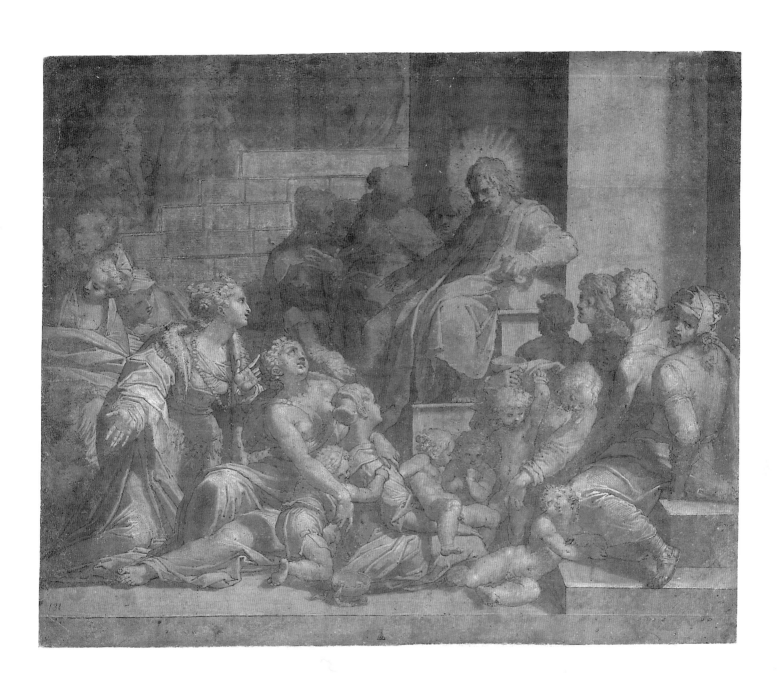

GIROLAMO MACCHIETTI

GIROLAMO DI FRANCESCO DI MARIOTTO DE' MACCHIETTI; GIROLAMO DEL CROCIFISSAIO

Florence c. 1535–Florence 1592

.

A pupil of Michele Tosini, Macchietti left the master's shop to serve for six years, from about 1556 to 1561, in Vasari's *équipe*, which was then refurbishing the Palazzo Vecchio. His employment in the palace, apparently as a designer of tapestries, was followed by two years of study in Rome (c. 1561–63). By 1563 Macchietti had returned to Florence, where he became a member of the newly founded Accademia del Disegno. Under the academy's auspices, in 1564 he created, with his friend Mirabello Cavalori, a grisaille painting of *Lorenzo the Magnificent Receiving Michelangelo in the Garden beside San Marco* (lost) for Michelangelo's catafalque in San Lorenzo.

Macchietti possibly made another brief trip to Rome just prior to executing in 1568 an *Adoration of the Magi* for the della Stufa Chapel in San Lorenzo. While the style of that altarpiece is primarily Vasarian, numerous features of the work seem to derive from paintings by Parmigianino or Raphael's school in Rome. In his *Holy Family with Saint Anne* (c. 1568; Budapest, Szépmüveszéti Múzeum) and *Madonna della Cintola* (1569; Florence, Santa Agata), Macchietti's Mannerism yielded to a more restrained Counter-Reformation style. The change may be due to contemporary works he viewed in Rome or to pictures conceived in a Counter-Reformation spirit in Florence, such as Santi di Tito's *Adoration of the Shepherds with Saint Francis* (c. 1566; San Giuseppe) and Cavalori's *Pentecost* (c. 1567–68; Badia).

The two paintings Macchietti created for the Studiolo of Francesco I in the Palazzo Vecchio—the *Baths of Pozzuoli* and *Medea and Aeson* (c. 1570–72)—also may be partially indebted to Cavalori, whose Studiolo pictures (see Feinberg, above, fig. 20) have the same naturalism of light and space and similarly Pontormesque and Sartesque figure types. In his *Martyrdom of Saint Lawrence* (1573; Florence, Santa Maria Novella), Macchietti rejected Florentine Mannerist tradition, basing his composition on Venetian models, particularly Titian's rendition of the subject in the Church of the Gesuiti, Venice. Macchietti was less adventurous in his late altarpieces, such as the *Saint Lawrence in Glory* (Empoli, Museo della Collegiata), in which he employed a schematic Counter-Reformation mode. His last years were spent mainly in Naples and Benevento (1578–84) and in Spain (1587–89).

24

SEATED MALE NUDE
WITH ARMS OUTSTRETCHED

.

Red chalk heightened with white on paper tinted yellowish brown, squared with black chalk, 210 × 167 mm

Inscriptions: on recto in pen and brown ink at lower left, *Rosso*

Provenance: Dan Fellows Platt (Lugt supp. 750a and 2066b, on lower left of verso)

References: Philip Pouncey, "Contributo a Girolamo Macchietti," *Bollettino d'arte*, vol. 47 (1962), pp. 237–38; Jacob Bean, *Italian Drawings in the Art Museum, Princeton University* (1966), p. 25, no. 18; Janos Scholz, "Italian Drawings in the Art Museum at Princeton University," *Burlington Magazine*, vol. 109 (1967), p. 295; Felton Gibbons, *Catalogue of Italian Drawings in the Art Museum, Princeton University* (1977), no. 410; Scott Schaefer, "The Studiolo of Francesco I: A Checklist of the Known Drawings," *Master Drawings*, vol. 20, no. 2 (1982), p. 128

The Art Museum, Princeton University, Bequest of Dan Fellows Platt, 48.579

Strongly reminiscent of life studies of about 1525 by Pontormo,[1] this drawing, probably made from a studio model, seems to have been preparatory for a painting of Saint Jerome. Macchietti's figure appears to be holding in his right hand a rock, the instrument with which Jerome performed his penance in the wilderness. The drawing cannot be connected with any of Macchietti's known paintings,[2] and the artist's biographers, Vasari and Baldinucci, do not mention any pictures of the saint by him. Pouncey and Gibbons have rightly compared the present study to some of the preliminary drawings Macchietti executed for his Studiolo painting of the *Baths of Pozzuoli*; the Princeton sheet is especially close to the studies of a *Figure Reclining on Stairs* (Louvre, no. 8819) and a *Seated Figure Holding His Leg* (Louvre, no. 13717), which are among his most Pontormesque drawings.[3] These analogies suggest a date for the Princeton study of about 1570–71.

1. Particularly, Pontormo's *Study of a Seated Nude Figure* for the Certosa *Supper at Emmaus* (Uffizi, no. 6656F), and his *Seated Nude* (Uffizi, no. 6513F) for the Santa Felicita *God the Father with the Four Patriarchs* (destroyed); see Janet Cox-Rearick, *The Drawings of Pontormo* (Cambridge, Mass., 1964), vol. 1, nos. 217, 263, and vol. 2, figs. 211, 250.
2. Schaefer ("Checklist of Studiolo Drawings," p. 128) lists the Princeton drawing as preparatory for the *Baths of Pozzuoli*. The figure does not directly correspond with any of the bathers in Macchietti's painting, and it appears that the Princeton nude is seated on a rocky outcropping and not on the dressed steps of a public bath.
3. For the Louvre sheets, see Luisa Marcucci, "Girolamo Macchietti disegnatore," *Mitteilungen des Kunsthistorischen Institutes in Florenz*, vol. 7 (1955), pp. 121–22; Pouncey, "Girolamo Macchietti," p. 237; Catherine Monbeig-Goguel, *Dessins toscans de la deuxième moitié du XVIe siècle. Vasari et son temps* (Paris, 1972), nos. 35–36; and Schaefer, "Checklist of Studiolo Drawings," p. 128.

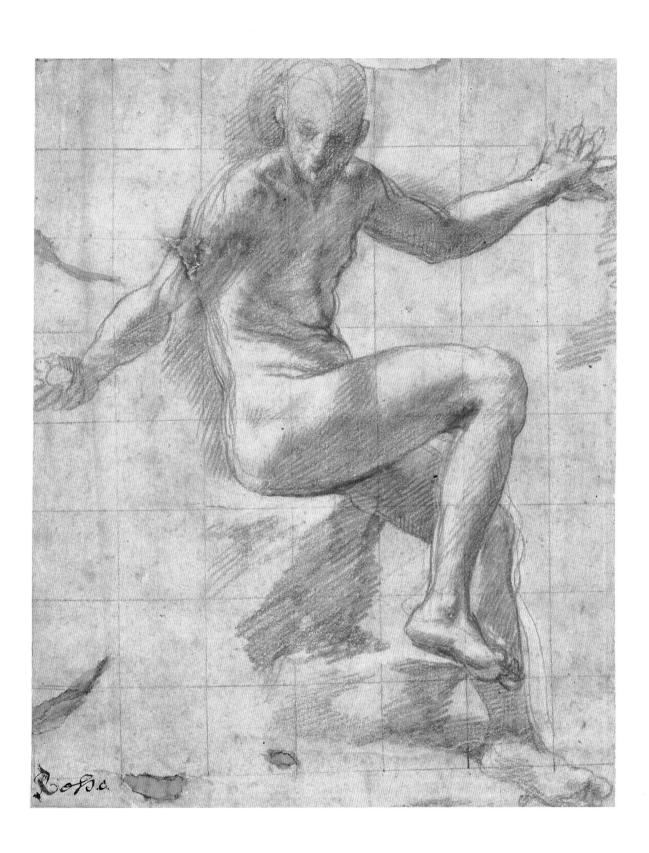

2 5

STUDIES OF A CROUCHING MALE NUDE
AND TWO HEADS RECTO

PROFILE STUDY VERSO

.

Red chalk with faint black chalk underdrawing, 169 × 253 mm
Inscriptions: on recto in pen and brown ink at lower right, *di Cecchin Salviati*
Provenance: R. Gilli, Milan

Private collection, United Kingdom

These studies, probably made from life, cannot be connected with any of Macchietti's known paintings. Nevertheless, the attribution of the sheet to him is fairly certain based on stylistic similarities to a number of his drawings, particularly a *Study of a Seated Nude* in Edinburgh[1] and a *Study of a Nude Reclining on Stairs*, for the Studiolo *Baths of Pozzuoli*, in the Louvre.[2] Both the figure on the left of the present sheet and the Edinburgh *Seated Nude* demonstrate how Macchietti, like Pontormo, was fond of rendering the neck, shoulders, and buttocks of the figure as one continuous bowed line, with the shoulder pulled forward so as not to interrupt the rhythm of the contour.

This sort of subtle reworking of the visual data, made, it would seem, almost automatically as the artist looked at his model, can also be seen in his handling of the head at the top center of the sheet. That profile, apparently an elaboration on the head of the model at right, has been made to conform with Macchietti's typical facial types. It is very close in its smoothed, flattened shape to the head of the allegorical figure of Wealth in his painting in the Ca' d'Oro, Venice,[3] and to that of Saint Lawrence in his altarpiece in Santa Maria Novella, Florence (see Feinberg, above, fig. 33).

1. See Keith Andrews, *Catalogue of Italian Drawings: National Gallery of Scotland* (Cambridge, England, 1968), p. 69, fig. 486, and Valentino Pace, "Contributi al catalogo di alcuni pittori dello studiolo di Francesco I," *Paragone*, no. 285 (1973), p. 72, pl. 35b.
2. Luisa Marcucci, "Girolamo Macchietti disegnatore," *Mitteilungen des Kunsthistorischen Institutes in Florenz*, vol. 7 (1955), p. 121, fig. 5, and Philip Pouncey, "Contributo a Girolamo Macchietti," *Bolletino d'arte*, vol. 47 (1962), p. 238, fig. 4.
3. Pace, "Contributi al catalogo," p. 72, pl. 34.

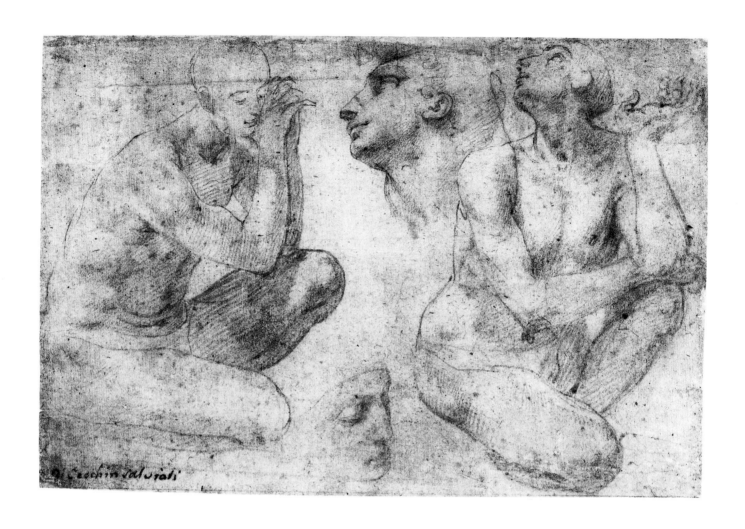

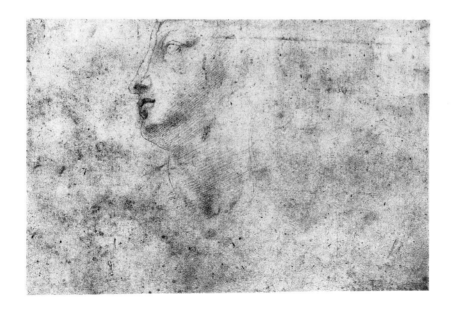

MASO DA SAN FRIANO

TOMMASO D'ANTONIO MANZUOLI

Florence 1531–Florence 1571

.

One of the principal participants in the Pontormo and Sarto revivals in Florence, Maso received his initial training from either Pier Francesco Foschi or Carlo Portelli. The style of Maso's earliest known work, the *Portrait of Two Architects* (1556; Rome, Palazzo Venezia), suggests that he was a pupil of Foschi. By 1560 Maso's reputation was sufficient to earn him an important commission for an altarpiece for the de' Pesci Chapel in San Pier Maggiore in Florence and another for the Convento della Trinità in Cortona. The de' Pesci *Visitation* (signed and dated 1560), now in Trinity Hall, Cambridge, reveals Maso's early, intense fascination with the art of Andrea del Sarto. In its High Renaissance compositional structure and grandness of movement, the work pays homage to some of Sarto's large altarpieces, such as the Passerini *Assumption of the Virgin* (Florence, Palazzo Pitti). Maso's *Madonna and Child with Saints* in Cortona, primarily a simplification and geometric abstraction of paintings by Sarto, contains elements from the works of Foschi and Pontormo.

Maso's stylistic allegiances vacillated in his religious works of the mid-1560s, when some pictures continued to be strongly influenced by Sarto (e.g., *Trinity with Saints*, Florence, Accademia), while others (e.g., *Ascension of Christ*, Oxford, Ashmolean Museum, and the drawing of the *Entombment of Christ*, Chatsworth Collection, Duke of Devonshire) depended more on works by Pontormo. Maso, like Cavalori and Macchietti, stood apart from other Pontormo revivalists in his attraction to the master's mature works of 1526–30 and in his interest in capturing subtle and dynamic effects of light. This latter concern is especially apparent in some of his drawings, such as his *Nativity of Christ* (c. 1560; Uffizi, no. 7279F). In his *Adoration of the Shepherds* (c. 1566–67; Florence, Santissimi Apostoli) Maso's *Sartismo* reached its peak. Virtually every figure in the altarpiece makes Sartesque allusion; the central angel was copied, with few alterations, from Sarto's *Birth of the Virgin* in the Annunziata.

Maso's *Holy Family with Saint John* (c. 1569–70; Oxford, Ashmolean Museum) and *Madonna and Child with Saint John and Two Angels* (c. 1569–70; Leningrad, Hermitage) imitate the broad, sweeping shapes and quality of irrational excitement he observed in the late proto-Mannerist pictures of Sarto and in the paintings of Pontormo. The restless treatment of those works is found also in the two paintings he produced for the Studiolo of Francesco I: the *Diamond Mines* and the *Fall of Icarus* (c. 1570–71). He appears to have executed the *Diamond Mines* only after careful study of the Story of Joseph paintings Pontormo made for the bedchamber of Pier Francesco Borgherini, particularly the *Joseph in Egypt* (c. 1517–18; London, National Gallery). The anatomical construction and sprightly movement of Maso's actors recall the Borgherini pictures as well as works by Rosso and even the paintings of the anonymous early sixteenth-century artists known as the Florentine Eccentrics.

2 6

ADORATION OF THE SHEPHERDS

.

Black chalk on blue paper, 240 × 233 mm
Provenance: Sotheby's, New York, 13 January 1989, lot 223
Elmar W. Seibel

This sheet is a preliminary study for the principal figures in one of Maso's impor-tant paintings, the central panel of an altar triptych (c. 1566–67) for the church of Santissimi Apostoli in Florence.[1] The attitudes of the figures in the drawing differ only slightly from those in the painting; in the latter, the shepherd at the right is turned toward the viewer, so as to interrupt the strict symmetry of the drawing, and the Christ Child is less agitated. The beautiful sweep of gesture toward the child is also less pronounced in the altarpiece, where Maso has imposed upon the actors a Sartesque calm. Concomitantly, the drapery is not so full and billowing in the painting but more closely approximates Sarto's angular and crisp drapery style. As noted in the artist's biography above, for the central angel in the altar, Maso appropriated with little alteration an angel from Sarto's *Birth of the Virgin* in the Annunziata.[2] His study for that figure, also in black chalk on blue paper, and another full compositional sketch for the painting, are preserved in the Uffizi (nos. 6466F, 6500F).[3]

1. See Valentino Pace, ''Maso da San Friano,'' *Bollettino d'arte*, vol. 61 (1976), pp. 76–77, 83, figs. 6–8, and Peter Cannon-Brookes, ''A Madonna and Child by Maso da San Friano,'' *Apollo*, vol. 92 (Nov. 1970), p. 347.
2. Cannon-Brookes was apparently the first to observe that Maso's angels carrying the instru-ments of the Passion seem to be inspired by those in Bronzino's *Deposition* (before 1545) for the Chapel of Eleonora of Toledo in the Palazzo Vecchio, now in the Musée des Beaux-Arts et d'Archéologie, Besançon; see Peter Cannon-Brookes, ''Maso da San Friano'' (Ph.D. diss., University of London, Courtauld Institute of Art, 1968), p. 102.
3. Pace, ''Maso da San Friano,'' pp. 77, 86, figs. 4–5.

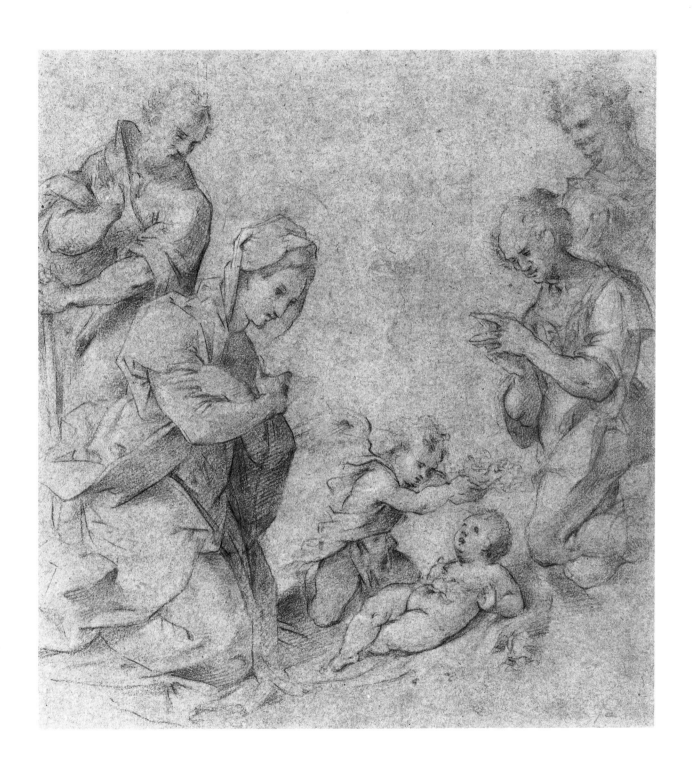

2 7

SAMUEL ANOINTING DAVID WITH OIL

.

Pen and brown ink and black chalk, 157 × 242 mm
Provenance: Hill-Stone, Inc., New York
Private collection

This drawing illustrates the climactic moment of the Old Testament story of how Samuel, at God's command, traveled to Bethlehem to choose one of Jesse's sons to succeed King Saul (I Sam. 16:1–13). Samuel, the spiritual leader of the Israelites, passed over seven of Jesse's sons before he found David, who had been in the field tending sheep. In Maso's study, Samuel anoints David with oil he pours from a horn, while an attendant catches the spillage in a basin. Another attendant, holding a vessel of oil, stands beside Jesse at the left. Behind and to the right of the protagonists are David's seven brothers, who watch the ceremony with varying degrees of surprise and disbelief. The stage-play format of Maso's design, with the figures distributed across a shallow space and the principal actor placed at the center of a compositional "X," derives from Sarto (see Feinberg, above, pp. 23–24), as does the style of drapery (see cat. no. 45). Although this study cannot be associated with a specific painting by Maso, the attribution to him can be confirmed by comparing this sheet with other, certain drawings by him, such as those on a page from Vasari's *Libro dei disegni* preserved in the Louvre (no. 1306).[1]

This episode in the life of David, a patron saint of Florence, frequently appeared in decorations commissioned by the grand dukes, who wished to promote the ideas of Medici dynasty and divine-right succession. The scene was represented on the triumphal arch that stood on the Canto de' Carnesecchi, one of the *apparati* erected in celebration of Francesco I's wedding in 1565. According to Vasari, the story of David's anointment on that arch dedicated to the Casa Medici was intended to allude to the election of Cosimo as duke.[2]

1. See Catherine Monbeig-Goguel, *Dessins toscans de la deuxième moitié du XVIe siècle. Vasari et son temps* (Paris, 1972), no. 45. Note particularly the drawings at the top left and top center of the page.
2. Giorgio Vasari, *Le Vite de' più eccellenti pittori, scultori, ed architettori* (1568), ed. Gaetano Milanesi (Florence, 1878–85; rpt., 1906), vol. 8, p. 546. Federico Lamberti (called Il Padovano) was responsible for the paintings on the Arco de' Carnesecchi; see Piero Ginori Conti, *L'Apparato per le nozze di Francesco de' Medici e di Giovanna d'Austria* (Florence, 1936), p. 33.

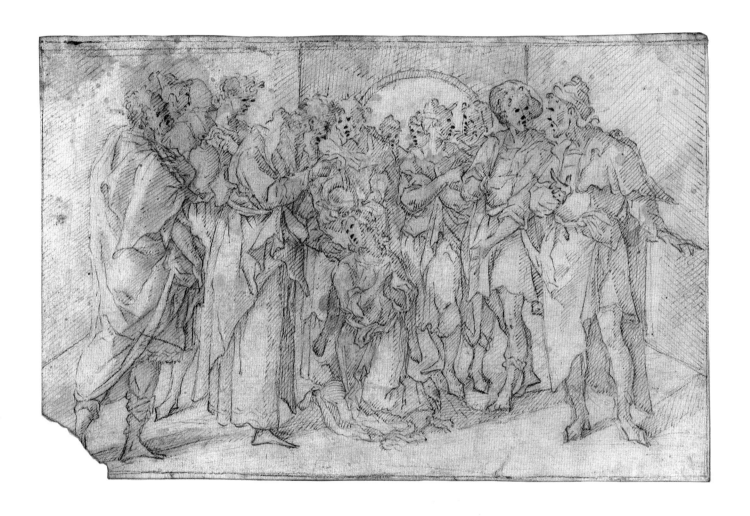

28

THREE STANDING SOLDIERS

.

Black chalk, 209 × 241 mm
Inscriptions: in brown ink at lower right, *Federico Zuccaro*
Provenance: H. Schickman Gallery, New York
Exhibitions: *Old Master Drawings from American Collections*, exh. cat. by Ebria Feinblatt, Los Angeles County Museum of Art (1976), no. 30; *The Draftsman's Eye: Late Italian Renaissance Schools and Styles*, exh. cat. by Edward J. Olszewski, Cleveland Museum of Art [1979] (Cleveland and Bloomington, 1981), no. 18

Los Angeles County Museum of Art, Gift of Graphic Arts Council, M.75.34

This spirited study of three soldiers—with a fourth faintly outlined—would appear to date from Maso's last years (c. 1570–71). In their springy, twisting movements and bulging contours the figures are analogous to those in Maso's Studiolo paintings. He employs a similar graphic manner in several extant drawings, notably the sketch for a *Nativity* in the Louvre (no. 9969), which probably predates the Los Angeles sheet by a few years, and the studies for an *Ecce Homo* in the Louvre (no. 11423) and Uffizi (no. 999S).[1] Drawings made by Maso before the 1570s, especially those imitating the works of Andrea del Sarto, tend to be more angular and brittle in style.[2]

Typical of Maso is the restless parallel hatching, which he used primarily to create patterns of light and shade, and only secondarily to reinforce the volumetric presence of the figures. His optical concerns and inclinations toward geometric revision were shared by Andrea Boscoli, whose drawing style (cat. nos. 7, 9) may owe something to Maso. The quick, abstracting light of Maso's studies for an *Annunciation* in the Louvre (no. 1310) and a *Nativity of the Virgin* and a *Three Marys at the Tomb* in the Uffizi (nos. 7279F, 7277F) can be observed in numerous Boscoli drawings.[3]

1. Paola Barocchi, Anna Forlani, et al., *Mostra di disegni dei fondatori dell'Accademia delle Arti del Disegno*, exh. cat., Gabinetto Disegni e Stampe degli Uffizi (Florence, 1963), no. 47; Feinblatt, *Old Master Drawings*, no. 30; Catherine Monbeig-Goguel, *Dessins toscans de la deuxième moitié du XVIe siècle. Vasari et son temps* (Paris, 1972), nos. 51–52; and Valentino Pace, "Maso da San Friano," *Bollettino d'arte*, vol. 61 (1976), p. 81n48.
2. See, for example, the *Religious Allegory* (signed and dated 1565) in the Louvre (no. 1307), reproduced in Monbeig-Goguel, *Vasari et son temps*, as no. 46.
3. Anna Forlani, *I disegni italiani del Cinquecento* (Venice, 1962), p. 244, fig. 95; Luciano Berti, "Nota a Maso da San Friano," *Scritti di storia dell'arte in onore di Mario Salmi* (Rome, 1963), vol. 3, p. 86, figs. 6–7; Luciano Berti, *La casa del Vasari in Arezzo e il suo museo* (Florence, 1955), no. 50; Monbeig-Goguel, *Vasari et son temps*, no. 50; and Pace, "Maso da San Friano," p. 87, figs. 33–34.

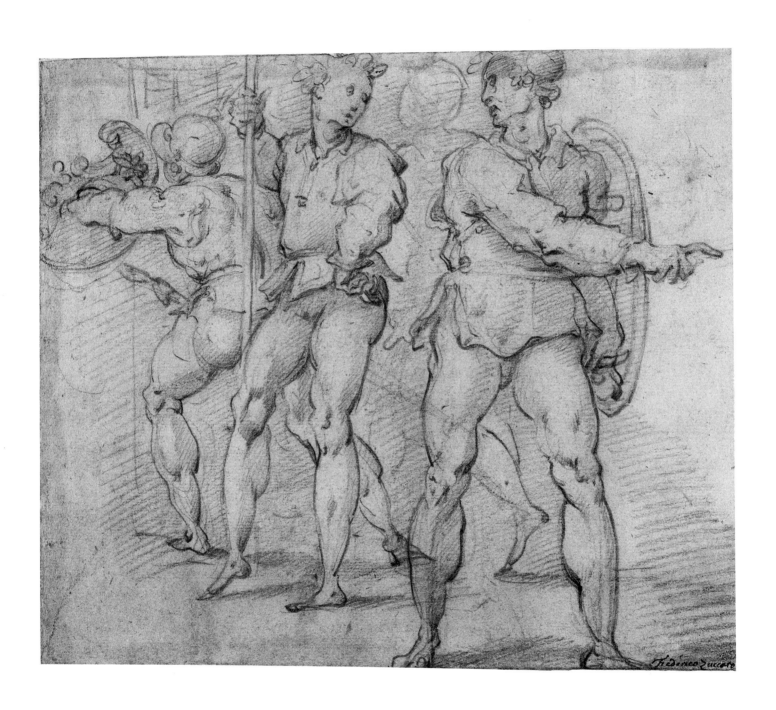

GIOVANNI BATTISTA NALDINI

Fiesole c. 1537–Florence 1591

.

Naldini's early apprenticeship with Jacopo Pontormo, from about 1549 until the master's death in 1557, to a large degree determined his mature artistic personality. His first drawing style was derived from Pontormo's, and the apparent mental activity and movement of Naldini's actors, their alertness and reflex action, are reminiscent of those of some of Pontormo's figures. A brief sabbatical in Rome (1560–c. 1561), which naturally involved intensive study of ancient sculpture, preceded Naldini's enlistment in Vasari's *équipe* in 1562. He served Vasari as an executant, and perhaps occasionally as a designer, of frescoes in the Sala del Cinquecento and other rooms in the Palazzo Vecchio. Although the experience of Roman art and his relation with Vasari seem to have had a hardening effect on Naldini's paintings, his draftsmanship remained fluid and flexible and akin in spirit, if not always in detail, to Pontormo's. Surviving drawings by Naldini after Sarto's Scalzo frescoes reveal how closely and enthusiastically he studied the works of that master as well. With the prose of Sarto's art and the polish of Allori's and Bronzino's, Naldini tempered the eccentricities of his *Pontormismo*.

Two paintings that Naldini executed for the Pistoia Cathedral, a *Supper of the Hebrews* and a *Fall of Manna* (both 1566) are populated by stodgy Vasarian figure types and reveal how easily he could assimilate another artist's manner. In his *Way to Calvary* (1566–67; Florence, Badia), a commission probably procured for him by Vasari, Naldini employed his most Vasarian style. Yet there, too, the quality of emotion, a blend of hypersensitivity and vulnerability (particularly in the face behind the cross at center) recalls that of Pontormo's works. Naldini's Pontormism asserts itself again in his two Studiolo pictures, the *Allegory of Dreams* and the *Gathering of Ambergris* (both 1570). Naldini was only one of a number of Studiolo artists who, in creating scenes

of fantasy—visual divertissement for Francesco's *Wunderkammer*—found inspiration in Pontormo. Whereas in their Studiolo pictures Maso and Poppi almost exclusively emulated Pontormo's *prima maniera* eccentricities of form, Naldini's actors hark back not only to those but also to Pontormo's academic figures of about 1526–30, moderated further by Sarto's naturalism. Responsible for the sense of unreality in Naldini's Studiolo panels is the mature to late Pontormesque character of movement and light: irrationally complex, swift, and cursive. Naldini's lush handling of the paint also contributes to the dreaminess of the scene; the liquescent shapes of the *Gathering of Ambergris*—foaming and vanishing—seem not only described by the brush but stirred, and the material identity of form appears to be as unstable as the color.

The poetic license that Naldini enjoyed in conceiving the Studiolo paintings could not be extended to religious paintings meant for a large public audience. For the latter he vacillated between two conservative Vasarian modes—one, polished and sculptural (e.g., the *Deposition* of 1572 in Santa Maria Novella), the other, soft and painterly (e.g., the *Nativity* of 1573, also in Santa Maria Novella). A trace of Pontormo's style can be observed in some of Naldini's works executed as late as the 1580s, such as the *Entombment* in Santa Croce. The influences of Vasari and Michelangelo are prevalent in that composition and overwhelm what was left of Naldini's *Pontormismo*. But Naldini's continuing interest, even in his last years, in Pontormo's works is apparent in such paintings as his *Passion of Christ* (Prato, Galleria Comunale), in which Naldini archaizes figures seized from Pontormo's Certosa frescoes by giving them the ropy drapery style and oleaginous surfaces found in works by Pedro Berruguete and other fifteenth-century and *retardataire* sixteenth-century masters.

29

STUDY OF MICHELANGELO'S
STATUE OF LORENZO DE' MEDICI

.

Black and white chalk, 437 × 291 mm

Watermark: crossbow in circle

Inscriptions: on recto in brown ink at lower left, *Battista Naldini da michelagiolo*

Provenance: Lord Rowan; Max Goldstein (Lugt 2824); Dan Fellows Platt (Lugt supp. 750a), Goldstein sale, New York, American Art Galleries, March 2–5, 1920, no. 473

References: Jacob Bean, *Italian Drawings in the Art Museum, Princeton University* (1966), no. 20; Janos Scholz, "Italian Drawings in the Art Museum of Princeton University," *Burlington Magazine*, vol. 109 (1967), p. 294; Felton Gibbons, *Catalogue of Italian Drawings in the Art Museum, Princeton University* (1977), no. 453

The Art Museum, Princeton University, Bequest of Dan Fellows Platt, 48.761

One of the most prolific Florentine draftsmen of the later sixteenth century, Naldini continually made sketches after sculpture, both ancient and contemporary. Michelangelo's tombs for the minor Medici dukes Lorenzo the Younger, duke of Urbino, and Giuliano the Younger, duke of Nemours, became, soon after their installation in 1534, schools of study for generations of artists (see Barzman, above, fig. 4). Naldini's copy is fairly faithful to the model, although certain passages, such as the left leg and the drapery across the lap, have been rendered with bulging Pontormesque contours that make explicit the restrained energy that Michelangelo had left implicit in his work. Naldini's fine hatching system is probably not meant to imitate Michelangelo's drawing style but is instead intended to offer a literal description of the surface of the sculpture, which is covered with a fine pattern of claw chisel marks.[1] Naldini's emphasis on descriptive literalness, with his primary interest in the structure of the figure, can also be seen in his elimination of or lightening of many of the heavy shadows that obscure areas of the sculpture when it is seen in situ. For example, areas of the obolus-box beneath Lorenzo's left elbow are deeply cut, creating strong contrasts of light and shade that make the bat mask on the coffer prominent. Concerned primarily with the figure of Lorenzo, Naldini only summarily sketched the money box, neglecting to indicate the play of shadows. The allusive character of the bat, a creature of the night and so a poetic attribute of the contemplative Lorenzo, was overlooked by Naldini in his striving for academic correctness.

A pendant drawing by Naldini after Michelangelo's *Statue of Giuliano de' Medici*, rendered in the same controlled manner, is also preserved in the Art Museum at Princeton.[2]

1. Comparable in drawing technique is a Naldini *Female Head*, probably after an antique statue (Uffizi, no. 7498Fv); see Paola Barocchi, "Itinerario di Giovambattista Naldini," *Arte antica e moderna*, vols. 31–32 (1965), p. 266, fig. 111d.
2. Gibbons, *Italian Drawings in Princeton*, no. 454.

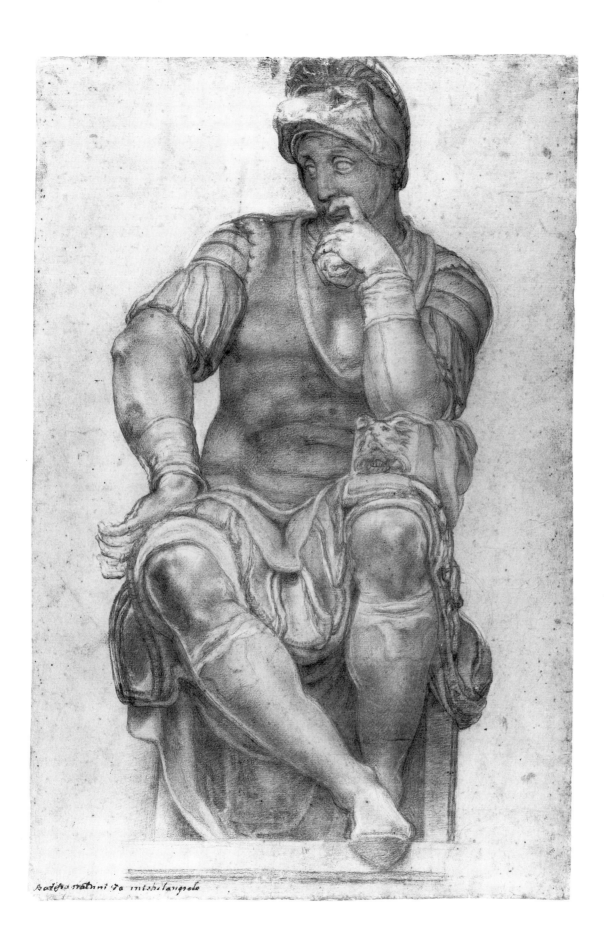

Bastista naldini fa michelangelo

30

STUDY OF A STANDING MONK
HOLDING A BOOK

.

Red, white, and black chalk on paper tinted pink, 229 × 139 mm
Provenance: Archibald G. B. Russell (Lugt supp. 2770a), Sotheby's, London, 28 June 1979, lot 56
Private collection, United Kingdom

Like Pontormo,[1] Naldini used colored chalks in combination with white heightening on pink-tinted paper not only to create highly finished drawings but frequently for rough preliminary studies, even *primi pensieri* (''first-idea'') sketches. This mixed-media technique allowed the artist to make numerous changes without completely muddling his sketch. White heightening (or chalk) was used in some cases to mask mistakes or abandoned ideas and in other instances, as here, to reinforce the draftsman's final decision.

Few sheets by Naldini exceed the present one in graphic freedom.[2] In this respect, it is very close to certain drawings by Sarto and, especially, to some of Pontormo's early Sartesque drawings of about 1515–17. The quickly set down geometric construction of the *Standing Monk*—a creation by triangulation—is similar to Sarto's *Study of a Male Figure* (Louvre, no. 232r) and to Pontormo's *Study for a Visitation* (Munich, Staatliche Graphische Sammlung, no. 14042) and *Compositional Study for the San Michele Visdomini Altar* (Rome, Farnesina, F.C. 147r).[3] The last drawing is executed with black chalk and white heightening on pink prepared paper and thus is comparable to the present sketch in technique as well as in style.

1. See Feinberg, above, pp. 17–18.
2. The sheet may be compared to the Naldini *Figure Studies* (Uffizi) reproduced in Paola Barocchi, ''Itinerario di Giovambattista Naldini,'' *Arte antica e moderna*, vols. 31–32 (1965), fig. 107b.
3. For the Sarto drawing, see John Shearman, *Andrea del Sarto* (Oxford, 1965), vol. 1, pl. 63a; for the Pontormo sheets, see Janet Cox-Rearick, *The Drawings of Pontormo* (Cambridge, Mass., 1964), vol. 1, nos. 17, 29, and vol. 2, figs. 21, 37.

3 1

SEATED YOUTH

.

Red chalk, brush, and pink wash, with white corrections, 226 × 203 mm
Provenance: C. G. Boerner, Düsseldorf (1971)
References: Edmund P. Pillsbury and John Caldwell, *Sixteenth-Century Italian Drawings: Form and Function*, exh. cat., Yale University Art Gallery (New Haven, 1974), no. 32
Yale University Art Gallery, anonymous gift, 1972.38

Once given to Pontormo,[1] this vigorously executed study, done perhaps from life, demonstrates the dependence of Naldini's draftsmanship on his master's drawings of about 1516–18, particularly those Pontormo made in preparation for his San Michele Visdomini altar (c. 1517–18).[2] Naldini emulated Pontormo's figure canon and the splintery strokes he used in his early studies. From Pontormo he also learned to use white heightening to make corrections in drawings on pink-tinted paper (see cat. no. 30). Distinguishing Naldini's manner from Pontormo's is a sometimes heavy-handed reinforcement of contours and a tendency to use repetitive, lashing strokes that bind the movements of his figures. The nervous flow of Pontormo's contours, in contrast, seems to increase the possibility of movement in his figures. Naldini's line works to solidify the figure, Pontormo's to allow the figure to unfold in space.

Pillsbury and Caldwell have noted the similarity of the present drawing to a number of works preserved in the Uffizi.[3] Naldini's debt to the graphic work of Sarto is apparent in all these sheets, in the regularizing of contour, the sfumatesque blurring of some contours, and the attention to surfaces.

1. Sales catalogue, C. G. Boerner, Lagerliste 56 (Düsseldorf, 1971), no. 137.
2. Uffizi, nos. 8976Sv, 6744Fv, 6662Fr; see Janet Cox-Rearick, *The Drawings of Pontormo* (Cambridge, Mass., 1964), vol. 1, nos. 30, 35, 61, and vol. 2, figs. 39, 41, 62.
3. Pillsbury and Caldwell, *Sixteenth-Century Italian Drawings*, no. 32. The drawings they cite are reproduced in Paola Barocchi, "Itinerario di Giovambattista Naldini," *Arte antica e moderna*, vols. 31–32 (1965), figs. 100c, 102d, 107d, 108a, 110a. To this group one can add the *Standing Male Nude* (Uffizi, no. 17808F), illustrated in Annamaria Petrioli Tofani and Graham Smith, *Sixteenth-Century Tuscan Drawings from the Uffizi* (Oxford, 1988), p. 135, no. 58.

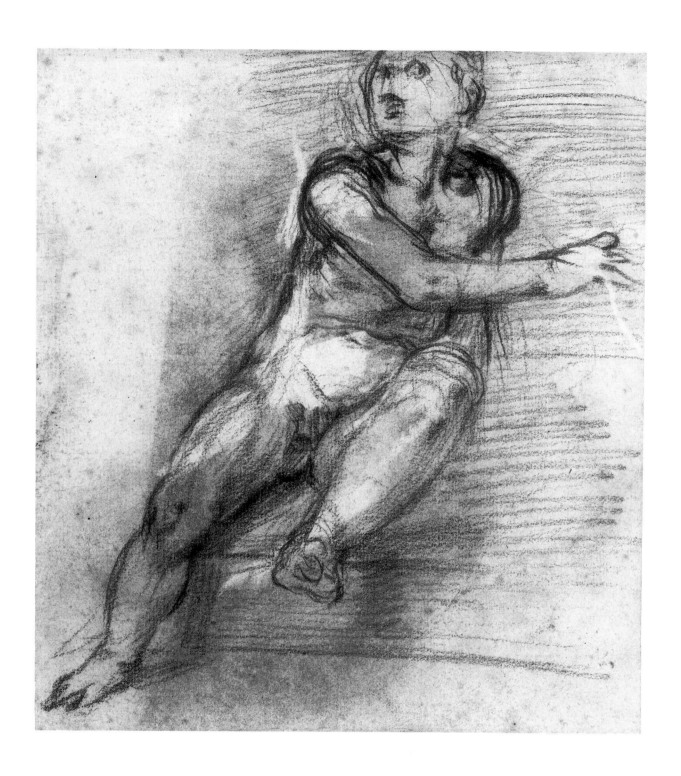

3 2

S I B Y L RECTO

T U R B A N E D H E A D A N D
A N A T O M I C A L S T U D Y O F A N A R M VERSO

.

Red chalk with erased highlights (recto); black chalk, pen and brown ink (verso), 285 × 207 mm

Inscriptions: on recto in red chalk at upper left, *16*; on verso in chalk, *14 / 5 / 24 / 15*, and at bottom center, *Pontormo*

Provenance: Charles A. Loeser

References: Bernard Berenson, *The Drawings of the Florentine Painters* (Chicago, 1938), vol. 3, no. 1754G; Agnes Mongan and Paul J. Sachs, Jr., *Drawings in the Fogg Museum of Art* (Cambridge, Mass., 1940), no. 131; Janet Cox-Rearick, *The Drawings of Pontormo* (Cambridge, Mass., 1964), vol. 1, A13; Paola Barocchi, "Itinerario di Giovambattista Naldini," *Arte antica e moderna*, vols. 31–32 (1965), p. 245; Agnes Mongan, Konrad Oberhuber, and Jonathan Bober, *The Famous Italian Drawings at the Fogg Museum in Cambridge* (Milan, 1988), p. 43, fig. 28

The Fogg Art Museum, Harvard University, Cambridge, Massachusetts, Bequest of Charles A. Loeser, 1932.143

Although this sheet is now catalogued by the Fogg Art Museum as "Jacopo da Pontormo(?)" after a recent attempt to reattribute it to the master,[1] in my opinion the drawing should still cautiously be assigned to Naldini. The study of the *Sibyl* closely resembles some figure drawings by Pontormo of about 1518–19, particularly a study in the Uffizi for the Saint John the Baptist in the San Michele Visdomini altarpiece and a study in the Farnesina for his *Saint Cecilia* fresco (destroyed) for the Compagnia di Santa Cecilia in Fiesole.[2] Clearly the draftsman responsible for the Fogg drawing used these or similar sheets as touchstones for developing his own manner; the Fogg study may even copy a lost Pontormo drawing.[3] Careful comparison of the Fogg *Sibyl* to the Uffizi *Baptist*, in which the figure strikes an almost identical pose, reveals acute differences in the quality and style of draftsmanship. Whereas the

subtle modulation of Pontormo's contours at once captures the structure of the pose and creates volume, the line of the Fogg sheet is far less articulate; it establishes the relations of the various body parts but creates no depth and splays the figure awkwardly across the picture plane. Moreover, the sibyl carries almost all her weight, unnaturally, in her upper torso, while in Pontormo's figures, movements and contours are exquisitely responsive to the pull of gravity. Even in his earliest known studies, Pontormo conceived his figures in terms of movement outward from the spine and indicated the action of gravity on the central core of the figure. The artist who created the present sheet does not so much posit as organize his figure on the sheet, subjecting it to a rigidifying system of diagonals. This sort of structuring is typical of Naldini (as is the tendency to reinforce contours with heavy, splintering lines) and can be seen in numerous drawings by him.[4]

1. Catalogue entry prepared by Philip Walsh in May 1986 for Konrad Oberhuber's drawing connoisseurship class; the paper is preserved in the files of the Fogg Drawings Study.
2. Uffizi, no. 7452Fr, and Rome, Gabinetto Nazionale delle Stampe, no. F.C. 146r; Cox-Rearick, *Drawings of Pontormo*, vol. 1, nos. 39, 93, and vol. 2, figs. 46, 92.
3. The turbaned head on the verso appears to be a crude variation on a beautiful study by Pontormo that is preserved in the Uffizi (no. 449Fr); see Cox-Rearick, *Drawings of Pontormo*, vol. 1, no. 236, and vol. 2, fig. 234.
4. See, for example, the Uffizi figure studies Naldini executed when preparing his *Presentation in the Temple* for Santa Maria Novella; reproduced in Barocchi, "Itinerario di Naldini," as figs. 103a, b, d.

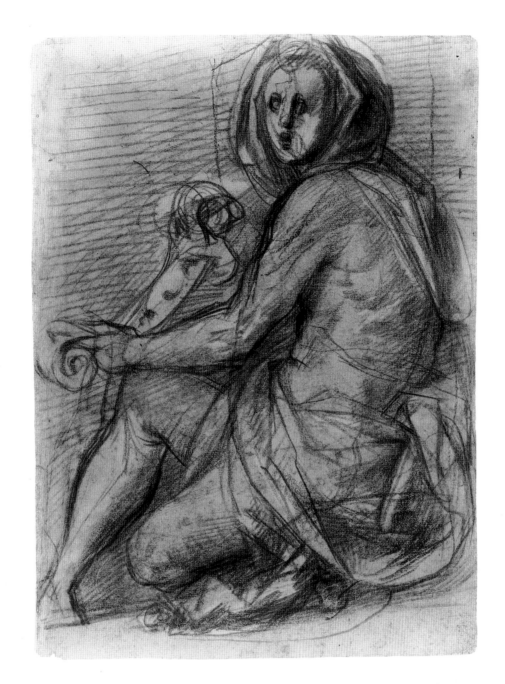

NALDINI

137

STUDY FOR THE LOWER HALF OF AN ASCENSION WITH THE TWELVE APOSTLES, SAINT AGNES, AND SAINT HELEN

.

Pen and brown ink with brown wash on pink prepared paper, 188 × 181 mm

Inscriptions: in pen and brown ink at lower center, *m 157*

Provenance: Padre Resta, H. S. Olivier (Lugt 1373); private collection, England

Exhibitions: *The Age of Vasari*, exh. cat., University of Notre Dame Art Gallery and University Art Gallery, State University of New York at Binghamton (1970), no. D11; *Sixteenth-Century Italian Drawings: Form and Function*, exh. cat. by Edmund P. Pillsbury and John Caldwell, Yale University Art Gallery (New Haven, 1974), no. 31

References: Catherine Monbeig-Goguel, *Dessins toscans de la deuxième moitié du XVIe siècle. Vasari et son temps* (Paris, 1972), p. 88, no. 96

Private collection

This spirited drawing was preparatory for the lower half of the *Ascension* altarpiece (before 1576; destroyed by fire in the eighteenth century) that Naldini created for the church of Santa Maria del Carmine in Florence. The work was originally commissioned in 1564–65 for the Compagnia di Santa Agnese by Elena Ottonelli, who entrusted Maso da San Friano with the project. Unfortunately, Maso died in 1571, and he seems only to have progressed to the final drawing stage; his *modello* and two other studies for the painting are preserved in the Uffizi (nos. 602S, 14419F, 14424F).[1] Naldini inherited the commission and painted the altarpiece, which, though lost, is known from a surviving painted *modello* (Oxford, Ashmolean Museum), the present sheet, and another red chalk and wash drawing in the Louvre (no. 10306).[2] The study in this exhibition is almost identical to the Louvre sheet in the placement and attitudes of the figures. It appears that the Louvre study, with its firmly drawn and reinforced contours, was executed first and the present sheet

shortly afterward, to work out the placement of highlights and shadows. As noted elsewhere (see Feinberg, above, p. 22, cat. nos. 20, 41–42), this was a fairly common procedure in late sixteenth-century Florence.

When he took over the commission, Naldini made use of Maso's abandoned designs. Like Maso, he organized the twelve apostles in a roughly circular format and emphasized the figures of Saint Helen, the namesake of the patron, and Saint Agnes, the patron saint of the religious company whose chapel the work was to adorn, by placing them in the foreground. Naldini has increased the sense of movement and rotation, transforming the more static *Sartismo* of Maso's design into a composition that is very similar to those of two of Pontormo's Certosa designs for a *Way to Golgotha* and a *Nailing to the Cross*. In fact, Naldini seems to have been not only interested in the Certosa paintings but also familiar with Pontormo's preliminary drawings for them. His Louvre study for the lower half of the *Ascension* is quite close to Pontormo's drawings for the *Nailing* (see Feinberg, above, fig. 10) and the *Way to Golgotha* (Uffizi, 6643Fv).[3]

1. For reproductions of Maso's drawings and an account of the commission, see Peter Cannon-Brookes, "Three Notes on Maso da San Friano," *Burlington Magazine*, vol. 107 (April 1965), pp. 195–96, figs. 32–34.

2. The Oxford *modello* is illustrated in Cannon-Brookes, "Three Notes on Maso," fig. 31. For the Louvre study, see Monbeig-Goguel, *Vasari et son temps*, no. 96, where it is catalogued and reproduced.

3. Janet Cox-Rearick, *The Drawings of Pontormo* (Cambridge, Mass., 1964), vol. 2, illustrates the study for the *Way to Golgotha* as fig. 191.

BERNARDINO POCCETTI

San Mariano di Valdelsa 1548–Florence 1612

.

Having begun his career as a painter of grotesques and decorator of façades, Poccetti advanced to the status of *frescante* in 1580, when he was asked to assist in the decoration of the Chiostro Grande of Santa Maria Novella, a Counter-Reformation project that since 1568 had required the services of a number of his colleagues. He brought to the church an opulent Mannerist style, which he had developed while in Florence and during a brief period of study in Rome (c. 1579–80), that was not quite in keeping with the sober tone of the majority of paintings in the cloister. In its lavish detail and anecdotal cheer, however, the manner was well suited for secular scenes, such as those he executed in the Palazzo Capponi between 1583 and 1590. By the time he began to paint his frescoes in the later 1580s in the cloister of the Confraternita di San Pier Maggiore, Poccetti had sufficiently adjusted his manner to suit the tastes of his Counter-Reformation patrons and their concerns for didactic clarity. Gradually, he assimilated stylistic elements from Santi di Tito and other reformers and, like them, became retrospective in his works, consulting the examples of Raphael and even Domenico Ghirlandaio. The influence of all these masters can be seen in the frescoes he created for the Certosa di Val d'Ema, such as the *Funeral and Translation of Saint Bruno*, depicted in a lunette (1592–93).

Intermittently he reverted to a Mannerist mode, as in his decorations (completed in 1599) for the Giglio Chapel of Santa Maria Maddalena dei Pazzi in Florence, and the Palazzo Usimbardi (now Acciauoli, 1603), which are rife with illusionistic devices and demonstrations of artistic grace. Despite their compositional complexity and richness, derived—it would seem—from the decorative schemes of Perino del Vaga and Salviati, Poccetti's Palazzo Acciauoli paintings retain a pedestrian character. As is especially apparent in many of his drawings, his actors are dependent on the naturalistic, even prosaic, figure types of Sarto.

34

THE DEATHS OF THE BLESSED
UGOCCIONE AND SOSTEGNO RECTO

STUDY OF THE FARNESE HERCULES VERSO

(BY ANOTHER HAND)

.

Black chalk, brush and brown ink, brown wash, and white gouache heightening on blue-green paper, squared in red chalk (recto); pen and brown ink (verso), 276 × 417 mm
Inscriptions: on recto in brown ink at top left and bottom center, *Poccetti*; on verso in brown ink at lower right, *Di Gio Navarretti*, and in black ink at upper right, *Bernardino Pocce*
Provenance: Baron Horace de Landau, Paris and Florence; Mme Hugo Finaly, Florence; Tor Engestroem, Stockholm; sale, Christie's, London, 5 July 1983, lot 54; art market, London
References: Walter Vitzthum, *Die Handzeichnungen des Bernardino Poccetti* (Berlin, 1972), p. 75; Paul C. Hamilton, *Disegni di Bernardino Poccetti*, exh. cat., Gabinetto Disegni e Stampe degli Uffizi (Florence, 1980), pp. 81, 83; George R. Goldner, with Lee Hendrix and Gloria Williams, *European Drawings* (Malibu, 1988), vol. 1, no. 32; *J. Paul Getty Museum Journal*, vol. 14 (1986), p. 236, no. 174

The J. Paul Getty Museum, Malibu, California, 85.GG.223

Exhibited at Oberlin

In the Chiostro Grande of Santissima Annunziata, Poccetti frescoed fourteen lunettes with scenes from the lives of the founders of the Servite monastery of Monte Senario. Among these paintings, executed between 1604 and 1612, was the *Deaths of the Blessed Ugoccione and Sostegno*, for which seven preliminary studies survive, including the Getty sheet and another squared compositional study in the Uffizi (no. 851F).[1] After carefully working out the shadows and squaring the present drawing, Poccetti apparently had second thoughts about his design. In the Uffizi sheet,[2] which corresponds more closely to the fresco, he reversed the central kneeling figure and arranged the heads of the background mourners in a horizontal line; the latter change, made presumably to give the composition a greater sense of ceremonial order, prosified what (in the Getty drawing) had been an evocative presentation of intimate ritual and veiled emotions.

The composition of the Getty drawing, conceived in terms of quincunxial arrangements of prominent figures on the picture plane and set into space, is derived from Andrea del Sarto (see fig. 22 and Feinberg, above, pp. 23–24).[3] The neo–High Renaissance figure types Poccetti has devised for this calm, classicizing scheme also owe something to Sarto. But in their broad, simplified drapery style and stately amplitude, the figures seem to depend more on those of Santi di Tito (see cat. no. 43).

1. See Hamilton, *Disegni di Poccetti*, pp. 78–85, nos. 66, 68–71.
2. Ibid., no. 68, fig. 88.
3. Cf. Sarto's *Funeral of San Filippo Benizzi* (1510), Santissima Annunziata, reproduced in Sydney J. Freedberg, *Andrea del Sarto* (Cambridge, Mass., 1963), vol. 1, fig. 15.

3 5

Design for a Lunette over an Arch
with Nude Figures

.

Red chalk, 227 × 342 mm

Watermark: Mountain surmounted by a fleur-de-lis, in a circle (Briquet 11935, Rome, 1554)

Provenance: Dr. L. Pollak (Lugt supp. 788b); W. Burgi; [H. Schickman Gallery, New York] Laura P. Hall Memorial Collection

References: Felton Gibbons, *Catalogue of Italian Drawings in the Art Museum, Princeton University* (1977), no. 500

The Art Museum, Princeton University, Museum Purchase, Laura P. Hall Memorial Fund, 70.6

In the course of decorating numerous vaults in *palazzi*, churches, and other public buildings in the late sixteenth and early seventeenth century, Poccetti became adept at organizing figures within the rounded shape of an arch or lunette. The present drawing resembles studies Poccetti executed (c. 1608–12) for frescoes in the Palazzo Ferroni (now Spini) and in the Ospedale degli Innocenti, and may be a discarded idea for one of those projects. The putti of the Princeton sheet are very similar to those supporting an escutcheon in a drawing preserved in the Uffizi (no. 404 Orn.), for an *anticamera* in the Palazzo Ferroni.[1] The reclining figure at the right is close in facial and figure type to the studies of the personifications of Fortezza and Carità that Empoli created for the Ospedale degli Innocenti (Uffizi, nos. 14646Fv, 14647Fr, 14647Fv).[2] Gibbons has pointed out that the soft technique of the Princeton drawing can be found also in a red chalk sketch in the Louvre (no. 1210).[3]

The inchoate state of Empoli's design makes identification of the subject difficult. The sketch may represent a moralizing allegory of some sort involving Pleasure (the creature with a woman's torso and serpent's tail, at the center)[4] and Prudence (or lack thereof), suggested by the sleeping figure with armaments at the right (Athena?).

1. Paul C. Hamilton, *Disegni di Bernardino Poccetti*, exh. cat., Gabinetto Disegni e Stampe degli Uffizi (Florence, 1980), no. 89, fig. 110.
2. Ibid., nos. 97–98, figs. 120–21, 123.
3. Gibbons, *Italian Drawings in Princeton*, no. 500.
4. Pleasure is depicted in this way in Cesare Ripa, *Iconologia*, ed. Piero Buscaroli (Padua, 1608, rpt., Turin, 1986), vol. 2, pp. 116–17.

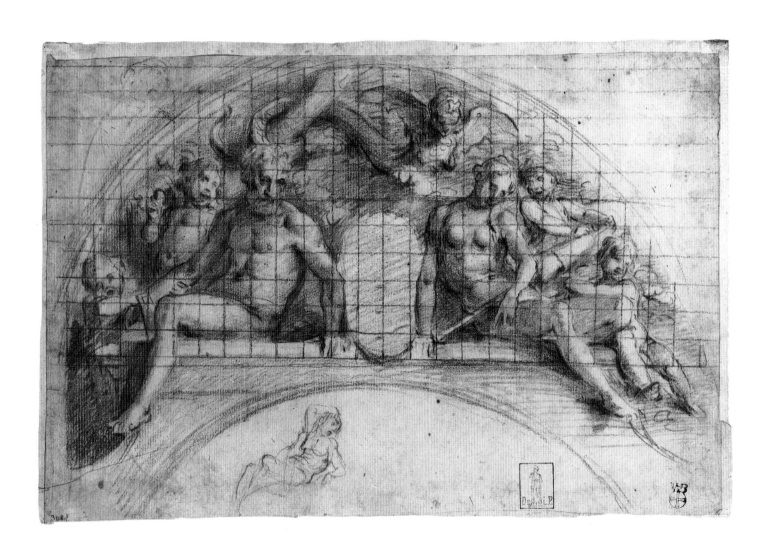

Jacopo Pontormo

Jacopo Carucci

Pontormo 1494–Florence 1557

.

Responsible, with Rosso Fiorentino, for the development of the first Mannerist styles in Florence, Pontormo is generally known for the eccentricities of his art and his behavior. Although his art does represent an idiosyncratic and personal vision, and he apparently was somewhat neurotic, Pontormo was not, contrary to Vasari's implications, isolated from the artistic developments and community of late sixteenth-century Florence. Rather, having served as the unofficial Medici court painter for decades, he was much revered, and his art was emulated by many of the young painters working in the city in the last four decades of the century. For those generations of artists, who were particularly interested in Pontormo's life studies and his more naturalistic essays in paint, he was something of an academic model.

According to Vasari, Pontormo studied successively with four masters—Leonardo da Vinci, Piero di Cosimo, Mariotto Albertinelli, and Andrea del Sarto. During the period of these apprenticeships, the Leonardesque style of the painter Fra Bartolommeo (1472–1517) was dominant in Florence, and Pontormo's works, like those of some of his teachers, came to be shaped by it. His earliest known works, such as his San Ruffillo altarpiece (1514; now Florence, Santissima Annunziata), *Visitation* (1515–16; Santissima Annunziata), and *Madonna with Saints* (1518; Florence, San Michele Visdomini) formally owe much to Fra Bartolommeo, but their odd, restless, expressive tenor differs from the *frate*'s calm classicism. In his contributions to the decorations for the bedchamber of Pier Francesco Borgherini, panels depicting the Story of Joseph (1516–18), Pontormo continued to test the limits of—and even subvert—his classical inheritance; for inspiration he looked to Northern prints, specifically to those of Albrecht Dürer and Lucas van Leyden. Engaged by the Medici in 1520–21 to join Sarto and Franciabigio in painting lunettes in the villa at Poggio a Caiano, Pontormo produced a fresco depicting Vertumnus and Pomona. His treatment of the theme, with rural gods lounging around a garden wall, was unprecedented in Florentine art both in the casualness of its presentation and in its disregard for long-standing notions of narrative structure and decorum. When, in 1522, he left Florence to avoid the plague and went to work in the Certosa di Val d'Ema at Galluzzo, he took with him woodcuts and engravings of the Passion by Dürer; Pontormo consulted those prints before painting his Passion frescoes in the cloister of the monastery (1523–24). Much maligned by Vasari for their Germanisms, the frescoes represent a particularly personal, and perhaps unresolved, experimental phase in Pontormo's art, in which spatial and narrative credibility were sacrificed to create compositional schemes that demand the involvement of the spectator. The *Supper at Emmaus* (1525; Uffizi) that he created for the Certosa, also dependent for its composition on a Dürer print, is proto-Baroque in its illumination and inclusion of natural details—the monks in the background—which are virtually unaltered translations into paint of chalk studies he made from life.

Soon after his return to Florence, Pontormo was engaged to decorate the Capponi Chapel in Santa Felicita. His *Deposition* (c. 1526–28; fig. 8) there, one of the masterpieces of sixteenth-century art, infuses into the grand drama and grace of Michelangelo, whose works he must have viewed in Rome, the sense of vulnerability and intense empathy that he invested in his Certosa paintings. From the early 1530s until his death, Pontormo was almost continuously employed by the Medici, who asked him, in 1532, to contribute more decorations to Poggio a Caiano and subsequently commissioned him to paint frescoes (now lost) in their villas at Careggi (1535–36) and Castello (1537–43). In his last years, he painted frescoes, at Cosimo I's request, in the choir of the Medici church of San Lorenzo.

36

SEATED FIGURE RECTO

RECLINING FIGURE VERSO

.

Red chalk, 294 × 200 mm

Inscriptions: on recto in black ink at center, *Exec E.S.B.*

Provenance: Private collection, Geneva; H. Schickman Gallery, New York

The J. Paul Getty Museum, Malibu, California, 90.GB.34

Exhibited at Oberlin

The studies on both sides of this sheet are preparatory for one of Pontormo's most important early commissions from the Medici—the lunette fresco of *Vertumnus and Pomona* (1520–21) in the villa at Poggio a Caiano outside Florence. The pose of the boldly drawn adolescent model on the recto was altered in a subsequent study (Louvre, no. 2903r), which was then consulted for the figure to the upper right of the oculus in the center of the painting.[1] Although the reclining nude on the verso has reasonably been connected with an abandoned idea for the project—a design that prominently featured four reclining male figures (Uffizi, no. 454F)[2]—it seems possible that the study was salvaged and evolved, after a reversal of the pose, into the woman in the lower right corner of the fresco. Other surviving preliminary studies for that figure have an arm similarly outstretched and supported by a stick, a studio prop used to help the model hold the position.[3]

Assured life studies by Pontormo such as these, with their efficient notation of the structure of the pose and beautifully modulated contours, were much admired and frequently copied by the generation of Florentine artists that matured in the 1560s and 1570s.[4] The graphic styles of Cavalori, Empoli, Macchietti, Maso, and Naldini all depend, to varying degrees, on that of Pontormo, whose thorough working method, which involved the careful study of models and the creation of myriad preparatory drawings for each painted figure, also served as an example to young academicians. Few, however, were able to achieve in their figure drawings the energy and tension that Pontormo did, through his manipulation of contour and his sensitive indication of the relative tautness or slackness of skin.

1. See Janet Cox-Rearick, *The Drawings of Pontormo* (Cambridge, Mass., 1964), vol. 1, no. 155, and vol. 2, fig. 149. Kelly M. Pask made these observations in a draft of an entry on the drawing for the Getty *Journal*. She kindly made her unpublished entry available to me (letter of 4 January 1991).
2. The association was made by Pask, see note 1. For the Uffizi drawings, see Cox-Rearick, *Drawings of Pontormo*, vol. 1, no. 131, and vol. 2, fig. 123.
3. Uffizi, nos. 6515Fv, 6673Fv; reproduced in Cox-Rearick, *Drawings of Pontormo*, vol. 2, figs. 139–40.
4. See Feinberg, above, pp. 18–20, 30.

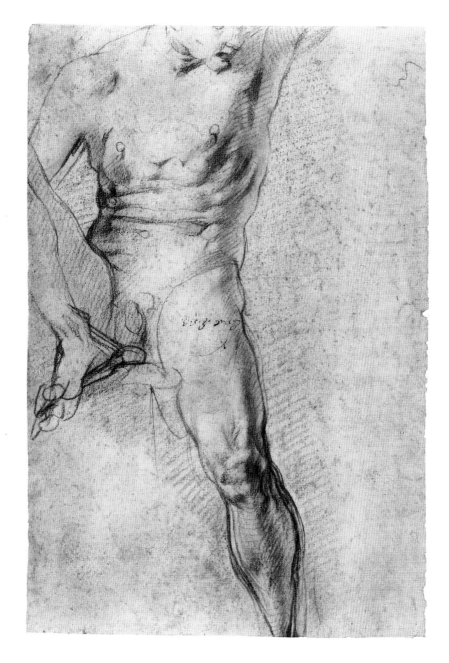

3 7

COPY AFTER PONTORMO'S STUDY
FOR AN ENTOMBMENT

.

Red chalk, 162 × 330 mm

Inscriptions: in pen and ink at lower left, *Andrea no. 152*

Provenance: Durlacher Brothers, New York

Exhibitions: *Bacchiacca and His Friends*, exh. cat., Baltimore Museum of Art (1961), no. 63; *Drawings and Prints of the First Maniera 1515–1535*, exh. cat., Museum of the Rhode Island School of Design (Providence, 1973), no. 54; *Six Centuries of Drawings in the Ackland Collection*, Ackland Art Museum (Chapel Hill, 1976)

References: Janet Cox-Rearick, *The Drawings of Pontormo* (Cambridge, Mass., 1964), vol. 1, no. A235; William Hayes Ackland Memorial Art Center, *An Introduction to the Collection, 1958–1962* (Chapel Hill, 1962), no. 47

Ackland Art Museum, The University of North Carolina at Chapel Hill, Ackland Fund, 60.12.1

The present sheet is a copy of a Pontormo drawing of about 1519–20 in the Uffizi (no. 300F), which Cox-Rearick describes as a *Pietà*,[1] but which probably represents Christ being placed in his tomb, having just been taken from his mother's lap. The implication of the recent removal of Christ from his mother's arms, which intensifies the sense of loss, was made again by Pontormo in his so-called *Deposition* in Santa Felicita, a work that can be more accurately described as a depiction of Christ being carried to the tomb.[2] In certain respects, the Uffizi sheet, possibly a design for the lunette of Pontormo's San Michele altar (c. 1519; Empoli, Museo della Collegiata),[3] can be regarded as the germ of the theme developed in the Santa Felicita painting.

As is to be expected, the line of the copy is less varied and refined than that of the original drawing, and some of Pontormo's changes, or pentimenti, have been omitted. The copyist is also more literal in his rendering of forms, giving a slightly unctuous specificity to their surfaces. Typical of later sixteenth-century Florentine drawings is a dramatic handling of light, even in fairly rudimentary studies created primarily to work out compositions. When reproducing the Uffizi sketch, the author of the Ackland sheet accentuated the play of light and shadows, transforming Pontormo's rapid notation into more sculptural terms. Although in some aspects, particularly the splintery contours and strong reinforcement of some lines, the design is reminiscent of Naldini's draftsmanship, the sheet cannot be assigned to him. Naldini, who frequently copied Pontormo's drawings, had a sprightly graphic manner that enlivened as much as it solidified the designs he replicated.

1. Cox-Rearick, *Drawings of Pontormo*, vol. 1, no. 103, and vol. 2, fig. 105.
2. See John Shearman, *Pontormo's Altarpiece in Santa Felicita* (Newcastle upon Tyne), 1971.
3. Cox-Rearick, *Drawings of Pontormo*, vol. 1, no. 103.

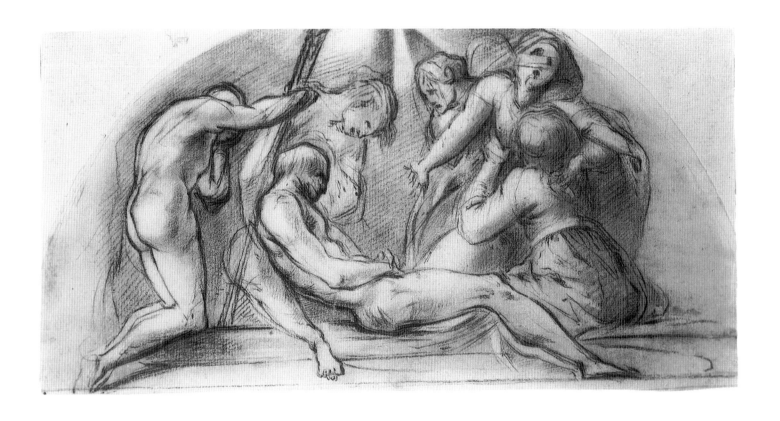

FRANCESCO MORANDINI, CALLED IL POPPI

FRANCESCO DI SER FRANCESCO MORANDINI

Poppi (Casentino) 1544–Florence 1597

.

Shortly after the gifted young Poppi arrived in Florence, he was introduced to Giorgio Vasari and Vincenzo Borghini, the prior of the Ospedale degli Innocenti, who became his protector. Poppi received artistic training from Vasari and joined his crew, which was then remodeling the Palazzo Vecchio for Cosimo de' Medici. It appears that he executed (c. 1562), following Vasari's designs, several frescoes in the vault of the small room known as the Tesoretto of Cosimo I.

Whereas he deferred to Vasari's style now and then in subsequent paintings, Poppi apparently felt a greater kinship with Vasari's deputy, Giovanni Battista Naldini, another Borghini protégé. There exist a few paintings of the mid-1560s by Poppi that are based on compositions by Naldini. Poppi's *Lamentation* in the Ospedale degli Innocenti copies Naldini's representation of the theme in the church of San Simone, Florence. In that work, Poppi imitated and even exaggerated Naldini's very painterly, coloristic manner. Poppi's two paintings in Santa Croce in Boscomarengo—the *Sacrifice of Isaac* and *Saint Antoninus Healing a Possessed Man*—also depend on designs by Naldini. Although the *Saint Antoninus* employs Naldinian figure types, the picture has the strange and private emotions of the early Mannerist works of Pontormo and Rosso.

Despite the new direction of his art, Poppi maintained a working relationship with Vasari through the late 1560s and early 1570s. Fulfilling a commission from Francesco I, Poppi translated into paint a drawing Vasari made representing the Age of Gold (Louvre, no. 2170). Poppi's painting (c. 1570; Edinburgh, National Gallery of Scotland) has the rich flow of paint and compositional flux of Naldini's *Gathering of Ambergris* in the Studiolo of Francesco I.

In designing his own pictures for the Studiolo, Poppi joined several of his peers, namely Cavalori, Macchietti, Maso, and Naldini, in reviving the style of Pontormo. For his Studiolo ceiling frescoes and panels, *Alexander Giving Campapse to Apelles* (1571) and *Bronze Foundry* (1572), Poppi looked to Pontormo's last works and improvised on their attenuations and malleability of form. The influence of Parmigianino is also detectable, along with stylistic elements from Naldini and Sarto. Revealing and embellishing Poppi's whimsical compositions are complexities of light and color that place him among the more progressive artists working in Florence at the time.

Probably in response to Counter-Reformation pressures, Poppi's works beginning in the mid-1570s were less optically indulgent and, with few exceptions, became compositionally more restrained. In his painting of *Tobias and the Angel* in San Niccolò, Florence, Poppi tempered his Mannerism with references to the art of Sarto. Poppi's religious works of the 1590s (e.g., the *Crucifixion* of 1594 in San Francesco in Castel Fiorentino) demonstrate his desire to approximate the naturalism of the Florentine artistic reformers, such as Santi di Tito, and to recall, as they did, some of the principles of High Renaissance classicism.

The Israelites Gathering Manna
in the Wilderness

.

Red chalk over black chalk, 257 × 202 mm

Provenance: G. Piancastelli; Brandegee family, Brookline, Massachusetts; Janos Scholz, New York

Exhibitions: *Pontormo to Greco: The Age of Mannerism*, exh. cat. by Robert O. Parks, John Herron Museum of Art (Indianapolis, 1954), no. 14; *Drawings of the Italian Renaissance from the Scholz Collection*, exh. cat. by Creighton Gilbert, Indiana University Art Museum (Bloomington, 1958), no. 39; *Drawings from Tuscany and Umbria, 1350–1700*, exh. cat. by Alfred Neumeyer and Janos Scholz, Mills College Art Gallery (Oakland, 1961), no. 55; *Italian Drawings to Commemorate the Four-Hundredth Anniversary of the Death of Michelangelo*, exh. cat. by Jack Wasserman, Department of Art History Gallery, University of Wisconsin, Milwaukee (1964), no. 33; *The Age of Vasari*, exh. cat., University of Notre Dame Art Gallery and University Art Gallery, State University of New York at Binghamton (1970), no. D18; *Sixteenth-Century Italian Drawings from the Collection of Janos Scholz*, exh. cat. by Konrad Oberhuber and Dean Walker, National Gallery of Art and the Pierpont Morgan Library (Washington, D.C., 1973), no. 31

References: *Report to the Fellows of the Pierpont Morgan Library, 1984–1986*, ed. Charles Ryskamp (New York, 1989), p. 363

The Pierpont Morgan Library, New York, The Janos Scholz Collection, 1986.96

Exhibited at Oberlin and Dartmouth

The phantomlike figures of this sheet, inspired by the works of Bandinelli and Rosso, are similar to those in drawings by Poppi preserved in the Louvre (nos. 9059, 10721) and the Uffizi (no. 471F).[1] In the sheer recklessness of its draftsmanship the Morgan study is especially close to the second Louvre sheet (a *Cavalry Battle*) and to the Uffizi sketch (*Ulysses and the Winds*), the latter of which, like the present drawing, is executed with a combination of black and red chalks. The parallel hatching system is reminiscent of Maso's and the faceting of form strongly recalls the early works of Rosso, whose *Moses Defending the Daughters of Jethro* (1523–24; Uffizi) seems to have been a point of departure for Poppi's composition.[2] Oberhuber and Walker have noted the drawing's relationship to certain sheets by Bandinelli, particularly a *Laocoön* study (Uffizi, no. 14785F), which, in the construction of the face, uses comparable patches of shadow.[3]

1. Oberhuber and Walker, *Sixteenth-Century Italian Drawings*, no. 31, and *The Age of Vasari*, no. D18. For illustrations, see Catherine Monbeig-Goguel, *Dessins toscans de la deuxième moitié du XVIe siècle. Vasari et son temps* (Paris, 1972), nos. 79, 82, and Paola Barocchi, *Mostra di disegni del Vasari e della sua cerchia*, exh. cat., Gabinetto Disegni e Stampe degli Uffizi (Florence, 1964), no. 102, fig. 56.

2. Creighton Gilbert (in Oberhuber and Walker, *Sixteenth-Century Italian Drawings*, no. 31) seems to have been the first to make the connection between the National Gallery sketch and Rosso's *Moses*. At one time, the sheet was attributed to Rosso.

3. See Oberhuber and Walker, *Sixteenth-Century Italian Drawings*, no. 31, and Paola Barocchi, Anna Forlani, et al., *Mostra di disegni dei fondatori dell'Accademia delle Arti del Disegno*, exh. cat., Gabinetto Disegni e Stampe degli Uffizi (Florence, 1963), no. 4, fig. 7.

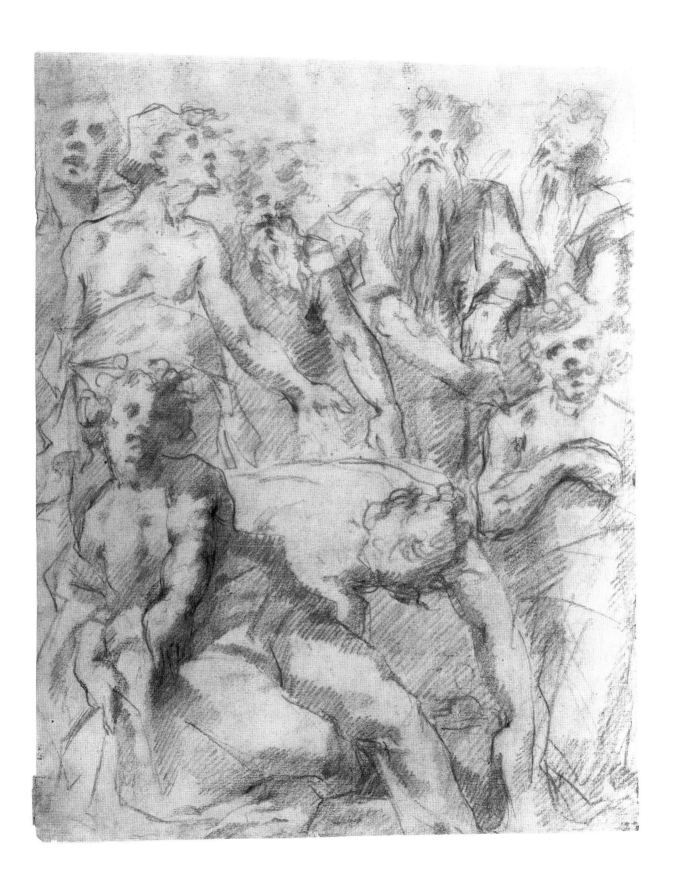

3 9

THREE PUTTI

.

Red chalk on paper tinted pink, 190 × 166 mm
Provenance: Sotheby's, Florence, 6 May 1980, lot 142

Private collection, United Kingdom

A fine example of Poppi's draftsmanship at its most effervescent, this drawing cannot be connected with any of his known paintings. Such flickering movements and broad facial types with foamy hair and heavy eyelids appear frequently in Poppi's art—e.g., the *Study of the Head of an Angel* and the drawing of the *Visitation* in the Uffizi (nos. 6402F, 6393F).[1]

1. See Paola Barocchi, ''Appunti su Francesco Morandini da Poppi,'' *Mitteilungen des Kunsthistorischen Institutes in Florenz*, vol. 11 (Nov. 1964), p. 134, fig. 19; and Annamaria Petrioli Tofani and Graham Smith, *Sixteenth-Century Tuscan Drawings from the Uffizi* (Oxford, 1988), no. 59.

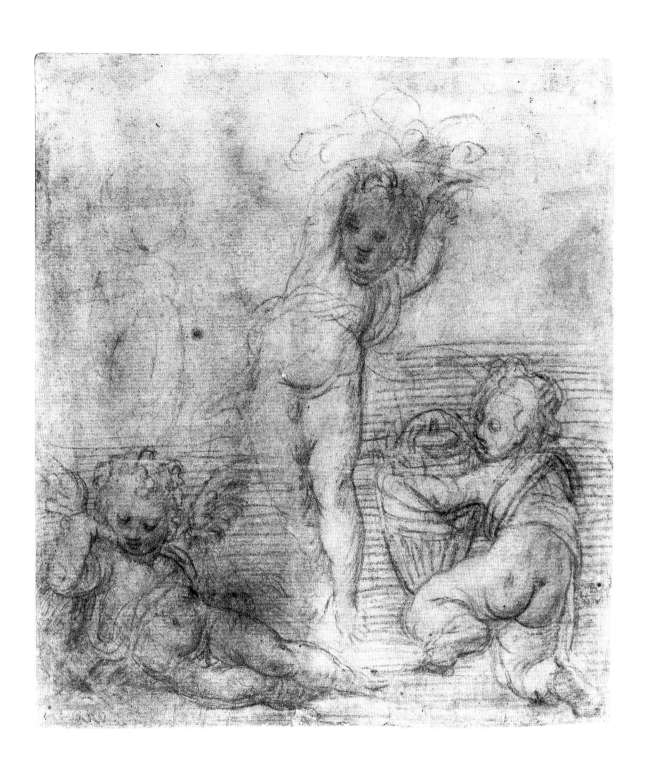

4 0

SAINT SYLVESTER
BAPTIZING CONSTANTINE

.

Pen and brown ink and black chalk on blue paper turned brown, 540 × 276 mm
Provenance: P. and D. Colnaghi, London
Exhibitions: *An Exhibition of Old Master Drawings*, exh. cat., P. and D. Colnaghi (London, 1983), no. 7
Private collection

In celebration of the birth and baptism of his first legitimate son, Filippo, in 1577,[1] Francesco I sponsored grand festivals and had decorative structures (*apparati*) erected around the Florentine Baptistry.[2] One of these was a temporary portico, made to resemble a triumphal arch, which was placed before the Baptistry's entrance. According to an iconographical scheme devised by Vincenzo Borghini, the *apparato* was decorated with paintings, executed mainly by Allori and Poppi, on both interior and exterior. The two largest interior pictures, located to either side of the door of the portico, were Poppi's *Saint Sylvester Baptizing Constantine* and *Saint Felix Baptizing the Florentines while the Idol of Mars Is Destroyed*. As Borsook has noted, the subjects were quite appropriate, because it was believed at the time that the two saints were responsible for the conversion of the Florentine Baptistry from an ancient temple of Mars to its present use.[3] After Filippo's baptism, the portico was dismantled and Poppi's two paintings were taken to the Medici villa at Pratolino, where Raffaello Borghini, author of the dialogue *Il Riposo*, saw them.[4] Although gravely damaged by the flood in Florence in 1966, the works (reportedly) survive and are preserved in the Uffizi.[5]

In his drawing, probably the *modello*, for *Saint Sylvester Baptizing Constantine*, Poppi's usual graphic exuberance is restrained by his relatively staid composition and by his desire to imbue the figures and their actions with a sense of gravity.[6] This Roman quality of *gravitas* and the interlacing of figures were probably intended to suggest the reliefs on actual triumphal arches and other Roman monuments. The crisply delineated contours of the design, like the marks placed at regular intervals on the sides of the sheet, were no doubt made to facilitate the transfer of the composition to the cartoon.

1. Francesco's mistress, Bianca Cappello, gave birth to his first son, Antonio, in 1576.
2. For descriptions of the festivities and decorations, the primary source is Vincenzo Borghini, *La Descrizione della pompa, e dell'apparato fatto in Firenze nel battesimo del serenissimo principe di Toscana* (Florence, 1577), esp. pp. 8–9. See also Eve Borsook, "Art and Politics at the Medici Court, II: The Baptism of Filippo de' Medici in 1577," *Mitteilungen des Kunsthistorischen Institutes in Florenz*, vol. 13 (1967), pp. 95–114, and Giovanna Gaeta Bertelà and Annamaria Petrioli Tofani, *Feste e apparati medicei da Cosimo I a Cosimo II*, exh. cat., Gabinetto Disegni e Stampe degli Uffizi (Florence, 1969), pp. 38–44.
3. Borsook, "Baptism of Filippo de' Medici," p. 106.
4. Raffaello Borghini, *Il Riposo* (Florence, 1584; rpt., Milan, 1967), p. 642.
5. Gaeta Bertelà and Petrioli Tofani (*Feste e apparati medicei*, pp. 40–41) viewed the *Saint Sylvester* painting and made the association between it and the drawing. Unfortunately, I cannot confirm this connection because the painting can no longer be located.
6. Philip Pouncey was the first to recognize the sheet as Poppi's.

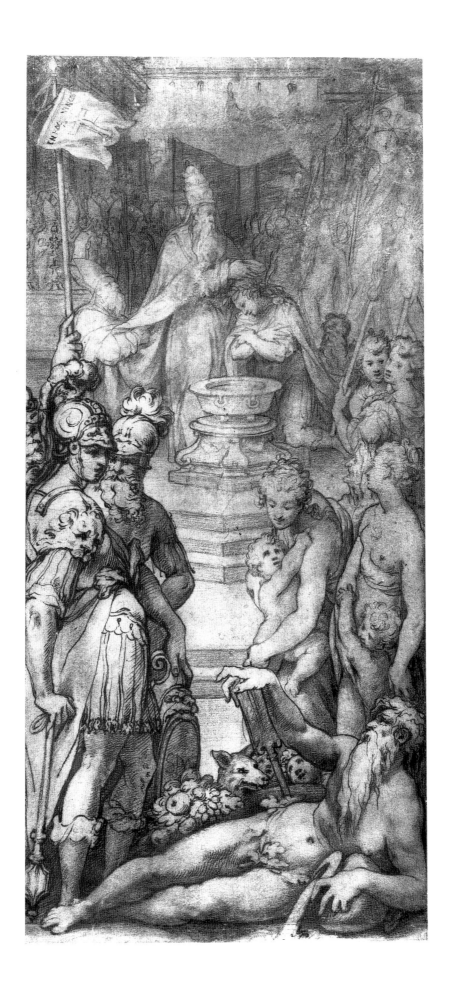

SANTI DI TITO

Borgo San Sepolcro 1536–Florence 1603

.

Recognized as one of the chief reformers of Mannerist painting in Florence in the later sixteenth century, Santi di Tito was perhaps the first artist in that city to develop a true Baroque style. After receiving some initial instruction from the minor painter Bastiano da Montecarlo, a pupil of Raffaellino del Garbo, Santi entered the busy studio of Agnolo Bronzino. According to Raffaello Borghini, Santi also became a member of Baccio Bandinelli's shop at some point.

In 1558 the young artist journeyed to Rome, where he studied the works of Michelangelo and Raphael and collaborated with Federico Barocci and Federico Zuccaro on the decoration of the Casino of Pius IV. His exposure to the works of the High Renaissance masters, Barocci, and Federico Zuccaro's brother, Taddeo, led Santi to formulate a naturalistic and, in some respects, retrospective artistic style. When he was commissioned, between 1559 and 1561, to decorate a chapel in the Roman Palazzo Salviati, he used as models the recent paintings of Taddeo Zuccaro and Girolamo Siciolante da Sermoneta, who had established in Rome by mid-century a conservative, Counter-Reformation strain of art.

After he returned to Florence in 1564, Santi immediately sought to reconcile this new manner, radical in its approximation of works by Michelangelo and Raphael created as many as fifty years earlier, with contemporary Florentine art. Consulting the works of Bronzino, he fashioned a style in his Studiolo paintings, the *Origin of Amber* and the *Discovery of Purple* (both 1570–72), that makes prosaic the classicizing figure types of his master and inserts them into a (relatively) credible natural environment. An even more remarkable and uneasy fusion of Bronzino's *maniera* and Santi's naturalism is achieved in his Santa Croce *Resurrection* (c. 1574; see Feinberg, above, fig. 25), where Mannerist ornament and embellished quotation coexist with realist detail worthy of Caravaggio. The intense flash of light, beautifully captured by Santi's brush, also anticipates the painting of the next century.

In subsequent works, even in the *Supper at Emmaus* (1574), which Santi completed for Santa Croce just after the *Resurrection*, the Mannerist artifice subsides. While the simple, expository style of the *Supper at Emmaus* derives from Pontormo's very naturalistic version of the theme (see Feinberg, above, fig. 14) and from the compositions of Sarto, its dramatic diagonal orientation depends on Venetian art. Santi was undoubtedly familiar with Macchietti's *Martyrdom of Saint Lawrence* (see Feinberg, above, fig. 34), created in 1573 for Santa Maria Novella, which employed a similar, Titian-inspired, oblique format. In the works he executed in the last decade of his life, such as the *Vision of Saint Thomas Aquinas* (1593; Florence, San Marco), he continued to exploit Venetian compositional devices as well as Venetian painterly techniques to create works of almost trompe l'oeil effect, with figures and environments given an unprecedented immediacy by a mobile and varied light.

His pupils, Boscoli, Cigoli, and Gregorio Pagani among them, responded strongly to Santi's example, witnessed by the vast number of life studies they did and the extremely optical nature of their work.

4 1

THE RESURRECTION

.

Pen and brown ink over black chalk on blue paper, 376 × 253 mm
Inscriptions: on verso in graphite, *G. Vasari/N10/fis 15000*(?), and two illegible inscriptions in graphite and brown ink
Provenance: Pierre Crozat, Paris (?; his collector's mark?); private collection, Switzerland; sale, Sotheby's, New York, 16 January 1985, lot 4; Robert Dance, New York
References: *J. Paul Getty Museum Journal*, vol. 15 (1987), no. 89

The J. Paul Getty Museum, Malibu, California, 86.GA.18

Exhibited at Oberlin

This early preparatory sketch for Santi's altarpiece in Santa Croce (see Feinberg, above, fig. 25), much influenced by Bronzino's painting of the same subject in the Annunziata, seems to predate the study belonging to the Art Institute of Chicago (cat. no. 42). Christ's banner is arranged in the same way as the one in Bronzino's work, and Santi has not yet turned Christ's head to the right, as it appears in the Chicago drawing and in his painting. In those works, Santi also reversed the position of the angel at the empty tomb, creating a spatial void and accentuating the rupture in the composition caused by Christ's ascent. Santi made numerous other changes before arriving at the final design for his altar, but he did retain, with little alteration, the wildly gesturing soldiers in the lower corners of the composition. Apparently pleased early on with his ingenious recasting of Michelangelo's figure of Jonah from the Sistine Chapel as the soldier at the right, this is the only figure that seems to have escaped significant revision in Santi's lengthy design process.[1]

The scratchy outline style of the Getty sheet was picked up by Santi's pupil, Cigoli, who used it when copying Santi's painted *Resurrection*[2] and in designing his own. Sketches for a *Resurrection* by Cigoli on both sides of a sheet in the Yale University Art Gallery (cat. no. 15) imitate not only Santi's graphic manner — with its alternation of fluid and brittle line — but motifs in his painting of the *Resurrection* and in the preliminary studies for it.

1. The soldier assumes the same position in Santi's earliest known compositional study for the *Resurrection* — another drawing on blue paper in the Farnesina (F.C. 130623); reproduced in Simonetta Prosperi Valenti Rodinò, *Disegni fiorentini 1560–1641*, exh. cat., Villa della Farnesina, Gabinetto Nazionale delle Stampe (Rome, 1979), fig. 10. In addition to the above-mentioned Farnesina, Getty, and Chicago drawings, nine studies for the Santa Croce *Resurrection* survive, six in the Uffizi, including the definitive *modello* (nos. 7687F [*modello*], 764F, 7756F, 7705F, 2396S, 2416S); one in the Kunsthalle, Hamburg (no. 21449); one in the Graphische Sammlung, Munich; and a second sheet in the Farnesina (F.C. 130629).
2. For Cigoli's copy, see Simona Lecchini Giovannoni and Marco Collareta, *Disegni di Santi di Tito, 1536–1603*, exh. cat., Gabinetto Disegno e Stampe degli Uffizi (Florence, 1985), no. 94, fig. 108.

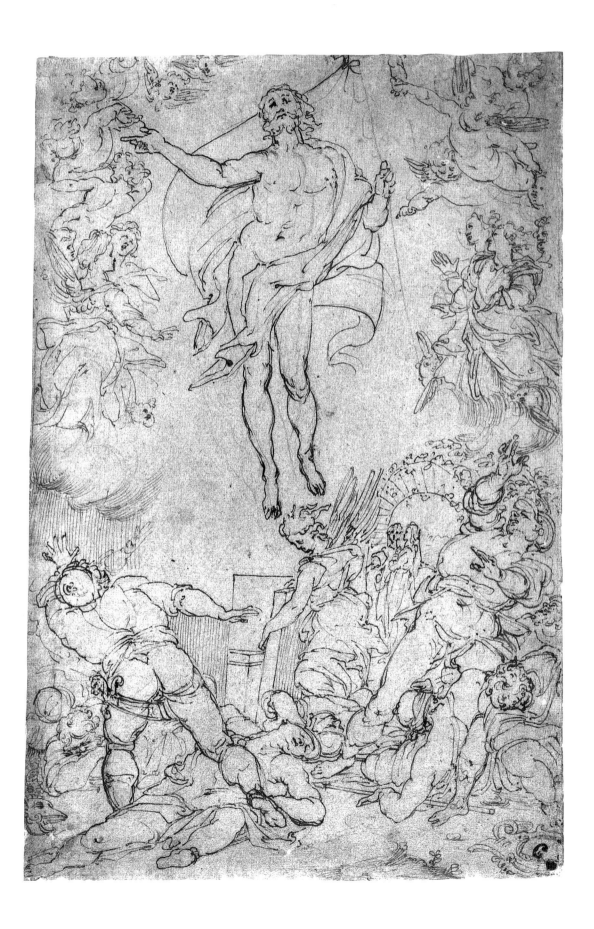

42

THE RESURRECTION

.

Pen and brown ink with brush and brown wash, heightened with white, 303 × 200 mm
Watermark: encircled fleur-de-lis, topped by a star (Briquet 7117, Ascoli 1536)
Provenance: Peter Lely (Lugt 2092); P. H. Lankrink (Lugt 2090); William F. E. Gurley; Leonora Hall Gurley Memorial Collection (Lugt supp. 1230b)
References: Harold Joachim and Suzanne Folds McCullagh, *Italian Drawings in the Art Institute of Chicago* (Chicago and London, 1971), no. 32; Simona Lecchini Giovannoni and Marco Collareta, *Disegni di Santi di Tito, 1536–1603*, exh. cat., Gabinetto Disegni e Stampe degli Uffizi (Florence, 1985), p. 29

The Art Institute of Chicago, Gift of William F. E. Gurley, The Leonora Hall Gurley Memorial Collection, 1922.5509

Exhibited at Oberlin and Bowdoin

Executed after the Getty sketch (cat. no. 41) and perhaps just before the *modello* in the Uffizi (no. 7687F), the Chicago drawing indicates how carefully Santi considered and adjusted the pose of each figure and the action of the light on it. Whereas many of his contemporaries would have simply changed individual figure studies and then incorporated the alterations into the cartoon (see Feinberg, above, pp. 21–22), Santi, concerned with achieving a consistent illumination, went to the trouble of making numerous full compositional studies. In certain details, the present sheet and the Uffizi *modello* are closer to Bronzino's version of the theme in Santissima Annunziata than is Santi's painting (see Feinberg, above, fig. 25); the draperies in the drawings, to a greater degree than those in the painting, are rendered with the ornamental lines found in Bronzino's art, and Christ's banner in the preparatory studies relates more closely to the one in Bronzino's altarpiece.

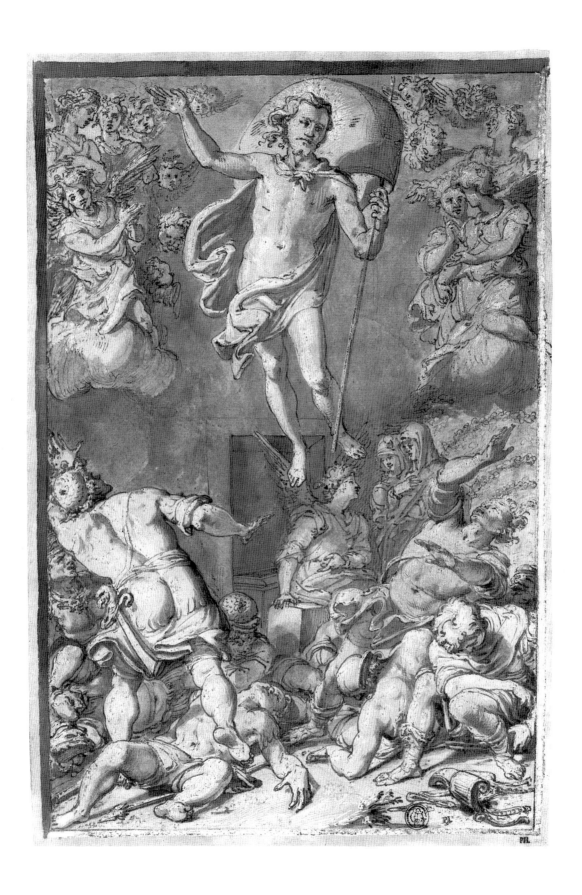

4 3

STUDY OF A
STANDING MALE SAINT RECTO

STUDIES OF A BOY, WITH STUDIES
OF HEADS AND ARMS VERSO

(BY ANOTHER HAND)

.

Black chalk (recto); red chalk (verso), 317 × 215 mm
Inscriptions: on verso in pen and brown ink at upper right, *G3d9r3*, in graphite in corners, *156/36/12/10*
Provenance: Sotheby's, Florence, 23 May 1979, lot 788

Private collection, United Kingdom

Although this study cannot be connected with any of Santi di Tito's known paintings, the facial type and heavy drapery style are characteristic of him and can be compared with those of figures in several works of the 1570s and 1580s. Similarly rendered are the figures of Christ in Santi's *Raising of Lazarus* (1576; Florence, Santa Maria Novella) and Saint John in his *Crucifixion with Thieves* (1588; Florence, Santa Croce).[1] Characteristic of Santi is the placement of the feet too far forward, out of line with the center of gravity of each figure, seen in his depictions of Christ, Saint John, and the present saint. This deviance from anatomy reveals that the artist was not studying a model when he conceived this drawing. In light of the stiff quality of the saint's robe, which does not react naturally to the pull of gravity, it seems probable that Santi made the drapery study first, referring to fabric arranged on an armature,[2] and later appended the head, hands, and feet. Corroborating this suggestion is the fact that stylus marks can be found on the drapery but not on other areas of the figure, indicating that Santi made a study of the drapery alone on another sheet and then transferred it to this one.

1. See Jack Spalding, *Santi di Tito* (New York, 1982), nos. 44, 68.
2. For this practice in late sixteenth-century Florence, see Feinberg, above, p. 29.

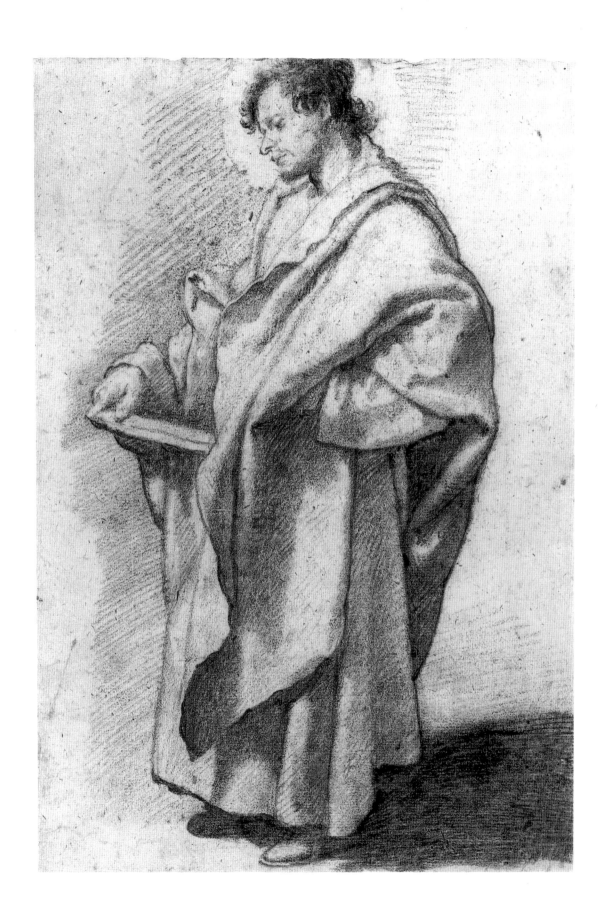

44

ADORATION OF THE SHEPHERDS RECTO AND VERSO

.

Pen and brown ink and brown wash with white heightening on blue paper (recto); pen and brown ink and brown wash with black chalk underdrawing (verso), 200 × 165 mm

Provenance: Kurt Meissner, Zurich; Yvonne Tan Bunzl, London

Exhibitions: *Handzeichnungen Alter Meister aus Schweizer Privatbesitz* (Bremen and Zurich, 1967), no. 37; *Handzeichnungen Alter Meister aus Schweizer Privatbesitz*, exh. cat., Staatliche Kunsthalle Baden-Baden (1968), no. 87

Elmar W. Seibel

The drawings on the recto and verso of this sheet were preparatory for a painting on panel that was on the art market in 1970.[1] Santi executed the highly finished drawing on the recto first, then apparently decided to reverse the composition and transferred the design through the sheet with a stylus. After reinforcing the stylus marks on the verso with black chalk, he outlined the scene with pen and ink, substantially altering the pose of Joseph to make him a more active participant, and added a light wash for areas of shadow. Satisfied with this composition, he squared the sheet for enlargement and then reproduced (or had an assistant execute) the scene in paint with only a slight revision of the pose of one auxiliary figure and the deletion of another.[2]

Similar in handling to the drawing on the recto are a number of sheets by Santi, including a *Holy Family* (Oxford, Ashmolean Museum), his *modelli* for the *Construction of the Temple of Solomon* (Uffizi, nos. 752F, 755F), and a *Madonna* (Uffizi, no. 754F).[3] The Uffizi sheets also bear his characteristic hatching with white heightening. The sparse outline technique on the verso of the present sheet can be found also in a study by Santi for a *Saint John the Baptist Preaching* (Uffizi, no. 762F).[4]

1. The painting was sold at Sotheby's, London, 15 July 1970, lot 41. See Jack Spalding, *Santi di Tito* (New York, 1982), p. 514, fig. 121, who assigns the picture to Santi's shop.
2. Vasari sometimes produced similar simple, unambiguous outline drawings when he wished his designs to be translated into paintings by assistants. See, for example, his drawing of the *Painter's Studio* and Poppi's painting after it, reproduced in Paola Barocchi, *Mostra di disegni del Vasari e della sua cerchia*, exh. cat., Gabinetto Disegni e Stampe degli Uffizi (Florence, 1964), figs. 15–16. The drawing on the verso of the present sheet may have had a like purpose; according to Spalding (*Santi di Tito*), the ex-Sotheby's painting of the *Adoration of the Shepherds* was probably produced by one of Santi's assistants.
3. For the Ashmolean drawing, see K. T. Parker, *Catalogue of the Collection of Drawings in the Ashmolean Museum* (Oxford, 1956), no. 720, pl. 160. The three Uffizi sheets are reproduced in Paola Barocchi, Anna Forlani, et al., *Mostra di disegni dei fondatori dell'Accademia delle Arti del Disegno*, exh. cat., Gabinetto Disegni e Stampe degli Uffizi (Florence, 1963), figs. 44, 48–49.
4. See Spalding, *Santi di Tito*, no. 43, fig. 70.

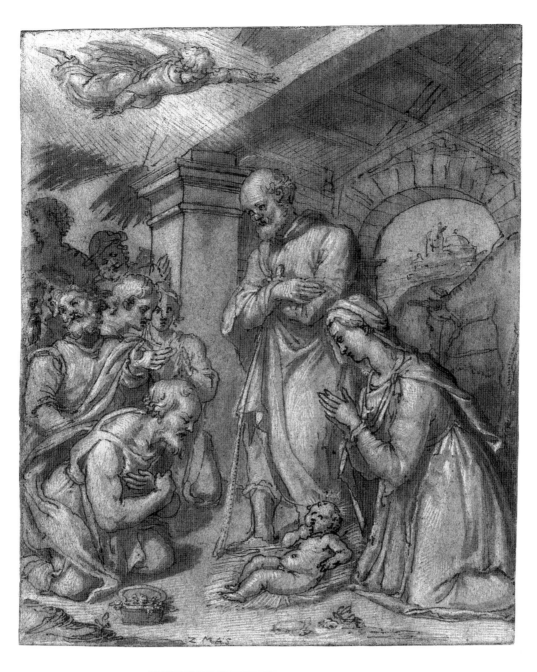

SANTI

169

ANDREA DEL SARTO

ANDREA D'AGNOLO

Florence 1486–Florence 1530

.

Trained by Piero di Cosimo and Raffaellino del Garbo, Andrea gradually shed the Quattrocento style he learned from them as he absorbed the lessons of Leonardo and Raphael. Following those masters, and Fra Bartolommeo, he became one of the chief practitioners of a High Renaissance manner in Florence. His inclinations toward a grand, classicizing style were reinforced by his association with the painter Franciabigio, with whom he shared a workshop for a time.

Sarto first demonstrated this manner on a large scale in his frescoes of the life of Saint Filippo Benizzi (1509–10) and a *Procession of the Magi* (1511) in the forecourt of Santissima Annunziata. When in 1513–14 he returned to the church to paint his *Birth of the Virgin*, he had already attained artistic maturity. In that fresco, Sarto arranged figures of Raphaelesque monumentality and stately grace according to an ostensibly casual compositional scheme. The naturalism of his narration and his reportage of mundane detail seem to have appealed to Florentine artists of the late sixteenth century, who made numerous drawings after the fresco (see Maso da San Friano).

The same can be said of the frescoes of the life of Saint John the Baptist that Andrea executed during several periods of activity in the cloister of the Floren-tine Confraternity of the Scalzo. The six narratives he painted during his last campaign there, from 1521 to 1526, were extremely influential because of his successful integration of natural, even prosaic, detail into compositional schemes of rigorous logic and geometric clarity. Works such as the Scalzo *Visitation* (see Feinberg, above, fig. 22), served as models for artists who had to create, often on short notice, legible and credible scenes for propagandist Medici decorations (see Feinberg, above, fig. 23, and cat. no. 19).

Although the studied calm of some of Andrea's works after 1520 was punctuated by dissonant Mannerist elements, his most important late pictures—the *Madonna del Sacco* (1525; Florence, Santissima Annunziata) and the *Last Supper* (1526–27; Cenacolo di San Salvi)—exhibit the classicistic restraint and unaffected poise of paintings he produced a decade before, such as the *Madonna of the Harpies* (1517; Uffizi).

Because a great number of Andrea's drawings were stolen from the assistant who inherited them, few were available to subsequent generations of Florentine artists, and, it would seem, his graphic work exerted less influence on participants in the late sixteenth-century Sarto revival than his paintings did (see Feinberg, above, pp. 22–23).

45

STUDY FOR THE

SAINT MICHAEL IN THE QUATTRO SANTI

.

Red chalk on rose-tinted paper, 277 × 174 mm

Inscriptions: on recto in gold at lower right, *Velasquez 1570*, in pen and brown ink at right, *44*

Provenance: F. Renaud; earl of Aylesford; Charles Fairfax Murray

Exhibitions: *Italian Drawings, 1330–1780*, exh. cat., Smith College Museum of Art (Northampton, Mass., 1941), no. 18; *Bacchiacca and His Friends*, exh. cat., Baltimore Museum of Art (1961), no. 34

References: Charles Fairfax Murray, *A Selection from the Collection of Drawings by Old Masters* (London, 1905), no. 31; F. di Pietro, *I disegni di Andrea del Sarto negli Uffizi* (Siena, 1911), p. 83n1; I. Fraenckel, *Andrea del Sarto: Gemälde und Zeichnungen* (Strasbourg, 1935), p. 187; Bernard Berenson, *The Drawings of the Florentine Painters* (Chicago, 1938), vol. 1, p. 293, and vol. 2, no. 141; Agnes Mongan, "Italian Drawings, 1330–1780: An Exhibition at the Smith College Museum of Art," *Art Bulletin*, vol. 24 (1942), p. 93; Sydney J. Freedberg, *Andrea del Sarto* (Cambridge, Mass., 1963), vol. 2, p. 170; John Shearman, *Andrea del Sarto* (Oxford, 1965), vol. 2, pp. 273, 366–67; Cara D. Denison and Helen B. Mules, *European Drawings, 1375–1825* (New York, 1981), p. 44; Annamaria Petrioli Tofani, *Andrea del Sarto. Disegni* (Florence, 1985), under no. 38; *Andrea del Sarto, 1486–1530. Dipinti e disegni a Firenze*, exh. cat., Palazzo Pitti (Florence, 1986), under no. 83, p. 303, and 347–48

The Pierpont Morgan Library, New York, I, 31

Exhibited at Oberlin and Dartmouth

This drawing, primarily a drapery study made from a model, was created by Sarto in preparation for his late (1528) *Four Saints Altar* (Saints Michael, Giovanni Gualberto, John the Baptist, and Bernardino degli Uberti) for the Chiesa del Romitorio delle Celle at Vallombrosa (now Uffizi).[1] Another, earlier, drapery study for the figure of Saint Michael is preserved in the Uffizi (no. 288F).[2] Sarto designed the draperies of his actors with scrupulous care, often preparing several studies for a single figure. His mastery of drapery did not go unnoticed by later artists, particular those working in the last four decades of the sixteenth century, such as Maso, who frequently massed draperies in the sweeping, over-the-shoulder manner seen here (see cat. no. 27).[3] Although, as noted above (see Feinberg, p. 23), Maso and his contemporaries probably had relatively few drawings by Sarto to study, they did manage to assimilate certain characteristics of his draftsmanship, including his system of hatching and his tendency to create rounded forms through the intersection and subtle joining of straight lines.

1. See Freedberg, *Andrea del Sarto*, vol. 1, pp. 87–88, and vol. 2, no. 75; Shearman, *Andrea del Sarto*, vol. 1, p. 107, and vol. 2, no. 86; and *Andrea del Sarto* (Palazzo Pitti), no. 22, illus. pp. 145, 147.
2. Petrioli Tofani, *Andrea del Sarto. Disegni*, no. 38.
3. See Peter Cannon-Brookes, "Three Notes on Maso da San Friano," *Burlington Magazine*, vol. 107 (April 1965), fig. 32, and Valentino Pace, "Maso da San Friano," *Bollettino d'arte*, vol. 111 (1976), fig. 18.

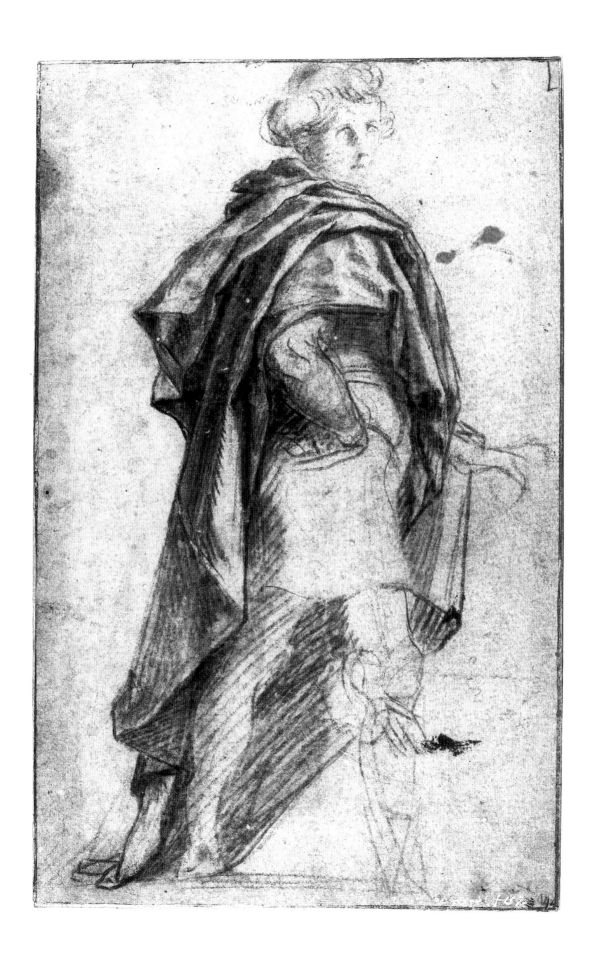

SARTO

173

GIOVANNI STRADANO

JAN VAN DER STRAET OR STRAETEN; GIOVANNI STRADANUS

Bruges 1523–Florence 1605

.

A pupil of the painter Pieter Aertsen in Antwerp, Stradano became an independent master in 1545 and then, in the same year, traveled to Florence, via France and Venice. Apparently soon after he arrived in Florence he was recruited (probably by fellow Flemish expatriates) into the ranks of Cosimo's recently established Arazzeria; he found lifelong employment there as a designer of tapestries. Despite a few years' sojourn in Rome (beginning in 1550) and exposure to the contemporary work of Michelangelo and his Roman followers, Stradano's art was fundamentally based on that of Vasari, whose principal assistant he became in the later 1550s.

Probably in 1561 Stradano joined the corps of artists, headed by Vasari, engaged in the decoration of the Palazzo Vecchio. Assigned a large portion of the decorations in the Quartiere di Eleonora of the palace, Stradano employed a Vasarian manner with a distinctly Flemish accent; he retained his native penchant for exaggerated foreshortenings, decorative richness of detail, and genre anecdote. These interests served him particularly well in 1567, when he was commissioned to design a series of tapestries for the Medici villa at Poggio a Caiano. According to Vasari, the scenes of hunting, fowling, and fishing that Stradano created for this series followed a program that Cosimo I had devised himself. Although Northern in flavor, with extensive landscapes and allusions to the works of Albrecht Altdorfer, Albrecht Dürer, and Joachim Patinir, Stradano's tapestry designs were praised by Vasari as evidence of the Fleming's assimilation of the Italian style.

Stradano's Northern training asserted itself more forcefully in the two paintings he executed for the Studiolo of Francesco I—*Circe Transforming the Companions of Ulysses into Animals* and *Francesco I (Seated) in His Alchemy Laboratory* (1570; see Feinberg, above, fig. 2). Returning to the lessons of Aertsen, he conceived the latter picture in the busy elfin-workshop mode of Northern genre painting. In his religious paintings of the same years he continued to employ a style that conformed to the manner of Vasari. The *Ascension* (1569) he created for the Asini Chapel of Santa Croce and the *Baptism of Christ* (c. 1572) he painted for the Bacelli Chapel of Santa Maria Novella—his contributions to Vasari's major renovation of those churches—are slippery and somewhat inert approximations of Vasari's style. More interesting and successful are his *Crucifixion* (1569) altarpiece in Santissima Annunziata and the *Expulsion from the Temple* (1572) in Santo Spirito, works in which his Flemishness is not so repressed. Those paintings, punctuated by grotesque detail, are enlivened by strangely abrupt and emphatic gestures and a Northern fascination with eccentric silhouette.

Although the historian Filippo Baldinucci says that Stradano embarked on his career as a designer of engravings in 1575, after he returned from a trip to Naples, Hieronymus Cock published prints after his designs as early as 1570.

46

TITLE PAGE FOR
HOMER'S ODYSSEY

.

Pen and brown ink with blue and brown wash and white heightening, 211 × 305 mm

Inscriptions: in pen and ink on the book at bottom right, *ioannes stradanus*; at bottom left, *titola*; at bottom, beneath the armor, *Arme*; at bottom center, *NavigAzatione di Ulisse da Luj narate Alla cenna / del Re Alcinoo nj Corfu / Cauata da Homero—*; at bottom, beneath female figure, *musa*

Provenance: Joseph Green Cogswell; Mortimer L. Schiff; Moore S. Achenbach

Exhibitions: Mills College Art Gallery (Oakland, 1954); *Master Drawings from California Collections*, exh. cat., ed. Juergen Schulz, University Art Museum, University of California, Berkeley (1968), no. 72, pl. 158

References: G. S. Hellman, *Original Drawings by the Old Masters: The Collection Formed by Joseph Green Cogswell, 1786–1871* (New York, 1915), no. 245

The Fine Arts Museums of San Francisco, Achenbach Foundation for Graphic Arts, 1963.24.471

The design of Stradano's title page for a never-published edition of Homer's *Odyssey* was inspired by a type of small Roman relief of the first century A.D., known as a *tabula iliaca*. These reliefs, which often illustrated scenes from Homer, typically combined framed vignettes in the manner seen here. Nees has demonstrated that Marcantonio Raimondi's engraving *Quos Ego* (c. 1515–16), after Raphael, depends on the same antique sources.[1] Stradano was no doubt familiar with and perhaps imitated the Marcantonio print that depicts, in addition to the Quos Ego (Neptune calming the seas), nine other scenes from Homer's *Iliad*.[2] The Flemish artist felt free to apply the antique format to religious projects as well; the title page of his engraved Great Passion series similarly has a central rectilinear frame lodged between two ovals.[3]

In Stradano's drawing, which would have been printed in reverse, Ulysses stands heavily armed at left, while a laurel-crowned Homer, with lyre and pen, is placed at right. Stradano seems to have depicted in the top oval a scene described in book 6 (ll. 50–53) of the *Odyssey*: Nausicaa, wishing to tell her parents (King Alcinoüs and Queen Arete) of her plans to wash the family's clothes in preparation for her impending marriage, finds her mother with attendant women turning yarn on a distaff. (That this domestic scene is set in the kingdom of Alcinoüs is suggested by the artist's inscription at bottom.) In the other oval, Stradano illustrated the moment (book 22) when the recently-returned Ulysses kills his wife Penelope's would-be suitors with the bow that, in a contest, only he was able to string. These two stories seem to be connected only by their allusions to marriage (an impending wedding and a marital reunion) and its sanctity. The book may have been commissioned as a wedding gift or in commemoration of a marriage.

1. Lawrence Nees, "*Le Quos Ego* de Marc-Antoine Raimondi: L'Adaptation d'une source antique par Raphael," *Nouvelles de l'estampe*, nos. 40–41 (1978), pp. 18–29.
2. See Innis H. Shoemaker and Elizabeth Broun, *The Engravings of Marcantonio Raimondi*, exh. cat., Spencer Museum of Art and Ackland Art Museum (Lawrence, Kans., 1981), no. 32.
3. For Stradano's drawing for the title page of the Great Passion, see Gunther Thiem, "Studien zu Jan van der Straet, genannt Stradanus," *Mitteilungen des Kunsthistorischen Institutes in Florenz*, vol. 8, no. 2 (Sept. 1958), p. 106, fig. 14. The series was engraved by Philip Galle, Adriaen Collaert, Crispijn de Passe, and Wierix.

Nauigatione d'Vlisse da Lo' manate Alla corma
del Re Alcinoo in corfu
Camera da Homero

4 7

The Park

.

Pen and brown ink with brown wash, 432 × 280 mm. A 3 cm wide strip of paper was added to the top of the drawing, and the design was extended by a later hand.

Inscriptions: on recto in pen and ink at bottom right, *100 / no. 19*; on verso in pencil, *Stradanus / Wien / 35 / 32 / #22*

Exhibitions: *Fifteenth and Sixteenth-Century European Drawings*, selected by A. Hyatt Mayor, exh. cat., American Federation of Arts (New York, 1967), no. 22

Suida Manning Collection, New York

This design for a wall decoration, with an illusionistic view onto a park and a fantastic revision of the garden façade of the Palazzo Pitti, was probably created by Stradano toward the end of his career. Although the handling of the pen is similar to that in Stradano's *modello* (Paris, Ecole des Beaux-Arts, L. 829a) for the central tondo of the Sala di Penelope in the Palazzo Vecchio, which he painted in 1561–62,[1] the present drawing is more closely related to his *Study for a Bookplate or Frontispiece* (after 1591; Uffizi, no. 460 Orn).[2] The figures in the bookplate design resemble those in *The Park* not only in physiognomy and figure canon but also in the very Northern manner in which they are rendered, with loopy, calligraphic lines. Both drawings suggest the influence on Stradano of the Netherlandish artist Friedrich Sustris, who became a member of the academy and worked for Vasari in Florence between 1563 and 1567. In his later studies, Stradano seems to have adopted the attenuated, elegant figure style and facial types of such Sustris drawings as the *Allegory of Grammar* (Uffizi, no. 1649 Orn).[3] The subject and composition of the Suida-Manning drawing—numerous figures engaged in various activities such as courting, hunting, and fishing (in incongruous proximity) in an extensive park or garden, viewed from above—became very popular in Netherlandish art in the sixteenth century.[4]

1. For the *modello*, see R. A. Scorza, "A *Modello* by Stradanus for the Sala di Penelope in the Palazzo Vecchio," *Burlington Magazine*, vol. 126 (July 1984), pp. 432–37, fig. 59.
2. The Uffizi drawing is catalogued and its dating discussed in E. K. J. Reznicek, *Mostra di disegni fiamminghi e olandesi*, exh. cat., Gabinetto Disegni e Stampe degli Uffizi (Florence, 1964), no. 29, fig. 28. But see also Scorza, "A *Modello* by Stradanus," p. 437, and Gunther Thiem, "Studien zu Jan van der Straet, genannt Stradanus," *Mitteilungen des Kunsthistorischen Institutes in Florenz*, vol. 8, no. 2 (Sept. 1958), p. 110.
3. Reznicek, *Mostra di disegni fiamminghi e olandesi*, no. 28.
4. See Kahren Jones Hellerstedt, *Gardens of Earthly Delight: Sixteenth- and Seventeenth-Century Netherlandish Gardens*, exh. cat., The Frick Museum (Bloomington, 1986), pp. 12–13, and ill. p. 12, figs. 5–6.

STRADANO

179

48

CHRIST WASHING THE FEET
OF HIS DISCIPLES

.

Pen and brush, brown and red watercolor over black chalk, 148 × 105 mm
Provenance: Giovanni Piancastelli; E. D. Brandegee; Rudolph Wien; Janos Scholz
Exhibitions: *The Life of Christ*, University of Notre Dame Art Gallery (1964), no. 65; *The Age of Vasari*, exh. cat., University of Notre Dame Art Gallery and University Art Gallery, State University of New York at Binghamtom (1970), no. D23
References: *Report to the Fellows of the Pierpont Morgan Library, 1978–1980*, ed. Charles Ryskamp (New York, 1981), p. 216

The Pierpont Morgan Library, New York, The Janos Scholz Collection, 1979.14:3

Exhibited at Oberlin and Dartmouth

The present drawing was quickly rendered in the rough, wiry manner that Stradano usually employed in his compositional sketches for engravings. Hundreds of similar preparatory drawings, mainly designs for prints, are preserved in the Cooper-Hewitt Museum in New York.[1] Those sheets, like the Morgan study, were at one time part of the vast number of drawings in the possession of Giovanni Piancastelli, director of the Borghese Gallery in Rome.

It has not been determined whether *Christ Washing the Feet of His Disciples* was intended to be translated into a print or a painting. In either case, Stradano could have advanced from this study to a highly finished pen and wash *modello* without much alteration of his compositional design. Such a progression can be seen in his preliminary drawings for his engraving *Women Winding Silk* (*Vermis sericus*) in the Cooper-Hewitt Museum and at Windsor Castle.[2] Stradano seems to have inherited his mentor Vasari's efficient working procedures. The paucity of known drawings of studio models by Stradano and the stock, often anatomically ambiguous figure types in his paintings and prints suggest the influence of Vasari, who, taking short cuts, often developed compositions without making life studies.

1. Michel N. Benisovich, "The Drawings of Stradanus (Jan van der Straeten) in the Cooper Union Museum for the Arts of Decoration, New York," *Art Bulletin*, vol. 38 (Dec. 1956), pp. 249–51.
2. Ibid., fig. 2b, and Leo van Puyvelde, *The Flemish Drawings in the Collection of His Majesty the King at Windsor Castle* (Oxford and New York, 1942), fig. 163. The design was engraved by Philip Galle.

4 9

THE ARNO WITH FISHERMEN

.

Pen and brown ink, brown and blue wash, and white gouache heightening on gray paper; irregular section cut out and replaced at bottom by artist, 203 × 300 mm

Inscriptions: on recto in pen and brown ink at bottom left, *j. Stradanus*.

Provenance: William Adolph Baillie-Grohman, London and Château de Matzen, Tyrol (Lugt 370); John Clermont Witt, London (Lugt 656a); private collection (sale, Christie's, Amsterdam, 15 November 1983, lot 3)

References: *J. Paul Getty Museum Journal*, vol. 12 (1984), p. 270, no. 7; George R. Goldner with Lee Hendrix and Gloria Williams, *European Drawings* (Malibu, 1988), vol. 1, no. 100

The J. Paul Getty Museum, Malibu, California, 83.GG.380

Exhibited at Oberlin

The series of twenty-eight Hunting tapestries that Stradano designed (c. 1566) at the request of Cosimo I for the villa at Poggio a Caiano were so well received that the Antwerp publisher Hieronymus Cock, in 1570, issued engravings after six of them. The success of those prints encouraged Cock to publish a dozen more several years later, and Philip Galle produced two series of engravings after designs that Stradano made expressly for translation into prints. The Getty drawing was created around 1580 for Galle's first series of engravings of hunting and fishing scenes.[1] As Hendrix has suggested, the irregular section may have been patched into the sheet to include a personification of the river.[2] Though stylistically compatible, the river god figure and Florentine *marzocco* attending him are more Vasarian in manner than the surrounding fishermen, who are represented with a Northern genre anonymity.[3] Stradano has adeptly integrated not only this addition into the design but all the figures into the landscape through his sensitive rendering of the raking, early morning light, which seems not only to reveal but to enliven what it touches.

Goldner notes the existence of another drawing (London, Witt Collection, no. 1634) for an engraving by Stradano—of fishing on the Arno at flood season—that complements this one.[4]

1. See W. Bok-van Kammen, *Stradanus and the Hunt* (Ann Arbor, 1977), pp. 35, 532–33, and cat. no. 50. The engraving for which the drawing was made was no. 42 in a series of forty-four prints.
2. Hendrix, in Goldner, *European Drawings*, p. 226.
3. Cf. the *Allegory of Chianti* and *Capture of Vicopisano* (both 1563–65), executed by Stradano after Vasari's designs, on the ceiling of the Salone del Cinquecento in the Palazzo Vecchio; reproduced in Ettore Allegri and Alessandro Cecchi, *Palazzo Vecchio e i Medici. Guida storica* (Florence, 1980), p. 245, fig. 54,29, and p. 247, fig. 54,41.
4. The drawing, which depicts the Arno from the opposite view and at the end of the day, is illustrated in William Adolph Baillie-Grohman, *Sport in Art: An Iconography of Sport* (London, 1919), as fig. 78.

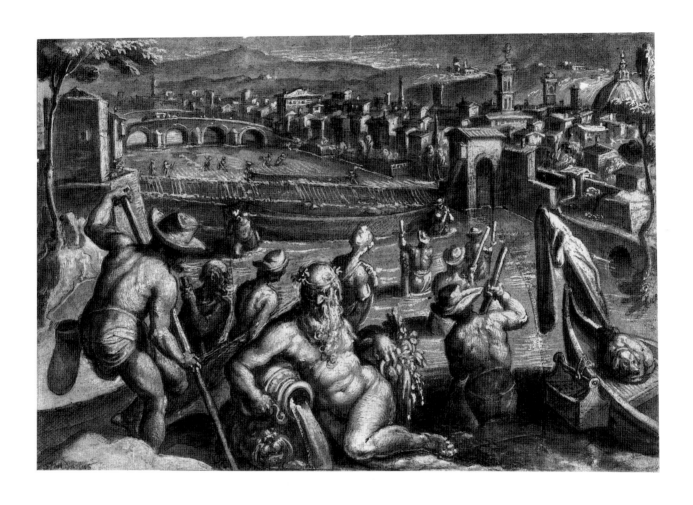

5 0

STORKS FIGHTING SNAKES

.

Pen and dark brown ink, brown wash, and white heightening on brown paper, 181 × 268 mm
Provenance: John or Thomas Thane (Lugt 1544 or 2461); Sir Thomas Lawrence (Lugt 2445); Susan Dwight Bliss
Exhibitions: *Old Master Drawings at Bowdoin College*, exh. cat. by David P. Becker, Bowdoin College Museum of Art (Brunswick, Maine, 1985), no. 6
References: Bowdoin College Museum of Art, *Handbook of the Collections*, ed. M. R. Burke (Brunswick, Maine, 1981), p. 165

Bowdoin College Museum of Art, Brunswick, Maine, 1956.24.266

The Bowdoin drawing is the *modello* for one of the sixty-one prints that comprised Galle's second series of hunting and fishing engravings, entitled "The hunts of quadrupeds, birds and fishes, the fights with animals and of animals against each other" (see cat. no. 49). Probably published in Antwerp between 1596 and 1602,[1] the second series purported to illustrate the hunting practices of men and beasts in foreign lands. Stradano found the subject of the Bowdoin sheet in the *Natural History* (first century A.D.) of Pliny, who described, in book 10, how storks were employed (and protected by law) in Thessaly to control the snake population.[2]

On the engraving after the present drawing, the publisher included verses by the philologist and poet Cornelius Kiel which embellish and alter Pliny's account. Translated from Latin, Kiel's lines read: "Vast Apulia nourishes the scaly snakes. The crane and the stork attack their offspring. Here they wage a bitter war with beak and bite. This sportive event is watched by many farmers."[3] The publisher may have changed the location of the scene to increase the appeal of the print to the Italian market. A conflation of bestiary and travelogue, Stradano's series reflected the tastes of the Medici grand dukes, who engaged the services of another artist, Jacopo Ligozzi, to record the imported specimens of wildlife in their large menageries.

Becker has observed that the engraver carefully traced the Bowdoin drawing with a stylus to transfer its design, in reverse, to the printing plate.[4] To accommodate the printmaker, Stradano rendered the scene with even, unmodulated lines and equally unsubtle (but, for the engraver, informative) applications of white heightening. The eccentric postures and movements of the animals and the richness of detail allow the drawing to rise above the deliberateness of its execution.

1. W. Bok-van Kammen, *Stradanus and the Hunt* (Ann Arbor, 1977), p. 36.
2. Ibid., p. 424.
3. Becker, *Old Master Drawings*, p. 15. For additional information on the print, see Bok-van Kammen, *Stradanus*, pp. 423–24.
4. Ibid.

GIORGIO VASARI

Arezzo 1511–Florence 1574

.

Although best known as the author of the monumental *Lives of the Artists* (published in 1550 and, in greatly expanded form, in 1568), Vasari was also an accomplished architect and painter. He began his artistic education in his native town of Arezzo, under the guidance of the French glass painter and fresco painter Guillaume de Marcillat. His intellectual prowess, as much as his artistic talent, impressed Silvio Passerini, cardinal of Cortona and tutor to Alessandro and Ippolito de' Medici, and Passerini arranged to have the twelve-year-old Vasari sent to Florence in 1524. There he became a member of the Medici household, receiving the same privileged literary education as the young Medici and, with them, even some instruction from Michelangelo. While in Florence, he worked for a time in the shop of Sarto and then was placed by the Medici under the tutelage of Baccio Bandinelli, who gave him drawing lessons. He also probably became acquainted in this period with Francesco Salviati, who was to become a close personal friend and source of inspiration, and with Rosso Fiorentino.

One of the most peripatetic of artists, Vasari spent a few years wandering between Florence, Pisa, Bologna, and Arezzo before he journeyed to Rome in 1532 and entered into the service of his boyhood friend Ippolito de' Medici, by then a cardinal. In Rome, Vasari carefully studied the works of Michelangelo and Raphael as well as recent paintings of Salviati and Raphael's followers Polidoro da Caravaggio and Perino del Vaga. He returned in the same year to Florence, where he found sponsors in Alessandro de' Medici and, later, Ottaviano de' Medici. Throughout the 1530s and 1540s, Vasari traveled extensively, visiting (and sometimes working in) Rome, Bologna, Venice, Modena, Parma, Mantua, Verona, Rimini, and Naples. He responded enthusiastically to the works by Parmigianino he found in Bologna, Parma, and Rome. Of the Northern Italian paintings he admired, Parmigianino's seem to have had the strongest influence on his art.

In light of his extraordinarily diverse education and wide travels, it is not surprising that Vasari as an artist was almost pathologically eclectic. His earliest style, seen in his *Entombment* of 1532 (Arezzo, Casa Vasari) is a dry, intellectual synthesis of the manners of Sarto, Rosso, and Bandinelli. He shared their predilection for arbitrary geometric abstraction, but, in contrast to those masters, his interest was more in formulaic expediency than in expressive effect. By 1540, when he painted his *Crucifixion* for the Camaldoli at Arcicenobio, he had fabricated a mature style, based on what he had seen in the art of Michelangelo, Raphael, Salviati, and Parmigianino. He achieved this amalgam by organizing the disparate borrowed elements within a rigorous geometrical scheme, which, while preserving particularly graceful passages, often had the effect of neutralizing the expressive qualities of his various pictorial sources.

Requiring greater nimbleness of mind than of hand, this style served Vasari well over the course of his career, enabling him to create decorations quickly for impatient patrons (e.g., the frescoes in the Sala dei Cento Giorni of the Roman Palazzo della Cancelleria). Because his art involved the infinite recombination of stock figures and standardized compositional formats, Vasari's style could easily be imitated by his army of assistants, who helped him with the many projects he undertook for the Medici. As the Medici court painter, Vasari was charged with overseeing the refurbishing of the Palazzo Vecchio, Duke Cosimo's state and living quarters. Vasari and his *équipe* restructured the palace and decorated it with scores of allegories and Medici histories, following the elaborate iconographical programs devised by G. B. Adriani, Cosimo Bartoli, Vincenzo Borghini, and other learned *letterati*. Within the palace walls, Vasari's most ambitious projects were the decoration of the vast Sala Grande (Salone del Cinquecento) and its appendage, the Studiolo of Francesco I, for which Vasari commissioned paintings from most of the leading young artists of Florence. These completed, he accepted the herculean task of painting the interior of the dome of the Florentine cathedral, but died before he could complete the work.

51

THE INCREDULITY OF SAINT THOMAS

· · · · · · · · · · · · · ·

Pen and brown ink with brown wash over black chalk, squared in black chalk, 215 × 176 mm
Inscriptions: in pen and ink in the cartouches above and below the image, *Beati qui no viderut / et crediderunt* (Blessed are they that have not seen, and yet have believed; John 20:29)
Exhibitions and References: omitted at owner's request
Private collection

This final working drawing, squared for transfer, has not been connected with a known painting. The slim decorative border, seemingly too small for a tapestry and inappropriate for a frame, might indicate that this is the design for a processional banner. Charles Saumarez-Smith, noting correspondences between the poses and physiognomies of the actors in the present sheet and those in Vasari's painting of *Saint Roch Healing Victims of the Plague* of 1568 (Arezzo, Museo Civico), which once served as a processional banner for the Compagnia di San Rocco in Arezzo, has assigned *The Incredulity of Saint Thomas* to the late 1560s.[1] He also relates it to a painted version of the theme (1569) by Vasari in the Guidacci Chapel of Santa Croce and to another processional banner (1557), depicting *Saints Peter and John the Apostle Blessing*, now in the Staatliche Museum, Berlin.[2]

Because Vasari was so adept at reusing compositional schemes and in recasting stock figures, it is often very difficult to assign dates to undocumented works. To attempt to establish a chronology for his oeuvre on the basis of figural motifs alone is especially dangerous. Although the figure of Saint Thomas in the present sheet does resemble those in

Vasari's works of the late 1550s and 1560s, it is not rendered in the graphic equivalent of their dry, sculptural manner. The study is closer to Vasari's drawings of the 1540s, such as the *Pietà* in the Louvre (no. 2096), which dates to 1542, and the *Study of Christ Standing against the Cross and Pouring His Blood into a Chalice* (Uffizi, no. 1433S), which is usually assigned to the 1540s.[3] The rendering of the head and extremities of Christ in this latter sheet is very similar to that of Saint Thomas. The figure of Thomas, with its soft, Poppiesque hair and gentle visage, compares also to the Christ in Vasari's painting *The Calling of Saint Peter* of 1551, in the Badia di Santa Flora e Lucilla, Arezzo.[4] In light of these stylistic analogies, perhaps the present work should be placed in the later 1540s.

A copy of the drawing, almost certainly by Naldini, is preserved in the Uffizi (no. 233S).[5]

1. For a reproduction of the *Saint Roch Healing Victims of the Plague*, see Paola Barocchi, *Vasari pittore* (Milan, 1964), pl. 23.
2. Ibid., pls. 71, 96.
3. Catherine Monbeig-Goguel, *Dessins toscans de la deuxième moitié du XVIe siècle. Vasari et son temps* (Paris, 1972), no. 194, and Annamaria Petrioli Tofani and Graham Smith, *Sixteenth-Century Tuscan Drawings from the Uffizi* (Oxford, 1988), no. 36 (illus.).
4. Barocchi, *Vasari pittore*, no. 39, fig. 39.
5. *Giorgio Vasari. Principi, letterati, e artisti nelle carte di Giorgio Vasari. Pittura vasariana dal 1532 al 1554*, exh. cat., Casa Vasari and Sottochiesa di San Francesco, Arezzo (Florence, 1981), chap. 8, no. 59, fig. 126.

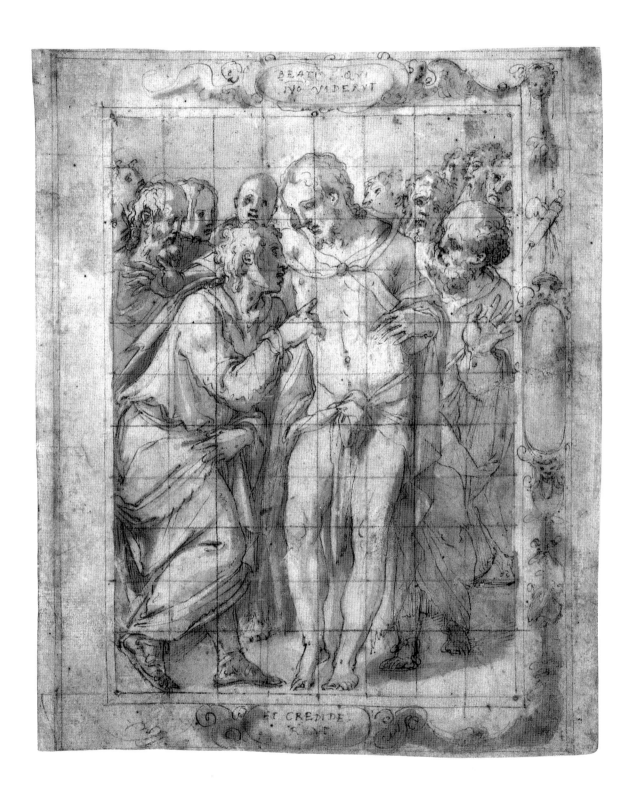

5 2

THE FIRST FRUITS OF THE EARTH
OFFERED TO SATURN

.

Pen and brown ink with brown washes, over traces of red chalk, 171 × 392 mm

Provenance: E. Calando (Lugt 837); J. A. Gere

Exhibitions: *Italian Sixteenth-Century Drawings from British Private Collections*, exh. cat., Merchants' Hall (Edinburgh, 1969), no. 89; *European Drawings Recently Acquired, 1972–1975*, exh. cat. by Jacob Bean, Metropolitan Museum of Art (New York, 1975), no. 31

References: Walter Vitzthum, "Reviews: Paola Barocchi, *Vasari pittore*; *Complementi al 'Vasari pittore'*; *Mostra di disegni del Vasari e della sua cerchia*," *Master Drawings*, vol. 3, no. 1 (1965), p. 56; Ettore Allegri and Alessandro Cecchi, *Palazzo Vecchio e i Medici. Guida storica* (Florence, 1980), p. 71; Jacob Bean, *Fifteenth- and Sixteenth-Century Italian Drawings in the Metropolitan Museum of Art* (New York, 1982), no. 262

The Metropolitan Museum of Art, New York, Rogers Fund, 1971, 1971.273

Exhibited at Oberlin and Bowdoin

This sheet is a preliminary drawing Vasari made for a fresco executed by his assistant Cristofano Gherardi (1508–56) in the Sala degli Elementi of the Palazzo Vecchio.[1] Created between 1555 and 1556, the painting follows the design closely in many respects; the principal difference is the inclusion in the fresco of a few additional figures, trees, and buildings.

In his first *ragionamento*, Vasari explained to Francesco I de' Medici that the scene depicts the presentation to the Roman agricultural deity Saturn (or Chronos) of the fruits of Earth (personified at left)— flowers, fruit, oil, milk, and honey.[2] Because the ancient Greeks confused the name of the old agricultural god Cronus with the word for time, *chronos*,

the rural deity also took on the identity of Father Time, and his attributes and domain were expanded. Here Vasari placed in his hand the traditional symbol of eternity, a serpent biting its tail, which the artist described to Francesco as "an Egyptian hieroglyph" that represents "the rotundity of the heavens."[3] Next to Saturn, Vasari included the adopted astrological sign and *impresa* of Francesco's father, Cosimo I, who was the patron of the decorations. Although born under a different astrological sign, Cosimo took Capricorn the Goat as his own, because Capricorn was ascendant in his horoscope and was the birth sign of Emperor Augustus.

To ensure maximum legibility and to facilitate Gherardi's translation of the design into paint, Vasari employed his most distilled and traceable manner. He used a similarly simple outline style of draftsmanship in his design for the *Age of Gold* (Louvre, no. 2170), created for Francesco I, which Poppi rendered in paint (Edinburgh, National Gallery of Scotland).[4]

1. The fresco is illustrated in Adolfo Venturi, *Storia dell'arte italiana* (Milan, 1933), vol. 9, pt. 6, fig. 183.
2. Giorgio Vasari, *Le Vite de' più eccellenti pittori, scultori, ed architettori* (1568), ed. Gaetano Milanesi (Florence, 1878–85; rpt., 1906), vol. 8, pp. 30–31.
3. Ibid., p. 31.
4. For illustrations, see Paola Barocchi, *Vasari pittore* (Milan, 1964), fig. 92; and Luciano Berti, *Il Principe dello Studiolo. Francesco I dei Medici e la fine del Rinascimento fiorentino* (Florence, 1967), figs. 81–82.

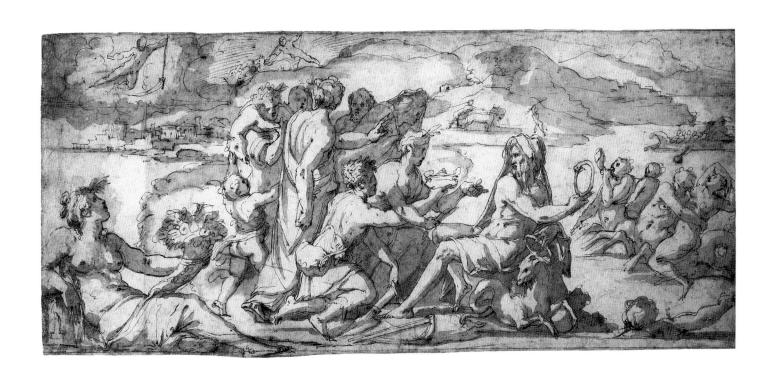

53

STANDING MAN HOLDING A PIKE (?) AND FOUR HEAD STUDIES RECTO

STUDY OF A YOUTH AND OF A LEG VERSO

.

Black chalk, 280 × 193 mm

Provenance: Richard Johnson (Lugt 2216); sale, Sotheby's, New York, 16 January 1985, lot 14

Elmar W. Seibel

The figure on the recto of this sheet resembles the pikemen and infantrymen that appear in the frescoes of the *Entry of Cardinal Giovanni de' Medici (later Pope Leo X) into Florence* and the *Capture of the Fortress of San Leo* in the Palazzo Vecchio's Sala di Leone X, with which Vasari and his crew were occupied from 1558 to 1562.[1] The soldier is also similar, in physiognomy and drawing manner, to the studies of soldiers that Vasari made for the *Capture of San Leo* on a sheet now in the Teylers Museum, Haarlem (no. 61).[2]

In the confident handling of the chalk, with which Vasari created crackling variations in contour and bold accents, the *Standing Man Holding a Pike(?)* approaches some of the artist's most accomplished mature studies, such as the *Seated Prophet* (c. 1565–74; Uffizi, no. 14274F).[3]

The three heads at the upper right of the sheet reveal a lingering appreciation of Parmigianino, whose drawings Vasari copied[4] and who often grouped and contrasted facial types in this manner.

1. For a reproduction of the latter painting, see Paola Barocchi, *Vasari pittore* (Milan, 1964), pl. 67. One may also compare the soldier in the present study to pikemen that appear in the Vasari-Naldini fresco of *Emperor Maximilian Preventing the Siege of Livorno* (c. 1565–71) in the Sala Grande, Palazzo Vecchio.
2. Illustrated in J. Q. van Regteren Altena, *Les Dessins italiens de la reine Christine de Suède* (Stockholm, 1966), p. 97, fig. 68.
3. See *Giorgio Vasari*, exh. cat., Casa Vasari and Sottochiesa di San Francesco (Arezzo, 1981), no. III, 24, fig. 122.
4. For Vasari's imitation and copying of Parmigianino's drawings, see David McTavish, "Vasari and Parmigianino," in *Giorgio Vasari tra decorazione ambientale e storiografia artistica*, ed. Gian Carlo Garfagnini (Florence, 1985), pp. 135–43.

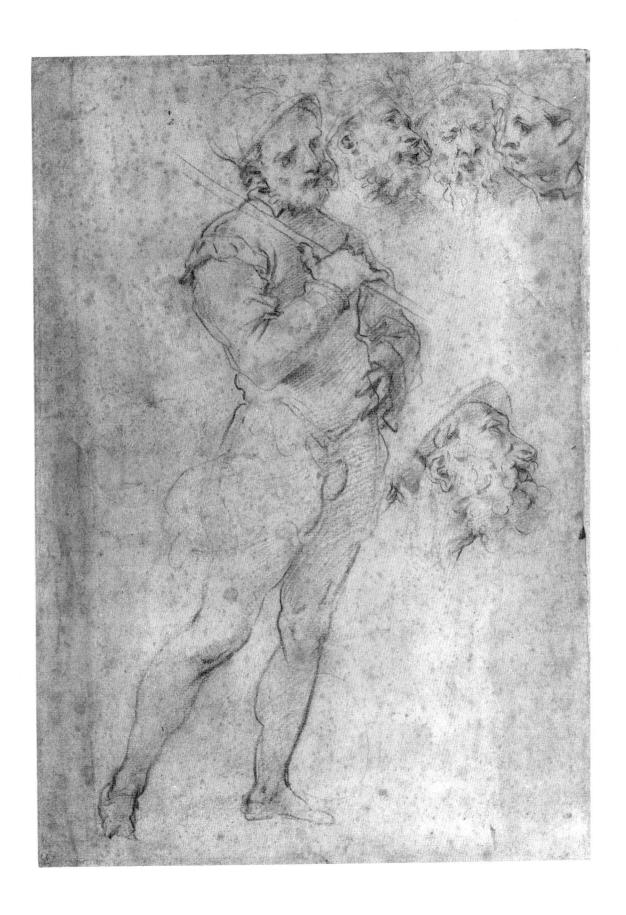

5 4

STUDY FOR THE CEILING OF THE
SALA DI CLEMENTE VII

.

Pen and brown ink with brush and brown wash, over ruled lines in graphite and red chalk, 362 ×
237 mm; on verso is a slight sketch for a ceiling in pen and brown ink and graphite
Inscriptions: on recto in pen and brown ink at upper left, *Fontana Prospero*
Provenance: G. Vallardi (Lugt 1223); J. J. Lindman (Lugt supp. 1479a); William F. E. Gurley; Leonora
Hall Gurley Memorial collection (Lugt supp. 1230b)
Exhibitions: *A Catalogue of Early Italian Drawings from the Leonora Hall Gurley Memorial Collection*,
exh. cat., Art Institute of Chicago (1922), no. 16 (as Prospero Fontana); *The Age of Vasari*, exh. cat.,
University of Notre Dame Art Gallery and University Art Gallery, State University of New York at
Binghamton (1970), no. D9
References: Catherine Monbeig-Goguel, "Giorgio Vasari et son temps," *Revue de l'art*, vol. 14,
(1971), pp. 106, 108; Harold Joachim and Suzanne Folds McCullogh, *Italian Drawings in the Art
Institute of Chicago* (Chicago and London, 1971), no. 18

The Art Institute of Chicago, Gift of William F. E. Gurley, The Leonora Hall Gurley Memorial Collection, 1922.42

Exhibited at Oberlin and Bowdoin

The present sheet is an early, preliminary design for the ceiling of the Sala di Clemente
VII in the Palazzo Vecchio; the device of a sun shining on a crystal globe, an illustration of the motto of that Medici pope, "Candor Illaeus," appears in a lower-central
compartment, above the profile of a bearded man.[1] As realized, the ceiling decorations
are much more complicated, with depictions of important events in the life of Pope
Clement VII (Giulio de' Medici; 1477/78–1534) filling the compartments occupied by
reclining allegorical figures and paired putti in the Chicago drawing.[2] The geometrical
configuration of the ceiling is somewhat different in the final scheme, in which the
allegorical figures are relegated to small corner triangles, serving as lively punctuation
marks for Vasari's rather banal historical prose.

Vasari eventually eliminated from his design the central scene of Rebecca and
Eliezer, but not before he had worked up the composition in some detail in a pen and
wash study (Windsor Castle, no. 6005).[3] As can be observed also in his design for the
Sala Grande (cat. no. 56), Vasari continually revised his decorative schemes, which
evolved from written programs provided by his literary advisors and long discussions
with them.

1. For other examples of this device, see Karla Langedijk, *The Portraits of the Medici: Fifteenth to
 Eighteenth Centuries* (Florence, 1982), vol. 2, nos. 102,51 and 102,68.
2. Vasari identified the various frescoed scenes and allegorical figures in the Sala di Clemente VII
 in his *Ragionamenti*, published in Giorgio Vasari, *Le Vite de' più eccellenti pittori, scultori, ed
 architettori* (1568), ed. Gaetano Milanesi (Florence, 1878–85; rpt., 1906), vol. 8, pp. 165–83.
3. A. E. Popham and Johannes Wilde, *The Italian Drawings of the Fifteenth and Sixteenth Centuries
 in the Collection of His Majesty the King at Windsor Castle* (London, 1949), no. 999.

STUDY FOR THE CEILING OF THE
SALA DI PENELOPE

.

Pen and brown ink with brown wash and white heightening over traces of black chalk, 404 × 243 mm
Inscriptions: in pen and ink around oval, *L'al[t]eza delo ovato b[raccia] 4 la largeza c ragione*, and at lower right, *2 bachanti*
Provenance: De Luca; Timothy Clifford
Exhibitions: *Sixteenth- and Seventeenth-Century Italian Drawings*, Abbot Hall Art Gallery (Kendal, England, 1981), no. 24
References: Timothy Clifford, "Stradanus and the Sala di Penelope," *Burlington Magazine*, vol. 26 (Sept. 1984), p. 569, figs. 46–47 (as Stradano)

Mrs. A. Alfred Taubman

This lively *all'antica* design was created by Vasari for the ceiling of the Sala di Penelope, one of the rooms in the Quartiere di Eleonora di Toledo of the Palazzo Vecchio. At some point, he turned over the responsibilities for the decorations to Stradano, who, after slightly revising the format and composition of the central scene, painted the vault in 1561–62. The Flemish artist changed Vasari's oval into a circle and increased the number of servants in the grand courtyard where Penelope works at a loom. As Scorza has noted, Vasari and Stradano did not illustrate a specific episode from the *Odyssey* but instead intended the scene to suggest, in almost emblematic fashion, certain "female" virtues, such as industriousness, patience, and loyalty.[1] Stradano underscored this last quality by including a dog, the traditional symbol of fidelity, in his *modello* for the tondo (Paris, Ecole des Beaux-Arts, no. L.829a) and in his painting.[2] According to Homer, Penelope concentrated on her weaving (secretly undoing her work at night) in a ploy to make herself unavailable to would-be suitors. A noblewoman (the wife of Ulysses, lord of Ithaca) who was

faithful to her spouse despite his long periods of absence, Penelope must have seemed to Eleonora an appropriate heroine and model.

Clifford has assigned the present sheet to Stradano, based on its similarity to the Paris *modello* and other drawings by him.[3] In my opinion the figures, particularly those in the oval, correspond more closely to those of Vasari in their proportions and the (relative) flexibility of their movements. Penelope and her retinue have the typically enlarged heads of Vasari's actors (a figure canon he frequently used on ceilings to permit facial expressions to be read more easily from the floor, see cat. no. 56). Moreover, Vasari tended to conceive his figures in terms of taut, compact shapes with bulging contours—in the manner that Penelope's handmaidens are rendered here. Stradano, as seen in his *modello* and other sheets, created figures whose postures are at once more angular and more slack and who seem, in comparison with Vasari's figures, to be unraveling.

A decorative scheme very similar to the one Vasari originally planned for the vault of the Sala di Penelope—with an oval surrounded by grotesques and small roundels—was employed by Zucchi in the Villa Medici, Rome.[4]

1. R. A. Scorza, "A *Modello* by Stradanus for the Sala di Penelope in the Palazzo Vecchio," *Burlington Magazine*, vol. 126 (July 1984), p. 434.
2. Ibid., pp. 433–37, figs. 59–60.
3. Clifford, "Stradanus and the Sala di Penelope," p. 569.
4. See Edmund P. Pillsbury, "Drawings by Jacopo Zucchi," *Master Drawings*, vol. 12 (1974), fig. 7.

5 6

DESIGN FOR A SERIES OF
SIX FRESCOES TO DECORATE THE SALA
GRANDE OF THE PALAZZO VECCHIO

.

Pen and brown ink with brown wash; left sheet, 219 × 110 mm, right sheet, 219 × 109 mm

Inscriptions: (left sheet) on recto in brown ink, top rectangle, *papa Leone X da privilegi / la presa de brigantini bisarri dall . . . / la rotta di pio m bino a turchi;* middle rectangle, *Restauratione o amplificatione di fiorenza / rotta de vinitiani in casentino al bastione / scaramuc c ia di marciano in a n zi alla v[o]lta;* bottom rectangle, *Carlo V* [crossed out] / *batterie del soccorsi fr . . . barbagianni / la presa di Montereggioni;* (right sheet) top rectangle, *Papa Alessandro 4 da linsegna ad / presa di cascina / la scaramuc[c] ia di munistero;* middle rectangle, *Edificatione di fiorenza / consiglio della guerra con la deliberazione / Deliberazione vigilanza patienza fortez[z]a prudenzia;* bottom rectangle, *Carlo 4 da privilegi* [crossed out] / *la presa di vico pisano / la presa di Casoli;* on verso in brown ink, *Rafaele d'Urbino* [crossed out] / *Vasari mgh,* and in graphite, *f / 10 ½* [crossed out] *41012*

Provenance: Charles A. Loeser

Exhibitions: *Pontormo to Greco: The Age of Mannerism,* exh. cat. by Robert O. Parks, John Herron Museum of Art (Indianapolis, 1954), no. 17; *Anxiety and Elegance: The Human Figure in Italian Art, 1520–1580,* exh. cat., Fogg Art Museum (Cambridge, Mass., 1962), no. 44; *The Age of Vasari,* exh. cat., University of Notre Dame Art Gallery and University Art Gallery, State University of New York at Binghamton (1970), no. D42; *Old Master Drawings: Selections from the Charles A. Loeser Bequest,* exh. cat., Konrad Oberhuber, ed. (Cambridge, Mass., 1979), nos. 22a–b; *European Master Drawings from the Fogg Art Museum,* exh. cat., National Museum of Western Art (Tokyo, 1979), no. 18

References: Agnes Mongan and Paul J. Sachs, Jr., *Drawings in the Fogg Museum of Art* (Cambridge, Mass., 1940), no. 197; Gunther Thiem, "Vasaris Entwürfe für die Gemälde in der Sala Grande des Palazzo Vecchio zu Florenz," *Zeitschrift für Kunstgeschichte,* vol. 23 (1960), pp. 102–5, 108; Paola Barocchi, Anna Forlani, et al., *Mostra di disegni dei fondatori dell'Accademia delle Arti del Disegno,* exh. cat., Gabinetto Disegni e Stampe degli Uffizi (Florence, 1963), p. 62; Paola Barocchi, *Vasari pittore* (Milan, 1964), p. 58; Paola Barocchi, *Mostra di disegni del Vasari e della sua cerchia,* exh. cat., Gabinetto Disegni e Stampe degli Uffizi (Florence, 1964), p. 65; Nicolai Rubinstein, "Vasari's Painting of the Foundation of Florence in the Palazzo Vecchio," *Essays in the History of Architecture Presented to Rudolf Wittkower* (London, 1967), pp. 65–66n27; Gunther Thiem, "Neuentdeckte Zeichnungen Vasaris und Naldinis für die Sala Grande des Palazzo Vecchio in Florenz," *Zeitschrift für Kunstgeschichte,* vol. 31 (1968), p. 144; Edmund P. Pillsbury and John Caldwell, *Sixteenth-Century*

Italian Drawings: Form and Function, exh. cat., Yale University Art Gallery (New Haven, 1974), under no. 18; Edmund P. Pillsbury, "The Sala Grande Drawings by Vasari and His Workshop: Some Documents and New Attributions," *Master Drawings,* vol. 14 (1976), pp. 129–30, 139, no. 14, p. 140n18; Agnes Mongan, Konrad Oberhuber, and Jonathan Bober, *The Famous Italian Drawings at the Fogg Museum in Cambridge* (Milan, 1988), no. 37

The Fogg Art Museum, Harvard University, Cambridge, Massachusetts, Bequest of Charles A. Loeser, 1932.157

The Fogg sheet represents an intermediate stage in the planning of one of Vasari's most ambitious undertakings as a painter, the fresco decoration of the ceiling of the Palazzo Vecchio's Sala Grande (Salone del Cinquecento). In consultation with the director of the academy, Vincenzo Borghini, and probably with the patron, Duke Cosimo, Vasari revised the iconographical program of the ceiling at least three times between 1563 and 1565. The original scheme, which called for the depiction of the principal historical events of Florence, with emphasis on the glorious tradition of its districts—the Quartieri and Gonfaloni—and its guilds, was rejected for a plan that featured allegories of the territories Florence seized from its Tuscan rivals, Pisa and Siena. At Borghini's suggestion, this revised scheme, too, was altered; scenes of important battles between Florence and Pisa and Siena were included, along with episodes of the city's expansion.[1]

Fourteen of the scenes depicted or indicated by inscription on the Fogg sheets appear in the third scheme. Six subjects are retained from the second. Of the six scenes illustrated on the Fogg drawings, only the *Foundation of Florence* (right sheet, middle panel) was eventually translated into paint. The four secondary scenes, which portray the dispensing of papal and imperial privileges, were eliminated, and the scene recounting Charlemagne's rebuilding and enlargement of Florence (left sheet, middle panel) was rejected in favor of one that offers an account of

the construction of the third circle of walls around the city in 1284.[2] The present drawing was executed, therefore, after the development of the third scheme but before November 1564, when Borghini informed Cosimo that the decoration of the ceiling was almost finished.

A number of drawings by Vasari and his assistants can be connected with the Sala Grande project, among them five sheets by Giorgio that are very similar in execution to the Fogg sketches: four *Allegories of Tuscan Towns* in the Uffizi (nos. 961S, 962S, 963S, 964S) and one in the Scholz collection.[3] In all of these, Vasari used an efficient notation that establishes the placement and, roughly, the gestures of the figures as well as the distribution of light and shadow. The illumination, especially in the right Fogg sheet, falls across the forms in a manner akin to

the way raking light reveals a relief on an antique triumphal arch or sarcophagus. Such formal allusions to ancient art are appropriate here, since the ceiling decorations were supposed to carry imperial connotations. But clearly Vasari applied his washes in these schematized patterns primarily for reasons of speed and economy, and perhaps to invigorate and enhance designs that might have been reviewed by Cosimo himself.

1. The first and third plans are reproduced and discussed by Rubinstein, "Vasari's Painting of the Foundation of Florence," figs. 1–2. The second scheme is reproduced in Thiem's "Vasaris Entwürfe für die Gemälde in der Sala Grande," fig. 1.
2. Oberhuber, *Old Master Drawings*, p. 56.
3. See Thiem, "Vasaris Entwürfe für die Gemälde in der Sala Grande," pp. 101, 128n20, figs. 3–4, and Pillsbury, "The Sala Grande Drawings," pp. 128–29, pl. 3.

JACOPO ZUCCHI

Florence c. 1540–Rome c. 1596

.

Zucchi received his training in the atelier of Giorgio Vasari, where, like Naldini, he rose to the position of a chief assistant to the master. In late 1561 he followed Vasari to Pisa and remained there to work on a commission awarded to him by doctors in that city. Zucchi returned to Florence by 1563, when he joined Naldini, Stradano, and others of Vasari's *équipe* in the decoration of the ceiling of the Sala Grande (Salone del Cinquecento) of the Palazzo Vecchio. For that project, as for previous works, he subordinated his style to Vasari's. After entering the academy, he contributed to the decorations for Michelangelo's funeral held in the Medici church of San Lorenzo. He accompanied the peripatetic Vasari to Rome in 1567 and then again in the early 1570s to serve as the master's executant for the decoration of three chapels in Saint Peter's (San Michele, San Pietro Martire, and Santo Stefano; 1570–71). Soon afterward, he apparently decided to remain in Rome and embark on an independent career. As far as we know, he did not return to Florence to live until about 1589.

In Rome, he continued to secure Medici patronage; his first major commission there came from Cardinal (later Grand Duke) Ferdinando de' Medici, who asked the artist to decorate his Palazzo Firenze (c. 1574). As Zucchi assimilated the lessons of contemporary Roman art, his Vasarian manner waned, and he fabricated a style that was partly dependent on the exuberant Mannerist example of Taddeo Zuccaro. The frescoes he executed in the Roman church of Santo Spirito in Sassia (1582–89) and the Palazzo Rucellai (now Ruspoli) are dense compendia of Roman Mannerist illusionistic devices and figurative conceits. They are punctuated, however, by elements of a proto-Baroque naturalism that call to mind the innovations of Annibale Carracci.

When, late in life, he abandoned Rome for his native Florence, Zucchi again found employ with the Medici, who engaged his talents in the Sala delle Carte Geografiche in the Uffizi. His works in that room make slight concessions to the indigenous Tuscan style in their imitation of the pedestrian character of the works of several Florentine reformers, such as Santi di Tito and Poccetti.

5 7

THE STORY OF PROMETHEUS

.

Pen and brown ink with wash and white heightening with black chalk underdrawing on paper tinted ochre, 354 × 251 mm

Provenance: Phillip's, London (sold as Abraham Bloemaert)

Private collection

Edmund Pillsbury has connected this *modello* with a (lost) painting that Zucchi created for Cardinal (later Grand Duke) Ferdinando de' Medici. Records indicate that a painting of the *Story of Prometheus*, along with three others by Zucchi—a *Madonna*, a *Transfiguration* (a copy after Raphael's work), and a *Battle of Lepanto*—entered the Medici Guardaroba between 7 May 1572 and 10 March 1573.[1] These must have been among the first paintings that Zucchi executed after taking up residence in Rome as court painter to Ferdinando.

Obviously wishing to impress his new patron, Zucchi offered in his *Story of Prometheus* brilliant demonstrations of foreshortening and resourceful quotation. The prone figure of Prometheus in the foreground derives from the Sistine Adam and the fallen Saul in Michelangelo's *Conversion of Saint Paul* in the Pauline Chapel in the Vatican. The pose of the other representation of Prometheus (using a torch to enliven the man he has fashioned from clay) seems to be based on that of the Saint John the Baptist in Sarto's *Baptism of the People* in the Chiostro dello Scalzo in Florence. It is probably no coincidence that Zucchi should allude in his depiction of the creation of man by Prometheus to God's creation of Adam represented on the Sistine ceiling. The theme of creation or birth is underscored by the equation Zucchi has made, through his reference to Sarto, between fire as a catalyst for the birth of man in the ancient myth, and water as an agent for spiritual rebirth in Christian theology. The fluid turbulence of Zucchi's design, with its sweeping lines and flickering light, accords visually with the notion of metamorphosis, the underlying theme in this and other tales related by Ovid.

In style and technique the present drawing is very similar to a number of *modelli* by Zucchi, particularly the *Atlas and Hercules* (Copenhagen, Royal Museum of Fine Arts),[2] and the *Martyrdom of Saint Apollonia* (cat. no. 59).

1. Edmund P. Pillsbury, "The Cabinet Paintings of Jacopo Zucchi: Their Meaning and Function," *Monuments et mémoires. L'Académie des Inscriptions et Belles-Lettres*, vol. 13 (1980), p. 188.
2. Edmund P. Pillsbury, "Drawings by Jacopo Zucchi," *Master Drawings*, vol. 12 (1974), p. 16, pl. 17.

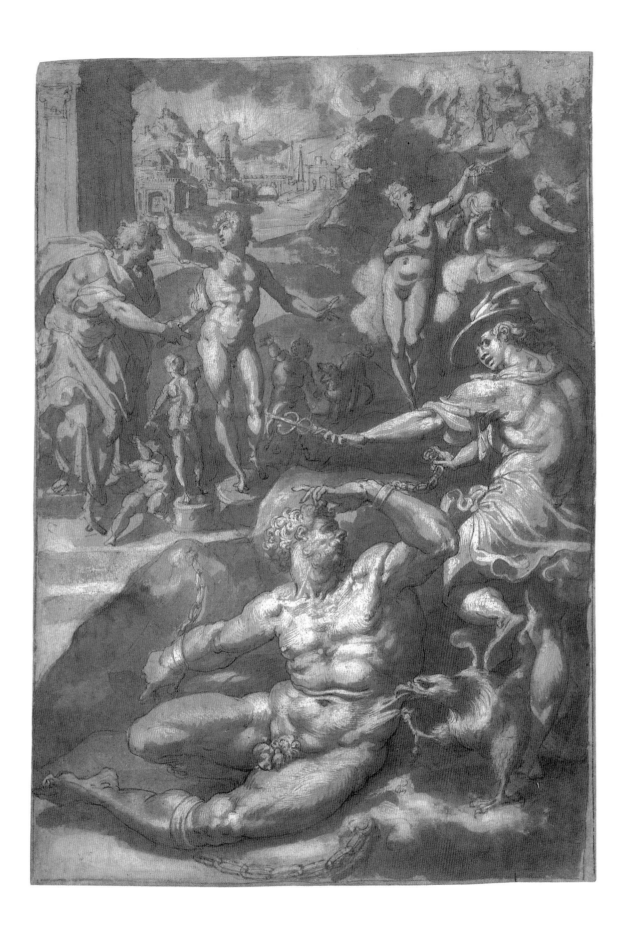

58

STUDY FOR A CATAFALQUE
DEDICATED TO COSIMO I DE' MEDICI

.

Pen and brown ink with brown wash over black chalk, 349 × 287 mm

Inscriptions: in pen and brown ink in the cartouche, *MAG COSMUS ETRURIE*; at the right on the top plan, *pisa carara*(?) / *fiorenza siena*; on the middle plan, *creatione* / *trionfo* / *coronatione* / *cavalieri*; on the bottom plan, *carita* / *fortitudine* / *justizia* / *liberalita*; at upper center, *Insom Zuccari*

Provenance: late nineteenth-century Italian collection; P. and D. Colnaghi and Co.

Exhibitions: *The Age of Vasari*, exh. cat., University of Notre Dame Art Gallery and University Art Gallery, State University of New York at Binghamton (1970), no. D26; *Florence and the Arts: Five Centuries of Patronage*, exh. cat. by Edmund P. Pillsbury, Cleveland Museum of Art (1971), no. 60; *Italian Renaissance Festival Designs*, exh. cat., Elvehjem Art Center, University of Wisconsin (Madison, 1973), no. 14

References: Eve Borsook, "Art and Politics at the Medici Court, I: The Funeral of Cosimo I," *Mitteilungen des Kunsthistorischen Institutes in Florenz*, vol. 12 (1965–66), pp. 50–54, fig. 11; F. Adams, ed., *Fourteenth Report to the Fellows of the Pierpont Morgan Library, 1965 and 1966* (New York, 1967), pp. 106–7; Edmund P. Pillsbury, "Drawings by Jacopo Zucchi," *Master Drawings*, vol. 12 (1974), pp. 16–18, 30, pl. 18

The Pierpont Morgan Library, New York, Gift of the Fellows, 1965.5

Exhibited at Oberlin and Dartmouth

This sheet is the more elaborate of two designs Zucchi made for a catafalque commemorating the death of Cosimo I in 1574; the other, also for a three-tiered, freestanding structure, is in a private collection in the United States.[1] Because Zucchi, who was living in Rome in the 1570s, does not appear to have been involved with the decorations for Cosimo's official funeral in the church of San Lorenzo in Florence, his designs can be assumed to be for a temporary structure that would have stood in one of the many Italian churches in which services were held in Cosimo's honor.[2] Pillsbury has suggested that Zucchi's scheme is for the catafalque erected in San Giovanni dei Fiorentini in Rome.[3] Documents found by him in the Vatican archives indicate that the catafalque in that church bore an inscription that began with the same words written in the cartouche of the Morgan drawing. Moreover, as Pillsbury has noted, Zucchi's most important patron in Rome, Ferdinando de' Medici, paid for the materials used in those commemorative decorations.[4]

Like the catafalque fabricated for Michelangelo's funeral in San Lorenzo, Cosimo's, in the Morgan sheet, is three-tiered with a sarcophagus and statues of river gods and other allegorical figures. In addition to these elements, Zucchi's design incorporated statues of the principal cities and rivers of Tuscany and pictures of the most important political events in Cosimo's life: his election as duke, his defeat of Siena, his founding of the Knights of Saint Stephen, and his coronation as grand duke.[5]

1. For the alternative design, see Pillsbury, "Drawings by Zucchi," pp. 16–18, pl. 19.
2. Ceremonies honoring Cosimo at his death were held in Pisa, Rome, Lyons, and Paris; see Borsook, "The Funeral of Cosimo I," p. 51.
3. Pillsbury, "Drawings by Zucchi," p. 18.
4. Ibid.
5. Ibid., p. 17.

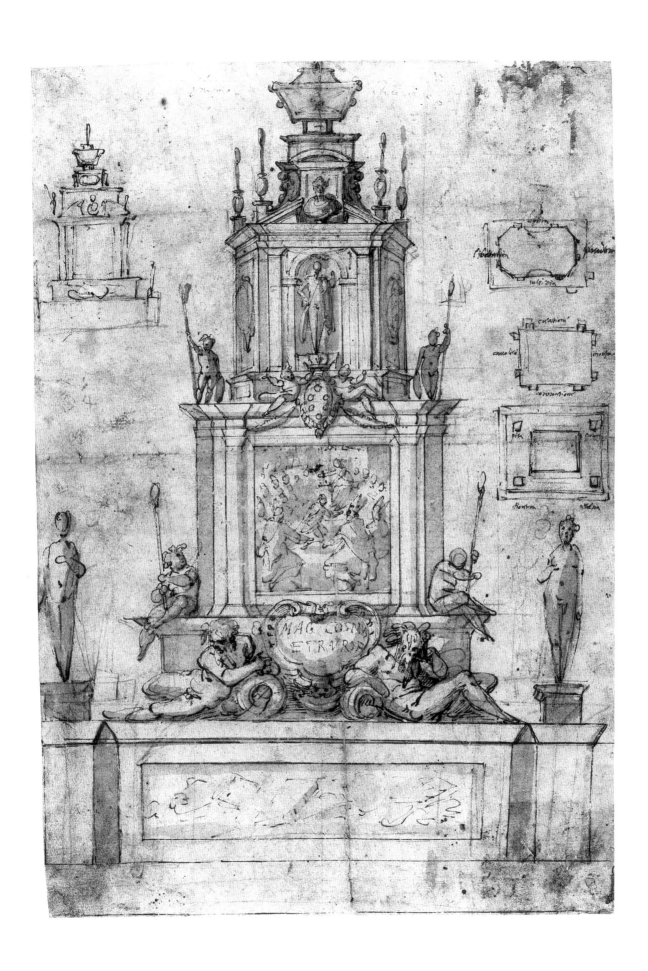

5 9

THE MARTYRDOM
OF SAINT APOLLONIA

.

Pen and brown ink with brown wash, heightened with white, over black chalk, 252 × 129 mm
Inscriptions: on verso in pencil, *T. Zuccaro*
Provenance: Rockman Gallery, New York; Ingrid and Julius S. Held, New Bennington, Vermont
Exhibitions: *Selections from the Drawing Collection of Mr. and Mrs. Julius S. Held*, exh. cat., University Art Gallery, State University of New York, Binghamton (1970), no. 141; *The Age of Vasari*, exh. cat., University of Notre Dame Art Gallery and University Art Gallery, State University of New York at Binghamton (1970), no. D29; *Master Drawings from the Collection of Ingrid and Julius S. Held*, exh. cat. by Laura Giles, Elizabeth Milroy, and Gwendolyn Owens, Sterling and Francine Clark Art Institute (Williamstown, Mass., 1979), no. 3; *Julius S. Held: Drawings from His Collection*, Miriam and Ira Wallach Art Gallery, Columbia University (New York, 1990)

National Gallery of Art, Washington, D.C., Julius S. Held Collection, Ailsa Mellon Bruce Fund, 1983.74.20

Exhibited at Oberlin and Bowdoin

Executed in Zucchi's typical windswept manner, this *modello* for an unknown altarpiece depicts the moment in the events that led to Apollonia's martyrdom when the Romans knocked out her teeth. Because of this indignity, she came to be recognized as a patron saint of dentists and of those who suffer from toothaches and other ailments of the mouth. Her popularity—and the serious nature and extent of dental problems in the Middle Ages and Renaissance—can be gauged by the great number of representations of her in Italy and Northern Europe.

Relating the serpentine movement of the saint to that of Zucchi's allegorical figure of *Religion* in the Sala Vecchia degli Svizzeri in the Vatican, painted in 1583, Edmund Pillsbury has dated the National Gallery sheet to about 1580.[1] Pillsbury has also compared the drawing to a less finished study for an *Apotheosis of a Female Saint* (United States, private collection), suggesting that the latter drawing, similar in composition and style, was done as a pendant to the present sheet. Both sheets reveal the degree to which Zucchi had shed his Vasarian inheritance by the early 1580s and had developed a Roman predilection for robust figures of exaggerated gravity. He also adopted the Roman habit of rendering forms in sculptural terms; his hatching and cross-hatching of the body of Apollonia's principal tormenter resembles the work of a sculptor's claw chisel. Despite these Romanisms, his figures are rarely ponderous, for he enlivens them with complex, corkscrewlike movements and, in places, with extremely vigorous and painterly touches of the brush.

A contemporary copy of the drawing was sold in London at Christie's in 1969 and eventually passed to a private collector in New York.[2]

1. Pillsbury, "Drawings by Zucchi," p. 15, and Giles, Milroy, and Owens, *Master Drawings from the Held Collection*, p. 16.
2. Pillsbury, "Drawings by Zucchi," p. 29–54.

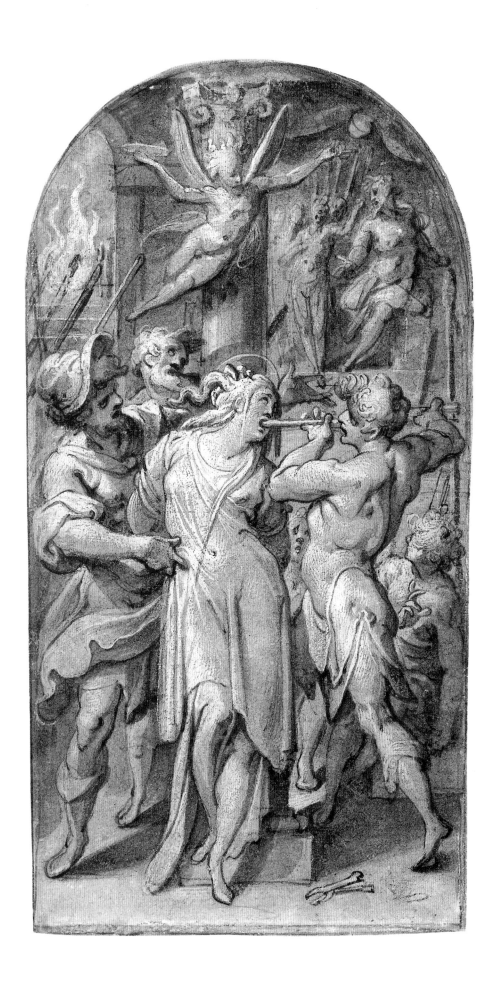

60

The Festival of Orpheus

Study for the Age of Gold(?)

.

Pen and iron gall ink over black chalk, 279 × 212 mm

Inscriptions: on recto in ink at upper center, *dis[e]gno d[e]lla gloria*; at left, *cantano / scherzano / ballano / orpheo co[l]llu[n]go saluto*(?) */ soldati asposano*(?) */ carri cavalli / come*[—]; at lower left, *Anitoni vandyck p*

Provenance: Victor Winthrop Newman (Lugt 2540); A. L. Nicholson; Frank Jewett Mather, Jr. (Lugt supp. 1853a)

Exhibitions: *Exhibition of Drawings by Old Masters from the Private Collection of Professor Frank Jewett Mather, Jr.*, exh. cat., Roerich Museum (New York, 1930), no. 39; *Italian Drawings in the Art Museum, Princeton University*, exh. cat. by Jacob Bean, Metropolitan Museum of Art (New York, 1966), no. 22

References: Felton Gibbons, *Catalogue of Italian Drawings in the Art Museum, Princeton University* (1977), no. 709; Edmund P. Pillsbury, "Drawings by Jacopo Zucchi," *Master Drawings*, vol. 12 (1974), pp. 12, 27, 33

The Art Museum, Princeton University, Gift of Frank Jewett Mather, Jr., 47.151

Pillsbury has suggested that this rapid sketch (*schizzo*) is an early preparatory study for Zucchi's painting of the *Age of Gold*, now in the Uffizi (see cat. no. 61).[1] This identification, though plausible, cannot be confirmed. Although the Princeton drawing is similar in composition and spirit to the *Age of Gold*, it differs in many respects, particularly in its inclusion of Orpheus at center (noted in the inscription). Furthermore, the composition of the present sheet, conceived in terms of pockets of figures and probably derived from the study of Northern landscapes, is not uncommon in Zucchi's works; he presents comparable, pitched-up, hilly landscapes in his design for the *Casa del Sonno* (Leipzig, Museum der Bildenden Kunst, no. 300) and in his painting of *Gold-mining* for the Studiolo of Francesco I.[2]

Several other surviving drawings by Zucchi employ the same wiry, searching line, including an *Adoration of the Shepherds* and a *Christ before Pilate* in the Louvre (nos. 21239, 11412).[3]

1. Pillsbury, "Drawings by Zucchi," p. 12. The title, *Festival of Orpheus*, which I prefer to retain, was given to the drawing by Gibbons (*Italian Drawings in Princeton*, p. 219).
2. Pillsbury, "Drawings by Zucchi," p. 14, pl. 13, and see Walter Vitzthum, *Lo Studiolo di Francesco I a Firenze* (Milan, 1969), pl. 46. Pontormo, in his *Martyrdom of the Ten Thousand* (Florence, Palazzo Pitti), was one of the first Florentines to borrow this Northern landscape scheme.
3. Pillsbury, "Drawings by Zucchi," pls. 9a–b.

Pen and brown ink, brown and ochre wash, and white heightening, 480 × 378 mm

Inscriptions: on recto in pen and brown ink on banderole at top, *O Belli Anni Del Oro*, and in brown ink at bottom, illegible inscription; on verso in graphite, *John Rottenhammer*

Provenance: Sir Thomas Lawrence, London (Lugt 2445); Adolphe-Narcisse Thibaudeau, Paris (sale, Ch. Le Blanc, Paris, 20 April 1857, lot 303); P. H. Philipp Huart(?), Paris; sale, Hôtel Drouot, Paris, 10 October 1983, lot 31; art market, Geneva

References: George Goldner with Lee Hendrix and Gloria Williams, *European Drawings* (Malibu, 1988), vol. 1, no. 57; *J. Paul Getty Museum Journal*, vol. 13 (1985), p. 194, no. 107

The J. Paul Getty Museum, Malibu, California, 84.GG.22

Exhibited at Oberlin

This is the *modello* for Zucchi's panel painting of the *Age of Gold* (c. 1578–81), preserved, together with his *Age of Silver* (c. 1578–81), in the Uffizi.[1] The largest of Zucchi's pictures on panel, and executed on wood rather than on his usual copper support, they appear to have functioned originally as portrait covers.[2] The Age of Gold became a popular theme in late sixteenth-century Florence, as Cosimo I and his sons, like their ancestor Lorenzo the Magnificent, saw (and promoted) it as a metaphor for Medici rule.[3] Pillsbury notes that this first era of unmitigated happiness on earth was evoked for the wedding of Cosimo I in 1539 and again in 1565 for Francesco's marriage.[4] He also points out that the words written across the banner, "O belli anni del oro" (O beautifully golden years), are the opening lines of a poem by Giovanni Battista Strozzi, which was sung for the third *intermedio* of *Il Commodo*, performed in 1539 as part of Cosimo's wedding festivities.[5]

Iconographically and, to some degree, compositionally, Zucchi's *Age of Gold* depends on a drawing of the theme by Vasari (after an elaborate program by Vincenzo Borghini), which was translated into paint by Poppi for Francesco I.[6] Vasari's design also features, within a comparable setting, an airborne banner bearing a similar inscription, a circle of

women holding hands in the middle distance, and reclining and bathing figures in the foreground.[7] Although the Zucchi sheet in Princeton (cat. no. 60) is reminiscent in its composition of Vasari's drawing and the present *modello*, Pillsbury's suggestion that it is preliminary for the *Age of Gold* is not convincing.[8]

The doughy, malleable character of Zucchi's figures may be due, partly, to his study of Northern art; similar types appear in the works of the contemporary Dutch artist Abraham Bloemaert. Goldner, too, has remarked on the Northern flavor of the Getty drawing, calling particular attention to the standing nude at right, which recalls figures by Bartolomeus Spranger.[9]

1. Both paintings are reproduced in Edmund P. Pillsbury, "The Cabinet Paintings of Jacopo Zucchi: Their Meaning and Function," *Monuments et mémoires. L'Académie des Inscriptions et Belles-Lettres*, vol. 63 (1980), figs. 5–6.
2. Ibid., p. 200.
3. See Janet Cox-Rearick, *Dynasty and Destiny in Medici Art: Pontormo, Leo X, and the Two Cosimos* (Princeton, 1984), pp. 15–31, and Thomas Puttfarken, "Golden Age and Justice in Sixteenth-Century Florentine Political Thought and Imagery: Observations on Three Pictures by Jacopo Zucchi," *Journal of the Warburg and Courtauld Institutes*, vol. 43 (1980), pp. 130–49. Stradano also took up the theme of the Medicean Golden Age; his drawing of the subject (Uffizi, no. 1476F) is reproduced in Annamaria Petrioli Tofani and Graham Smith, *Sixteenth-Century Tuscan Drawings from the Uffizi* (Oxford, 1988), no. 41.
4. Pillsbury, "The Cabinet Paintings of Zucchi," p. 202.
5. Ibid.
6. Vasari's drawing is in the Louvre (no. 2170) and Poppi's painting is in the National Gallery of Scotland, Edinburgh. Puttfarken has shown that Zucchi's image of the Age of Gold derives primarily from Ovid, while Poppi's seems to refer also to Lucretius' *De rerum natura*; see Puttfarken, "Golden Age," pp. 134–35.
7. See Paola Barocchi, *Vasari pittore* (Milan, 1964), pl. 92.
8. Pillsbury, "Drawings by Zucchi," p. 12.
9. Goldner, *European Drawings*, p. 136.

SELECTED BIBLIOGRAPHY

The Age of Vasari. Exh. cat. University of Notre Dame Art Gallery and University Art Gallery, State University of New York at Binghamton (Notre Dame, 1970).

Allegri, Ettore, and Alessandro Cecchi. *Palazzo Vecchio e i Medici. Guida storica* (Florence, 1980).

Bacci, Mina, et al. *Il Primato del Disegno. La Scena del Principe. Firenze e la Toscana dei Medici nell'Europa del Cinquecento.* Exh. cat. Palazzo Strozzi (Florence, 1980).

Baldinucci, Filippo. *Notizie de' Professori del Disegno,* 7 vols. Ed. Paola Barocchi (Florence, 1974–75).

Barocchi, Paola. *Vasari pittore* (Milan, 1964).

――――. *Scritti d'arte del Cinquecento.* 2 vols. (Milan, 1971).

Barocchi, Paola, Anna Forlani, et al. *Mostra di disegni dei fondatori dell'Accademia delle Arti del Disegno.* Exh. cat. Gabinetto Disegni e Stampe degli Uffizi (Florence, 1963).

Barzman, Karen-edis. *The Università, Compagnia, ed Accademia del Disegno* (Ann Arbor, 1985).

Berenson, Bernard. *The Drawings of the Florentine Painters.* 3 vols. (Chicago, 1938).

Berti, Luciano. *Il Principe dello Studiolo. Francesco I dei Medici e la fine del rinascimento fiorentino* (Florence, 1967).

Bigongiari, Piero, et al. *Il Seicento fiorentino. Arte a Firenze da Ferdinando I a Cosimo III.* 2 vols. Exh. cat. Palazzo Strozzi (Florence, 1986).

Borghini, Raffaelo. *Il Riposo* (Florence, 1584; rpt., Milan, 1967).

Borsook, Eve. "Art and Politics at the Medici Court I: The Funeral of Cosimo I." *Mitteilungen des Kunsthistorischen Institutes in Florenz,* vol. 12 (1965–66), pp. 31–54.

――――. "Art and Politics at the Medici Court II: The Baptism of Filippo de' Medici in 1577." *Mitteilungen des Kunsthistorischen Institutes in Florenz,* vol. 13 (1967), pp. 95–114.

Ciardi, Roberto Paolo, and Lucia Tongiorgi Tomasi. *Immagini anatomiche e naturalistiche nei disegni degli Uffizi, secc. XVI e XVII* (Florence, 1984).

La Corte, il mare, i mercanti. La Rinascita della scienza. Editoria e società. Astrologia, magia, e alchimia. Firenze e la Toscana dei Medici nell'Europa del Cinquecento (Florence, 1980).

Cox-Rearick, Janet. *The Drawings of Pontormo.* 2 vols. (Cambridge, Mass., 1964; rev. ed., New York, 1981).

――――. *Dynasty and Destiny in Medici Art: Pontormo, Leo X, and the Two Cosimos* (Princeton, 1984).

Dempsey, Charles. "Some Observations on the Education of Artists in Florence and Bologna during the Late Sixteenth Century." *Art Bulletin,* vol. 62 (Dec. 1980), pp. 555–69.

Gaeta Bertelà, Giovanna, et al. *Palazzo Vecchio: Committenza e collezionismo medicei 1537–1610. Firenze e la Toscana dei Medici nell'Europa del Cinquecento.* Exh. cat. Palazzo Vecchio (Florence, 1980).

Gaeta Bertelà, Giovanna, and Annamaria Petrioli Tofani. *Feste e apparati medicei da Cosimo I a Cosimo II.* Exh. cat. Gabinetto Disegni e Stampe degli Uffizi (Florence, 1969).

Giorgio Vasari. Principi, letterati, e artisti nelle carte di Giorgio Vasari. Pittura vasariana dal 1532 al 1554. Exh. cat. Casa Vasari and Sottochiesa di San Francesco, Arezzo (Florence, 1981).

Goldstein, Carl. "Vasari and the Florentine Accademia del Disegno." *Zeitschrift für Kunstgeschichte,* vol. 38 (1975), pp. 145–52.

Hale, John Rigby. *Florence and the Medici: The Pattern of Control* (Plymouth, 1976).

Hall, Marcia B. *Renovation and Counter-Reformation: Vasari and Duke Cosimo in Sta. Maria Novella and Sta. Croce 1565–1577* (Oxford, 1979).

Heikamp, Detlef. "Appunti sull'Accademia del Disegno." *Arte illustrata,* vol. 5 (Sept. 1972), pp. 298–304.

Hughes, Anthony. "An Academy for Doing. I: The Accademia del Disegno, the Guilds and the Principate in Sixteenth-Century Florence" and "II: Academies, Status and Power in Early Modern Europe." *Oxford Art Journal,* vol. 9, nos. 1 and 2 (1986), pp. 3–9 and 50–62.

Jack Ward, Mary Ann. "The Accademia del Disegno in Late Renaissance Florence." *Sixteenth Century Journal,* vol. 3 (Oct. 1976), pp. 3–30.

Monbeig-Goguel, Catherine. *Dessins toscans de la deuxième moitié du XVIe siècle. Vasari et son temps* (Paris, 1972).

Mongan, Agnes, Konrad Oberhuber, and Jonathan Bober. *The Famous Italian Drawings at the Fogg Museum in Cambridge* (Milan, 1988).

Olszewski, Edward J. *The Draftsman's Eye: Late Italian Renaissance Schools and Styles.* Exh. cat. Cleveland Museum of Art (Cleveland and Bloomington, 1981).

Pace, Valentino. "Contributi al catalogo di alcuni pittori dello studiolo di Francesco I." *Paragone,* vol. 285 (1973), pp. 69–84.

Paollucci, Antonio, et al. *La Comunità cristiana fiorentina e toscana nella dialettica religiosa del Cinquecento. Firenze e la Toscana dei Medici nell'Europa del Cinquecento.* Exh. cat. Chiesa di Santo Stefano al Ponte (Florence, 1980).

Petrioli Tofani, Annamaria, and Graham Smith. *Sixteenth-Century Tuscan Drawings from the Uffizi* (Oxford, 1988).

Pillsbury, Edmund P., and John Caldwell. *Sixteenth Century Italian Drawings: Form and Function.* Exh. cat. Yale University Art Gallery (New Haven, 1974).

Schaefer, Scott. *The Studiolo of Francesco I de' Medici in the Palazzo Vecchio in Florence.* 2 vols. (Ann Arbor, 1976).

――――. "The Studiolo of Francesco I: A Checklist of the Known Drawings." *Master Drawings,* vol. 20 (1982), pp. 125–30.

Turner, Nicholas. *Florentine Drawings of the Sixteenth Century* (London, 1986).

Valenti Rodinò, Simonetta Prosperi. *Disegni fiorentini 1560–1640.* Exh. cat. Gabinetto Nazionale delle Stampe (Rome, 1977).

Vasari, Giorgio. *Le Vite de' più eccellenti pittori, scultori, ed architettori (1568).* Ed. G. Milanesi. 9 vols. (Florence, 1878–85; rpt., 1906).

――――. *Le Vite de' più eccellenti pittori scultori e architettori, nelle redazioni del 1550 e 1568.* Ed. Rosanna Bettarini and Paola Barocchi, 9 vols. (Florence, 1878–85; rpt., 1966).

Venturi, Adolfo. *Storia dell'arte italiana, IX. La Pittura del Cinquecento.* Pts. 1–7 (Milan, 1925–34).

Viatte, Françoise. *Dessins baroques florentins du Musée du Louvre* (Paris, 1981).

Viatte, Françoise. *Dessins toscans XVIe–XVIIIe siècles.* Vol. 1, *1560–1640* (Paris, 1988).

Vitzthum, Walter. *Lo Studiolo di Francesco I a Firenze* (Milan, 1969).

Voss, Hermann. *Die Malerei der Spätrenaissance in Rom und Florenz.* 2 vols. (Berlin, 1920).

Waźbiński, Zygmunt. *L'Accademia medicea del Disegno a Firenze nel Cinquecento. Idea e istituzione.* 2 vols. (Florence, 1987).